HOW TO STUDY ART WORLDS

How to Study Art Worlds

On the Societal Functioning of Aesthetic Values

Hans van Maanen

AMSTERDAM UNIVERSITY PRESS

Cover: Studio Jan de Boer, Amsterdam, The Netherlands
Design: V3-Services, Baarn, the Netherlands

ISBN 978 90 8964 152 6
E-ISBN 978 90 4851 090 0
NUR 640 / 756

Table of Contents

Introduction

From 1960 onwards, first art philosophy and then art sociology gave birth to a stream of theories describing and analyzing the dynamics of the world of arts. This was in reaction to the difficulties encountered when attempting to understand artworks as artefacts with particular distinctive features that are produced by the unique activity of artists. While each of the scholars who contributed to this approach emphasized the importance of the relationship between the production of art and the reception of it, they mainly studied the domain of production; very little attention was paid to the domains of distribution and reception in these attempts to understand how the arts function in society.

On the basis of a critical overview of the art world, as well as field, network, and system theories, this study attempts to bring together the thinking on the organizational side of the world of arts and an understanding of the functions art fulfils in a culture; to put it more precisely: to find out *how the organization of the art worlds serves the functioning of arts in society.*

It is not at all superfluous to rethink the relationship between theoretical approaches and how the art worlds function in a practical way. On the contrary, in both areas one can notice a tendency to avoid making distinctions between various types of art; instead, a more general idea of art or even culture is favoured. As a consequence, the value of art can be formulated only on a very general level, whereas in practice very different types of art function in very different ways for very different groups of users. Hence, this book has two aims: first, to provide art world practitioners with a theory regarding what the arts can do – both within local communities as well as in society at large – in order to support the strengthening of the societal power of the different forms of art and, second, to supply theoreticians with information regarding the organizational consequences of theories for making the arts function in society.

In 1964, Arthur Danto introduced his notion of 'the Art world' as an answer to the changes in aesthetic production in the 1950s and 1960s. He described the dif-

ficulties when giving meaning to the products of these changes, called artworks, which, however, look like everyday objects. He argued in his famous article in the *Journal of Philosophy* that 'to see something as art requires something the eye cannot descry – an atmosphere of artistic theory, a knowledge of the history of art: an art world' (Danto 1964: 577). The art world is considered a world in which artists, museums, collectors and others create and discuss developments in art; it is a context in which a work can be seen as an artwork.

Since this 1964 article, the term 'art world' has established its place in philosophical and sociological thinking on art, first in the institutional approach of George Dickie and the interactional approach of Howard S. Becker in the English-speaking world, and then on the European continent as well, particularly under the substantial influence of Pierre Bourdieu. Bourdieu, however, strongly preferred the term 'field' instead of 'world' and attacked Becker for his 'pure descriptive, even enumerative' understanding of the latter term.[1] The main ways of thinking based on the art world concept during the last three decades of the twentieth century will be discussed in the first part of this book by following the most influential authors on this subject: George Dickey, Howard S. Becker, Paul Dimaggio, Pierre Bourdieu, Niklas Luhmann, Bruno Latour and Nathalie Heinich. A glance at the table of contents will make clear how institutional approaches changed over time: from Danto's and Dickie's efforts to understand art in a historical and institutional context, via Bourdieu's attempt to develop a complete theory on the dynamics of the artistic (and other) fields to the de-structuralization and 'rhizomization' in the particularly French reaction to Bourdieu. Luhmann, finally, developed a meta-theory of how social systems operate and relate to each other, not considering actors, individuals or organizations as the basic elements of such systems anymore, but communications; communications in the sense of utterances, including artworks. It can be questioned, by the way, whether the last two approaches can be called institutional any longer.

Although the specific values of these approaches will be discussed thoroughly here, this book seeks to find agreements between ways of thinking and opportunities to connect various points of view, rather than to detail the differences between the approaches discerned. Because of this none of the authors will be studied extensively; only those parts of their work that are concerned with how organizational relations in an art world, field, or system might influence the functioning of the arts in society will be discussed. Sometimes it was necessary to give some background to make the ways of thinking understandable; additionally, I've attempted to return to these authors' key insights and to avoid the (often more than interesting but too specific) details that didn't serve the aim of this book.

Nowadays, it is safe to say that the core of the original notion of an 'art world' as meant by Danto – the necessity of understanding an historical-theoretical

context for a work in order to consider it art – has very quickly been banished to the margins of the Anglo-Saxon discussion in order to make room for an institutional attack on the old functionalist idea that works can be identified as artworks because of their specific values and functions. Whereas during the 1970s and 1980s, Monroe C. Beardsley had to defend this latter approach as best he could on the American side of the Atlantic, in Europe functionalists were supported historically by a long philosophical tradition of seeking out the distinctive features of art. In his *Definitions of Art* (1991), Stephen Davies investigated this discussion thoroughly for the Anglo-Saxon part of the world, but in spite of his deep respect for the possibility of specific values and functions in art, he finally drew the conclusion that

> Something's being a work of art is a matter of its having a particular status. This status is conferred by a member of the Art world, usually an artist, who has the authority to confer the status in question by virtue of occupying a role within the Art world to which that authority attaches. (Davies 1991: 218)

In this description, Davies relied heavily on Dickies' definitions – which have, as institutional definitions do, a circular quality – and didn't succeed in establishing specific values and functions of art, no matter how important they were in terms of his own viewpoint.

Maybe Davies was right to prefer the institutional definition to the functional one; for his point of view was that the institutional approach is a more general and neutral one than the historically or culturally standardized functional definitions of art. In this sense, the institutional approach is value free; but it is precisely this freedom of value which constitutes the weakness of institutionalism, because it blocks all thinking about the value the arts contribute to society and the functions they are able to serve.

After having studied the different approaches and the key terms used, it can finally be concluded that what is usually called a functional or functionalist approach especially concerns not the functions of art, but its values. The very early description by Beardsley, a functionalist *pur sang*, already makes this fully clear: 'Aesthetic objects differ from ... directly utilitarian objects in that their immediate function is only to provide a certain kind of experience that can be enjoyed in itself' (1958, 572) – the point is the aesthetic experience. This description gives rise to the question of whether it is necessary to consider art principally as a non-functional phenomenon. It seems to be more useful, however, to separate the production of aesthetic *values* from the intrinsic and extrinsic *functions* to be fulfilled through the realization of these values by users.

The thinking concerning the values and functions of the arts as developed in the field of philosophy is discussed in part two of this book. This is an intermediary section that bridges the gap between institutional approaches to art on the one hand and questions of how the arts acquire meaning and significance in a culture from an organizational perspective, on the other. This philosophical expedition can not and will not be exhaustive; instead, I try to categorize contemporary ideas on the characteristics of aesthetic experience which can then be used to study the functioning of art in society. Important questions to be discussed will include the roles of perception, imagination and understanding, the importance of a disinterested and an interested perception, as well as the difference between the terms 'aesthetic' and 'artistic'.[2]

After the first two parts, the third will show the main processes according to which art worlds operate and which allow art to function in society. Together with the more or less stable, historically shaped and changing patterns to which they are related, these processes form the basis for ways of production, distribution and reception of art, and even partially of the contextualization of the effects of aesthetic experiences. And, as an important consequence of this, one can expect that differences on the level of these patterns and processes will cause differences in the functioning of art in a society. With this in mind, one of the motivations for writing this book is to find ways of thinking which might allow one to discover whether (and if so, how) the functioning of art in different countries might well be based on the differences in the organisation of production, distribution or reception.

The functioning of art worlds

In art theory a kind of overlap or entanglement exists between the terms value, function and functioning (e.g. Kieran 2002 and Davies 1991). In this study, *value of art* will be used to describe the capacity of artworks to generate aesthetic experience in the act of reception. Through this description it will become clear that the value of art is, on the one hand, considered to be an objective category in the sense that an artwork holds within itself the very conditions for a *possible* aesthetic experience and that all artworks have this value in common; while, on the other hand, it has an aesthetic value which has to be seen as a subjective category, in the sense that the value of a work exists in its being felt as an experience by art consumers and, consequently, as something specific in a personal or in a group-bound way. Whereas the value of art lies in its capacity to generate aesthetic experiences, the value of *an* artwork can be found in the way in which this particular work is able to generate aesthetic experiences. As already noted,

this concept will be worked out in the second part of this book, but, provisionally, Althusser's description offers a good starting point:

> The real difference between art and science lies in the specific form in which they, in a totally different way, provide us with the same object: art in the form of 'seeing', 'perceiving' or 'feeling', science in the form of knowledge... (Althusser 1966)

In the same text, Althusser offers the reader an even more subtle description: 'the special character of art is that it makes us perceive something ... that alludes to reality'. Although the specific value of art appears here to be very close to the specific function, the first can be identified as generating an aesthetic experience by forcing the perception domain to produce new schemata, *in order to* sharpen perceptive capacity or to strengthen imaginative power, which can be seen as aesthetic functions.

Once one begins to wonder why the production of aesthetic value is of any importance, or once one begins to read the phrases which governments use to legitimize their financial support for the arts, the thinking on the *functions* of art starts. In short, the difference between value and function is that the first serves the second.

The term *functioning* brings us back to the main topic of this book. This is a complex notion because it can refer to art as such, as well as to the art world. The former will be seen here as a part of the latter. In addition, not only can the operation of the system (in structures and processes) be meant when using the word *functioning* in the context of art or the art world, but also the various outcomes of the operation in terms of types of artworks and the use made of them by people or groups of people. Counting four different domains in, or directly linked with, an art world (domains of production, distribution, reception and context) and three levels at which these domains can be studied (individual, institutional and societal), the question of how an art world functions can be approached in at least 87 ways. Figure 0.1 shows a third of these ways, those related to the societal level: twelve different fields which can be studied, as well as seventeen different relationships between domains or fields.

Organizational structures, processes and outcomes are actually three moments in the operation of a system.[3] In order to allow for a detailed study of the operation of art worlds, not only the three operational moments, but also the four subsystems or domains will be defined.[4] In addition to the subsystems, which together constitute the core of the art world system, that is, production, distribution and reception, a fourth domain has been included in the model, the domain of contextualization. This can be regarded as an adjunct domain, by means of

which links with other systems can be studied. On the one hand, contextual systems (politics, education, economy) can be of significance for the operation of the art world; on the other hand, the results of the operation of the art world can have an impact on those very contextual systems. These processes can be defined as processes by which the assimilation of the outcomes of one system is organized in another system. It should be clear from the diagram that all the various fields and domains are functionally connected by arrows which symbolize the interdependent relationships between them: venues welcome certain types of performances; types of events 'produce' a need in the minds of possible audiences; the educational world values certain artists; and, first and foremost, structures make processes possible and types of processes generate types of artworks, be they theatre productions, sculptures, songs, comic strips, or poems.

Figure 0.1 Fields and relationships to be studied concerning the functioning of an art world on the societal level

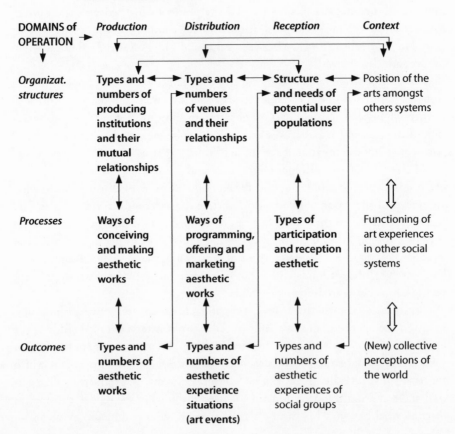

This schema is not only helpful in identifying fields and relationships systematically and in making the functioning of parts of an art world understandable, it can also be read as a model of a process that starts with the making of artworks and, via the columns of distribution (which make them available in events) and reception (in which the events are experienced), ends up with the use made of them to produce new mental schemata in order to perceive the world. In this way the functioning of an art world can be considered a process that leads to an end, whereas the structures, processes and outcomes of the fields and the operation of the relationships can be considered as various stages in this overall process.[5] It is in this sense that the functioning of the art world will be studied in the present book.

Because of this choice and in spite of the fact that all parts of the model are equal, some columns and rows can be indicated as being more crucial than others, as is shown in figure 0.2 by bold print.

The first row, called 'organizational structures', is really just a basis *for* the art world, although it is often understood *as* the art world system itself, and these structures condition the types of processes and their outcomes throughout the various domains. Within that row most authors on art worlds restrict themselves to the structure of the production field and the financial relationship with the political world.[6]

Figure 0.2 Two axes which strongly condition the functioning of an art world, in this case on the individual level

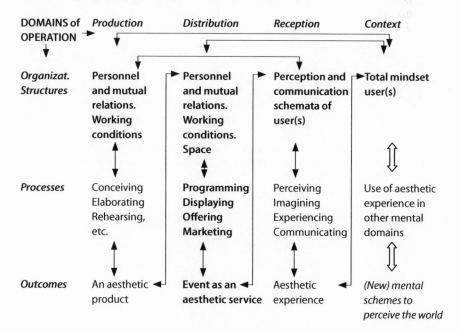

The domain most underexposed is undoubtedly that of distribution. In many cases this domain is understood as an extension of art production, whether in the form of exhibitions or performances. But even in that particular case the fact is that audiences meet an extensive aesthetic service, with the original artwork at its core, but it is this service as a whole that will attract people, make an aesthetic experience possible for them and carve out a place in their lives. So, the column of distribution, in which the aesthetic production is transformed and made available in events, is very central to the functioning of an art world, in that it brings production and reception together and organizes the aesthetic experience in specific ways.

It is hoped that this line drawn from institutional thinking on the arts, via an effort to discern various values of the arts, towards the organizational patterns and processes in art worlds, will help scholars in this field, as well as practitioners and even politicians, to understand how art world systems can support the functioning of the arts in society; or, in other words to shape conditions for the societal realization of their values.

Notes

1 Bourdieu 1996: 205

2 Provisionally, the term 'aesthetic' will be used for all types of experiences stemming from artworks. In the second part, a distinction between aesthetic and artistic experiences will be discussed further.

3 I have introduced this way of systematizing the study of the functioning of art worlds in two earlier publications on theatre: Van Maanen 1998 and 1999.

4 In this respect, the model differs from the models in Van Maanen 1998, in which the domains of distribution and reception were amalgamated in one domain called consumption. In the model presented here, the term reception has been preferred over the term consumption, in order to emphasize that, in perceiving, art audiences carry out their own production process. The fourth domain is now called 'contextualization' to emphasize the mutual movement of diffusion.

5 This is based on the choice of whether to consider the (societal) use made of art as the first function of an art world, rather than the development of art as such, which remains, of course, an essential condition.

6 See e.g. Van Maanen & Wilmer 1998.

PART ONE

THE ART WORLD AS A SYSTEM

I The Institutional Theory of George Dickie

1.1 Introduction

George Dickie (born 1926) devoted 25 years of his active life, from 1964 until 1989, to the promotion and further development of his institutional theory. In a number of articles and four books published during this period, he defended his approach against what he called instrumental, traditional or romantic theories; all of these, however, were discussed by Stephen Davies as functional theories in his thorough comparison of institutional and functional definitions of art (Davies 1991). Davies's book provides a detailed picture of the fight which took place from 1964 until the mid-1980s between Anglo-Saxon – particularly North American – institutionalists and functionalists; the two primary figures at the core of this struggle were George Dickie and Monroe C. Beardsley.

Beardsley had been searching for the distinctive features of aesthetic experiences since 1958, because he held a strong conviction – which he maintained throughout the years – that the typical character of works of art lies in their capacity to generate aesthetic experience. Reading Dickie means a continuous confrontation with Beardsley, with whom he more or less seems to be fascinated. As should be clear already from the titles of some of his articles, Dickie reacted directly to Beardsley's efforts. In 1964, he wrote 'The Myth of the Aesthetic Attitude' (in *The American Philosophical Quarterly*) and a year later published 'Beardsley's Phantom Aesthetic Experience' (in *The Journal of Philosophy*). At the same time, his list of books also shows a deep interest in the characteristics and values of artworks. In 1971, Dickie wrote an introduction to aesthetics with chapters entitled 'The Theory of Beauty', 'The Theory of Art' and 'The Aesthetic Attitude'. Only ten pages of the book were devoted to 'Art as a Social Institution' and the introduction to part V, 'The Evaluation of Art', is called 'Beardsley's Theory.' Seventeen years later, his *Evaluating Art* discusses the evaluation theories of seven philosophers, among them Beardsley again, but also Sibley, Goodman and Hume.

Even in Dickie's main works, in which he develops his institutional approach, Monroe Beardsley turns up remarkably often; when Dickie starts to write about the aesthetic object in *Art and the Aesthetic. An Institutional Analysis* (1974), he notes:

> In developing my own conception of aesthetic object I will be following the lead of Monroe Beardsley. In so doing, it will be necessary to reject one part of his theory and to develop a network of ideas underlying his theory but not explicitly recognized by him. (Dickie 1974: 147)

And ten years later, when Dickie aimed to improve and complete his institutional theory, he wrote *The Art Circle. A Theory of Art* (1984); this book was dedicated to none other than...Monroe Beardsley. Stating that there is more about art than the institutional theory can tell, Dickie makes fully clear in one statement how he sees the difference between his approach and Beardsley's: 'The theory Beardsley has in mind is a theory of what works of art do, not of what they are' (1984: 85). A more distinct description of Beardsley's position as a functionalist is hardly possible: artworks have a specific function and that is to generate aesthetic experience.[1]

That should be enough for the moment about Beardsley. His views will play a part in the second part of this book dealing with the values and functions of art. For now the task is to lay bare Dickie's institutional theory.[2] However, before we begin, the relationship between Dickie and another well-known colleague, Arthur Danto, has to be brought to the fore.

1.2 Dickie and Danto

Arthur Danto was the one who in 1964 introduced the notion 'Art world' in his so-often quoted article 'The Art world' in *The Journal of Philosophy* (no. 61: 571-584). He stated that the new art forms of his time – in which pop art, minimal art and conceptual art presented themselves and won a position – couldn't be seen as art without the introduction of the notion 'art world.' In the article, Danto discusses two problems with which contemporary art confronted him. The first problem arose as soon as an object is considered to be art but looks exactly like a real object. Something is needed to make a distinction between the two objects possible and in order to see the one as reality and the other as a work of art. Here, the famous example of Andy Warhol's *Brillo Boxes* is presented:

> What in the end makes the difference between a Brillo box and a work of
> art consisting of a Brillo box is a certain theory of art. It is the theory of art
> that takes it up into the world of art, and keeps it from collapsing into the
> real object it is. (2003 [1964]: 41)

With the help of Shakespeare, Danto begins to unveil a possible art theory by
adding: 'Brillo boxes may reveal us to ourselves as well anything might: as a
mirror held up to nature, they might serve to catch the conscience of our kings'
(2003[1964]: 44). Apart from the functional implications of this view and leaving
aside the interesting question of who it was Danto considered to be the kings of
his time, the essence of this statement is that Brillo boxes as artworks have some-
thing to say, something to express themselves and are not purely a repetition of
real Brillo boxes. There is a certain space between Brillo boxes as artworks and
Brillo boxes as reality, and this space is filled by the artwork through its saying
something about reality.

The second difficulty Danto felt himself presented with was that pure abstract
forms of art do not represent anything. He gives the example of a work consisting of
an entirely white field crossed by a black line and entitled 'No. 7.' How can this ob-
ject, not referring to anything, be seen as an artwork? The answer, writes Danto, lies

> in the fact that this artist has returned to the physicality of paint through
> an atmosphere compounded of artistic theories and the history of recent
> and remoter painting. (...) and as a consequence of this his work belongs in
> this atmosphere and is part of this history. (2003[1964]: 40)

And following this path Danto comes to his founding statement: 'To see some-
thing as art requires something the eye cannot descry – an atmosphere of artistic
theory, a knowledge of the history of art: an art world' (ibid.).

The developments in art production in the 1950s and 1960s that brought
Arthur Danto to his concept of the art world also served as the basis for the
origin of the institutional theory, although Dickie stresses that his approach did
not arise from Danto's intervention. As will be shown in the next sections, Dickie
is quite critical of Danto's argumentations and Danto, for his part, thinks that
Dickie studies the art world too much as an institution, much more than neces-
sary to solve the problems Danto has identified (Danto 1986). In point of fact,
Danto deliberately aimed to shift the attention of art historians, critics and other
professionals from the traditional idea that artworks have intrinsic and typical
features which make them art, to the view that works become art on the basis of
their position in the (historical) context, in other words because of their position
in an art world.

In *The Art Circle*, Dickie devotes an entire chapter to Danto's efforts to get a grip on contemporary art (1984: 17-27). In the first place, Danto's claim that an art theory is a requisite for the presence of artworks is attacked wrongly, I think, because Dickie is wondering whether Danto thinks 'that one must be consciously aware of an art theory and be able to state what the theory is in order to create a work of art' (1984: 19). Here Dickie shows a certain unwillingness to follow Danto, not taking seriously his example about the painters of Lascaux, who in Danto's view couldn't be artists because a concept of art most likely was lacking then. Dickie misinterprets this approach:

> I take Danto to be implying that the painters of Lascaux or any other persons must either be aestheticians and consciously hold an art theory or have an art theory told to them by an aesthetician so that they can consciously hold the theory in order to create works of art. (1984: 20)

Because the paintings of Lascaux were produced 'a very long time before anyone consciously formulated any art theory', Dickie states that Danto's claim must be false, turning around Danto's argument that something can only be *understood* (not necessarily made) as art with the help of an art theory.

In my opinion, Danto is right not only for his own time, but also for the periods before. His concern was that objects or works could only be seen as art if a conscious distinction between art and non-art was available. Over the centuries, mimesis, expression and formalist theories in all their varieties served the consciousness of this distinction, but, as stated above, in the middle of the twentieth century, Danto was confronted – as were Dickie and Beardsley – with works that couldn't be seen as art on the basis of traditional distinctions. The *Brillo Boxes* by Warhol, or John Cage's 4'33"[3] (as well as the ready-mades Duchamp had already produced at the beginning of the century) called for a revision of art theories, in such a way that the context of works would explicitly be taken into consideration.

Dickie's institutional theory is a radical attempt to do this, although it overshoots Danto's mark and in the end would appear to be quite limited in its capacity to help distinguish art from reality.

A second controversy between Dickie and Danto concerns the contributions of the latter to the much-needed revision of art theory. Dickie supposes a break between the opinion that an art theory is a necessary condition for understanding something as art and Danto's attempts to contribute to such a theory:

> The theory that art theories make art possible seems to be replaced by an-
> other theory in the later articles; at the very least, Danto puts forth another
> account of what is necessary for art. (1984:20)

What Danto is doing in the two articles Dickie refers to (Danto 1973 and 1974) is
looking for more general – or at least more adequate – features of artworks than
traditional theories offer to discern contemporary art from not-art. He examines
the difference between artworks and the things they refer to – one of the articles
is indeed entitled 'Artworks and Real Things' – as already was the case in his 1964
article.

The difference between artworks and other representations is, in Danto's
opinion, that artworks not only purely re-present ('present again') their subjects,
but also 'speak' about them in one way or another. Artworks make statements, he
says, and, in the words of Dickie, Danto thinks that 'to be an artwork it is neces-
sary for that thing to be at some remove from reality by being a statement' (Dickie
1984: 22). Dickie disputes this because in his opinion pure abstract works, for in-
stance, don't say anything about something, whereas Danto's opinion is that even
these types of work make statements, be it about art itself or about the relation
between art and reality.

Finally, Dickie formulates two essential differences between his institutional
approach and Danto's views. In the first place Danto is only looking for one or
two necessary conditions for works to be art (they need to relate to an art histori-
cal context and they need to make statements), whereas the institutional theory
'is an explicit attempt to give the necessary and sufficient conditions of art' (1984:
25), meaning an attempt to define what art really is. In the second place, the back-
ground of artworks Danto makes use of consists of certain art historical condi-
tions; in Dickie's theory this background is 'a structure of persons fulfilling various
roles and engaging a practice which has developed through history' (1984: 26).

In both conceptions Dickie finds a space between artworks and something
else. For Danto it is the space between the artwork and what it represents that
matters; for the institutional theory it is the space between art and not-art. This
distinction by Dickie springs of course from the fact that he does not accept
Danto's 'aboutness' as a necessary condition for works to be art.

On the basis of this, Dickie concludes that Danto has a number of statements
which sound institutional, but that he has nothing to say 'about the institutional
nature of art as art' (1984:17). The institutional theory is 'an attempt to sketch
an account of the specific institutional structure within which works of art have
their being' (1984:27). Davies, however, who has examined Dickie's work thor-
oughly, not only in relation to Beardsley's but also to Danto's, is of the opin-
ion that Danto can best be understood as 'proto-institutionalist' (1991:80). And

I agree with Davies because Danto's argumentation for the introduction of the concept 'art world', which he sees as necessary for understanding contemporary works as art, has opened up the possibility of considering the study of the contextual frames of these works as being decisive for this understanding. That Dickie has difficulties in recognizing this could be caused by the fact that Danto tries to integrate his contextual concept with his interest in intrinsic features of art. Dickie, in addition, cannot free himself from the latter interest, if only because of his relationship to Beardsley. He sees this integration as a threat to the pureness of institutional theory and will only accept that Arthur Danto's 'The Art world' inspired the creation of the institutional theory of art.

1.3 Dickie's theory

1.3.1 Artifactuality

In 1956 Morris Weitz stated that art had no essential and unique characteristics, no properties which were necessary and sufficient to define art and to distinguish it from other phenomena, so that art principally could not be defined (1956: 27-35). Of course, he was reacting with this statement, as Danto and Dickie would do a couple of years later, to the inability of traditional efforts to define art on the basis of intrinsic properties, such as aspects of form, expression or mimesis; he rightly establishes that works can always be found which do not meet the criteria in these terms, but which are, nevertheless, considered artworks. From this it is evident that Weitz is the one who paved the way for Dickie's institutional approach. But from his first major publication onwards (1971, *Aesthetics: an Introduction*), the latter also criticized Weitz for his conclusion that art had no essence and *thus* could not be defined, saying that this view could be true for the traditional aesthetic theories mentioned, but not necessarily for all art theories. Dickie thought an institutional definition of art was definitely possible.

That Weitz was wrong in his conclusion had, in Dickie's opinion, to do with two factors: first, the question of 'artifactuality' – the idea that artworks have to be products of human activity; second, the fact that Weitz didn't make a distinction between the two meanings of the notion 'artwork.' Dickie postulated the difference between the term 'work of art' in a *classificatory* sense and in an *evaluative* sense. In the first case, the expression 'this is art' or 'this is an artwork' means that the work 'belongs to a certain category of artefacts' (1971: 99), namely those which are called artworks. In the evaluative sense the same expression ascribes 'a substantial, actual value' to the work (1974: 43).

The institutional theory is fully based on the classificatory meaning of the notion of artwork. As Dickie reiterates, only because of the entanglement of both

senses can Weitz conclude that artworks don't need to be artefacts, objects or utterances made by human beings, but that unique natural objects can be considered art as well. An example of this might be a finely formed piece of wood or stone which can be seen as art simply because the wonderful or surprising appearance of a bird can be recognised in it, thus making it as beautiful as art. In his later work (e.g. 1974: 25-27), Dickie also discerned a third meaning in the expression 'this is art,' the *derivative* sense, based on the principle of resemblance: this work looks like artworks or a particular artwork. This third meaning suddenly opens up the possibility of being art to three types of works: forgeries, results of activities of animals, and natural objects. In judging the fine piece of wood in the form of a bird to be an artwork, both the evaluative and the derivative meaning are active. Dickie finally tried to prevent this confusion from happening in the first place by making a distinction among the different meanings of the expression 'this is art' and then by considering the classificatory sense as the only one on which a definition of art can be based.

In order to speak of artworks in this classificatory sense, artifactuality is for Dickie a *conditio sine qua non*. Forgeries, natural objects and a monkey's work are not artefacts but only resemble them. For the sake of argument he accepts a distinction between two types of art: 'artifactual art' and 'similarity art' in order to state then that human activities by which either form was produced differed so strongly from each other that the results of these activities definitely could not belong to the same category. Artifactual art was the result of an 'activity of making' (many others would say an activity of creativity, but for Dickie this term was associated too much with an evaluative approach to art); similarity art, on the other hand, was the result of 'the noticing of similarities' (1984: 36). Activities of such a different type could not generate similar types of outcomes, and, from this point of view, it was not illogical, according to Dickey, that the entire philosophy of art had always been occupied with artifactual art (1984: 35).

Artifactuality, consequently, played a central part in the definitions Dickie presented from 1971 on. His interpretation of Danto's views generated his first prudent effort: 'Perhaps the substance of Danto's remark can be captured in a formal definition' (1971: 101):

> A work of art in the classificatory sense is 1) an artifact 2) upon which some person or persons acting on behalf of a certain social institution (the art world) has conferred the status of candidate for appreciation. (ibid.)

Dickie repeated this definition and worked it out in *Arts and the Aesthetics, an Institutional Analysis* (1974), his first main study on the institutional theory of art. But in 1984, when he published his second main work on the same topic, he dis-

cussed the criticism of his concept, rejected his own definition and came up with a new one, which he considered more or less definitive for the institutional theory.

One of the problems his first definition raised was the fact that art history includes artworks that seem not to have been produced by the activity of artists. Duchamp's ready-mades are often cited as examples. In 1974 Dickie still held the opinion that in the act of exhibiting not only the status of candidate for appreciation, but also that of artifactuality, should be ascribed to the object. By 1984 he had come to the understanding that this was not the case: 'Of course it is not just the motion of lifting and affixing or the like which makes something an artifact' (1984: 44). Something else happens indeed: the fine-formed piece of driftwood, exhibited in an art museum, turns into another object, a 'driftwood-used-as-an-artistic-medium', and becomes an 'artefact of an art world system' (1984: 46-47). The wood is no more than the material out of which art world artefacts have been made, and the same is true for Duchamp's *Fountain* or other ready-mades. With this view, Dickie seems not too far away from Danto's opinion that 'to see something as art, requires…an art world.'

1.3.2 *The essential framework*

After having discussed his favourite subjects – the failures of Arthur Danto and the importance of artifactuality – Dickie devoted the central part of *The Art Circle* to 'The Institutional Nature of Art' (chapter IV) and to 'The Art world' (chapter V). And once again he started with a reaction to Beardsley: 'I shall first note and accept some of the criticisms Beardsley makes of my theory, thus amending my conception of the institutional nature of art' (1984: 51).

Beardsley distinguished between institution-types and institution-tokens (1976), meaning by the first a type of practice, such as storytelling or marriage, for instance, and by the latter the organizations in which these practices operate, such as film companies or the Roman Catholic Church. Beardsley stated that in Dickie's concept the art world was an institution-type, a set of practices, but that his definition contained elements strongly based on the concept of the institution-token, for example, 'conferring status' and 'acting on behalf of (a certain social institution)'; 'Beardsley is, I think, completely right on this point', Dickie wrote, 'The formulation of the institutional theory I have given is not coherent' (1984: 51-52). In Dickie's view, however, this didn't alter the fact that a coherent institutional theory could indeed be formulated and on the very same page he started to develop a new one:

> What I now mean by the institutional approach is the view that a work of art is art because of the position it occupies within a cultural practice, which is of course in Beardsley's terminology an institution-type. (1984: 52)

Before he worked this view out, Dickie got lost in his tendency to negate what he called the 'romantic conception of art.' This conception would have to be based on the idea of a fully autonomous and free creation by artists, which was a no-contest situation, because in twentieth-century art philosophy or sociology, there were no scholars who supported this idea. This was also true for Beardsley who stated that an artist's thoughts should be 'moulded by his acquired language and previous acculturation', in other words, that an artist's work should take place within an 'atmosphere of artistic theory, a knowledge of the history of art: an art world' (to use Danto's words again). Dickie was fighting windmills, and rather than trying to keep a 'romantic view' alive by disputing it, he should have taken seriously the merits of the functional approach in relation to the institutional one, which, in fact, he finally seemed to do by the end of *The Art Circle*.

Dickie asked the rhetorical question of whether art can be created independently of a framework. To answer it he made use of the idea of 'a person totally ignorant of the concept of art' creating a representation (1984: 55). His argument is especially notable in relation to the dispute with Danto, discussed above: 'such a creation would not be a work of art... he [the creator, HvM] would not have any cognitive structures into which he could fit it so as to understand it as art' (ibid.). After more than ten years, Danto's statement about the painters of Lascaux not being artists seemed finally to be recognized by Dickie, who now definitively reformulated the view that 'a framework is essential for an object's being art' (1984: 63). Moreover, he stated 'that the notion of a framework which makes possible the creation of art has been present all along in theorizing about art but that it has not been developed' (1984: 64), referring to theories of mimesis, expression and form which all stressed the properties of artworks as such and by doing so kept their own framing capacity hidden.

Finally, and this is what is really important for the present study, Dickie added that, besides artists and artworks, the public had a role in this framework:

> The institutional theory sets works of art in a complex framework in which an artist in creating art fulfils a historically developed cultural role for a more or less prepared public. (1984: 66).

Although Dickie emphasized that works that were not presented to a public could also be artworks if they were only intended to be presented to a public – a view which would be impossible in a more functional approach – he finally does seem to consider the role of the (intended) audience as being something quite essential to the framework. He characterizes the public along two lines: all their members had to be aware of the fact that 'what is presented to them is art' and had

to have 'the abilities and sensitivities which enable one to perceive and understand the particular kind of art with which one is presented' (1984: 72).

In 'a society of any complexity' the roles of artists and audiences are often made functional by means of a third type of role, filled by mediating personnel, such as producers, theatre managers, art dealers and critics. Dickie liked to stress here that he, using the term personnel, did not mean a particular group of persons in a formal organization, but rather the roles being filled in the art world: 'The art world consists of the totality of roles (...) with the roles of artist and public at its core' (1984: 74-75). It will become clear that the roles played in the art world, mostly in 'an art world system,' as Dickie calls theatre, literature, painting, and so on, require knowing and acting on the basis of conventions. Dickie speaks only in a very general sense about conventions, making a distinction between nonconventional basic rules – such as the artefact rule – and conventional rules, 'which derive from the various conventions employed in presenting and creating art,' so that 'the art enterprise can be seen to be a complex of interrelated roles governed by conventional and non-conventional rules' (1984: 74). With this description Dickie is not far removed from Howard S. Becker anymore; Becker made the role of conventions one of the core themes of his approach, as will be discussed in the next chapter.

In chapter V of *The Art Circle*, Dickie finally formulated his new institutional theory. For the last time he returned to his approach in *Art and the Aesthetic*, where he 'focused on the 'center' of what I'm now calling art's essential framework – works of art themselves' (1984:79). Now he thinks that a series of definitions, not only of the centre, but of all vital parts of the framework should serve to conclude his 1984 arguments. He starts with the artist, '*a person who participates with understanding in the making of a work of art*' (1984: 80), stressing that there is a difference between how a carpenter who builds props understands the work and the way in which an artist is aware of the artistic process and his intentions within this. As Dickie noted, this first definition leads 'naturally' to the definition of a work of art: '*A work of art is an artifact of a kind created to be presented to an art world public*' (ibid.). The term 'kind' does not concern genres or disciplines here but is connected with 'to be presented': artefacts of a kind to be presented, which, by the way, in Dickie's view, does not mean that they have to be actually presented in order to become artworks. This definition leads to the definitions of 'public' and 'art world': '*A public is a set of persons the members of which are prepared in some degree to understand an object which is presented to them*', and '*The art world is the totality of all art world systems*' (1984: 81). By art world systems, Dickie means different systems such as 'literary system, theatre system, the painting system, and so on' (1984: 82).[4] In the final definition of the 'art world system,' 'the whole set of definitions becomes transparent,' in Dickie's view: '*An art world system is a frame-*

work for the presentation of a work of art by an artist to an art world public' (ibid.).
To make it a bit more concrete: the theatre world is a framework for the presentation of a theatre production by theatre artists to an audience, the members of which possibly understand this production.

Besides this new and, for the present study, significant emphasis on the presentation aspect of the system – instead of the usual attention paid to the production part of it, of course – the circularity of the definition is striking. Dickie is aware of this and also knows that in modernist scholarly work this type of definition is not acceptable. He therefore devotes a number of pages to this question in order to defend his understanding that 'the only correct account of it [art, HvM] would have to be a circular account' (1984: 78). He gives two reasons: first

> a philosopher's definition of 'work of art' does not and cannot function in
> the way a definition is supposed to function (...) – to inform someone of the
> meaning of an expression one is ignorant of by means of words one already
> knows. (1984: 79)

Coupled with this view is Dickie's opinion that the philosophical definition's only aim is 'to make clear to us in a self-conscious and explicit way what we already in some sense know' (ibid.). The second reason why a definition of art has to be circular is, in Dickie's view, the 'inflected nature of art', 'a nature the elements of which bend in on, presuppose and support one another' (ibid.).

To complete the description of his institutional theory, Dickie's own evaluation of the definition set discussed here is presented in his own words:

> ...what the definitions reveal and thereby inform us of is the inflected nature
> of art. The definitions help us get clear about something with which we are
> already familiar but about whose nature we have not been sufficiently clear
> from a theoretical point of view. What the definitions describe and thus
> reveal is the complex of necessarily related elements which constitute the
> art-making enterprise. (1984:82)

1.4 The benefits of Dickie's institutional theory

Over the twenty-year period when he was developing his institutional approach, Dickie always kept an eye on colleagues who were thinking more about the values of art. In his publications he even devoted a certain amount of attention to these matters, mostly in the form of a dispute within the framework of his own theoretical attempts. In *The Art Circle*, for example, he returns to Beardsley who had

insisted 'that there is a function that is essential to human culture (...) and that works of art fulfil, or at least aspire or purport to fulfil' (Beardsley 1976: 209). The surprising reaction Dickie has is that Beardsley's essentialist view is not in competition with traditional theories of art – which consider specific properties, such as mimetic, expressive or formal qualities essential for objects being artworks – nor with the institutional theory: 'The theory Beardsley has in mind is what works of art do, not of what they are' (1984: 85). In Dickie's view, nevertheless, the essential properties of art will not be found in the aesthetic experience Beardsley has in mind when he speaks about 'the function...essential to human culture ... that artworks fulfil.' He fairly admits that

> The institutional nature of art does not prevent art from serving moral, political, romantic, expressive, aesthetic, or a host of other needs. So there is more to art than the institutional theory talks about...(1984: 86)

Only to emphasize, finally: 'but there is no reason to think that the more is peculiar to art and, hence, an essential aspect of art' (ibid.). Consequently the essence of art can only be formulated within an institutional theory. Whether this point of view can be considered a correct one will be the subject of research in the second part of the present study.

When Dickie wrote *The Art Circle* he had the feeling that his institutional theory was ready and he was right: it was finished and sufficient; the circle was round and the statement had been made. As he says, his theory does not do very much to provide help with thinking about the functioning of art in society, nor does it strongly support the attempts to find out how art world systems make art, artists and artworks function in society; what this institutional theory mainly does is aim for the victory over definitions of art based on essential properties, values or functions. Nevertheless, Dickie's significance for the present study is that he, from a philosophical point of view and particularly by means of his debate with Beardsley, makes the distinction between an institutional and a functional way of thinking absolutely clear. For art sociologists who are trying to discover the functioning of art and art worlds, this understanding of the distinction between both ways of thinking opens up the possibility of investigating the possible relationships between them. In addition to this, two other elements of Dickie's approach are of indisputable importance. Firstly, there is his concept of roles and rules, which clarifies the significance of conventions in making an art world system operate; secondly, there is his emphasis on the essential role of the public, a public which exists as a more or less prepared addressee of the artist's activity. Both of these aspects have been extensively worked out by Howard S. Becker, as will be shown in the next chapter.

Notes

1 In the introduction I already proposed using the term *value* for the capacity of artworks to generate aesthetic experience and suggested reserving the term *function* for the usefulness and benefits of aesthetic experiences.

2 Dickie's institutional theory is part of a philosophical debate on art and should not be confused with what is also known as '(new) institutionalism', which is a sociological school. The latter will be briefly discussed in the next chapter in relation to Howard S. Becker's art world concept.

3 This piece of music consisted of the sounds heard during a period of four minutes and thirty-three seconds of not playing the instruments(s.)

4 Here Dickie very implicitly brings in the notion 'system', where the use of terms like 'literary world', 'theater world'; etc., would more likely be expected. This terminological question will be discussed in depth at the end of part one of this study.

2 The Institutionalist Pragmatism of Howard S. Becker and Paul Dimaggio

2.1 Introduction

Art Worlds, written by the sociologist Howard S. Becker and published in 1982, was a book-in-between. In the first place, it could have been based on the art world discussion of the 1960s and 1970s, but it only devoted an isolated chapter to this discussion, while at the same time it came out too early to react to Bourdieu's field theory, which was not to be extensively explained and demonstrated until 1992 in *Les règles de l'art (The Rules of Art*, 1996).¹ Secondly, Becker's book does not make any theoretical choices, except for the one that the art world has to be studied from a symbolic interactionist point of view, but that view alone does not offer a choice of theoretical defences for its position from among the contemporaneous theories such as structuralism, institutionalism, constructivism or deconstructivism. Thirdly, Becker's theoretical work on art was an activity positioned somewhere adjacent to his main concerns, which were with sociological methodology and the study of deviant behaviour.² *Art Worlds* is his only monograph on this topic, although based on a series of articles published over the years between 1974 and 1980.

Becker relates explicitly to the institutionalist approaches of his time, especially Dickie's, albeit based on the views in *Art and the Aesthetic. An Institutional Analysis* (1974); the work in which Dickie largely retracts these views would not be published until 1984, two years after Becker's book. In his chapter on 'Aesthetics, Aestheticians and Critics', Becker makes his position vis-à-vis the institutionalists fully clear:

> Philosophers tend to argue from hypothetical examples, and the 'art world' Dickie and Danto refer to does not have much meat on its bones, only what is minimally necessary to make the point they want to make. (...) None of the participants in these discussions develops as organizationally compli- cated a conception of what an art world is as in this book, although my de- scription is not incompatible with their arguments. (Becker, 1982: 149-150)

A former piano player, on the one hand confronted with the daily activities and difficulties of that way of living, while, on the other, a representative of the Chicago School of Symbolic Interactionism, stressing the role of individual activity in the organization of the world, Becker argues that extensive empirical knowledge of what goes on in an art world should be helpful in order to 'make headway on some problems in which the philosophical discussion has bogged down' (ibid.). Four of these problems are discussed briefly, under the titles: Who? What? How Much? and How Many?

The first question, referring to Dickie's old definition of art, is 'Who can confer on something the status of candidate for appreciation, and thus ratify it as art?' (ibid.) And the answer is that, although the people involved seldom completely agree on who is entitled to speak on behalf of the art world,

> the entitlement stems from their being recognized by the other participants in the cooperative activities through which that world's work are produced and consumed as the people entitled to do that. (151)

What Becker adds to Dickie's view here is one of the essential concepts of his approach, as will become clear later: the understanding of the art world as cooperative activities and links between participants. This also means that the status of artworks depends on an often unstable consensus among participants in an art world, which, by the way, is not at all in contradiction to the institutional approach.

The second question concerns the inevitable debate on 'the characteristics an object [must] have to be a work of art' and especially whether 'anything may be capable of being appreciated' (153). Entirely according to the institutional tradition, Becker states that no constraints on what can be defined as art exist, except those which 'arise from a prior consensus on what kinds of standards will be applied and by whom' (155).

The 'how much' and 'how many' questions Becker poses are less essential, but will also help in understanding his approach to the art world. First he wonders 'how much institutional apparatus' is required to use the term art world. He comes to the conclusion, based on former chapters, that there is no fixed number of persons to be involved or amount of equipment to be used, because 'at an extreme, any artistic activity can be done by one person, who performs all the necessary activities' (157). In connection with this Becker poses the strategy ('often and with considerable success') of 'organizing de novo an art world which will ratify as art what one produces' (156), which raises the fourth question of how many art worlds can be spoken of. Dickie discerned art world systems based on the main disciplines and felt it likely that 'a new subsystem would be added within a

system' (158). Bourdieu, as we will see, is a bit more precise on this point, stating that activities influencing an existing field can be considered part of it. Becker points out, however, that the worlds of various disciplines are often subdivided into 'separate and almost noncommunicating segments' (158). Because he defines art worlds in terms of the activities their participants carry on collectively, Becker tends to discern many different art worlds, although he also sees two types of factors which concern all of them, so that from a certain point of view one can speak about one art world as well.[3] The first one consists of external factors that constrain all sorts of art worlds in the same way, such as economic recession or censorship. All participants will, in their reactions, 'engage in a form of collective activity and thus constitute an art world' (161). The same holds for the second type of factors, referring to the situation in which various art worlds may deal with the same themes and perspectives, as happens, for instance, when 'during periods of intense nationalism artists may try to symbolize the character and aspirations of their country or people in their work' (161). Neither factor has very much to do with the principal arguments of institutionalism, but they do show the central position 'collective activity' occupies in Becker's approach.

The founding fathers of symbolic interactionism at the University of Chicago, such as C.H. Cooley (1854-1929), G.H. Mead (1863-1931) and H. Blumer (1900-1987), developed the social psychology of the Chicago School in a direction that gave more space to human beings in their struggle with existing social structures. Whereas Mead still explained human behaviour as an adaptation to the social environment, tending even to social determinism, Blumer considered human beings able to give meaning and direction to the situation they were living in on the basis of expectations from the social environment and people's self-image.[4] In the latter direction Becker developed his concept of the relationship between institutions (although reduced by him to the weaker notion of 'conventions') and participants in the art world. The Dutch art sociologist Ton Bevers calls this approach the social-scientific perspective, which

> takes a position in the middle between two poles: the individual and society. It avoids the metaphysics of the genius-concept as well as the sociologism of the puppet show syndrome, by moving the centre of gravity to the middle, to the forcefield of what takes place among people: the social relationships. (Bevers 1993: 12)

Bevers holds the opinion that this is true for such different sociologists as Becker *and* Bourdieu, which raises the question of which position in the field of sociology exactly is meant by researching 'the field of powers of what takes place among people: the social relationships.' For the struggle between institu-

tions and agents, central in sociological theory, had been expressed more than adequately already by Karl Marx in 1856, when he wrote in *The Eighteenth Brumaire of Louis Bonaparte*: 'People create their own history, but they do so under given and traditional circumstances they are immediately confronted with'. Since then the task of sociology could no longer be to choose between the 'individual' and 'society' but instead to discover the characteristics of the relationships between the two, as will be made clear from the continuing discussion on the relationship between agency and social structure. This challenge has also been taken up by Becker and Bourdieu, but in two essentially different ways, based on their points of view as well as their working methods. More about this will become clear in this and the following chapter, but here it can already be said that both, in doing research on social relationships, stake out very different positions on the scale between the individual and the institution. Whereas Becker, coming from an interactionist tradition, stresses that human beings make their own history, his European counterpart, coming from a structuralist tradition, bases his research especially on the given circumstances with which human beings are confronted.

2.2 Becker's concepts

In the first chapter of *Art Worlds*, Becker presents his entire set of concepts and then works them out in a number of other chapters by applying them to such different themes as 'Resources', 'Art and State', 'Art and Crafts', 'Editing' or 'Reputation'. Before these thematic elaborations take place, a conceptual chapter is devoted to the role of conventions.

The two central notions in Becker's understanding of an art world are 'collective (or cooperative) activity' and 'conventions'.

> I have used the term [art world] (...) to denote the network of people whose cooperative activity, organized via their joined knowledge of conventional means of doing things, produces the kind of art works that art world is noted for. (Becker 1982: X)

For the circularity of the definition Becker uses exactly the same reasoning as Dickie, that it 'mirrors the analysis which is less a logically organized sociological theory of art than an exploration of the potential of the idea of an art world' (ibid.).

2.2.1 Collective activity

One of Becker's favourite aims is to make his readers believe that no reason can be found which can prove that some people in the cooperative work, which art is, in his view, are more important than others:

> Growing up in Chicago – where (...) Moholy-Nagy's Institute of Design gave a Midwestern home to the refugee Bauhaus' concern for the craft in art – may have led me to think that the craftsmen who help to make art works are as important as the people who conceive them. (IX)

Although the activities to be done vary from one (sub)discipline to the other, Becker composes a provisional list of seven regular activities in making art. First, one or more 'originators' have to *develop an idea* (1) about the kind of work and its form. The next stage is that *the idea*, be it a film script, a composition or a design for a monumental sculpture, *has to be executed* (2). For many disciplines it is also true that execution of the idea needs *materials and equipment*, such as paints, cameras or musical instruments *that have to be manufactured* (3). The activities already mentioned take time, or, in other words, require money, which artists (the 'originators'?) raise, 'usually, though not always, (...) by *distributing* (4) their works to audiences in return for some form of payment' (p. 3, italics HvM). To develop ideas, to execute them and to distribute the results requires in most cases various *supporting activities* (5), such as copy editing, sweeping the stage, bringing coffee and manipulating machinery. 'Think of support as a residual category, designed to hold whatever the other categories do not make an easy place for' (p. 4). Two other types of activities, finally, are not concerned with the making of artworks as such, but can still be seen as necessary for their existence. Both have far-reaching theoretical backgrounds, which are not discussed here by Becker, but are simply taken for granted. The first is the '*activity of response and appreciation*' (6) without which a work does not exist. In Dickie's view, as was mentioned in the former chapter, being made for presentation should be sufficient for a work to be art, but Becker goes two steps further: it has to be presented and to be responded to as well. This view, by the way, goes back as far as Marx's early work, where, in texts still worth reading, he thoroughly analyzes the multiple relationships between production and consumption and notes: 'in contrast with the merely natural object, the product affirms itself as a product only in the consumption of it, becomes only a product in this act. By decomposing the product, it is the consumption that gives the product its finishing touch' (Marx 1974 [1859]: 492). The final activity mentioned by Becker 'consists of *creating and maintaining the rationale* (7) according to which all these other activities make sense and are worth doing' (p. 4., ital-

ics HvM). Danto's argument for the inevitability of the notion art world, as well
as Dickie's idea of the essential framework, seem to be echoed here. But it only
seems so, for, after having presented this list of activities that must be carried out
'*for any work of art to appear as it finally does*' (p. 5), Becker likes to emphasize that,
if some activities were not to be executed, the work would occur in some other
way, though 'unsupported,' 'unappreciated.' 'It will not be the same work. But that
is far different from saying that it can not exist at all unless these activities are
performed' (ibid.). And a number of examples follow showing how poets copied
their own manuscripts or even decided not to make them public at all (Emily
Dickinson). It can be questioned, of course, whether these examples tackle the
theory, for a couple of pages further on, Becker stresses again that full autonomy
is impossible for artists, if only because of 'the background against which their
work makes sense (...) Even so self-sufficient a poet as Emily Dickinson relied on
psalm-tune rhythms an American audience would recognize and respond to' (14).

It is not essential for understanding the art world to know how many people
participate in making artworks (this can vary from one person to a great number
of specialists and all possibilities in between), but it is necessary to know their
'bundles of tasks': 'To analyze an art world we look for its characteristic kinds of
workers and the bundle of tasks each one does' (9). Again, a number of examples
of labour division and training activities on the basis of which labour division can
occur are presented to convince the reader of the importance of this view: a lot of
meat on very thin bones, so to speak.

Besides the question of whether the structures of an art world can really be
analyzed by knowing the kind of work(ers) involved in it, a main problem raised
by Becker's idea of cooperation concerns the bundle of tasks and the position of
the artist within the collective activity. He makes a fine distinction between the
work of all the cooperating people that he calls 'essential to the final outcome' and
the core activity of the artist 'without which the work would not be art' (24-25).
What the core bundle of tasks of the artist consists of is not described explicitly;
probably Becker means that the artist is the same as what he calls earlier 'the orig-
inator' and consequently that his main task is to produce 'artistic ideas', whatever
they may be.[5] But in a sense he questions the core position of the artist by asking
how big his contribution to the work should be in order to call him the artist and
by wondering who should be considered the artist in a collectively made work,
such as a film or a performance.

The first question, 'how little of the core activity can a person do and still
claim to be an artist?' is implicitly answered with the help of a number of very
well-known examples varying from the rough compositions by John Cage and
Karlheinz Stockhausen – who left much to be decided by the musicians who had
to play them – to Duchamp's painting of a moustache on a reproduction of the

Mona Lisa or the addition of a signature on a urinal. So the answer simply appears to be: as little as is imaginable can be enough.

The second question is a bit more complex, because in collectively made works like films, concerts or theatre performances, different participants can be expected to deliver 'artistic ideas'. The work of authors of scripts, composers, directors and conductors, as well as actors and set designers can be seen as artistic core activity. Although Becker tends to consider classical musicians and theatre actors as executing personnel, the latter especially have been emancipated artistically in the last quarter of the twentieth century by strengthening their position in relation to the figures they have to play; in other words, more than trying to represent the written figure, they present how they experience the figure in relation to themselves, which can be considered an 'artistic task'.

Becker points out that people who like to give the artistic credit of a collectively made work to a core person see the intentions of this contributor as central to the work. But, as he notes, the interpreter's or even audience's intentions can also dominate the experience of the work. Problems arise, according to Becker, 'when participants disagree and standard practice produces unresolvable conflict' (21). He thinks he has found a sociological solution to studying 'the philosophical and aesthetic problem,' which would be fine if there ever had been such a problem. But there is only a sociological problem, because the philosophical question of who should be the artist in collectively made works can easily produce a pluralistic answer based on a thorough aesthetic analysis of the work.

It will become clear that seeing the making of art as a cooperative activity is based on what Becker calls cooperative links, which for their part are executed in shared practices based on a joint knowledge of conventions. The essential feature of these links is interdependency: 'Wherever he [the artist, HvM] depends on others, a cooperative link exists' (25). This is all the more interesting when specialized personnel, such as musicians, printers or technicians, participate in executing the work. They have their own interests and especially their own craftsmanship, both of which can conflict with the artist's ideas; for instance when musicians find a composition too difficult to play, or when roller marks should be part of an artistic design, but in the eyes of printers can appear as a lack of craftsmanship.

Becker makes especially clear how conventions relate artists to people involved in the domains of the distribution and reception of art:

> composers write music which requires more performers than existing organizations can pay for. Playwrights write plays so long that audiences will not sit through them. Novelists write books that competent readers find unintelligible or that require innovative printing techniques publishers are not equipped for. (27)

The result is, according to Becker, that artists make what distribution institutions can assimilate and what audiences appreciate. In relation to aesthetics this is a rather poor situation, but, fortunately, there are some exceptions in the form of 'non-standard distribution channels, adventurous entrepreneurs and audiences. Schools often provide such an opportunity' (28). From a late-twentieth-century European point of view, based on aesthetics in which the very challenge of conventions is a central theme, this does not sound very hopeful, but maybe a cultural difference between the United States' and the European art worlds in the 1980s is what is at stake here.

2.2.2 Conventions

Conventions play an essential role in making cooperation possible. They 'dictate' the materials to be used, 'the abstractions to be used to convey particular ideas or experiences' (29) and 'the forms in which materials and abstractions will be combined' (ibid.). Conventions 'suggest' the appropriate dimensions of a work and they 'regulate the relations between artists and audience, specifying the rights and obligations of both' (ibid.).

Becker pays special attention to the role of conventions in the relations between artists and distributors, on the one hand, and between artists and audiences, on the other. His point of departure is that the domain of distribution is there to generate income for the artists, so that they can make new work and so on and so forth:

> Fully developed art worlds (...) provide distribution systems that integrate artists into their society's economy, bringing art works to publics who appreciate them and will pay enough so that the work can proceed. (93)

What appreciation by the public means here will probably become clearer in the sections on the cooperation between artists and audiences, but it is worth noting already that distribution systems could also be imagined which integrate artists or their works in society's ideological world, in which people use them to experience the world or to examine their moral values.[6] Economic thinking, however, brings Becker – and others as well[7] – to a point where he turns around what Max Weber calls substantive-rationality (referring to the essentials of social activity) and instrumental-rationality (referring to forms of organization), by putting the second one in the first place. Maybe the strength of this lies in the fact that the public-sale system can be considered the most general type of art distribution in the industrialized world. Becker sums up the six 'basic workings' of it:

(1) [E]ffective demand is generated by people who will spend money for art. (2) What they demand is what they have learned to enjoy and want, and that is a result of their education and experience. (3) Price varies with demand and quantity. (4) The works the system handles are those it can distribute effectively enough to stay in operation. (5) Enough artists will produce works the system can effectively distribute that it can continue to operate. (6) Artists whose work the distribution system cannot or will not handle find other means of distribution; alternatively, their work achieves minimal or no distribution. (107)

The second point will be discussed in the next sections on the cooperative links between artists and their public. For now it is important to note that the intermediaries who run distribution systems 'want to rationalize the relatively unstable and erratic production of 'creative' work, because they are in business' (93-94).[8] And because, as said before, Becker is fully – and correctly – convinced of the central, often even dominant, position distribution systems have, 'Artworks always bear the marks of the system which distributes them' (94).

But opportunities for artists to escape from overly strong constraints imposed by a distribution system seem to exist. 'You can always do things differently if you are prepared to pay the price in increased effort or decreased circulation of your work' (33). One possibility has been mentioned already: artists who are refused by an existing system can try to develop a new one, more adequate to their work. If their work is already strong enough and already offers the existing distribution system an opportunity to make some money or to have hope for doing so at a future time, deviant work can even try to change the existing distribution system.[9] Two other possibilities for avoiding limitations caused by distribution systems are discussed in Becker's vast chapter on distribution, but do not have much to do with it: self-support and patronage can set the artist free from existing distribution systems in a financial sense, but not from distribution as such, at least if he wants to be an artist. For, as has been noted before, works have to be experienced by others in order to be artworks, according to Becker, and artworks make the artist. So self-support and patronage can be considered resource systems in the domain of production which break the chain of producing-presenting-selling-buying and materials-making for new work. In a patronage system, possible constraints on the production level, as well as on the distribution level – albeit entirely different ones than in a public-sale system – are not so remote, and in a self-supporting system – which means that the artist is financially independent – the self-chosen distribution system by which the 'originator' becomes an artist can certainly not be thought of as free from any conventions, although it does open opportunities for challenging them.

The most general way – although not mentioned by Becker – for artists to escape from the market's requirement to produce work that serves audiences in a conventional way is to get state subsidy, which is not the same as government patronage. In the latter case there has to be something of an employment situation within which the artist delivers the type of works asked for.[10] Just like self-support, state support gives artists the opportunity – if their plans pass the advisory committee – to make what they want, but in most cases this means not changing or avoiding the conventional distribution systems, because, in exchange for the subsidy they get, they have to make their production available to the public.

To challenge conventional distribution systems is not without significance, simply because distribution institutions, such as museums or concert and theatre halls, are the organizers of the encounters between art and audiences. But, because of the conventionalized way of organizing the aesthetic encounter, it will always be of a certain type and for a public with a certain background. Self-supporting artists, students, amateurs, in addition to artists 'who are prepared to pay the price', can break ground for new types of encounters with new audiences who will get new types of aesthetic experiences.

The challenge to break through conventional ways of experiencing art and, as a result, of experiencing reality is not only central in most art policy programs of democratic states, but also has a place in Becker's discussion about the links between art production and art reception, albeit an ambiguous one. Speaking about the role of conventions in aesthetic experience, Becker states that 'each work, and each artist's body of work invites us into a world defined in part by the use of materials hitherto unknown and therefore not at first completely understandable' (64). And: 'Each work in itself, by virtue of its differences (...) from all other works, thus teaches its audiences something new: a symbol, a new form, a new mode of presentation' (66). The strange thing is not what is said here – it sounds very familiar from an art philosophical point of view, but that Becker says it – he who stresses so often that artists who try to play with conventions will not be published, staged or exhibited. The problem, in Becker's own words, is that:

> breaking with existing conventions and their manifestations (...) increases artists' trouble and decreases the circulation of their work, but at the same time increases their freedom to choose unconventional alternatives and to depart substantially from customary practice. If that is true, we can understand any work as the product of a choice between conventional ease and success and unconventional trouble and lack of recognition. (34)

It sounds illogical, however, that there can be artists who don't break with existing conventions and choose for ease and success, if at the same time each work, to be an

artwork, has to invite the recipients 'into a world hitherto unknown' to teach them something new. A solution might be that Becker means that each aesthetic system is based on conventions known by the participants, including the possible renewing of these conventions and that participants who don't make use of this possibility cannot be called artists. This attractive solution should mean that the makers of fully conventional films, musicals, songs, paintings, or plays work in the art world, but not as true artists, although their works can teach its audience something new.

The last-mentioned possibility depends on the extent to which an audience is prepared to cooperate with the artist in responding to his work and in this way provide financial resources to continue making art. Becker discerns three groups of possible publics: 1) well-socialized people, 'who have little or no formal acquaintance with or training in the art to participate as audience members' (46); 2) serious and experienced audience members, who know about 'characteristic features of different styles and periods in the history of the art (...), development and practice of the art' and 'have the ability to respond emotionally and cognitively to the manipulation of standard elements in the vocabulary of the medium' (48); and 3) (former) art students, who know 'the technical problems of the craft (...) and abilities to provoke an emotional and aesthetic response from an audience' (54). The first group can be considered the backbone of the art world in a broad sense because its members provide the public and the income for 'the art forms designed to reach the maximum number of people in a society' (46). The second group is the group 'whose attention artists hope for, because they will understand most fully what they have put into the work' (48) and provide a solid income base for the artists as well. Becker seems to mean the 'real' artist here, for the knowledge of this second audience type 'often conflicts with what well-socialized members of society know, because of innovative changes' (ibid.). An interesting element in cooperation by the third group is that it, 'having been on the other side of the line,' is 'the most understanding and forgiving of audiences, one on whom the riskiest experiments may be attempted' (54). A consequence of this is, in Becker's view, that this audience helps both other groups to discover which new forms of art can be of value to them, having passed the preliminary sorting. Becker is more than clear about his opinion that conventions do change and the distribution of conventional knowledge with them.

2.3 Problems and benefits of Howard S. Becker's approach

As has been mentioned at the beginning of this chapter, Becker tries to position himself in relation to philosophers such as Danto and Dickie, claiming to generate more insight into the art world by offering a sociological analysis instead of

an aesthetic theory. The philosophical concept of the art world does not have enough 'meat on its bones,' according to Becker, to be able to deliver a concrete understanding of what is going on in that world. One of the important aspects of a sociological analysis of a social world, he notes, is how participants draw the lines between what is characteristic for that world and what not. Art worlds try to find out 'what is and what isn't art, what is and isn't their kind of art, and who is and isn't an artist' (36). In relation to this, Becker claims that 'by observing how an art world makes those distinctions rather than trying to make them ourselves we can understand much of what goes on in that world' (ibid.). This is definitely true, but whether it can be called a sociological analysis is questionable. Becker develops two concepts, 'cooperative activity' and 'conventions' and uses them to *describe* 'what goes on' in the art world. It provides a wealth of information, even indeed understanding, but to call it an analysis of the art world, frankly, is putting too much 'meat' on 'bones' that are too thin.

Two other, more theoretical difficulties, both already mentioned, keep coming up throughout the text. The first concerns the relationship between the core character of the artist's activity and the concept of cooperativity. Becker feels forced by society (and by the feeling that someone in the collective does something special) to give the 'artist' a special position and to speak of 'support personnel,' whereas he himself would prefer to give all participants the same status. This problem cannot be solved without using a theoretical concept of the 'artistic act,' in other words, without consulting the philosophy of art.

The same holds for the second difficulty which concerns Becker's view that conventions shared by artists, distributors and audiences provide a more or less closed system of aesthetic life within a society. As has become clear, Becker cannot and will not defend this view against his own opinion that art becomes art only by challenging conventions, but this should lead to the idea that so-called artists who do not innovate on conventional ways of aesthetic perception should not be called artists anymore, at least not in art sociological studies. Also, further to this point, an art philosophical choice should be made to find a solution.

These points of critique do not mean that Becker's book is not helpful in trying to understand how the organization of art worlds contributes to the functioning of art in society. In the first place, Becker is right when he states that no other study has opened up so many views on so many activities and links between them in the art world. It definitely gives a very concrete picture of what is going on in that world, as well as a lot of material and a new understanding of what is worth studying further. In the second place, Becker's struggle with the role of conventions in art production and reception is at the heart of the discussion on the functioning of art in society, because it connects the organizational aspects of the art world with the substantive question of the value of art reception for audiences

and for the culture they live in. In this sense, Becker's concern with conventions foreshadows the second part of the present book.

The most important contribution to the study of art worlds and the understanding of their functioning lies, however, in the amount of attention Becker devotes to the distribution system. Although he does not define, categorize or study it very systematically, he does deal with it as the central domain in an art world where production and reception come together and where the functioning of art in society is organized for a large part. This is a huge step forward in the direction this study should go.

2.4 Art sociology and the New Institutionalists

Institutionalism is a strongly developed field in sociology that can be traced back to Emile Durkheim himself, who defined the new discipline – as the other godfather of sociology, Max Weber, noted – as 'the science of institutions, of their genesis and of their functioning'[11]. In a sense, sociology without institutional thinking is not really imaginable, but the main issue behind many conflicts between sociological schools concerns just this: the extent to which institutions dominate participant behaviour, or the other way round. Becker, as we saw, barely discusses the concept of institutions and prefers to think along the lines of conventions, because they leave more room open for considering the participants themselves as being responsible for their types of interactivity. Paul DiMaggio and Walter Powell state that 'institutions begin as conventions, which, because they are based on coincidence of interest, are vulnerable to defection, renegotiation, and free riding' (DiMaggio and Powell 1991: 24). Institutions, on the other hand, can be seen as '[w]ebs of interrelated rules and norms that govern social relationships,' according to Victor Nee (1998: 80). How compellingly they govern social relationships, as well as how much space for change or deviance they leave, are points of discussion among institutionalists.

Why the New Institutionalists, who are especially active in the sociological study of organizations, are discussed here, is because some of them, especially DiMaggio, have applied their views to parts of the art world. Besides the implicit criticism of symbolic interactionism institutionalists have, the empirical way in which they research concrete institutionalizing, as well as institutionalized processes in the art world, legitimizes the introduction of the New Institutionalists at the end of this chapter devoted to Howard Becker. In addition, as will become clear, they offer a nice bridge to Bourdieu's theory of fields, the subject of the next chapter.

2.4.1 Main themes in new institutionalism

New institutionalism presupposes a relationship with old institutionalism. DiMaggio and Powell try to trace this relationship in their introductory chapter in *The New Institutionalism in Organizational Analysis* (1991), highlighting the work of Philip Selznick (1949, 1957) and Talcott Parsons (1951). Both institutionalisms

> share a scepticism towards rational-actor models of organization, and each views institutionalization as a state-dependent process (...). Both empha- size the relationship between organizations and their environments (...). Each approach stresses the role of culture in shaping organizational reality. (1991: 12)

But the significant differences between old and new institutionalism are, accord- ing to DiMaggio and Powell, the greater interest of the first in political back- grounds of behaviour in organizations; the location of organizational irration- ality in the formal structure itself, as highlighted by the new institutionalism, instead of explaining this irrationality by the presence of external influences; and the scale on which the environments are studied: old institutionalism analyzes organizations as embedded in local communities, while new institutionalism fo- cuses on organizational fields, often on an (inter-) national level, environments which 'rather than being coopted by organizations (...) penetrate the organiza- tion, creating the lenses through which actors view the world' (1991: 13).

DiMaggio and Powell explain the new forms of institutionalism in organiza- tion sociology as 'not merely a return to scholarly roots, but an attempt to provide fresh answers to old questions about how social choices are shaped, mediated, and channeled by institutional arrangements' (DiMaggio and Powell 1991: 2). Also, Nee posits that '[t]he new institutionalist paradigm rests firmly within the choice-theoretic tradition' (1998: 10), but adds that basic assumptions of the ra- tional choice theory are disputed by the new institutionalists, favoring a concept of 'context-bound rationality' (ibid.).

Nee and Brinton introduce part I of *The New Institutionalism in Sociology* by saying that the authors 'explore the ways in which institutions as systems of rules constrain or encourage innovative individual action' (1998: XVI). They not only refer to the relationship between individual and institutional influence on so- cietal processes, but also to the question of how institutions enable changes to occur. Usually institutions are thought of as constraining change as well as in- novative action within organizations, especially because they reduce uncertainty. Nee and Ingram show how a change of paradigms in the institutional environ- ment (often launched on a governmental level) makes new organizational forms

possible; and the other way around, how change in formal norms in organizations stems from organizational actors (1998: 32). DiMaggio and Powell come close to Nee and Ingram, noting that different institutions can conflict with each other on the organizational level and at the same time, especially in organizations that depend on high professionalism, 'competing claims of professionals create conflicts and heighten ambiguity' (ibid.).

Finally, new institutionalism as a theoretical approach has to compete with network theories. Nee and Ingram describe networks of social relations as 'always in flux insofar as individuals respond to perceptions of costs and benefits in exchanges, and invest or divest themselves of particular social ties' (1998: 19).[12] And Nee states that 'an emphasis on norms as cultural beliefs that constrain opportunism distinguishes the new institutionalist approach from the instrumental view of network ties' (1998: 8-9). So networks are seen as sets of relationships directly connected to exchange or transactional activities, whereas institutions function in relation to these networks as sets of guiding and controlling principles, norms and patterns of acting, operating around the network, as well as inside it and internalized by actors in the network. DiMaggio and Powell point out that the last aspect has been developed further in Bourdieu's habitus concept, which will be discussed later.

2.4.2 DiMaggio's research into organizational fields (in the art world)

In 1985, DiMaggio and Stenberg published the results of their 'empirical analysis' of the backgrounds for innovativeness in residential theatres in the US (*Poetics* 14). They researched the influence of environmental and organizational factors on artistic innovation and didn't come up with very noteworthy outcomes. The main result appeared to be that theatre programmes that could be based on the presence of a substantial amount of cultural capital – be it in the form of highly trained artistic personnel or in the form of highly educated subscribers and spectators – were more innovative than the programs of theatres which strongly depended on 'general market preferences'. The authors concluded that 'artistic innovation depends on the behavior of formal organizations' and that 'if we are to understand art, we must understand the dynamics of such organizations and the principles that govern their relationship to their economic and social environment' (1985: 121).

Some methodological aspects of the research were definitely more worth mentioning than the outcomes. DiMaggio and Stenberg emphasized that usually too much attention is paid to individual artists in regard to innovativeness, because works of art are constituted socially and controlled to a certain extent, and formal organizations 'have [increasingly] become the key "gatekeepers", determining the

structure of artistic opportunity and regulating the flow of new work to the public'
(1985: 108). For that reason they consider the theatre rather than the creative art-
ist as their unit of analysis, relying on Becker (1982) and Bourdieu, among others.

A less important but striking methodological aspect is the concept of artistic
innovation in theatre. The authors consider a programme innovative when new
dramatic works enter into the repertoire or when old plays 'fallen into disuse' are
revived. Emphatically they state that the measure should not address stage de-
sign or performance style, but that they 'believe that it is an efficient measure of
what experts mean when they speak of artistic adventuresomeness and what most
educated laypeople mean when they speak of "innovation"' (1985: 112). It is ques-
tionable whether this very restricted idea of artistic innovation in US resident
theatres in the early 1980s has had any influence on research outcomes because,
from that period onwards, theatre people all over the world have experimented
with brand-new ways of performing well-known plays and regular theatre-goers
would have been exposed to important aspects of artistic innovation as well.

A third remarkable fact is that the authors didn't rely on the famous arti-
cle DiMaggio and Powell published in 1983, entitled 'The Iron Cage Revisited:
Institutional Isomorphism and Collective Rationality in Organizational Fields'
(*American Sociological Review* 48: 147-160).[13] That article included some challeng-
ing insights concerning the influences of institutionalizing processes on how art
organizations 'determine the structure of artistic opportunity and regulate the
flow of new work to the public', the same insight which DiMaggio and Stenberg
considered important to study two years later, as we saw already. Some of these
insights have been demonstrated by DiMaggio in his 'Constructing an Organiza-
tional Field as a Professional Project: U.S. Art Museums, 1920-1940' (Powell and
DiMaggio (eds.) 1991: 267-292), which will be discussed at the end of this chapter.

Departing from Max Weber's metaphor for the imprisoning of humanity in
the 'Iron Cage' of rationalist order and bureaucracy, DiMaggio and Powell argue
that bureaucracy and other forms of homogenization emerge 'out of the structur-
ation (...) of organizational fields' (1991: 63), without necessarily making organi-
zations more efficient. By 'organizational field' they mean

> those organizations that, in aggregate, constitute a recognized area of in-
> stitutional life: key suppliers, resource and product consumers, regulatory
> agencies, and other organizations that produce similar services and prod-
> ucts. (64-65)

With this description the authors wished to avoid the problems of network ap-
proaches that only take into account actors who actually interact, but instead
wished to direct attention 'to the totality of relevant actors' (65). The institu-

tionalizing process is central in defining a field. Based on DiMaggio (1983), the authors determined four parts to this process, presented here extensively in order to be able to compare them with the conditions Bourdieu formulates for the development of what he sees as a field:

1. An increase in the extent of interaction among organizations
2. The emergence of interorganizational structures of domination and patterns of coalition
3. An increase in the information load with which organizations in a field must contend
4. The development of mutual awareness among participants in a set of organizations that they are involved in a common enterprise (65)

The structuration (or institutionalization) of a field makes the actors become more similar to one another, if only because organizations in a structured field 're-spond to an environment that consists of other organizations responding to their environment, which consists of organizations responding to an environment of organizations' responses' (65).

DiMaggio and Powell call this process of similarizing 'isomorphism' and discern two main forms and three sub-forms of it. The first main form is competitive isomorphism, which seems most relevant for 'those fields in which free and open competition exists' (66). The second one is institutional isomorphism, 'a useful tool for understanding the politics and ceremony that pervade much modern organizational life' (66). Institutional isomorphism has three forms: coercive, mimetic and normative isomorphism. The first form results from formal and informal pressures by other organizations in the field and by cultural expectations in society. 'Such pressures may be felt as force, as persuasion, or as invitations to join in collusio' (67). Mimetic isomorphism means that organizations model themselves by imitating other (successful) organizations with a similar position in the field. Uncertainty and ambiguous goals stimulate mimetic processes, according to DiMaggio and Powell. Normative isomorphism, finally, stems more or less directly from professionalization, seen as 'the collective struggle of members of an occupation to define the conditions and methods of their work (...) and to establish a cognitive base and legitimation for their occupational autonomy' (70). DiMaggio and Powell determine two aspects of professionalization that cause isomorphism: a cognitive base produced by university specialists and professional networks that span organizations (and across which new models diffuse rapidly). This form of isomorphism runs parallel to structuration of the field, especially in the non-profit sector, for example, the art world:

executive producers or artistic directors of leading theaters head trade or
professional association committees, sit on government and foundation
grant-award panels, consult as government or foundation-financed manage-
ment advisers to smaller theaters, or sit on smaller organizations' boards,
even as their stature is reinforced and enlarged by the grants their theaters
receive from government, corporate, and foundation funding sources. (72)

DiMaggio and Powell elaborated their views in twelve hypotheses about the ex-
pectations of isomorphic change in a field, six on the level of organizations and
six on the level of the field. They all resulted more or less directly from the views
presented above, but two field-level hypotheses are of particular importance for
the sake of this study and are for that reason quoted fully here (76-77):

> The greater the extent to which an organizational field is dependent upon a
> single (or several similar) source(s) of support for vital resources, the higher
> the level of isomorphism.

> The greater the extent to which organizations in a field transact with agen-
> cies of the state, the greater the extent of isomorphism in the field as a whole.

As said before, some of the views DiMaggio and Powell have developed in 'The
Iron Cage Revisited...' have been worked out and tested by DiMaggio in his ar-
ticle on the structuration of the museum field in the US between 1920 and 1940.
In this article the role of professionals appears to be central in the structuration
of the field concerned.

By 1920, the dominant form of art museums in the US reflected the interests
of urban elites who governed these museums. Connoisseurship, 'high art' versus
(excluded) 'nonart' and 'authentic artistic perception' were core terms in this re-
flection. Conservation and sacralization of the collection were central tasks. But
there was a counterview, influenced by the experience of public libraries, which
'stressed broad public education and, as a means to that end, frequent special
exhibitions and generous interpretation of the works exhibited' (DiMaggio 1991:
270).

DiMaggio determines several factors that have influenced the decisive role of
professionalization in the struggle between both movements. Between 1920 and
1940, the number of art museums increased from 60 to about 400. In addition the
museums themselves grew rapidly, as well as, necessarily, their staff. Something
similar happened with higher education in the fine arts. In 1916 fewer than one
in four universities offered courses in art history, by 1930 almost all of them did.
This did not mean, however, that these new highly educated professionals and

their views were automatically adopted by the art museums. In that development, 'scientific philanthropy', which arose in the same period, played a significant role, for instance, by supporting the American Association of Museums (AAM), a society of museum workers that became the most important organization of professionals in the museum world. Between 1923 and 1932 the number of members grew from 81 to 208 museums and from 365 to 909 individuals (274). And, even more importantly, 'The AAM's focus on research, coordination, and pilot projects in the area of museum management and education won the favor of progressive foundations' (ibid.).

To illustrate this trend, DiMaggio sums up how Carnegie supported activities that could be considered as dimensions of professionalization and structuration. The first five dimensions are: production of university-trained experts; creation of a body of knowledge; organization of professional associations; consolidation of a professional elite; and increasing the organizational salience of professional expertise (275-276). The four dimensions of structuration, according to which projects supported by the Carnegie Corporation were carried out, concerned: increases in the density of interorganizational contacts; increases in the flow of information; emergence of a centre-periphery structure; and the collective definition of a field (277).

DiMaggio extensively elaborated the processes of professionalization and structuration – with the help of corporate philanthropy – for the case of what was known as 'neighborhood branch museum,' a favourite of the museum reform movement, modelled on the public library and widely established in the 1930s.

One of the striking findings of this case, however, appears to be that 'the same professionals who organized at the field level to effect institutional change were neither alienated nor oppositional in their organizational roles' (283). DiMaggio tends to explain this by stating that people execute different roles in their organization and in the field and that this requires 'distinctive forms of rationality, forms of discourse and orientations towards action'(286). In the workplace their behaviour was driven by organizational routine and defined by organizational superiors 'or posed by resource environment' (ibid.). 'Interorganizational contexts were, by contrast, characterized by formal equality and professional control' (ibid.).

If this case has any general value, DiMaggio concludes, it could be that 'professionals stimulate[d] change less at the intraorganizational level than *by mobilizing to construct an environment they could control at the level of the organizational field*' (287-288).

Figure 2.1 shows the central aspects DiMaggio and Powell discerned in the structuration of an organizational field, combined with findings of the museum case. The case of the construction of the US museum field between 1920 and

1940 at the very least affirms the working of the two aspects of isomorphism that DiMaggio and Powell determined in 'The Iron Cage Revisited...': a cognitive base produced by university specialists and professional networks that span organizations.

Figure 2.1 Structuration of organizational fields according to DiMaggio and Powell

STRUCTURATION:

 PHASES: RESULT:

 1. Increase in the extent of interaction

 2. Emergence of interorganisational structures ISOMORPHISM

 3. Increase of information load * competitive

 4. Development of mutual awareness * institutional

 coercive

 DIMENSIONS: mimetic

 1. Increasing density of interorganisational contact normative

 2. Increasing flow of information

 3. Emergence of center-periphery structure

 4. Collective definition of the field

PROFESSIONALIZATION

 DIMENSIONS:

 1. Production of university-trained experts

 2. Creation of a body of knowledge

 3. Organisation of professional associations

 4. Consolidation of a professional elite

 5. Increasing the organisational salience of professional expertise

To make a bridge to the next chapter it can be noted that the borders between subsystems within the field of art sociology are relatively strictly guarded; DiMaggio and Bourdieu seem to have developed their field theories without extensively exchanging or integrating their mutual efforts and views. In general, DiMaggio is particularly interested in developments in organizational practice, whereas Bourdieu tries to develop a 'grand theory' that can be illustrated by practices in a field.

Notes

1 Although parts of it were published in France in the 1970s and in English in the 1980s.
2 E.g. (1963) *Outsiders: Studies in the Sociology of Deviance.* New York: The Free Press.
3 The general system theory offers a better solution for this problem by using the concept of system borders which can be chosen by the system analyst on the basis of a level of aggregation, on the one hand, and the aspects to be analyzed, on the other.
4 See, for instance, G.H. Mead (1934) *Mind, Self and Society. From the Standpoint of a Social-Behaviorist.* Chicago: University of Chicago Press, and H. Blumer (1969) *Symbolic Interaction, Perspective and Method.* Englewood-Cliffs, N.J.: Prentice Hall.
5 Becker himself has difficulty giving the artist a special position on the basis of 'creative talents.' He stresses that in various cultures and historical periods crafts have played and even can still play a dominant part in what is considered art. His example of a technical activity that was seen as art at a certain moment in history, sound-mixing, is a weak one, because sound-mixing developed itself from a craft into an art just by becoming a different type of activity.
6 Further possibilities in this direction will be worked out in the third part of this book.
7 Something similar can be found in the most recent book by the Dutch art economist and artist Hans Abbing, *Why Are Artists Poor?* (2002).
8 Cf. Bourdieu's opinion that publishers and art dealers have a position between art and economics and hence a double ideology.
9 This was the strategy Brecht and Benjamin saw as a task for left-wing artists: to change the production (film) and distribution (theatre) system by having their work accepted.
10 Besides patrons, authorities can also be commissioners or buyers of artistic work; in these cases they act as a normal party in the market system. For more about this, see Abbing 2002.
11 See M. Weber (1958 [1895]), *The Rules of Sociological Method.* 2d ed. New York: Free Press.
12 This idea brings them close to what is known as the 'Actor Network Theory' (ANT) discussed in chapter four.
13 This study made use of a revised version of this article that is included in Powell and DiMaggio (eds.) 1991.

3 Pierre Bourdieu's Grand Theory
of the Artistic Field

3.1 Introduction

Undoubtedly Pierre Bourdieu (1930-2002) was the most influential art sociologist of the second half of the twentieth century. Leaning on, although also attacking, the French neo-Marxist-structuralist tradition of the 1960s (Althusser,[1] Hadjinicolaou, Macherey) he began his career with the critical study of education, in particular how educational systems reproduce class distinctions. In 1970 he wrote, together with Jean-Claude Passeron, *Réproduction: Élements pour une théorie du système d'enseignement*, which was translated into English in 1977 (*Reproduction in Education, Society and Culture*) and reprinted in 1990. Bourdieu's lifelong themes – the character of social distinction and the processes of societal reproduction of distinction – are already fully present in this first book of his. His magnum opus, published in 1979, is *La distinction: Critique sociale du jugement* (English translation in 1984: *Distinction: a Social Critique of the Judgement of Taste*), in which he shows how different tastes (in particular aesthetic tastes) are connected with, and in a sense determined by, levels of education and class background. This book, from which every art sociologist in the Western world had to quote during the two decades that followed in order to be taken seriously, will not be discussed here. It does not concern the main topics of the present study specifically, although some of the concepts developed in it (such as habitus or the distinction between aesthetic and functional disposition) are most useful for understanding the opportunities for art to function in society. These concepts will play a role in the second part of the present study, in which the possible values and functions of art will be discussed.

There is another set of publications in Bourdieu's oeuvre which directly concerns the issues of this book and which can be lumped together as his theory of fields. In 1976 he presented a paper at the *Ecole Normale Supérieure*, entitled *Quelques propriétés des champs* (Some Properties of Fields), which was pub-

lished in 1980 in *Questions de sociologie*. In this short text of about seven pages, Bourdieu listed his central thoughts about what fields are and how they work. A series of lectures and articles followed (*'La production de la croyance'*/'The Production of Belief', 1977; 'The Field of Cultural Production, or: The Economic World Reversed', 1983; 'Oekonomisches Kapital, kulturelles Kapital, sociales Kapital', 1983/'The Forms of Capital', 1986; 'Field of Power, Literary Field and Habitus', 1986), most of which were collected in *The Field of Cultural Production* (1993). But Bourdieu's main work on the theory of fields is *Les Règles de l'art. Genèse et structure du champs litéraire* (1992; *The Rules of Art. Genesis and Structure of the Literary Field*, 1996). In this book he brings all his views (as well as a lot of earlier written texts) on the working of cultural fields together, not only in a theoretical way, but also in order to demonstrate the working of field laws and mechanisms in the literary field during the second half of the nineteenth century in France. The present description of Bourdieu's theory of cultural fields is particularly based on the group of articles mentioned and on *The Rules of Art*.

This chapter will consist of two main parts. Firstly, Bourdieu's theoretical construct of the field concept will be described in three sections concerning respectively: basic concepts, general field laws and general field dynamics. In the last-mentioned section, special attention will be paid to the on-going problem of the relation between determination and opportunities for change in an institutional context, in this case, in a field.

The second part of the chapter will be devoted to some of the most significant comments on Bourdieu's field theory. The critical views of Laermans and Heinich, among others, will be discussed. They will help in finding out what can be considered to be the significance of Bourdieu's theory of the cultural field for the study of how the organization of a field influences the functioning of art in the culture concerned.

3.2 Field theory

Bourdieu considers his notion of field definitely superior to Becker's art world concept and takes a polemical pleasure in formulating this point of view[2]:

> Even further away, the notion of *art world*, which is in use in the United States in sociological and philosophical fields, is inspired by a social philosophy completely opposed to that which informs the idea of the Republic of Letters as Bayle presents it, and marks a regression in relation to the theory of the field as I proposed it. Suggesting that 'works of art can be

understood by viewing them as the result of the coordinated activities of all people whose cooperation is necessary in order that the work should occur as it does', Howard S. Becker concludes that the enquiry must extend to all those who contribute to this result, meaning 'people who conceive the idea of the work (...); people who execute it (...); people who provide the necessary equipment (...) and people who make up the audience for the work (...).'. Without entering into a methodological exposé of everything that separates this vision of the 'world of art' from the theory of the literary or artistic field, I will merely remark that the latter is not reducible to a *population*, that is to say, to the sum of individual agents linked by simple relations of *interactions* or, more precisely, of *cooperation*: what is lacking, among other things, from this purely descriptive and enumerative evocation are the *objective relations* which are constitutive of the structure of the field and which orient the struggles aiming to conserve or transform it. (1996: 204-205)

What Bourdieu tries to do, contrary to Becker, is to build a theoretical construct of concepts through which the working of a field (or world, network, configuration or system, as the Dutch philosopher Pels paraphrases the term without any scruples) can be analyzed.[3] If Becker is the one who shows the complexity of an art world by presenting a hundred and one examples, Bourdieu tries to discover general structures, laws and mechanisms in that complex world.

3.2.1 Basic concepts

In his introduction to a collection of articles by Bourdieu, Pels chose, out of the number of notions Bourdieu uses throughout his texts, three mutually related 'basic concepts which organize Bourdieu's oeuvre (...): field, habitus and capital' (Pels 1992: 12).

To get some grip on Bourdieu's way of thinking it might be useful to consider these three as a triangular core of the building constructed in his field theory and to 'furnish' it with about fifteen other key terms which each have their own place in this construction. Figure 3.1 presents this effort for the artistic field.

To be extremely brief, the figure can be paraphrased in just a couple of lines: An artistic field is a structure of relations between positions which, with the help of several forms of capital, on the one hand, and based on a joint *illusio* and their own *doxa*, on the other, struggle for specific symbolic capital (prestige). The positions are occupied by agents, who take these positions on the basis of their habitus.

Figure 3.1 The structure of key terms in Bourdieu's field theory

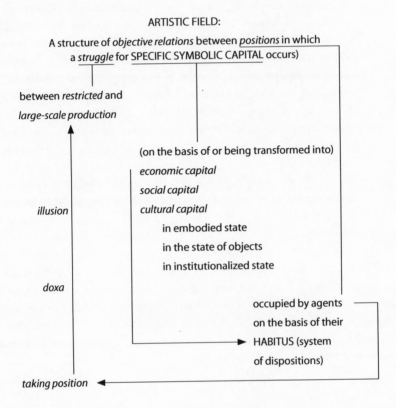

Most of the terms used here will be explained in the sections on field laws and field dynamics, but some of them have to be dealt with beforehand, especially for readers who are not very familiar with Bourdieu's texts, because of their more general character (several forms of 'capital') or the difficulty of a term in relation to the use other theories make of it (the notion of 'position').

POSITION

Speaking of position, in most theories, as well as in everyday language, the relationship between agents is referred to, in particular, in terms of their interdependency and mutual hierarchy. Although Bourdieu uses the term 'position' in several ways, he is very clear in the distinction he makes between a position and the occupation of it by agents: 'Fields are there as structured spaces of positions (or posts) the properties of which depend on their place in the spaces, and which can be analyzed independent of the features of the occupiers of the positions,' he wrote in his first, short but clear, essay on the properties of fields (1992b [1980]:

171). Thirteen years later, in 'The Field of Cultural Production', he still disputes the mode of thought

> which tends to foreground the individual, or the visible interactions between individuals, at the expense of the structural relations (...) between social positions that are both occupied and manipulated by social agents which may be isolated individuals, groups or institutions. (1993: 29)

So, a position in the artistic field is, in the first place, an artistic position featuring the type of art produced, as distinct from other types produced from other artistic positions in the field. Bourdieu uses the term genre in this context, noting that a position "'corresponds to a genre such as the novel or, within this to a sub-category such as the 'society novel' or the 'popular novel'"(1993: 30). Positions can be defined on several levels, from the very general, such as the level of the avant-garde or traditionalists, to the very detailed, such as the micro -level of the Dutch experimental flat-floor theatre of the 1990s or the large-scale American musical of the 1980s. The two main sub-fields Bourdieu discerns within the literary field in nineteenth-century France, those of restricted and large-scale production, can be considered two sets of positions, each, for its part, structured as a space of sub-positions.

The term position suggests a hierarchical relationship, usually between the agents in a field. In Bourdieu's vision, in the first instance, there is a hierarchy between the positions themselves. This hierarchy stems from the way in which the specific capital of the field has been divided among the artistic positions. Specific capital is the capital that 'governs success in the field and the winning of the external or specific profits which are at stake in the field' (ibid.). Because the artistic field is a field of symbolic production, the profits to be won have the form of symbolic capital, especially (artistic) prestige within the field and possibly, depending on the relationship with other fields, also within those other fields as well. The structure of distribution of this capital at a given moment is 'the structure of the field, i.e. of the space of positions' (ibid.). Strictly speaking, the artistic positions as such are not hierarchically organized (although they can only exist within a set of relationships), but the distribution of artistic prestige among the positions and the struggle to win more of it is what organizes the hierarchy.

As said before, artistic positions are (and, of course, have to be) occupied by organizations or individuals, who, as a consequence, take on a hierarchical relationship to one another. The place each agent has in such a set of relationships is usually called 'position' (i.e. towards the other agents, in terms of the distribution of power, resources or other aspects), but, again, if Bourdieu speaks about the positions of agents vis-à-vis each other, then it is only in terms of considering them

as occupiers of artistic positions. Terms like 'post' or even 'job,' which Bourdieu sometimes makes use of to refer to artistic positions, suggest a more agent-oriented meaning, but these terms have to be considered in a general way, as posts or jobs to be occupied, as types of functions: the function of artist, publisher, theatre director or, more specifically, of *poète maudit*, ballerina or pop musician. In short, two related meanings of the notion of position have to be discerned: on the one hand, Bourdieu's use of it as the result of artistic utterances in relation to other types, while, on the other hand, as the place in a hierarchy based on the distribution of specific capital, resources and the product of those resources.

All these positions are occupied by agents, art organizations (called institutions) or individual artists whose habituses correspond with the concerned position. More than that:

> To different *positions* (which ... can only be apprehended through the properties of their occupants) correspond homologous *position-takings*, including literary or artistic works, obviously, but also political acts and discourses, manifestos or polemics etc. (1996: 231)

CULTURAL CAPITAL

Habitus can be described as a set of dispositions, and dispositions as permanent structures of perception and evaluation which govern how people act. Bourdieu stresses that the habitus is something 'having transformed into a being'; so that agents are not or hardly aware of it; on the level of identity the individual and his or her habitus coincide. The dispositions active in the habitus are achieved through an implicit or explicit process of education, which brings us to the concept of cultural capital.

Bourdieu argues that the term capital has to be reintroduced, and not just to reduce the social world to 'a sequence of short-lived mechanical situations of balance, in which the agents can be seen as mutually exchangeable parts' (1992c [1983]: 120). He sees the social world as an accumulated history and the typical feature of capital (as compared to money) is exactly that it accumulates. In this respect Bourdieu leans heavily on Marx's theory of value, according to which

> Capital is accumulated labour (in materialized or 'embodied' form) that individual agents or groups can acquire (...), by which they can appropriate social energy in the form of objectified or live labour. (Ibid.)

In the last resort – and this is the core of Marx's theory of value – all value can be considered accumulated labour: 'The universal equivalent, the standard of all values, is nothing else than the working time (in the most extensive sense of the

word)' (idem: 139). That also holds for the three main forms in which capital can appear, and so Bourdieu discerns economic, social and cultural capital. The first and most materialized form can immediately be converted into money and be 'institutionalized in rights of ownership' (idem: 122) and can be understood as the form of capital the current economic theory relates to.[4] The other two, social and cultural capital, are symbolic forms of capital or, better, capital in a symbolic form. Capital is symbolic insofar as it is represented, which means 'considered symbolically, as an object of knowledge' (idem: 310). It is not recognized as capital, and can only function by not being recognized as capital, which means as accumulated labour. So, social capital, consisting of resources that stem from a network of relationships, including the forms and amounts of capital the members of the network (family and acquaintances) have at their disposal, can only support people in their social life, career or in the accumulation of their capital if it appears as non-capital, as free of economic features and interests, as something of a higher value than 'capital' can have.[5] This becomes definitely clear from the ways in which social capital is maintained and accumulated, namely through 'an unbroken sequence of transactions in which appreciation is (re)affirmed continuously' (idem: 134).

Something similar holds for cultural capital, described by Bourdieu as a form of knowledge that equips the social agent with appreciation for or competence in deciphering cultural relations and cultural artefacts. Cultural capital can appear in three different states. The one mentioned above is the *embodied*, or *incorporated state*, which means cultural capital as a set of dispositions an agent has at his disposal to handle cultural utterances. These dispositions are acquired during educational processes in the family and at school. They are a personal form of capital that cannot be transferred to others immediately. What makes this form of capital particularly appropriate as symbolic (thus unrecognizable) capital is that the process of acquiring it is invisible to a great extent. The appropriation of cultural capital takes place in a long-term, often implicit and veiled process that corresponds to socialization as a whole.[6] This process, moreover, has its basis in the cultural capital of the family and its network, accumulated over the years and becoming available within the private ambience of the family, not only through embodied cultural capital in the habitus of other family members and acquaintances, but also through the presence of cultural capital in the *objectified state*.

Cultural capital can be objectified in material carriers, such as books, paintings, songs, films, musical instruments or costumes. All these objects can be transferred as economic goods, but that is only half of the story, or less. Appropriating artworks as goods with the help of economic capital does not automatically include the appropriation of artworks as symbolic goods. The latter presupposes

the presence and use of cultural capital in an embodied state in order to make an aesthetic reception possible.

The third form cultural capital can adopt is the *institutionalized state*, in which it consists of diplomas, titles and other forms of institutional recognition. This form concerns the sanctioning of cultural capital 'by legally guaranteed educational qualifications, which are formally independent of the person who bears them' (idem: 130). The result can be that cultural capital in the institutionalized state does not correspond fully to the cultural capital a person has embodied at a certain moment. For the qualified person the diploma has a double value. First, he or she does not need to prove the presence of sufficient cultural capital in embodied state because this is guaranteed by the educational institution; second, the diploma has an economic value: it offers admittance to specific parts of the labour market and, under normal circumstances, to a field of jobs and matching income.

The last-mentioned feature of cultural capital in an institutionalized state makes clear that capital can be transformed from one form into another, in this case from the cultural into the economic. Strictly speaking all forms of capital can be traced back to economic capital, albeit at the expense of higher or lower transformation costs. As has been made clear before, symbolic forms of capital, such as social and cultural capital, give admittance to values simply by not being experienced as a form of economic capital. This means that the transformation of symbolic forms of capital into economic capital does not work if the first forms lose their peculiar capacity of accumulation in this process. If, for instance, a student shows in his attitude that he is more interested in the final diploma than in the subjects to be studied, his teachers will never recommend him for a job in the field concerned. And, the other way round, this means that to get high economic profits from social or cultural capital, one should not only invest time and money in both these forms, but also in the process of transformation into economic capital itself.

For artists who take up positions in an artistic field and participate in the struggle for specific winnings, that is, artistic prestige, the character and amount of their cultural capital in the three states is decisive, apart from the use they (can) make of economic and social capital. Social capital especially will often play a mediating role in the transformation of cultural capital into economic winnings.

3.2.2 *General field laws*

In *The Rules of Art*, Bourdieu describes extensively the genesis of his conception of a field, as a notion to indicate a theoretical position. He sketches how his first effort to analyze the intellectual field became bogged down in the immediately visible relationships between agents involved:

The interactions between authors and critics or between authors and pub-
lishers, had disguised from my eyes the objective relationships between the
relative positions that one and the other occupy in the field, that is to say,
the structure that determines the form of those interactions. (1996: 181-182)

He then proposes to approach a field as a *structure of objective relationships*, be-
cause 'each of these institutions could not deliver its singular truth unless, para-
doxically, it was set in the system of objective relationships constitutive of the
space of competition that it forms along with all the others' (idem: 181). In this
way Bourdieu tries to escape from the alternatives of understanding artistic devel-
opments as purely internal, autonomous questions, or as being fully determined
by external, societal factors. The value of his concept has to be proved, according
to Bourdieu, by comparing different types of fields, such as the intellectual, the
economic, the religious, and so on, in order to find out whether general properties
of fields can be discovered. And, indeed, he thinks he has found a set of 'field laws'
on the basis of which the dynamics of a field can be understood. These dynamics
are discussed more extensively in the next section, which concerns the artistic
field in particular.

In *Quelques propriétés des champs* Bourdieu formulates a set of general field laws
(or universal field mechanisms) which remain the stable basis for the elaborations
in the literary field he later undertakes ('The Field of Cultural Production,' 'The
Production of Belief', *The Rules of Art*). In that article he sums up a number of
laws, which can be divided into four field mechanisms and three aspects of field
identification, which are all reproduced here in brief (1992b [1980]: 172-175).

1 The structure of a field is a certain state of power relationships between agents
 or, in other words, the state of the distribution of the specific capital that has
 accumulated in earlier conflicts.
2 Agents with a complete monopoly on the specific capital tend to use conserva-
 tive strategies, defending orthodoxy, whereas newcomers are inclined to use
 subversive strategies, to heresy, bringing in heterodox positions.
3 Each field only functions if people are ready to play the game and are provided
 with the appropriate habitus, which implies knowledge and recognition of the
 immanent field laws and of what is at stake in the field.
4 Behind all antagonisms in a field hides an objective complicity, based on a
 shared interest in the existence of the field and in what is at stake and worth
 fighting for within the field:
 – Newcomers have to buy a right of admittance in the form of recognition of
 the value of the game and in the form of knowledge of the working prin-
 ciples of it.

- One of the factors that protect a game from a total revolution, is the very investment in time and effort necessary to enter the game.
5 One of the most reliable indications that a field has been constituted is the origin of biographers, art and literature historians, all people who 'make out a case for the preservation of what is produced in the field, who have an interest in that preservation, preserving that all, in self- preservation'.
6 A second indication of the functioning of a field is the 'trace of history of that field' in the work and life of the agents.
7 Finally, there is a field effect as soon as a work and the value of it cannot be understood without knowledge of the history of the production field of the work.[7]

The first two items relate in particular to what is going on in a field and are discussed in the next section on field dynamics. Points 3 and 4 concern conditions for the existence and functioning of a field. The notions *habitus, illusio, doxa* and *nomos* play an important role in this and will be elaborated further. The three other issues help to identify a field and can be compared with the factors DiMaggio (1983) determined as central in the development of what he calls an organizational field (see chapter 2).

With a little good will it can be said that DiMaggio's idea of the structuration of a field is not incompatible with the features of a field Bourdieu presents. Especially DiMaggio's view, that in a developing field 'interorganizational structures of dominations and patterns of coalition' emerge, fits with the first two field laws formulated by Bourdieu, albeit the latter deals more with the details of the dynamics of domination and coalition. Generally speaking, whereas Bourdieu searches for objective, underlying structures and processes that govern field dynamics, DiMaggio looks for visible changes in a developing field and especially finds an increase in interaction and the consequences of that in the form of structuration of the relationships and awareness of the participants in them. The latter aspect, by the way, can certainly become concrete in the rise of 'a corps of preservers of lives (biographers) and oeuvres' (1992b [1980]: 174), particularly in an intellectual field.

In Bourdieu's concept, fields function thanks to their immanent coherence. In this sense, Dickie's presentation of the art world as a circle is not totally another way of thinking. Figure 3.1 has a circular structure as well, and the notions to be explained here depend strongly on each other. The collusion of agents in the *illusio* – the involvement of people in the game, based on the belief that the game is worth playing, because of its stakes – 'is the root of the competition which pits them against each other and which makes the game itself' (1996: 228). After all, this *illusio* is shared by all the participants in their *collusio*, their veiled playing together. Whereas the *illusio* exists on the side of the agents, the *doxa* is a set of

rules, values, conventions and discourses that governs the field as a whole and is experienced or presented as a common sense, called by David Swartz 'the deep structure of fields' (Swartz 1997: 125).[8] The dominant class in a field defends orthodoxy, the prevailing discourse, to save the status quo in the field, while, on the other hand, several heterodoxies, sets of values, ideas and conceptions that challenge the status quo and the orthodoxy, can exist in a field. They are brought about in sub-fields or by newcomers and are experienced as heresy by the guardians of orthodoxy. In Bourdieu's view the struggle between orthodoxy and heterodoxy is a fundamental on-going process in each field. One of the most important weapons – at the same time at stake in the fight – is the legitimate definition of art, including its classifications and boundaries. This classifying principle is called the *nomos*, which, logically, is strongly connected to the *doxa* and the *illusio*. The habitus, finally, can be seen as the central notion in this circle of terms, because it connects the *illusio* to the *doxa*, or, put in a broader context, it links the agent and the positions in a field, one to another. Bourdieu developed the concept as an alternative to the dualisms of the individual versus society and for the 'structuralism and its strange theory of acting ..., which made the agent disappear by reducing it to the role of supporter or bearer (*Träger*) of the structure' (1996: 179). The habitus, as a 'system of dispositions acquired in an implicit or explicit learning process' (1992b [1980]: 177), is shaped in a field (a system of relationships between positions) and at the same time shapes the agent for the field, that is, by occupying a position in the field.[9]

> A position as it appears to the (more or less adequate) 'sense of investment' which each agent applies to it presents itself either as a sort of necessary locus which beckons those who are made for it ('vocation') or, by contrast, as an impossible destination ... or one that is acceptable only as temporary refuge or a secondary, accessory position. (1993: 64)

The personal history of the development of a habitus elucidates the 'astonishingly close correspondence between positions and dispositions, between the social characteristics of 'posts' and the social characteristics of agents who fill them' (ibid.).

3.2.3 Dynamics in the cultural field

In Bourdieu's view, two types of relationships govern the dynamics in a field: on the one hand, the struggle for dominance between positions in the field itself and, on the other hand, the relationship of (elements in) the field to (elements in) the environment, especially to the field of power.

Neither type can be thought of separately from the other, as will become clear in the next section.

AUTONOMY AND HETERONOMY

In subsequent figures, Bourdieu places the field of cultural production within the field of power, which is, for its part, embedded in the 'field of class relations' (1993 [1983]: 38) or in the '(national) social space' (1996: 124). In the first version a more or less simple notation indicates the dominant and dominated positions between and partly within the fields (see figure 3.2).

Figure 3.2 Relations of dominance between fields

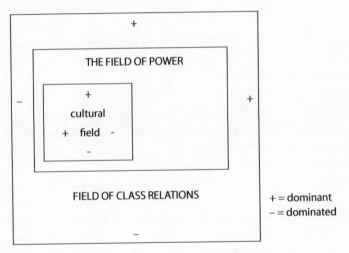

(Source: Bourdieu 1993: 38).

The field of power can be considered at best as a 'meta-field,' because it governs the roles and positions of different forms of capital in all fields. In *The Rules of Art*, Bourdieu defines it as

> the space of relations of force between agents or between institutions having in common the possession of the capital necessary to occupy the dominant positions in different fields (notably economical or cultural). It is the site of struggles between holders of different powers (or kinds of capital). (1996: 261)

The plus and minus signs within the cultural field itself are only used here to indicate that dominant relationships exist in that field too, that is, based on the distribution of specific capital between the positions. But the more important issue behind this figure is that the field of cultural production is contained in the field of power, so it is part of the dominant section of society, but, at the same time, within the field of power it is dominated. Bourdieu speaks about a double hierarchy:

> The *heteronomous* principle of hierarchization, which would reign unchallenged if, losing all autonomy, the literary and artistic field were to disappear as such (so that writers and artists became subject to the ordinary laws prevailing in the field of power, and more generally in the economic field), is *success* ... The *autonomous* principle of hierarchization, which would reign unchallenged if the field of challenge were to achieve total autonomy with respect to the laws of the market, is degree [of] *specific consecration*. (1993: 38).

In other words, struggles, positions and position-takings are governed by hierarchies on two different scales: a horizontal and a vertical one. The first concerns the relative degree of external versus internal, or heteronomous versus autonomous influence on the structure of the field, based on the position of the cultural field itself in the field of power. This degree can be expressed in terms of the autonomy of the field with respect to the environment. On the vertical scale, the hierarchy *within* the field is indicated, which refers to the different degrees of 'consecration' (to be expressed in the amount of prestige) of positions in the field. Both hierarchies are interwoven: the greater the autonomy of a field, the stronger the consecrated positions *within* the field; or, the other way around, the weaker the position of the field is in relation to the environment in terms of autonomy, the stronger are the market-oriented positions *within* the field.

The relationship between the different fields and the forms of capital has been worked out by Bourdieu in *The Rules of Art* (figure 3.3). The figure shows that lack of economic capital and presence of cultural capital are coherent with a high degree of autonomy, as is the case for the sub-field of restricted production, for example, forms of avant-garde art; and, on the other hand, that lack of cultural capital and presence of economic capital are connected with heteronomous influences, as is the case for large-scale art production, such as a musical or a Hollywood film.

Figure 3.3 **The field of cultural production in the field of power and in the social space (1996: 124)[10]**

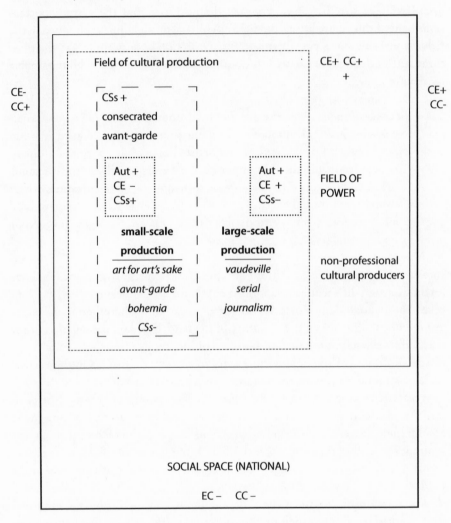

Some aspects of the model have to be qualified somewhat. In the first place, Bourdieu designed this figure for his study on the French literary field at the end of the nineteenth century, which does not mean that the model holds for all possible art worlds in all possible periods.

To be specific, in the first instance, the role of the state has remarkably changed the relationship between economic and cultural capital in the twentieth century, *a fortiori* since the Second World War, a point in time when state subsidy strengthened the autonomy of several art worlds, albeit not the literary world.[11]

In the second instance, it might well be true that specific symbolic capital (artistic prestige) and a high degree of autonomy do go hand in hand, but the combination does not fully exclude the attracting of economic capital, because the production linked to them does not necessarily take place in the sub-field of restricted production. Nobel Prize-winning authors and painters who are exhibited in the main museums for modern art throughout the world, on the contrary, occupy highly consecrated positions, although partly active in the sub-field of large-scale production where economic capital can easily accumulate.

In the 'Production of Belief' Bourdieu elaborates the underlying relationship between the cultural field, on the one hand, and the economic and political fields (main parts of the field of power), on the other.

> 'Symbolic capital' is to be understood as economic or political capital that is disavowed, misrecognized and thereby recognized, hence legitimate, a 'credit' which, under certain conditions, and always in the long run, guarantees 'economic' profits. (1993: 75)

Just this misrecognition and veiling of the economic and political sphere by the cultural field enables it to be

> the area *par excellence* of clashes between the dominant fractions of the dominant class, who fight there sometimes in person but more often through producers oriented towards defending their 'ideas' and satisfying their 'tastes,' and the dominated fractions who are totally involved in this struggle. (Idem: 102)

More especially, the orthodox representation of reality is likely to give people the feeling that what they experience is, indeed, the obvious representation of reality. Formulated in more general terms, finally:

> Specifically aesthetic conflicts about the legitimate vision of the world – in the last resort, about what deserves to be represented and the right way to

represent it – are political conflicts (appearing in their most euphemised form) for the power to impose the dominant definition of reality, and social reality in particular. (Ibid.)

These views, set out in the 'Production of Belief', refer possibly more to the cultural field as a whole – sometimes mentioned as the 'intellectual field' – than to the artistic field in particular. Because of the specific character of aesthetic languages, the degree of mediation in the field of artistic production is relatively high, as is the degree of autonomy of the field. Hence, the relative autonomy of the cultural field can be judged from its capacity to transpose or to 'refract' external influences or even commissions. The 'refraction effect', the conversion of external elements into field discourses, more specifically into field languages and practices, distinguishes professionals in the field from amateurs, since the latter tend to paint, write or play at least partly in less specific, more general languages (1996: 220-221).

Still, there will always be a continuing struggle for dominance between autonomous and heteronomous forces in the field, the (im)balance between which is determined by the degree of autonomy of the field as a whole. So, to conclude this section on the relationship between autonomy and heteronomy, field dynamics will always 'be affected by the laws of the field which encompasses it, those of economic and political profit' (1993: 39).

FIELD FIGHTS[12]

The subtitle of Bourdieu's article 'The Field of Cultural Production' is 'The Economic World Reversed'. Values typical for this field have a symbolic character, which means that economic value or interest is veiled and disavowed, in favor of pure aesthetic intentions and disinterestedness as core categories in the artistic field. Bourdieu argues that

> the anti-'economic' economy' of pure art [...] has been founded on the obligatory recognition of the values of disinterestedness and on the denegation of the 'economy' (of the 'commercialism') and of 'economic' profit (in the short term). (1996: 142)

A consequence of this is that the most radical defenders of the autonomous stance in the field 'make of temporal failure a sign of election and of success a sign of compromise with the time' (1996: 217). But the most fundamental consequence of the symbolic character of cultural production is that the specific capital to be accumulated in the field is artistic prestige, which, of course, can be transposed in the form of economic capital at certain moments, albeit, quite often only in

the long term. Prestige is strongly connected to consecration; the latter generates the first. Positions, agents and their work are more or less consecrated by the discourse in the field, based on, for example, by whom they are discussed, in what types of publications, and so on. The more autonomous a (sub-)field is, the more significantly the consecration will be generated within the inner circle of involved people. Bourdieu's picture of the French literary field in the second half of the nineteenth century, published in 'The Field of Culture' (see figure 3.4), later simplified in *The Rules of Art*, shows quite clearly not only the role of consecration in structuring the field of cultural production, but also how different forms of the capital and segmentation of audiences are related to it.[13]

The struggle between positions – and agents who occupy them – for artistic prestige goes hand in hand with the struggle for legitimacy, that is, the efforts of parties involved to keep or to make their own artistic position the most legitimate one. In *The Field of Cultural Production*, Bourdieu discerns three 'principles of legitimacy:'

> The recognition granted by the set of producers who produce for other producers, their competitors, i.e. by the autonomous self-sufficient world of 'art for art's sake,' meaning art for artists. Secondly, there is the principle of legitimacy corresponding to 'bourgeois' taste and to the consecration bestowed by the dominant fractions of the dominant class...Finally, there is the principle of legitimacy which its advocates call 'popular,' i.e. the consecration bestowed by the choice of ordinary customers, the 'mass audience.' (1993: 51)

'Principles' may not be the most proper term, because, in short, it might be said that the three principles are based on three different tastes (of professionals, 'bourgeois'[14] and mass audience), but that within each sub-field of taste the same principle holds, namely the struggle for dominance. Here a similar scheme as that discussed under the heading 'autonomy and heteronomy' can be recognized. In the previous section, the hierarchy was concerned with the relation between the cultural field and others, such as the fields of economics and politics, whereas on the vertical axis the distribution of consecration within the field was determined. Now, besides this internal vertical fight, a struggle for legitimacy on the horizontal axis appears to occur within the field itself as well. In figure 3.4, three different types of 'literature' (poetry, the novel and drama) and their audiences compete on the horizontal axis, whereas in all three areas a struggle is going on between consecrated positions and newcomers. In Bourdieu's words:

Figure 3.4 French literary field in the second half of the nineteenth century (based on Bourdieu 1993:49)

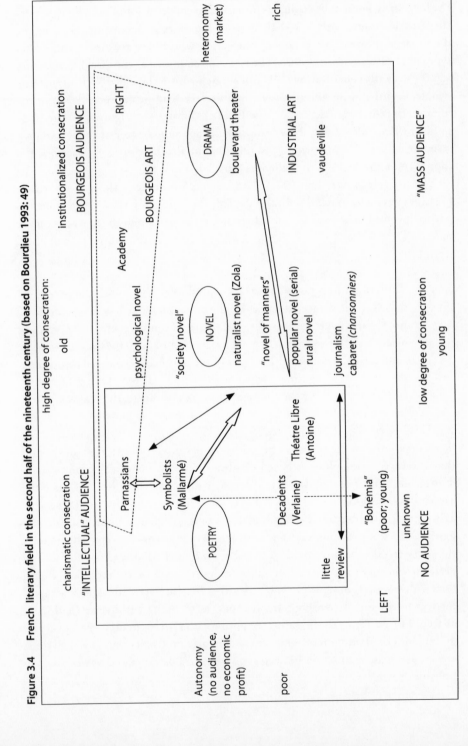

> The structure of the field of cultural production is based on two funda-
> mental and quite different oppositions: first, the opposition between the
> sub-field of restricted production and the sub-field of large-scale produc-
> tion, i.e. between two economies ... ; and secondly, the opposition within
> the sub-field of restricted production, between the consecrated avant-garde
> and the avant-garde, the established figures and the newcomers...(1993: 53)[15]

In both fights, the definition of art is at stake, or better, the right to formulate
the legitimate definition of what is art and hence 'the monopoly of the *power of
consecration* of producers and products' (1996: 224). Such a monopoly tries, as in
fact each effort to define does, to exclude works, methods of working, and artists
in order to establish a specific point of view on what real art is and who real art-
ists are as the 'fundamental law of the field, the principle of vision and division
(*nomos*) defining the artistic field (etc.) *as such*' (1996: 223).

The idea of a monopoly of the definition of art is, also according to Bourdieu, a
delusion because of the very open boundaries of the cultural field. He calls them
extremely porous and attributes this to the low degree of codification of the field.
The 'dynamic borders of the field' have not been translated into legal borders, of-
ficial rules of play and rights of admittance.[16] The result is that 'to produce effects
is already to exist in a field, even if these effects are mere reactions of resistance
or exclusion' (1996: 225-226).

THE SPACE OF POSSIBLES

Bourdieu is very conscious of the fact that his theory might be accused of too
much determinism, somewhere on the scale between the power of structures and
the power of agents. To make his point of view clear, he brings up 'the space
of possibles': 'The relationship between positions and position-takings is by no
means a mechanical determination. Between one and the other, in some fashion,
the space of possibles interposes itself' (1996: 235). For agents, this space presents
itself as the relationship between their own sets of dispositions and the structural
chance of access to positions (1993: 64-65). So, the space of possibles is, in a sense,
perceived through the agent's dispositions, which, for their part, will, stimulated
by this perception, become able to occupy a position. Hence Bourdieu calls the
space of possibles a 'discloser of dispositions' (1996: 235). And to put an end to all
doubt, he states that, in such a weakly institutionalized field,

> agents always have an objective margin of freedom at their disposal (which
> they can yes or no make use of, dependent on their 'subjective' dispositions), no
> matter how tight the requirements included in their position may be. (1993: 65)

This idea opens up opportunities for diversity in the field, meaning that agents with relatively different sets of dispositions can occupy similar positions, especially in avant-garde sub-fields, where access to the field is at stake in the first place. But it is questionable whether it also generates the possibility of more or less radical changes in the field. 'In the phase of equilibrium, the space of positions tends to govern the space of positions-takings' (1996: 231). This means that, for the agents, the margins of freedom will be smaller. More radical changes in the structure of positions – and hence more space for new or subversive agents to fill in positions – are only possible under two conditions. First, innovative products can only enter the field if they are already present in it in a potential state, as 'structural lacunas' so that they can be 'accepted and recognized as reasonable at least by a small number of people, the same ones who would no doubt have been able to conceive of them' (1996: 236). In general, because of the unbalanced relationship between their position and their habitus, these agents feel relatively free from the constraints inscribed in the structure. Second, the entrance of agents whose positions and position-takings 'clash with the prevailing norms of production and the expectations of the field ... cannot succeed without the help of external changes' (1993: 57). More than that:

> however great the autonomy of the field, the chances of success of strategies of conservation and subversion always depend in part on the reinforcement that one or another camp can find in external forces (for example in new clienteles). (1996: 234)

It is not difficult to imagine the direct (although always mediated by field characteristics) influence or pressure of technological, political and economic developments on the field of cultural production, but Bourdieu pays special attention to the role of audiences. He argues that there is a strong homology between the structures of the cultural field and the field of power, which creates a link between groups of agents in the first and possible audiences in the latter field. That the size of audiences is (perhaps) the most reliable and visible indicator of positions in the field, in Bourdieu's view (Rules 217-218),

> results from the homology between positions occupied in the space of production (...) and positions in the space of consumption; that is, in this case in the field of power, with the opposition between the dominant and the dominated fractions, or in the field of class relations, with the opposition between the dominant and the dominated classes. (1993:45)

And to give a challenging example:

> The cultural producers, who occupy the economically dominated and sym-
> bolically dominant positions within the field of cultural production, tend to
> feel solidarity with the occupants of the economically and culturally domi-
> nated positions within the field of class relations (1993:44).

Although – or perhaps because – this example seems at least partly to be inspired
by the spirit of the times in France during the 1960s and the 1970s, it allows one
to see how changes in the political and social world around the field of cultural
production could generate changes in the structure of positions in the cultural
field, since authors, theatre and film makers, musicians, in short, all sorts of art-
ists started to link their work to issues and points of view developed in the world
around. Bourdieu speaks in this respect about 'the play of homologies' between
the oppositions in the field of culture and in the fields of power and holds these
homologies responsible for the most important effects in the field of cultural pro-
duction (1993: 44); more precisely, these homologies create the opportunity for
external factors and agents to influence the (use of) the space of possibles within
the cultural field. In the case of the relationship between the field of cultural pro-
duction and the field of power Bourdieu sees an 'almost perfect homology,' based
on two chiastic structures:

> Just as, in the dominant class, economical capital increases as one moves
> from the dominated to the dominant fractions, whereas cultural capital
> varies in the opposite way, so too in the field of cultural production eco-
> nomic profits increase as one moves from the 'autonomous' pole to the
> 'heteronomous' pole, whereas specific profits increase in the opposite
> direction. Similarly, the secondary opposition, which divides the most
> heteronomous sector into 'bourgeois art' and 'industrial art' clearly cor-
> responds to the opposition between the dominant and the dominated
> classes. (1993: 44)

With this, the Bourdieusian circle of the field of art can be considered completed.

3.3 Some comments on Bourdieu's theory of the cultural field

Although Bourdieu's immense importance for the development of art sociology
has been recognized world-wide, from the mid-1990s, critical comments on his
views also occur (e.g. Laermans 1994 and 1997; Heinich 1998 a and b, 2003; Gielen

2003; and in a more philosophical and detailed sense, Shusterman 1999). Many of the comments circle around the classic problem of the relationship between structure and agency and several authors try to link Bourdieu's approach with structuralism as a negative reference. In the preface to a collection of her articles in Dutch, Nathalie Heinich calls Bourdieu the personification of the neo-Marxist tradition (Heinich 2003: 12).[17]

And, rereading and reviewing Becker's *Art Worlds* in 2000, she compares Becker's and Bourdieu's approaches by saying:

> he [Becker, HvM] insists more on the ongoing process – as in the interactionist sociological tradition – than on underlying structures of experience that are inherent in Bourdieu's structuralist trend. (Heinich 2000: 201)

A similar comment is made by Gielen, who has difficulties in understanding the role of artistic autonomy within Bourdieu's theory of fields and notices: 'in that respect the French sociologist remains marked by structuralism. According to that paradigm rigid underlying patterns organize the daily lived practice' (Gielen 2003: 11).[18] These efforts to push Bourdieu back into the camp of the structuralists – against which he resisted fiercely and in my opinion convincingly – stem from a strong fear that his theory does not provide enough space for agents to take things in hand, to change themselves, their work or their relationships in the field autonomously, independent of or even against the 'rules' of the system. Gielen goes so far as to say that the field theory presents social or collective mechanisms as the one and only possible explanation for artistic choices in a field (2003: 112). This opinion is based on his perception of Bourdieu's notion of the habitus, which he considers an 'amalgam' of a position and an occupier of that position, called by Bourdieu 'a structured structure' or an 'internalized exteriority' (Gielen 2003: 101). Gielen wonders:

> How can this structured structure do something else than reproduce the same again and again. Where can we find the inventiveness or agility of the exteriorization process ...? In my opinion this is just generated by the fundamental disunity of the habitus. The tension between a position and the occupier of this position enables reflectivity, through which also new possible action can be perceived. It is that tension, indeed, that co-determines the dynamic in a field. (Ibid.)

Gielen is absolutely correct here, but the remarkable thing is that he is repeating Bourdieu's own words, instead of showing a new and opposite point of view, as will be clear from how Bourdieu was quoted on the 'margin of freedom agents

always have' a couple of pages back. But the next fragment covers Gielen's perception even more:

> The summons contained in these gaps is only understood by those who, as a result of their position in the field, and their habitus and the (often discordant) relation between the two, are free enough from the constraints inscribed in the structure to be able to recognize as applying to them a virtuality which, in a sense, only exists for them. (Bourdieu 1996: 239)

Gielen and others may be fully right that Bourdieu's thinking is coloured by the forms of structuralism he comes from, but just as he defends his position towards Althusser, for instance, by blaming him for determinism, Gielen needed to react against Bourdieu (often in an oversimplifying way) in order to open up new ways of thinking.[19] This shows, by the way, exactly the type of struggle Bourdieu perceives in the field of scholarly production.

As an expert on Bourdieu's work, Laermans, too, was disappointed when *Les règles de l'art* was published. He criticized Bourdieu for repeating his well-known ideas, as well as for a number of inaccuracies and for the use of outdated concepts. He wondered whether Bourdieu had not made a mistake by picking the wrong opponent for his Flaubert study: the outdated Sartre instead of Derrida, who 'nowadays dominates the landscape of literature theory' (1994: 6). He was angry about the careless composition of the book, the 'rigid summary of earlier formulated insights', the 'more or less superfluous review exercise' and the 'extremely sharp tone of the piece of writing' (idem: 7-8). Laermans even wondered whether Bourdieu's success hadn't simply been generated by his polemical writing style. 'So much boyish and particularly rather unacademic swagger perhaps commands many readers-academics' admiration' (idem: 10). Of more importance for the goals of the present study is Laermans's critique of Bourdieu's effort to monopolize art sociology by means of his field theory and to exclude other types of art sociological study. Laermans's opinion is that Bourdieu ignores all types of changes in social behaviour. I disagree with Laermans on this point because of the space Bourdieu opens up for external influences on the dynamics of the artistic field. Concerning the relationship between the artistic field and the world around it, Laermans brings up another question, which he considers the most important methodological one, namely, how can the boundaries of a field be defined. He suggests, incorrectly in my view, that Bourdieu should exclude popular writers from the field of literature and, in doing so, as a sociologist he ends up favouring one of the definitions that circulate in the field as a whole. He asks the question:

How does (...) an art scholar who tends to the field approach know, that he takes a position that makes it possible indeed to have an objectifying and distant, as well as a full (over)view over the 'space of positions' investigated? (Idem: 16)

In my opinion, Bourdieu is, on the contrary, quite convincing in his effort to define the literary field in a rather neutral and technical way, although he is not very explicit or extensive in distinguishing typical features of the literary field from non-typical ones. On the one hand, he does sum up the types of institutions involved and the nature of their activities, while, on the other hand, he remains fully aware of – and underlines several times – how porous the boundaries of artistic fields are. Whether a 'full objectifying and distant overview' should be possible, is, in fact, not in question, because the automatic answer would be no. However, according to Laermans (and Heinich, as we will see later), it is questionable whether Bourdieu really can claim this position. In addition, the fact is that this point of view just does not wash. Bourdieu does, in fact, make use of a very polemical, offensive style in this, a methodological, discussion and even claims to be defending the best approach, but he still does not suggest that his approach guarantees an objective and complete analysis of the field. Defending a method in order to look for objective relationships, in the sense Bourdieu means, is not the same as claiming a *God's eye view* (idem: 16).

Disappointment with a former hero and reckoning with a terminology that represents a structuralist past seem to be the two important elements in Laermans' break with Bourdieu. In the same period, however, he goes on to discover Niklas Luhmann's work, which, as a pure theory of systems, ends up providing scholars with many more opportunities to free themselves from subjective positions in or towards the field they study.

Finally, the way in which Van Rees and Dorleijn (2006) discuss the literary field can be considered an implicit critique of Bourdieu's 'engagement'. The authors present Bourdieu's field theory as one of the most elaborated forms of the institutional approach and make use of the term 'field' as well for their own description of the organization of relationships between literary institutions. But, whereas Bourdieu's pictures of the field (see e.g. figures 3.3 and 3.4) show the types of literary positions and their mutual relationships, Van Rees and Dorleijn use the title 'the literary field' to map the types of organizations and institutions that are active in the field. They make a very clear distinction between three domains, covering respectively the 'material production' (authors, publishers); the 'distribution' (libraries, bookshops) and the 'symbolic production' (critics, education). Their model can be seen not only as an organizational blueprint, on the basis of which Bourdieu's field laws can be realized, but also as the necessary and

helpful operationalization of Becker's rough ideas about art worlds. One extra benefit of the model is that it gives the domain of distribution its own central place. The use of the term 'symbolic production' for the domain in which literary views are produced is clear and useful in this model, but interferes strongly with Bourdieu's more general use of the term and with his concepts of 'symbolic capital' (capital in symbolic form) and 'specific symbolic capital' (recognition and prestige in a field). Obviously, the latter form of symbolic capital is produced in Van Rees's and Dorleijn's domain of symbolic production.

3.4 Bourdieu's field theory and the functioning of art in society

Apart from Bourdieu's persistent plea for the investigation of 'objective relationships' instead of Becker's enumerations, and apart from his peculiar concept of positions in a field as artistic positions or 'functional posts', it is especially the internal coherence of a field that stands out. On a collective level, the binding effect stems from the shared illusio, on an individual level, from the habitus in particular; the habitus connects personal background and development with the requirements of positions.

This inflected nature of a field, as Dickie termed it, comes to the fore in all institutional approaches and gives at least the impression that changes within the field are difficult to reach and that the relationship with the outside world is of secondary importance. Bourdieu points out that both questions are strongly influenced by the degree of autonomy of the field; a lower degree makes the field more sensitive to external, especially market-oriented, influences. However, the other way around, it can be argued that a high degree of autonomy might be necessary and helpful to make artistic values function in fields other than those in which they are produced without losing their characteristics.

Bourdieu's theory almost entirely concerns the internal functioning of fields. This doesn't mean Bourdieu doesn't pay attention to external factors influencing the field from outside. Certainly not: he discusses the position of the cultural field within the field of power; in his opinion, changes in an artistic field can only be carried through with the help of external forces, and he states that there is a strong homology between the structure of positions within the artistic field and the structure of positions of different groups of users in the social space surrounding them. But all these excursions serve a better understanding of the internal functioning of the field, particularly the field of artistic production. So the notion of functioning refers particularly to the types of relationships in the field and the types of dynamics that govern these relationships more than to the artistic outcomes and the role they play in the fields surrounding them.

Nevertheless, the field theory helps to frame some questions about the functioning of art in society. For instance, if the cultural field is part of the field of power – and of course it is part of the social space in general – one might investigate under which circumstances the outcomes of the cultural field can play a role in society, and which different roles are possible. The existence of a space of possibles *within* the artistic field also makes it reasonable that homologies between relationships in the field of artistic production and those in the social space of users are not entirely fixed, and that, consequently, artistic communication can influence people's perception of their social space.

However, Bourdieu shows that the position of the cultural or the artistic field in the field of power determines the possible influence of cultural capital in the social space. In this space, the cultural field is dominated by other fields, particularly the economic and the political fields. It can be questioned whether this relationship of dominance can differ from culture to culture and over history, or, in other words, whether the opposition between heteronomously generated economic capital and autonomously generated cultural capital in the cultural field can be overcome, or at least mitigated. As Gisèle Sapiro points out, 'the situation of the different national literary fields depends on two main factors: the degree of economic liberalism and the degree of political liberalism' (2003: 442). Hence it is imaginable that if the political field set great store by a vivid cultural and artistic life in society, the cultural field could operate more autonomously, even less dominated by economic laws, without losing its societal significance. To make it more concrete: the degree of cultural background and interest not only within the political field, but of the political parties and politicians themselves as well, is likely to influence the degree of dominance of the cultural by the political field, paradoxically in an inverse way.[20]

So, based on Bourdieu's idea of the relationships within the field of power, the question may be asked under which circumstances cultural, and particularly artistic, values will adequately function in the social space, in addition to his own question regarding how these relationships influence the internal functioning of the cultural field.

In connection with these relationships in the field of power on a more instrumental level, the study of the ways in which the use of artistic expressions is organized in a culture is of great importance. Investigations of this kind cross the borders between the cultural and other fields in general and concern the organization of the distribution of cultural products in particular. Bertolt Brecht's 'sociological experiments' and Walter Benjamin's view that these experiments aimed to change then-current conditions of production and distribution, can contribute to understanding the relationship between the mechanisms according to which a field of production is organized and the possible effects of the products in their

surrounding world; as Benjamin said in the early 1930s regarding this: 'For, we are confronted with the fact (...) that the bourgeois production and publication apparatus is able to absorb appalling amounts of revolutionary themes, even to propagate them, without questioning its own survival (...)' (Benjamin 1966 [1934]: 104-105). If this is true, the societal functioning of art cannot be studied and understood separate from the analysis of the organization of the distribution domain.

As said earlier, Bourdieu, too, concentrates heavily on the domain of cultural production, where the autonomy of the field is more visible and certainly more present than in the domain of distribution, that is, generally speaking, more sensitive to laws and mechanisms of the market. But it is the domain of distribution that, in a concrete sense, can be considered the 'space of possibles', because there the encounter between art(ists) and audiences takes place and, as a consequence, the functioning of art gets its societal start.

Notes

1 In 'Le mort saisit le vif. Les relations entre l'histoire réifiée et l'histoire incorporée' (1980), Bourdieu blames Althusser for a deterministic approach, because he should be considering human behaviour as being a direct result of the systems people live in. It is questionable whether this is a correct reading of Althusser's famous article on ideology and ideological state apparatuses (1970). However, Bourdieu indeed did try to free himself from a structuralist position by conceiving the relation between societal factors and individual acting as always being mediated by the specific internal logic of the fields in which people act and the habitus of agents.

2 If one compares this fragment from The Rules of Art with the way in which Bourdieu quotes Becker in 'The Field of Cultural Production' (1983/1993), one can observe that his tone has become much more aggressive. In 1983, Bourdieu praises Becker for his view of 'artistic production as a collective action, breaking with the naïve vision of the individual creator', although he also disputes Becker's reduction of the field to population, 'a sum of individual agents, linked by simple relations of interaction' (1993: 34-35).

3 Pels 1992. By the way, Bourdieu also sometimes uses different terms such as network, configuration or system to describe what he means with his own category 'field' (champs), which is, because of its metaphorical background as playfield or even battlefield, his terminological choice.

4 Bourdieu points out that this theory is a limited one because it does not question its own presuppositions and so makes a general economy of human practice impossible, 'which sees the exchange of commodities as a particular case of exchange in all its different forms' (1992c [1983]: 122).

5 Bourdieu uses here the Roman Catholic theological term 'transsubstantiation' for what happens when purely material forms of capital present themselves in immaterial forms as social or cultural capital (1992c [1983]: 121). Hans Abbing's views in Why Are Artists Poor? (2002) have largely been based on this thesis of mystification in the experience of

art production and evaluation, but they go too far, strongly suggesting that no other value of art could be determined than an economic one or one based on this mystification.

6 Hence Bourdieu considers the period of time people use to acquire cultural capital 'the least inaccurate indicator of the amount of cultural capital' (1992c [1983]: 125). Although he links this view emphatically to the role of family background, it certainly also supports the idea that the longer the general school career, the more cultural competence one will acquire.

7 Again, Danto's argument for the introduction of the idea of an art world is not far off.

8 Swartz points out that Bourdieu's notion of field comes close to the term 'institution' as used in some sociological schools, such as 'the field of law' as an institution. But Bourdieu's fields have a broader meaning than that and 'can span institutions, which may represent positions within fields' (Swartz 1997: 120). In my opinion, the term *doxa* comes closest to the notion of institution, if seen as a historically grown and stable set of rules, habits, concepts and conventions.

9 Especially the implicit learning process, in which dispositions are developed and a habitus comes into being, has to be linked to the role of class background, Bourdieu argues (1993: 71-72).

10 As can be deduced from figure 3.2, the dimensions and places of the different sub-fields have been partly distorted for the sake of clarity of the picture.

11 Swartz notes that Bourdieu has paid little attention to the role of the state, which has become much more important for the cultural field since 1945. He quotes Bourdieu and Wacqant (1992) where the notion 'statist capital' is used for a form of capital which is struggled for within the field of power and that 'functions as a kind of "meta-capital", in that it exercises power over other forms of capital and particularly over their exchange rate' (Swartz 1997: 138). It can be questioned, however, whether subsidies should be understood as economic capital because of their minimal capacity to accumulate in a direct economic sense. On the other hand, they do help cultural capital (in embodied and objectified states) to accumulate. Bourdieu states that the degree of autonomy that the literary field reached in the second half of the nineteenth century has never been surpassed (Rules, 265). More especially, the literary field did not get much benefit out of the state support for the arts that arose during the twentieth century. Its characteristic possibility for reproduction makes literary products, just like photography, film and, later, music too, particularly attractive for economic capital.

12 Much of Bourdieu's terminology has been derived from the battlefield. He seems to jump back and forth from the metaphor of playing to the metaphor of war, the latter probably stemming from his Marxist roots, although he stresses regularly that agents are not consciously striving for power, dominance, prestige, and so on, but do what they have to do on the basis of the relationship of their habitus and the position they occupy.

13 I prefer to use the older figure Bourdieu presented here because it provides more information than the comparable figure in *The Rules of Art* (p. 122).

14 In terms of Becker, the general taste of 'well-socialized people' also might be meant.

15 In fact, Bourdieu confines himself here (and in general) to the distribution of consecration in the sub-field of restricted production, whereas, in principle, a similar axis can be studied in the two or three cultural taste fields.

16 Still, Bourdieu argues that 'The very severe and narrow definition of authorship we find obvious nowadays, is the result of a long row of exclusions and excommunications, meant to bar all kinds of producers who could consider themselves authors on behalf of a broader and opener definition, from an existence as authors worthy of that name' (1996: 224). Also it can be argued that the borders of some artistic sub-fields have become more severe since professional training schools have set the standard more and more. On the other hand, a public medium, such as television, has opened up new ways for talent to enter into the artistic field in other ways.

17 How Nathalie Heinich distances herself from Bourdieu will be discussed in the fourth chapter of this book, which is devoted to her art sociological approach.

18 Gielen 2003 is definitely an interesting and thorough effort to find the pragmatic values of both Bourdieu's theory of the cultural field and ANT by applying these approaches to the field of contemporary Flemish dance and to the field of contemporary Flemish visual art respectively.

19 The same kind of attitude is demonstrated by Gielen's opinion that Bourdieu neglects the influence of the field of power on the state-supported field in which the world of contemporary dance in Europe finds itself. He argues that this theatrical sub-field could not survive or develop without substantial financial support from the state. He considers this mechanism a transmission from symbolic to economic capital that would do harm to the autonomy of the field. As said earlier, it is very disputable whether subsidy should be considered a form of economic capital and hence whether it would end up doing harm to autonomy instead of strengthening it against market influences. In addition, it is difficult to maintain that Bourdieu should ignore influences from outside upon the field relations as such (see also note 11).

20 In present neo-liberal societies, in which the economic field dominates the cultural as well as the political fields, the opposite development can be perceived: cultural expressions increasingly are seen in the light of social and economic functions, easily losing significance on the basis of their intrinsic value as art.

4 From Theory to the Methodology of Singularity: Bruno Latour and Nathalie Heinich

4.1 Introduction

Generally speaking, critical comments on Bourdieu's field theory have come from sociologists who have problems with his efforts to uncover 'objective' relationships and mechanisms within the field of art and to develop a theory based on this effort. The theoretical heterodoxy which Gielen has defended, for example, tends to grant more significance to individual agency in shaping a field of artistic positions, at the expense of the idea that (general) regularities should govern the field. In his approach to the fields of dance and visual arts in Flanders from the perspective of systems theory, he has obviously been strongly inspired by Bruno Latour and especially by what he calls 'The Glorious Entry of Nathalie Heinich' (Gielen 2003: 115). Both of them, as well as the Actor Network Theory in general, draw a sharp line between structuralist (and especially critical) sociology and their own practice, referred to by Latour as the sociology of associations (versus the traditional sociology of the social).

In the first pages of his *Reassembling the Social* (2005), Latour states that neither a domain that could be called 'social', nor an entity that could be called 'society' and that ought to function as a context for human activity, really exist. On the contrary, in the sociology of associations, the term 'social' designates '*a type of connection* between things that are not themselves social' (2005: 5). In Latour's view, the sociology of the social considers the human world made out of social stuff and working on the basis of social structures that explain people's activities. It is especially critical sociologists – often understood by Latour, Heinich and Gielen as (post)structuralist sociologists – who have to pay for this shift.

> When faced with new situations and new objects, it [critical sociology, HvM] risks simply repeating that they are woven out of the same tiny repertoire of already recognized forces: power, domination, exploitation, legitimization,

fetishization, reification. (...) The problem of critical sociology is that it can never fail to be right. (Idem: 249)

Later on, this point of view will be discussed more thoroughly, but for now it can already be noted that it is close to the heart of the Actor Network Theory (ANT), which emphasizes the continuous processes of change in what is going on between actors: actors are entities that make other actors do things; travelling from one point in a network to another cannot happen without a change in that which is travelling; 'the social is a very peculiar movement of re-association and reassembling' (idem: 7), which means that associations, connections and relationships are not simply a result of 'the social', but are shaping and renewing it again and again. By these types of thinking ANT tries to distinguish itself fundamentally from conventional sociology, since while the latter might have been useful in nineteenth- and twentieth-century modernism, it is completely unsuitable to studying an atomizing culture.

Before moving over to Nathalie Heinich's work on sociology of art, which is strongly based on the Actor Network Theory, some of the key concepts of the latter will be described in the next section.

4.2 The Actor(-)Network Theory

Actor Network Theory and After (1999, 2004) presents not only a number of new discussions and applications within ANT, but opens with contributions by the founding fathers Bruno Latour and John Law, who make up their minds with regard to this theory that is actually not a theory.

Latour discusses what he calls 'four nails' he likes to 'hammer into the coffin of ANT', one for each element of the name of the approach: actor; network; theory and the hyphen between actor and network.[1] In the first place ANT has never been a theory, or at least has never been meant to be a theory, as Michel Callon remarks in the same collection of articles:

> We never claimed to create a theory. In ANT the T is too much ('*de trop*'). It is a gift from our colleagues. We have to be wary of this type of consecration especially when it is the work of our best friends. (Callon 2004: 194)

It could better be seen as one of the anti-essentialist movements that, according to Latour, seem to characterize the end of the latter century.[2] As we have seen before in art theory, this anti-essentialism was already present at an earlier point in

the century, when Moritz Weiss and George Dickie formulated their statements on the lack of intrinsic or essential features of artworks. Later on, postmodernism strengthened this way of thinking and disseminated it throughout the theoretical world. ANT might be considered a typical example of that development, but Latour advises not to confuse postmodern deconstruction of the 'grand narratives' with the ANT goals 'to check what are the new institutions, procedures, concepts able to collect and to reconnect the social' (Latour 2005: 11).

Latour links the non-theoretical nature of ANT strongly with one of its most important backgrounds, ethnomethodology, based on the insight that 'actors know what they do and we have to learn from them not only what they do, but how and why they do it' (Latour 2004: 19). He sees ANT as a 'very crude method to learn from the actors without imposing on them an *a priori* definition of their world-building capacities' (idem: 20) and criticizes the pretensions of social scientists 'to act as legislators'. 'Follow the actors' is the slogan, and therefore participating observation, focus group interviews and document analysis, which also play an important role in the work of Heinich, belong to the standard research methods of ANT. This approach does not try to explain social behaviour with the help of theoretical notions, but tries to discover procedures people use in their social activities. The practice of ANT is, in Latour's opinion, 'the *summing up* of interactions through various kinds of devices, inscriptions, forms and formulae, into a very local, very practical, very tiny locus' (idem: 17). It is surprising, by the way, how this formulation echoes Howard Becker's concept, as criticized by Bourdieu but praised by Latour, because his descriptions remain always incomplete, open ended and hesitant (Latour 2005: 243).

The key term in ANT practice is, undoubtedly, 'network'. Both Latour and Law discuss this notion. Latour points out that, when ANT originated, the term network was a fresh and open one, which provided the opportunity to face up to over-used concepts such as institution or society. But nowadays, he writes, network is 'the pet notion of all those who want to modernize modernization' (idem: 15). Latour is really disappointed by that change. Whereas the term was originally meant in the sense in which Deleuze and Guattari introduced the 'rhizome' concept – as an ongoing series of transformations – network now means, in his view, 'transport *without* deformation (...) unmediated access to every piece of information' (ibid.). Latour speaks about 'double click information' that 'has killed the last bit of the critical cutting edge of the notion of network' (ibid.). Networks are, moreover, mostly understood as existing sets of relations to be described, whereas Latour underlines that in ANT a network is not what is *to be described*, but a tool to help *describe* 'flows of translations' (Latour 2005: 131-132). In other words, it is to see something as 'a string of actions where each participant is treated as a full-blown mediator' (idem: 128).

John Law similarly stresses the relation of ANT with French postmodern philosophy and the rhizome character of the network concept. He calls the network theory a 'ruthless application of *semiotics*' (Law 2004: 3). Following in Derrida's footsteps, he states that entities have no inherent qualities, but only exist and acquire their performativity as a result of their relations with other entities, and so on.

If a network is considered by others as a structure of relations between actors, the network in ANT is an unstructured structure constructed by the researcher which changes and expands continuously and in which actors can 'travel' by entering new connections, in the words of Pascal Gielen 'a conglomerate of junctions and points connected to each other' (2003:130). As a result, the borders between different networks, such as those of the arts, education, politics or economy, are much more open than in other approaches. These fields have their own regimes but are interwoven, and actors can be transformed by moving from one to another. 'Consequently, an artwork, for instance, is something economical and political and pedagogical and artistic and organic material (...) according to the translations within the network' (ibid.). This also means that when actors enter into new connections, they are, in principle, changing: 'Actors are network effects' (idem: 5), or even, as Callon, Law and Rip have said, 'the actor is both the network and a point in it' (1986: xvi).

It will come as no surprise that the relatively small set of terms used in Actor Network studies includes a considerable number that refer to movement and change: passages, translations, transmutations, and translation centres are the core terms in ANT.

Passages can be understood in two ways: as the activity of going through a translation centre to come from one (place in a) network to another, or as the translation centre itself that has to be passed through. Whereas I prefer the first idea, Gielen chooses for the second: 'Within ANT these passages are also called translation centers' (2003: 131). But Moser and Law describe a passage as 'A movement between specificities' whereas this movement 'is also a specificity in its own right' (2004: 200-201). 'Specificities' have to be understood here as specific sets of relations between materials, actors and other entities, such as a school class visiting a theatre, the public space shading into a museum square, a political meeting versus a broadcast of it, or an artwork becoming an economic object. Passages and consequently translations can happen within one specific network, for instance when someone enjoys seeing plays and for this reason visits a theatre. But a translation centre can also be located at the borders between networks, for instance when a director of a museum, proud of and faithful to his collection as a curator, has to sell one of his works and finds himself in a purely economic set of relations. In both cases, the actors are changing for two reasons. First, a new

position in a network generates a new set of relations in which an actor functions, and hence a new actor as well, because an actor is considered the result of its relations with other entities, as we saw above. Second, translation centres, such as the formal and informal institutional settings of theatres, galleries, educational organizations or political debates, ask the passing actor to adapt in relation to these settings. This translation is also called transmutation, because in principle the passage changes the actor. Consequently, Gielen is absolutely right when he points out that what really matters in an art world is the organizing of the passages through which actors (for instance, artworks) can play their role as mediators and realize their values (Gielen 2003: 194)

The third and the fourth nail Latour likes to hammer in the coffin of ANT are linked to one another. Thinking of the actor, the author writes especially about the hyphen between actor and network. From the outset he objected to the hyphen, because it would remind sociologists of the agency-structure debate and lead them to situate the ANT within this frame. ANT did not try to take a position within this debate; nor did it try to overcome the contradiction between agency and structure; it only wanted to ignore it. To explain this, Latour shifts from the sociologists' tendency to choose between structure and agency to the formulation of two different types of dissatisfaction sociologists tend to feel. First, the need for more abstract explanation of concrete facts, and second, conversely, the need for understanding the world on a more concrete level than the abstract terms, such as culture, structure, values, and so on, allow. Latour sees ANT 'as a way of paying attention to these two dissatisfactions' (Latour 2004: 17), not to overcome them, but to understand them. 'Maybe', he writes, 'the social possesses the bizarre property of not being made of agency and structure at all, but rather of being a *circulating* entity' (ibid.). In ANT there is not 'the Big Animal that makes sense of local interactions', but only, as we have said before, 'the *summing up* of interactions through various kinds of devices, inscriptions, forms and formulae, into a very local, very practical, very tiny locus' (ibid.), in which the entire social is present, without being an existing structure, or to be precise, a societal context.

Finally, we can go back to the actor itself, a point in the network of which it is the result at a certain moment: 'If an actor is said to be an *actor*-network, it is first of all to underline that it represents the major source of uncertainty about the origin of action' (Latour 2005: 46); or in other words: 'an actor is what is *made to* act by many others' (ibid.). On the other hand, an actor is only an actor if its agency modifies a state of affairs, that is to say, if it leaves a trace. Anything that makes a difference can be understood as an actor: people, organizations, animals and objects as well, as long as 'they might be *associated* in such a way that they *make others do things*' (idem: 107). On the basis of this, Latour even tends to say farewell to the notion of actor; not only because it will be easily understood as a

human actor, but particularly because the term suggests an initiative or a start-
ing point, whereas ANT sees the actor as a web. 'It is made to exist by its many
ties: attachments are first, actors are second' (idem: 217). Hence, instead of actor:
actor-network.

4.3 Nathalie Heinich's singular approach of art worlds

Heinich is a product of the French intellectual tradition – as a PhD student
supervised by Bourdieu – and is a classic example of a scholar who, in order to
create some space for her own ideas, has distanced herself from her dominant
master. In a preface to a Dutch translation of a collection of Heinich's essays,
the sociologist Bevers has even suggested that this strategy is more common in
France, where sociologists are used to reacting to each other, than it is with col-
leagues outside of France (Bevers 2003: 15).

In order to discover any interesting ideas Heinich has to offer, the reader first
must get beyond her tendency to attack her fellow sociologists, something partic-
ularly evident in her articles, where Heinich seems to go for a quick score rather
than taking the time to offer the entire argument necessary in order to evaluate
her point of view.[3] A good example can be found in 'Legimated Art. A Critical
Study of the Practical Value of a Concept' (2003),[4] where she fulminates against
the critical approach in art sociology:

> The hierarchy which forms the basis for classification has to be considered
> unjust according to critical sociologists because it incites social inequal-
> ity. According to such reasoning every museum curator can be blamed for
> abuse of power nowadays if he refuses to buy or to exhibit a certain work
> of art...But anyone who succeeds in getting through from the outside into
> the officially recognized domain automatically incriminates himself on the
> grounds of having become an accomplice of the dominant class. (Heinich
> 2003: 55)

Heinich does not supply the names of those whom she calls critical sociologists,
but one can well imagine that none of them would recognize him or herself in
this vague caricature that stands midway between a vulgar form of Marxism and
a vulgar form of institutional theory.

Another attack on this supposed sociological practice comes in the opening of
Heinich's article 'A Sociological Analysis of Artworks. Towards a Methodology'
(2003)[5]:

The success of these disciplines [a reference to art history, aesthetics and art criticism, HvM] is, since time immemorial, inherent in the task of studying the artworks itself! Sociologists would love to enjoy this kind of success as well and for that reason they urge one another on investigating artworks in their own right, rather than for their societal context. (Heinich 2003: 41)

4.3.1 *Sociological attitudes*

Although superficial statements like those quoted above have a counterproductive and offensive touch to them, they do demonstrate one of the central issues of Heinich's approach: her effort to demarcate the genuine task of art sociologists.

In 'A Sociological Analysis', she discerns four incorrect types of sociology of art. The first she calls 'pedantic', the second 'critical' (and pedantic), the third 'the sociology of artworks' and the fourth 'epistemological prejudice'. Most sociologists who fall into these four categories are blamed for their attempt to take over the role of art historians or for considering themselves higher in the scholarly hierarchy.

Sociologists are pedantic when they penetrate into the field of other scholars, for example, when investigating the importance of the paint tube in the development of painting outdoors (which is the field of art historians) or when studying the processes which enable art consumers to experience and appreciate artworks (which is the field of psychologists). This attitude draws Heinich into a misplaced, if not itself pedantic, irony:

> For art enjoys a privileged place within the hierarchy of intellectual values. Therefore sociologists find it hard to accept that simple art historians, not to mention quite ordinary critics, should be able to monopolize scientific commentary on such a highly rated subject as art. (Heinich 2003a: 42)

She proposes clarifying where one's own discipline stops as being at the point where knowledge must be borrowed from a complementary discipline, something which, in fact, is done not only by Nathalie Heinich, but by most art sociologists. Even Gielen has the feeling that his concrete study of the field of visual arts has been restricted too much by a lack of art historical and art theoretical knowledge, particularly in 'observing how artworks – in which specific way – influence social life' (2003: 230).

Heinich is most critical when it comes to what she calls critical sociology, 'which denounces the dominant values and demystifies the suspect processes of legitimization' (2003a: 43). Heinich's point of view is that critical sociologists try to undermine people's belief in the unique aesthetic values artworks can have,

the very values through which artworks might become timeless or universal. 'In this critical sociology of art, paintings function as targets for scholarly practice' (ibid.). The third group of colleagues gets more credit. These sociologists concentrate on the artworks as such, speaking about the artists only insofar as this can contribute to the explication of the works, but because they also 'are caught within the hierarchal structure of the scholarly industry (...) they are inclined not to check their epistemological prejudices' (2003a: 44). And finally Heinich discusses the epistemologically oriented sociologists who devote their attention to the question of how social relations are reflected in artworks. In so doing, they enter into the field of art historians, 'but with critical intent. Their goal is to get even with the make-believe found in the art scene which blocks the art scene's own view upon the real meaning of artworks' (2003a: 45).

In short, Heinich turns out to have two main problems with current trends in art sociology: in her opinion, her colleagues tend to try and take the place of art historians without having the discipline-based capacity to do so and they try to expose 'the reality' behind what is experienced as reality. Her resistance to the latter, modernist, inclination can be understood as an attack on Bourdieu's efforts in particular, in line with Latour's fear regarding understanding the activities of actors as the results of existing structures.

In Heinich's 1998 books, *Ce que l'art fait à la sociologie* and *Le triple jeu de l'art contemporain*, the views mentioned above are elaborated in a more thorough and partly positive way. In the first book she presents five possible attitudes art sociologists could choose, or, better, five characteristics for a correct and adequate art sociology.[6] She asks that they be 'anti-reductionist', 'a-critical', 'descriptive', 'pluralist' and 'relativist'.

Of course *anti-reductionism* is discussed from the standpoint of the forms of reductionism Heinich perceives, such as 'biographism', 'that personalizes production by tracing it to a unique subject' or, especially,

> the reduction of artistic or literal production to the institutions which determine it (...): for instance the market, the field, the social origin incorporated in a 'habitus' (to use Pierre Bourdieu's terminology), or even the 'world' related to the creative act (according to the terms of Howard Becker). (Heinich 1998a: 15)

These forms of reductionism don't do justice to a particular feature of art production which Heinich called 'singularity', one of the most important concepts in Heinich's approach, and for that reason it will be discussed in more detail later. But in her chapter on anti-reductionism, she already introduces it when speaking of a distinction between the 'realm of singularity' and the 'realm of community';

the first is based on the ethics of rarity, the latter on the ethics of the general, but with both delivering possible systems of art evaluation.

Maybe Heinich's utmost wish, however, is for an *a-critical attitude*. She has a strong feeling that art sociologists are involved in valorizing artworks and in formulating value judgments, whereas their task is to make clear how value judgments are constructed. It is not the essence of art which should be analyzed, but the operations of production and reception of art, and, more especially, the representations of these operations by the actors. The sociological object of study 'is not what art is, but what it represents for the actors' (Heinich 1998a: 24). To give an example, singularity in art (here the central concept appears again) is not 'an objective property of objects (...), but a value projected on these objects, the result of an operation of valorization' (idem: 25). Although, in my opinion, Bourdieu is one of the sociologists who does try to study these types of operations, Heinich considers his notions, such as 'strategies of distinction', 'symbolic violence' or 'domination of the legitimated over the illegitimated', as being reductionist and critical, probably for two reasons. The first is that she does not like his 'structuralist' inclination to deduce mechanisms and generalizations from the study of operations in the field; the second is that she accuses Bourdieu of smuggling personal social values into his sociological analysis.

Heinich seems here to defend a value-free form of discourse analysis. She understands very well, by the way, that the idea of a value-free position has been quite seriously disputed in the course of sociological history and returns extensively to this issue in the concluding section of *Ce que l'art fait à la sociologie*.

The five attitudes Heinich advocates are all linked to one another, but the dominant position among them is held by *a-critical attitude*; the others can be considered necessary elaborations on that. This also holds true for the demand for a *descriptive attitude*. The key notion here is the change from explaining to making explicit (*de expliquer à expliciter*), which can be called, according to Heinich, a 'pragmatic turn' in sociology (idem: 33). The activity involved in explanation is strongly linked to judging artworks or analyzing their meanings and that is not what art sociology should do. 'Our sociology will be a '*pragmatique*' of contemporary art – a description of what it does, of the ways in which it works – and that's all', Heinich states emphatically in *Le triple jeu de l'art contemporain* (1998b: 72).

A descriptive or, better, 'expliciting' attitude is made possible by an a-critical position on the part of the researcher; in the same way such a position opens up the possibility of a *pluralist attitude* needed to avoid a 'defense by the sociologist of those who are considered dominated, which runs the risk of misjudging their resources in order to see the conditions of their dignity' (idem: 44). This quotation makes clear that a pluralist attitude strongly corresponds to an anti-reductionist one.[7] In *Le triple jeu de l'art contemporain* it becomes a bit clearer what it means

exactly to be a pluralist sociologist. It obliges one to take into account the plurality of the principles that govern the discourse on art,

> and especially the fact that, parallel to the political, economic and social arguments, there exist arguments in the ethical and the aesthetic domain, which deserve to be taken seriously, even if they don't contribute as obviously to the sociological analysis. (Heinich 1998b: 254)

In structuralist terms it could be said that the functioning of artworks is 'overdetermined', which directly raises the question from an analytical point of view of how the relationships between different factors function in terms of domination and which factor or factors determine these relationships in a given societal situation. Heinich's answer would be that these questions are not relevant, are even reductionist, because a pluralist view offers the *choice* of studying art from different angles, side by side.

Much of what Heinich has developed under the first four headings has already been repeated by the time she finally comes to write about the *relativist attitude*, but here she starts to relate it to an interesting distinction between a valorization regime that favours cultural democratization and a regime that favours the development of artistic quality (Heinich 1998a: 56-59). She argues that both regimes can function perfectly well side by side, but they will most likely be experienced as conflicting by people occupying positions at one of the two poles and as being contradictory by people who have to choose between them, speaking in terms of cultural mediators such as theatre managers or critics. Here the sociologist can be of service either as an expert or as a researcher. In the first role he/she can make explicit the differences or propose compromises. In the second role he/she investigates the conflict as such, 'divulging – in a descriptive and no longer a normative way – the principles of judging and acting that support it' (idem: 59). The latter position requires a relativist attitude, although not in the sense that the art sociologist has to see different aesthetic regimes as 'equivalents or at least not hierarchizable' (because that would already be normative), but in the sense that the relativity of different value systems can only be made explicit on a descriptive basis, making visible 'their plurality on the one hand, and their vulnerability to a contextual determination on the other' (idem: 60).

After having advocated this a-critical position and the attitudes which stem from it, it is not strange that Heinich sees the storm already on the horizon and decides to devote a chapter to what she calls 'Involved Neutrality' (*Neutralité engagée*). Relying on Max Weber's concept of axiological neutrality, she argues that this idea of value-free sociological practice is not a reality but a value, 'an action program', with the understanding being that this practice is always embedded

in certain value systems which a sociologist can only *try* to free himself from. In this context, a distinction between the individual who is a sociologist and the sociologist at work is not without any importance because the first has the possibility, even a responsibility (at least towards himself), to make social choices, whereas the latter has the responsibility to study social choices (and processes). The consequence, however, of the fact that both responsibilities come together in one person raises the question of whether it should be considered immoral to permit one, especially the intellectual individual, 'to escape the necessity of social involvement' (idem: 78). Here Heinich discerns three possible types of intervention: as a researcher, whose goal can only be to understand the social world; as an expert, who can advise his commissioners; and as a thinker, who can judge a social situation on the basis of his or her value system. The sociological researcher needs neutrality because it is the only instrument which makes changing positions feasible, and to change positions is, according to Heinich, the only opportunity

> to make people understand that others have their own reasons for permitting contradictory logics to co-exist and to confront them without being torn, scorned or destroyed. (Idem: 80)

Heinich states that this form of sociological practice is the exact opposite of what the dominant sociology was at the end of the 1990s:

> which serves to provide the critical capacities of actors with instruments, to proclaim the distinction of the dominants and the oppression of the dominated, to unmask the truth of the social from the illusion of the private. (Idem: 80)[8]

In opposition to this approach she introduces 'involved neutrality', an involvement through neutrality that opens up, as mentioned above, the opportunity for a mediating role and for the formulation of compromises between the different interests and values that are at stake.

It is definitely a noble position, although again, Heinich makes her arguments a bit less credible by ending her crusade with the ironic remark that this is

> a role less heroic than that of the militant fighting against the powers that be which have set themselves up for a whole generation as having the only attitude an authentic 'intellectual' should have. (Idem: 81)

Latour, too, devotes the final section of his 2005 book to the relationship between sociology and politics, departing from the same critique that the value-free ap-

proach of ANT should prevent political impact. His point of view is, very shortly, that 'If there is a society, *then no politics is possible*' (2005: 250), because 'society' is, in his opinion, a more or less permanent set of structures that governs a culture. Latour's idea is that this concept has been very useful during the social struggles of the nineteenth and a part of the twentieth century, but started to become paralyzing in times of crisis. The opposite notion Latour proposes is 'the collective', that has to be reassembled again and again out of the connections found in the traces of actors' activities. More than by fixed sociological concepts, based on a theory of how society is constructed, social forces can be 'inspected and decomposed' (here seen as the basics of politics), by 'reassembling' the social', or constructing the collective. Latour thinks that to study is always to do politics, because it 'collects or composes what the common world is made of' (idem: 256); so, in essence, science and politics go hand in hand. But 'the mistake is to interrupt the former because of the urgency of the latter' (idem': 260), also because the 'delicate question of what sort of collection and what sort of composition is needed (...) should not be solved by social scientists' (idem: 256-257). Although this principal defense of how science serves the social best on the basis of its autonomy, some doubts can be cast on this position with respect to the social responsibility of researchers.

Without denying the importance of scholarly distance from the various value systems included in social processes and the behaviour of agents who are under investigation, three remarks can be made particularly concerning Heinich's demand for an a-critical and neutral position.

The first is that it is questionable whether Heinich's intimations are correct that most art sociologists – and especially Bourdieu – fail to make a correct distinction between their position as thinker and that as sociologist. It is quite difficult to check on this because Heinich rarely mentions names, let alone offers quotations, but in the case of Bourdieu it can be said in his defense that he does not really valorize different art forms in relation to one another. Rather, he maps (especially in *Distinction*) the different ways of functioning different forms of art have for different groups of users, which can be termed a pragmatic approach. Moreover he makes very clear from which vantage point as a thinker he is attempting to conduct his descriptive, and, indeed, also his analytical, work as a sociologist, namely from that of his interest in social power relationships. This brings me to the second comment one can make concerning Heinich's concept of 'involved neutrality', which concerns precisely that relationship between one's position as a social thinker and that as a sociologist. Whereas Heinich seeks involvement by activating sociological methodology as an autonomous research tool whenever possible (which is absolutely necessary in my opinion as well), I would also like to grant some room to sociologists to follow their own social

involvement as intellectuals by choosing the issues to be researched, possibly even based on their convictions concerning societal questions. Such an approach would, of course, require total transparency and self-reflection on the part of the researcher's own position. Undoubtedly, this proposal has to do with my own view on society in which I expect that I differ strongly from that of Nathalie Heinich. And in that light, my third comment would be that her plea for an a-critical attitude seems to stem from either naivety or a neo-liberalist point of view. In the first case she seems to be working under the illusion that mediating between unequal parties can deliver equal possibilities by making use of these autonomously based sociological insights. The pragmatic questions here are, among other ones, who are the commissioners, who will get the reports, and who will decide about the societal value of the neutral results. In the second case, stating from a neo-liberalist view, she should already know that an equal use of results by unequal agents is an illusion, without caring about that.

4.3.2 Methodological proposals

Besides a thorough discussion of the art sociologist's attitudes, three concepts can be discerned in Heinich's work which are fundamental to her methodological thinking: 'singularity', 'pragmatism' and 'making explicit'.

SINGULARITY

Singularity is, as previously said, a basic concept in Heinich's thinking. In *Ce que l'art fait à la sociologie* she presents the world of art as typically a realm of singularity 'which tends to favor the subject, the particular, the individual, the personal, the private' as opposed to the realm of the community, which privileges 'the social, the general, the collective, the public' (Heinich 1998a: 11). She describes both realms as 'valorization paradigms' (Heinich 2000a: 161) and blames sociologists such as Becker and Bourdieu for neglecting the value of the exceptional, instead only valuing the general powers that determine creative work from the outside: the market or the social environment (Heinich 2000b: 201). In 2000, when she reread Becker's *Art Worlds*, one of the most important shortcomings of the book, observed Heinich, was the attempt to defend certain dominant values by means of 'the triple claim to democratism, relativism and scepticism' and to describe art as a collective activity. The result was, according to Heinich, that the imaginary and symbolic dimensions were totally neglected, which means 'the fact that art is commonly conceived of as singular, individual and irreducible to the plurality of collectives' was ignored (ibid.).

As a consequence, Heinich proposes to research the 'common experience of what is – or is not – an artistic event' (Heinich 2000a: 159).[9] An artistic event

is, in her opinion, the artistic act valorized in the realm of singularity. The other side of the coin is that many artistic manifestations will be 'non-events', because 'logically, artistic originality cannot be validated in the short term, unless by a small number of the initiated able to appreciate its value' (Heinich 2000a: 161). The distinction Heinich makes between events and non-events cannot be based on the value system of the researcher, of course, but only upon that validation by people who experience the work or the manifestation.[10] For 'rather than understanding what an event is, sociology should understand what *makes* an event for the actors' (idem: 164).

Heinich's strong plea for the study of the social functioning of singular artistic manifestations does not mean that these manifestations come into being autonomously, based on a total freedom of artists. On the contrary, she calls the freedom of the artist one of the central illusions in the game of art, 'an illusory belief in the artist's freedom', unmasked by Heinich as sociologist, 'that is, as someone better equipped to understand the collective constraints that underlie a socialized activity' (Heinich 1998c: 68). Quite the opposite of freedom, the artist is compared with a chess player who has internalized the rules of the game so perfectly that he feels totally free while playing (and looks that way as well), but 'who no longer sees that his freedom of choice is only upheld by the extremely constrictive limitation placed on his permissible moves' (idem: 69).

Nothing is, according to Heinich, more limited than the work of the artist who tries to cross borders without becoming excluded. He who does not play by the rules of the game is condemned to remain invisible.

> Only those will remain in the spotlight who successfully abide by this double limitation, this rigorous discipline that is on the one hand the mastery of the rules of the artistic game, while, on the other hand, the mastery of their possible modifications. (Heinich 1998b: 57)

This also means that other actors who figure around artists have to abide by the rules of the game and that, as a consequence, the idea of the 'arbitrariness of institutions' is an illusion as well. On the basis of Dickie 1973, Heinich suggests that this author has the idea that institutions operate in an arbitrary way, 'motivated by nothing, and especially not by the nature of the objects which are, in this way, provided with the title of art work' (idem: 61). She argues that institutional recognition is positively the result of manipulations by the artist which correspond to the same rules according to which the institutions categorize and classify works of art. With Jean-Marie Schaeffer, she concludes it is for this reason that the institutional theory can only be considered as just 'a parameter among many of the artistic definitions' (idem: 62), as Dickie already emphasized in his 1984 publica-

tion, *The Art Circle*, in which, moreover, he notes that the mutual relationships between different parties involved in the art world are presented as the core element in the circular concept. Heinich turns out not to be too far removed from that point of view:

> The propositions of the artists are by no means independent of the probabilities of their reception, their assimilation by the specialists is largely a function of anticipating the rejections of the public, who often protest more against the laxity of the institutions than against the provocations of the artists. This is the principle of the 'triple jeu': one cannot be thought of without the other two, the artists without audiences and without specialists, the transgressions without limits to be overturned, to be reaffirmed and to be moved. (Idem: 53)

What she adds to Dickie's theory – and this is an essential as well as certainly an essentialist element – is that one of the rules of the artistic game is transgression. In this sense she bridges the gap between Dickie and Beardsley by filling in the institutional theory of the first with an art philosophical value defended by the second. It is precisely this value that motivates Heinich's attention to the singular and particular and her plea for studying the functioning of works as singular phenomena.

EXPLICITISM AND PRAGMATISM

Although the relevant chapter in *Ce que l'art fait à la sociologie* is entitled 'La posture descriptive', Heinich makes it clear that making things explicit means more than simply describing them. It means bringing to light underlying relationships which are not experienced in immediate perception. This has nothing to do with discovering psychologically suppressed aspects or with unmasking illusions, Heinich emphasizes, but it does have to do with a hidden coherence at the level of the representational system, 'which, for it to function, does not require being made explicit' (Heinich 1998a: 34). To give an example, the art sociologist

> does not have to unmask or to give up the legend of *l'artiste maudit* in the common sense of the term, but should bring to light the richness, the complexity and the coherence of the representations at play, in spite of – and maybe thanks to – their lack of consistency with regard to the facts attested to by historical science. (Idem: 35)

'Hidden coherence' is a slightly dangerous term from an ANT perspective, because it suggests a structure that should exist as the basis of what becomes visible. Neither Latour nor Heinich likes these types of 'explanations'. A (hidden) coher-

ence should be understood as originating through the actions and connections
that are described and which construct the collective. In connection with this,
Latour strongly and repeatedly emphasizes that the ANT method is based com-
pletely on writing accounts and that descriptions which need explanations are
bad ones. 'A good account will *perform* the social in the precise sense that some of
the participants in the action (...) will be *assembled* in such a way that they can be
collected together' (Latour 2005: 138). Not surprisingly, Latour calls his sociology
of associations also a 'slowciology'.

The change from explaining to making explicit is of particular concern to the
way in which sociologists handle artworks. In Heinich's view, a sociologist should
not be interested in their value or in what they mean, but 'in what they *do*: it is an
approach which is no longer evaluative or hermeneutic, but, instead, pragmatic'
(1998a: 37). Heinich gives as examples a number of effects artworks can have,
varying from touching the users to confusing them, and from programming per-
ceptive frames to 'deconstructing the cognitive categories that help to construct
a consensus on what is art' (idem: 38). Other authors might call these types of
things what artworks do, the values, functions or meanings of art to be realized
by recipients, who thus give the artworks their finishing touch. Or the other way
round: values or meanings (in a neutral sense) can be seen as forms of what art-
works *do* (see, e.g. Shusterman 2000; Kieran 2002; Eldridge 2003). As a conse-
quence it is questionable how far Heinich distances herself from sociologists who
study artworks as such in order to understand the role of art in society:

> The sociologist can think in this way about 'the works themselves', showing,
> for instance, in which way they (...) produce or reproduce imaginative struc-
> tures: not to discuss their value, their causal determinations or their mean-
> ings, but to handle them as actors fully participating in societal life, neither
> more nor less important, neither more nor less 'social' – which means inter-
> acting – than natural objects, machines and human beings. (Idem: 38-39)

The difference Heinich wants to make is that she disputes the usefulness of anal-
yses of artworks made by sociologists themselves and instead advocates using
traces of what these works do, as can be found in all types of societal utterances,
as material for sociological description. According to Heinich

> a sociologist should close his eyes to the object that makes the actors speak
> in order to open them up to the very reasons that make them speak as they
> do. And so, rather than understand what an event *is*, sociology should un-
> derstand what *makes* an event for the actors. (Heinich 2000a: 164)

It is questionable whether this statement still fits with what she said about the subject in 1997 (reprinted in a Dutch translation in 2003): sociologists have to describe 'what the formal features of artworks are by means of which the patterns of behaviour, which are so typical of the art world, are evoked' (2003a: 52). Most likely Heinich's point here is that sociologists are allowed to concern themselves with formal aspects of artworks, but definitely not with the symbolic values and classifications based on them. From an art philosophical point of view this distinction between form and value is not very tenable, but the confusion can be traced directly back to Heinich's use of the term value, not in its neutral sense, but as a judgment loaded with valorization.

Heinich offers a whole series of aspects to be studied by art sociologists. In 'The Sociology of Contemporary Art, Questions of Method' (1998) she sums up what artworks do (numbers between brackets: HvM):

> First of all, they move people [1a+b], in both the literal sense [people travel to see them] and in the figurative sense [they raise emotions]. They make people act: to frame them, to transport them, to insure them, to restore them, to exhibit them [2a-e]. And then they make people talk; they make people write about them and discuss them formally [3] ... But they also displace those less palpable objects which are mental categories, frameworks of perception, criteria of evaluation [4 a-c]. (Heinich 1998c: 70-71)

In Heinich 1998a, these operations caused by artworks are presented more extensively and are then followed by an instruction to be followed by sociologists. They should describe, on the one hand, 'the behaviour of the actors, the objects, the institutions, the value judgments, based on and as a result of the artworks' and on the other hand 'what – in their properties [that is, of the artworks, HvM] – makes these behaviors necessary' (1998a: 38).

Although Heinich discerns a sociology of works, a sociology of reception and a sociology of institutions (or mediation), she emphasizes that they have to be linked to each other in order 'to reconstruct the logic of the movements' (1998c: 72). In addition, special attention is paid to the aesthetic experience itself, especially to the different dimensions it can take (figures between brackets, hvm):

> The analysis of the art objects themselves, identifying what it is that produces certain effects (1) ...the analysis of their reception by different categories of publics (2); the analysis of the mediations carried out by the different categories of specialists, from the collectors and dealers to the critics, exhibition organizers, curators and agents of the state (3). (Ibid.)

Remarkably, Heinich here uses the term analysis instead of description or explici-fication. And indeed she searches, as we have seen, for what is behind the utter-ances of actors, for example the motives behind the interest they show because 'such motives structure patterns of behaviour in the art world and determine which orientations of artistic values became dominant'(2003: 46).

OBJECTIVITY

Finally, besides these methodological proposals, Heinich has worked out some aspects of the methods themselves. In *The Sociology of Contemporary Art; Ques-tions of Methods* (1998c), she sums up three characteristics of the methods she makes use of (especially as practised in *Le triple jeu de l'art contemporain*). The first is based on the interdependency of the different stages of artworks in the world: their characteristics as such, their mediation or their being made available, and their reception. 'Internal' sociology, 'focusing on the description of works', and 'external' sociology, 'focusing on the description of the modes of circulation through the world', should be considered to be a continuum. 'Continuous descrip-tion' demonstrates 'the degree to which a phenomenon is objectified' (Heinich 2000a: 166). The meaning of objectifying here is defined as the capacity of the actors to categorize a phenomenon, and the capacity of the phenomenon to be categorized. Heinich uses the term 'rise in objectivity,' as going hand in hand with 'the rise in singularity':

> More or fewer words, more or fewer images, more or fewer material objects, more or less time, more or less space are necessary to the 'objective' percep-tion of a cultural phenomenon as an artistic event. And the sociologist's task consists precisely in observing and analyzing these movements. (Ibid.)

To make this operational, Heinich used a set of ranges – such as private/public; individual/collective; internal/external; short term/long term – by which the ex-tent of objectivity (or being objectified) could be shown. And the more the actors treat a phenomenon as public, collective, external and long term, states Heinich, the more it will 'objectively' be an event (ibid).[11]

With this elaboration on the need for 'continuous description' Heinich has implicitly arrived at a second aspect of her method. This is based on her plea for a pragmatic approach, 'to stress performance rather than competence' (1998c: 72). To do so, she uses methods bordering on ethnographic research, 'following the actors, observing and analyzing spontaneous reactions – for example, the texts in exhibition guest books' (idem: 73). Moreover, she tries to avoid statistics and interviews because of the danger of getting standardized answers. It may be clear, by the way, that in using ethnographic ways of collecting data as well as in using

the more traditional sociological methods, the usefulness of the results will depend upon the more specific ways of working with the collected data.

Heinich concludes her methodological reflections with a final statement on the relationship between a sociological and an aesthetic approach, reason in and of itself to quote it here in full:

> What forms the value of a work for an aesthetician are its intrinsic characteristics, whether they be material or spiritual, purely formal or expressive of more general meanings; what forms the value of a work, for a sociologist, is the valorization given to it by the actors, produced by the full set of aesthetic accreditations. It is comprehensible that under these conditions, the sociological project, even when it seeks to be purely descriptive, necessarily produces critical effects: it has every chance of being interpreted as an attack on the authenticity of artistic values – which adds to the misunderstandings that the sociologist's work provokes in the art world. (Idem: 74)

4.4 ANT and the functioning of art

At first glance, ANT does not offer much of a chance to find stable connections between how an art world is organized, nor of how the arts function in society. Summing up interactions, making descriptive accounts, tracing singularities and following the actors all seem to deliver a variety of empirical data – including about connections – but at the same time these activities appear to hinder the finding of more general patterns or dynamics. That is not very strange, because the ANT authors were just looking for weapons with which to attack structuralist sociology, which, in their opinion, turned the world upside down by analyzing it in terms of calibrated sociological concepts. As a result, in the first pages of ANT texts, readers are often confronted with caricatures of (post)structuralist sociologists. As if these colleagues claimed that what happens in art worlds is fully determined by markets and economic movements, or that power relations have to be considered the central concept in studying the arts.

Caricatures are very useful – and may be necessary – to get attention for new ways of thinking in a field, but a reader who has been through this passage will find several places where ANT radicalism is weaker and even in some cases comes close to the initial enemy.

Two aspects, in particular, on the work discussed above show this approach, or at least the difficulties in escaping from it. First, when Heinich disputes the autonomy of the artist, and second, when the relationship between description and 'making explicit' is raised.

Nothing is more restricted than the work of an artist, because if he tries to cross the borders of the field and work according to his own rules, he will be excluded. No, this is not Pierre Bourdieu speaking, but Nathalie Heinich. It is true that she tries to correct Dickie's institutional theory by giving the artists' activities a place in it – saying that institutional recognition is the result of manipulations by the artist – but she also emphasizes that these manipulations correspond to the same rules according to which the institutions categorize and classify works of art. Remember the example of the chess player, feeling himself totally free in the choice of his moves, but in fact being fully bound by the rules of the game. Heinich does not go very gently on this point. She calls the freedom of the artist 'an illusory belief' unmasked by a sociologist, 'someone better equipped to understand the collective constraints that underlie a socialized activity'.

Concerning the transition from description to rendering explicit, Heinich does not have any difficulty with using the term 'institution', in contrast with Latour, who seems to avoid the term; it shows up only four times in his 2005 book, mostly in quotes, and has not been included in the index. Of course Latour, in his amusing dispute with the student at the London School of Economics, emphasizes that a description that needs an explanation is a bad description. And he can say that, because a good description shows what actors do to other actors, so that not only the *types* of associations, but also the *types* of translations the actors undergo become visible. Also, his effort to 'reassemble the social' does suggest something 'institutional' emerging from a description. Both seem to feel a need for the opportunity to generalize some findings, or at least to find concepts that can express a structure in the connections discovered. Heinich uses the terms 'hidden coherence' and in her 1998 article on questions of method, she even proposes to *analyze* artworks, their receptions and the mediations by several types of actors. Latour finally removes the last doubts when he defines the goals of ANT as 'to check what are the new institutions, procedures, concepts able to collect and to reconnect the social' (Latour 2005: 11).

The Actor Network Theory offers two important concepts that can help in understanding how the organization of art worlds, in their different stages of production, distribution and reception, is connected with the functioning of artworks in people's lives. The first is the ANT idea that actors (objects, persons, animals, organizations) do something or, better, make other actors do things, so that they modify a state of affairs. What they do has to be traced by researchers. Heinich sums up a list of things artworks as actors can do, such as move people, make them talk and write, or change frameworks of perception; essential aspects in thinking about the functioning of art in a society. And to complete the story: the core of the present study consists in finding out what organizations in an art world, such as companies, venues, museums and their departments, turn out to

do as a contribution to, or in connection with, what artworks do within communities.

The second very helpful concept is that of 'passage', with its transmuting nature. Actors, often people, find themselves back in a new landscape of connections when they go through a translation centre: other actors to relate to, actually becoming another actor, as well as being forced by the nature of the translation centre itself – a church, a theatre venue, a community centre, a public square, a school, a stadium, a park, a streetcar, a meeting centre, an office, a museum, a studio, a concert hall – to make adequate connections with the other actors (artworks, the people around it and the translation centre itself). It will be clear that the description of what happens with different groups of people when they go through the different types of passages the art world provides, is also at the heart of the question of how art is made to function in a society. Conversely, the concept of passages challenges the art world to think about how its translation centres function and possibly could be reorganized to generate other or additional effects.

Notes

1 In his *Reassembling the Social* (2005) Latour apologizes for accepting the acronym ANT, instead of continuing to criticize the term. Now he sees the acronym as neutral, blind or an open set of connections.

2 Although, in his fictive discussion with a PhD student the professor remarks: 'It's a theory, and a strong one I think, but about *how* to study things, or rather how *not* to study them' (Latour 2005: 142). So, rather a useful methodology with respect to the question 'How to Study Art Worlds?'

3 From 2000-2003, Heinich was Professor of Art Sociology in Amsterdam on behalf of the Boekmanstichting. In light of her lightly provocative way of writing during this period, the title of her final article, in which she answered the critical contributions by Crane, Laermans, Morontate and Schinckel, was quite remarkable: 'Let us try to understand each other'.

4 Originally: 'Légitimation et culpabilisation: critique de l'usage critique d'un concept' (1999); translated into Dutch in 2003 as: 'Gelegitimeerde kunst. Een kritische studie naar de gebruikswaarde van een begrip'. English translation, HvM.

5 Originally: 'Pourquoi la sociologie parle des oeuvres d'art, et comment elle pourrait en parler' (1997); translated into Dutch in 2003 as: 'Een sociologische analyze van kunstwerken. Aanzet tot een methodologie'. English translation, HvM.

6 The original article 'Pourquoi la sociologie parle des oeuvres d'art, et comment elle pourrait en parler' was published in 1997 and can be considered a sketch for the studies later in 1998.

7 It can also be read very easily as an attack on Bourdieu's distinction theory, which seems to be understood by Heinich as a defense of the dominated. I don't share this interpretation of Bourdieu's thinking, which I consider much more analytical than something determined by a social choice.

8 The distinction between the two approaches can be considered on the axis of autono-
 mous-heteronomous sociologist praxis. Homologous with this is a distinction between
 art for art's sake and art as an instrument to serve social goals, as is the case in community-
 based art, for example. Also, in this case the distinction is not as unambiguous as Heinich
 suggests, as is evident from the work of Arianne Mnouschkine, Dario Fo, Peter Sellars,
 and many others.

9 At the end of her opening speech as a Boekman professor in Amsterdam, Heinich sug-
 gested a very strong connection between a sociology of singularity, the notion of event,
 and a sociology of artistic experience by stating, 'Indeed the notion of event (...) is at the
 very heart of what I call a sociology of singularity (...) As far as artistic events are con-
 cerned I may have failed to satisfy your curiosity, but I hope to have at least given you a
 small insight into what a sociology of artistic experience might be' (Heinich 2000a: 167).

10 Another possibility would be to use the term 'event' in a more neutral way for all possible
 artistic actions, such as performances, exhibitions or the reading of books. This notion (as
 used in Sauter 2002 and Cremona et al. 2004) affords the opportunity of understanding
 the artistic event as a 'contextualized moment of communication' in a general way.

11 The reader is invited to compare Heinich's view on objectivity with the way Bourdieu uses
 the notion.

5 Niklas Luhmann's System of Artistic Communications

5.1 Introduction

Like Howard S. Becker, Niklas Luhmann has written only one book, albeit a very thorough and large one, concerning the world of art, among a very broad oeuvre that finds strong cohesion within the author's system-theoretical thought. Educated as a jurist, he started his career as a scholar in the 1960s, with publications in the field of law and the organization of government administration. Already in the titles of those works his system-theoretical approach can be seen: *Funktionen und Folgen formaler Organization* (1964), *Grundrechte als Institution* (1965) and *Zweckbegriff und Systemrationalität* (1968). This line of investigation ends in his synthetic study *Das Recht der Gesellschaft* (1993). Between the 1970s and the 1980s, however, he works out his general thoughts, elaborated in *Soziale Systeme. Grundriss einer algemeinen Theorie* (1984), in very comprehensive studies on the religious system (1977), the educational system (1979), the economic system (1988) and, finally, the art system, entitled *Die Kunst der Gesellschaft* (1995) (translated into English as *Art as a Social System*, 2000). It goes without saying that this last publication is the most important for discovering Luhmann's possible contribution to the present study, all the more so because in this book he once again presents and partly updates his general views on social systems, as developed in 1984.

Just like the other authors discussed in the previous chapters, Luhmann appears to present a strongly philosophically coloured sociology of art, if not a work that may be considered even more as a philosophy of society and to some extent as a sociologically relevant philosophy of art. Especially the latter stems from the fact that large parts of *Art as a Social System* are devoted to the questions of how the arts become distinctive from other phenomena, how artworks work as communications and what they do, questions also brought up by such diverse authors as Beardsley and Latour. This strengthens the feeling that it is difficult indeed to study the art world as a system without trying to understand the typical properties and possible effects of artistic utterances. For this reason

Luhmann's thinking on the philosophy of art will also play a role in part two of the present study, since that is fully devoted to the understanding of values and functions of art.

5.2 Luhmann's idea of social systems

Whereas the term 'system' seems to be situated within the series of concepts like 'network', 'field' or 'world', Luhmann's use of it forces a fundamental break with these other notions. Becker, for instance, speaks of the art world as a network of *people* who cooperate, and Bourdieu calls a field a structure of relations between positions occupied *by agents*. Even in the Actor Network Theory, *actors* play a role, at least by becoming points in a network as a result of their travelling in it. So, if these authors were to use the term 'system' instead of their own terms, actors, whether considered individuals or organizations, would be basic elements in it. That is not the case in Luhmann's concept, not even in what he calls 'social systems'. For, social systems do not consist of relations between people, but between communications – communicative utterances – in Luhmann's view.

Luhmann discerns four types of systems: machines, organisms, social systems and psychic systems. It is especially the latter two and the relationship between them that are important for the present study, because the world of art is a social system, while mental systems operate in the direct environment of social systems. Maybe the most striking Luhmannian view is that the basic elements of social systems are not human beings but communications; physical, material utterances to which at least another utterance reacts. Hence Laermans could call his 1999 book on Luhmann's sociology *Communicatie zonder mensen* (*Communication without people*). This doesn't mean that people do not communicate; in a sense they participate in social systems, such as the art system, for example, by producing artworks (communications), by observing and interpreting them (operations of the psychic system) and by talking or writing about them (communications again). But they are not the materials of the system, because a social system consists of communications. Artworks are, among other types of utterances, elements of the art system, since they react to each other. For, as Laermans notes, 'one communication is no communication: social systems require at least two participants and two basic elements' (1999: 62).[1] Incidentally, this formulation also makes clear that Luhmann's way of thinking renders it impossible to understand a system as an existing structure; rather it comes into being each time that participants exchange communications. Here a reference to the 'rhizomizing structures' of ANT can be found, although Luhmann devotes more attention to the existence of social structures within social systems, which will be discussed later.

Thus individuals or organizations are not parts of the art system, but exist within its environment, whether as artists who make artworks, or as recipients who observe them and perhaps produce communications about them; the system itself consist of communications, in this case artistic utterances and reactions to them. It is not entirely clear what can be meant by 'participating' in a social system and at the same time 'existing within its environment'. In *Die Gesellschaft der Gesellschaft* (1997) Luhmann states: 'People cannot communicate, only communications can' (105). But, writing about the role of form in artistic communication, he observes 'enough of a common ground to speak of communication between artist and viewer' (2000: 43). And a hundred pages later in the same book, when he elaborates the relationship between artists and connoisseurs of art, he states that the interaction between artists, experts and consumers differentiates itself as communication [that] takes place only in the art system, which establishes and reproduces itself in this manner' (idem 166). Maybe Laermans's formulation offers a good escape from this confusion: 'People take part in processes of communication but will never form a part of them' (1999: 92). The processes themselves form the system, because, in essence, the meaning of previous communications within a process is determined by reactions to them, and so on. 'So, a social system will define its elements itself with the help of ...its elements' (ibid.), and consequently not with the help of the intentions of people who participate in the system. This explication is based on the autonomous and autopoietic character Luhmann ascribes to social systems in general and which will be worked out for the art system in particular in the next sections. First the differentiation of systems Luhmann proposes has to be completed.

In his 1984 book on social systems (p. 16) he offers the following figure:

Figure 5.1 Categories of systems (Luhmann 1984: 16)

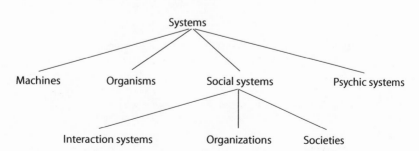

Three types of social systems are discerned here. Later on, Luhmann will add a fourth one: 'protest movements', because they are more or less closed systems as well, based on their own types of communications and autopoietic processes, without being one of the other three. A closer consideration makes it understandable that the four types of social systems are not on the same level, as suggested in Luhmann's figure above. In his later publications he makes it clear that 'society' can be understood as a super-system in which all communications take place. Interaction systems, organizations and protest movements organize parts of this totality of communications. But in a sense, the entire picture is even more complex, because societies have developed in the course of the last three centuries through what Luhmann calls functional differentiation.[2] Societies split themselves up more and more into different subsystems, which consequently developed in a professionalizing and autonomizing direction. The art system is one of these, in addition to such subsystems as economics, religion, education, law and media. Because of the extensive and perhaps almost complete functional differentiation in modern societies, the three other types of social systems (organizations, interactions and protest movements) can be thought to operate largely in relation to specific subsystems.

Most organizations, interaction systems and protest movements, all being relatively autonomous social systems, take part in the processes of one of the functionally differentiated subsystems; protest movements in particular, however, partly withdraw from this by crossing the borders between social subsystems in order to react to what is communicated in society as a whole. This provides an elaboration of the categorization that Luhmann presented in 1984.

Figure 5.2 Detailed categorization of systems (based on Luhmann 1984, 1995 and 1997)

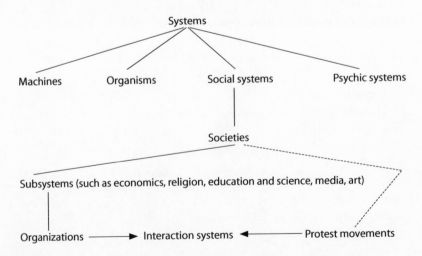

Finally, the position of interaction systems has to be clarified. The typical feature of interaction systems is that they take place between people who are present in a situation and can observe each other. Whoever is not there, does not take part in the interaction system. This feature does not hold for organizations or movements, the borders of which are determined by types of membership rather than by physical presence, but within which interaction systems function extensively. Luhmann even observed that 'societal communication largely (not exclusively) occurs as interaction' (1984: 574). This position makes interaction systems, such as parties, meetings, games, educational situations, masses, family gatherings or art events sensitive not only to what happens in organizations, but to the subsystem and even the society as a whole in which they are active. In Luhmann's words again:

> Society guarantees ... for each interaction also the possibilities of starting, ending and connecting its communication. In the interaction systems the hydraulics of interpenetration become operational. ... Society is, therefore, not possible without interaction nor interaction without society; but the two types of systems do not amalgamate, rather, with their difference, they are indispensable to each other. (1984: 566)

5.3 Social systems and psychic systems

Humans cannot be considered systems; they are, in Laermans' words, 'a hybrid, a conglomerate of different autonomous systems – a psychic system and diverse organic systems such as the nervous system and the blood circulation' (1999: 93). Humans live in the environment of systems, or conversely, it can also be said that systems exist in the environment of people. The psychic system is one of them.

Although psychic systems have to be distinguished from social systems on the one hand and from organic systems on the other, they are very close to them as well. Psychic systems run the operations of consciousness, and their outcomes are feelings, thoughts, imaginations and perceptions, but they can only run on the basis of operations in the nervous system, which receives stimuli from outside and makes perception possible. In contrast, communications, which are observations in a material form, are based on perceptions and are, in turn, perceived by others. Luhmann speaks of structurally coupled autonomous systems; *autonomous*, particularly because systems produce their own elements (*autopoiesis*), which as such cannot function within other systems; *structural* coupling because these systems cannot function without each other; and this coupling is *temporary*, because it has to be brought about each time anew.

The notion of observation is one of the key terms in Luhmann's theory and has to be distinguished from what he calls perception. Perception is a distinctive capacity of psychic systems, but the capacity to observe is shared by communication and psychic systems. In other words: perception and communicative utterances (particularly linguistic ones) are two types of observation, both in a genuine form.

Luhmann discerns three features of observation. First, he defines observation as making a purposeful distinction between one side of something and the other. The aspect observed is distinguished from what is not observed. But, second, the not-observed is nevertheless still present in a sense within the observation: '...the other side of the distinction is co-presented (...) so that the indication of one side is decoded by the system as information, according to the general pattern of 'this-and-not-something-else' (2000: 59). Finally observations are characterized by the fact that the indication they bring about

> is motivated by recursive interconnections – partly by prior observations, hence memory, and partly through connectivity, that is by anticipating what one can do with the distinction (...). In this sense, observation is always the operation of an observing system (...). Observation cannot happen as a singular event. (Ibid.)

As mentioned, Luhmann underlines that it is not only psychic systems that observe (in the form of perceptions), but that social systems are able to do so as well, 'on the grounds that such systems, in using language, simultaneously handle distinctions and indications' (2000: 60). This does not mean that observations made in both systems can communicate with each other. Psychic observations do not have a material form, whereas observations in a social system only exist in material form, for example as artworks. So once again, communication can neither receive perceptions, nor express them. Communication can only *indicate* perceptions, 'but what it indicates remains operatively inaccessible to communication as does the entire physical world' (2000: 10).

Until now, observation has been regarded as one type of psychic activity, but in fact a distinction can be made – not unimportant for the understanding of the art system – between first-order observations, second-order observations, third-order observations and so on. Whereas in the first category the observer concentrates on *what* he or she observes, in the second category the first-order observation is observed and the observer (who can be the same or another) concentrates on *how* the first-order observation is performed. In a second-order observation, the first-order observation becomes a theme. In a sense, the first-order observer lives in a world that is both probable and true (*in einer 'wahr-scheinlichen' Welt*) whereas the second-order observer sees the possible improbability (*Unwahr-*

scheinlichkeit) of the first-order observation (2000: 62; 1995: 103). Nor can the second-order observer, however, observe himself within this observation, which makes a third-order observation necessary for further reflection. The relationship between first- and second-order observations has a particular importance for the functioning of the art system and will, for that reason, be discussed further in section 5.4.

Although perception and communication are operatively closed systems which cannot interact, art has the capacity to integrate their results in a certain sense: 'Art makes perception available for communication' (2000: 48). How does it do that? By making the two 'disparate systems operate simultaneously (...) and constrain one another's freedom' (ibid.). This does not mean that both types of operation (perception and communication) will be confused or merged, but that the psychic system perceives *forms* in the art system produced *for the purpose* of communication. In other words: Artworks as communications are 'sensuously perceptible objects' used by the psychic system to generate 'intensities of experience' (that, by the way, remain themselves incommunicable).

Thus we have already reached Luhmann's concepts of art behind his theory of the art system. This will be worked out a bit further in section 5.4 and 5.5 and taken up again in part two of the present study.

5.4 Key concepts in Luhmann's theory of the working of a system

Most of Luhmann's key concepts have already appeared in the previous sections, but for a useful understanding of art as a social system, some of them (autopoiesis and observation) will be discussed further, and some other essential pairs of concepts will shortly be introduced, in particular utterance and information, self-reference and hetero-reference, and the reduction of complexity by social structures.

5.4.1 *Autopoiesis*

The functional differentiation of systems in human history has resulted in an increasing autonomy of these systems, which expresses itself particularly in their *autopoiesis*, understood in the literal sense of the word: systems produce their own basic elements and hence their own structures. Whereas nervous systems produce physical stimuli for the brain and psychic systems produce perceptive observations, feelings or thoughts, different social systems (e.g. the science system or the art system) produce their own types of communication (for example, scientific publications and reaction to them; artworks and reactions to them). None of these elements can be made by other systems or function *within* other

systems than in those producing them. So, the principle of *autopoiesis* is strong-
ly connected with the principle of operative closure (*Operative Geschlossenheit*)
of systems. Systems remain inaccessible for each other's operations. Luhmann
seems to say here on a theoretical level what Samuel Beckett tried to make oth-
ers able to experience through his plays: that the ways in which people perceive
the world and their lives cannot be communicated. On the other hand, although
Luhmann's concept of structural coupling (*strukturelle Kopplung*) of systems does
not neutralize the operative closure between perception and communication, it
does compensate for it. Structural coupling also means that *operatively* closed sys-
tems can be considered open to their environment: communications make use of
psychic observations and the other way round, just as psychic systems use stimuli
of the nervous system to produce perceptions. Hence, art, as already noted, can
make perceptions available for communication, which can help explain why Beck-
ett, in spite of his ideas on the impossibility of communication, produced, pub-
lished and performed artistic communications.[3] It is fundamental, however, to
understand that systems cannot take over each other's function and particularly
that the elements produced in different systems cannot take each other's place.

5.4.2 Observation

Luhmann calls observing (*Beobachtung*) 'a use of form' (2000: 37). Observation
presupposes a distinction between what it observes and what it does not, or bet-
ter, between what it selects and indicates on the one hand and what it de-actual-
izes on the other. For we have already seen that one of the typical aspects of ob-
servation is that 'the other side', although not actualized, is also present. Selecting
and indicating, the two aspects of observation, are realized in 'form'; perceptions,
thoughts, communications can only be distinguished from other perceptions,
thoughts and communications as different in form. So observation, as a result of
observing, almost coincides with form. Hence Laermans can call observing 'the
indicative operation with distinctions' and forms 'indicatively used distinctions'
(1999: 77-78). The indicating aspect refers to the fact that in the operation of
observing, one side of the distinction is actualized (which means, as we have seen,
that the other side will remain present as not actualized).

 The difference between first- and second-order observation has a certain im-
portance in relation to art. In full correspondence to the institutional theories as
discussed before, Luhmann states that what art is can only be described within
the art system itself, on the level of its self-description. All other observers are
second-order observers, who have to 'restrict themselves to reporting what the art
system designates as art' (2000: 244). This imposes a heavy burden on the art sys-
tem itself, according to Luhmann, because it 'must salvage a highly encumbered

"Firm" that has been dealing in "essences" and "referring signs", for which there is no market left' (ibid.). This does not mean that the search for essence has become impossible, but that it appears as one of the many possible ways to speak of art.

In fact, this use of the notion of second-order observation is on the highest level of aggregation; one level lower we will find what Luhmann sees as the historical origin of second-order observation *within* the art system of the late Middle Ages. The question of *what* is represented, so strongly connected to the notion of mimesis, shifts after the discovery of the antiquity to the question of *how* something is represented. This second-order way of observing required rules and programs, which explains their role in late medieval and Renaissance art production. This level is realized within the art system and can be seen as a primordial form of self-description. The same holds for the observations museums make (or in other fields, observations that refer to particular artworks as 'classic'). 'The decision observes observers, that is, it belongs to the level of second-order observation. Classicism, too, is a construct, created by observers to other observers' (2000: 131).

Finally, second-order observations can be discerned on the level of the artworks themselves. Luhmann discusses, for example, the development in eighteenth-century narrative towards a storytelling that goes beyond the pure representation of the real world and asks the reader to 'activate her or his self-experience' (idem 174). A common world is no longer self-evident. 'It requires a shift in level to become visible, a move toward second-order observation' (ibid.). In this sense, one can ask whether or not all art experiences – in the modern and postmodern senses of the word – are second-order observations, because each artwork forces the consumer to ask, in addition to the 'what' question, at least the 'how' question as well. Arthur Danto's statement, brought up in the beginning of this book that the lack of difference between real Brillo boxes and painted ones requires a theory of art to see the latter as art, most evidently confirms the necessity of second-order observation in art reception.

5.4.3 Self- and hetero-reference

There are another couple of elements in the notion of observation that are important for the understanding of art as a social system: the difference between utterance and information, and the related notion of the difference between self- and hetero-reference.

In a communication, three aspects can be discerned: utterance (*Mitteilung*), information (*Information*) and understanding (*Verstehen*). Understanding is not meant here as a psychic process, but as a communicative understanding, which means that a communication is followed by an adequate reaction. Artistic communications can especially be considered as an understanding of the difference

between utterance and information, because the first has, as a form, a specific relation with the latter.[4] Or, in other words, the aspect of utterance of a communication has a self-referential character, whereas the aspect of information refers to the world outside the communication itself.[5] The character of an aesthetic utterance makes Luhmann devote a lot of attention to the development of art in terms of the relationship between utterance and information, worth quoting at some length:

> All of these trends converge in the effort to eliminate an excess of communicative possibilities by means of the *form of the utterance (Mitteilung)* rather than via the *kind of information* it entails. In other words one tends to privilege self-reference over hetero-reference. This preference appears to be the decisive factor in the further development of art, especially in the twentieth century. (...) Hetero-reference is reduced more and more to the 'unmarked space'. (2000: 288)[6]

And a couple of pages further on, he states:

> Art approaches a boundary where artistic information ceases to be information and becomes solely utterance (...) or, more accurately, where information is reduced to conveying to the audience that art wants to be nothing more than utterance. (Idem: 298)

Here we once again encounter Arthur Danto's argument for the concept of the art world, since Luhmann discerns roughly three phases in the history of the arts: the symbolic phase, predominant in the classical period, when art 'searches for a higher meaning in its condensed ornamental relationships' (2000; 168); a semiotic phase, predominant during the court- and market-oriented period, when the art system develops its differentiation from other social systems and artworks refer to a common world or common experiences of artists and recipients; and, finally, a phase of 'forms', in which the art system has realized its operative closedness and 'one finds the nexus between self- and hetero-reference in the *formal combinations* of artworks that facilitate an observation of observations' (ibid.). In the eighteenth century, according to Luhmann, self-reference and hetero-reference were related to two different styles of art: aestheticism and realism. Although both styles have continued to develop new forms up until now, a radicalization of internal reflection in art has made self-referential art predominant over hetero-referential forms; an inevitable consequence of this is to favour the individual uniqueness of artworks and, as stated earlier, the danger that 'artistic information ceases to be information and (...) becomes solely utterance'.

Hetero-references in artworks are increasingly reduced to the 'unmarked space' in this evolution, but it has to be emphasized that hetero-reference cannot disappear, because of the simple fact that self-reference can only exist in a relationship to the other side, hetero-reference. But there is more; precisely because of the self-referential operation with the materials in which the artist works (stone, wood, colours, words or the body) under the protection of the differentiation of his or her own form of art, aesthetic hetero-references receive their particular function:

> ... actors on stage or in the novel can be endowed with motives, and paintings acquire representative functions that are not confused with ordinary social reality in a manner that implies both proximity and distance. (2000: 155)

With this quotation we come close to the relationship between interestedness and disinterestedness in aesthetic perception and to the rejection of utility as essential for this perception. Both are questions which will be discussed in the second part of this book.

5.4.4 Reduction of complexity by social structures

One of the basic elements in Luhmann's thinking is that each communication is a choice out of a – theoretically infinite – series of possible communications, and that the possibilities not chosen remain present as the unmarked part of the realized communication. This means that a social system is radically contingent (because communications are presentations of the unity of what is actualized and what was possible), and hence that it is extremely complex for participants in the system to select adequate communicative reactions.[7]

In addition, every communication realizes a new junction with a set of communications, with the result that a social system gets the same open and steadily renewing character as the network in ANT, since that should be considered the result of new relationships by which actors link themselves to each other.

Nevertheless, artistic communications, too, can function as elements in a system only if their openness is limited. In other words, a certain reduction of complexity – in the form of a limitation of the number of possible choices – is needed for a system to function. Two mutually connected concepts are central in this reduction of complexity: expectation and meaning (*Sinn*). Meaning has to be understood here as a shared whole consisting of concepts developed in the co-evolution of social systems and human beings. 'Meaning assures that the world remains accessible to the events that constitute the system – in the form of ac-

tualized contents of consciousness or communications' (Luhmann 2000: 107). Communications within a system or subsystem are based on shared and generalized observations which form a horizon of meanings for each new (and hence temporal) communication. In this sense, 'meaning' is the most important medium by which communication becomes possible.

Psychic and social systems function on the basis of 'meaning-oriented reduction of complexity' (Laermans 1999:83), which means that perceptions or communications will be constructed as selected possibilities which become *meaningful* against the background of historically developed sets of general schemata and forms of communication known to the participants in the system concerned. From this one can again deduce that communication fully depends on what happens in psychic systems and vice versa (although retaining the operative closedness of both types of system). And Laermans adds ironically that, because meanings have to be shared in a social system to function, 'quite a lot of forms of scholarly and artistic communication exclude quite a lot of psychic systems' (Laermans 1999: 101).

'Meaning', understood as a system of concepts shared by participants in a social system makes communication possible because it generates a pre-selection of possible and meaningful observing choices. For the participating psychic systems as well as in the communication system as such, this process of pre-selection is organized by 'a structure of expectations', which, by the way, has to be understood 'as a form of meaning [*Sinnform*], not as an intrapsychical process' (Luhmann 1984: 399). Laermans speaks of expectations as 'structural orientations', which 'retail selectively the horizon of meaningfully linked communications' (2000: 107). On a sociological level, this comes close to the concept of the 'horizon of expectations' (*Erwartungshorizont*) Jauss developed in the field of literary studies. Structures of expectations are strongly connected with the sociological concept of roles. In a system-theoretical view, roles are bundles of expectations, including expectations of expectations, because a role is always distinct from another role and both are carriers of expectations of what the other role expects. These sets of expectations, to a greater or lesser extent, take the shape of norms and can, in that capacity, bring about an experience of deviant forms of communication as disturbance.

In relation to the ways in which other authors make use of concepts like societal structures, institutions or conventions, it is interesting to observe how Luhmann thinks structures and expectations in a system together, in his own words:

> ...that structures of social systems exist in expectations, that they are *structures of expectations* and that social systems have no other possibilities to build structures, because they produce their elements as temporal actions. This means: structures are only there in the present time, each time again;

they seize at the time only within the horizon of the present time, integrat-
ing the present future and the present past. (1984: 399)

Again this idea of (social) structures is not far away from Latour's view that 'the
social' does not exist but is realized again and again in new junctions of relation-
ships. At the same time, one has to discuss how these ideas differ from an open
concept of institutions and, on a more detailed level, of conventions. This will be
done in chapter six.

5.5 What Luhmann sees as the distinctive features of art

As stated earlier, Luhmann's thoughts about what art is and what it does, in short,
his theory of art that forms a substantial part of his book on the art system, will
be used in the second part of the present study. But to complete the author's
approach to seeing the art world as a system, some remarks have to be made
first, particularly about how the art system differs from surrounding systems and
about which types of communication are constitutive of this system.

To start with the latter question, it seems that in a strict sense only aesthetic
utterances can be understood as the communications of an art system, because
they 'speak the same language', one that differs from other languages in its capacity
to produce perceptions in a material shape and consequently to focus on form.
After closer consideration, however, different types of reactions to aesthetic ut-
terances, such as reviews, catalogues and debates, also appear to be considered
by Luhmann as communications within the art system. This can be explained by
the fact that all different types of communications within this system, in the end,
are produced by the particular character of artworks, namely their compelling
capacity to make the *form* of the utterance (or the form information takes in this
utterance) the object of observation. Communications *about* art and works of art
can be understood as communications in the art system, since they are generated
by and react to this particular capacity of artworks. What is more,

> [t]he artwork ... only comes into being by virtue of recursive networking
> with other works of art, with widely distributed verbal communications
> about art, with technically reproducible copies, exhibitions, museums, the-
> atres, buildings, and so forth. (Luhmann 2000: 53)

All types of communications produced in this 'network' are seen as part of the art
system, because they contribute to the operative closedness and internal cohesion
of the system. More precisely, Luhmann states that works of art lead the autopoi-

esis of artistic communication in two different directions and, in doing so, 'expand and secure its continuation' (ibid.). On the one hand, observations of works of art can produce new works of art; on the other hand, 'one turns to the medium of language while retaining art and its works as a topic' (ibid.)

The fact that in the making as well as in the perception of art and the communication about it within the art system, the shape of utterances is the central object makes the system distinctive from other ones. In the first place, the symbolic character which works of art share with religious utterances offers the possibility of a distinction between reality and imagination, and consequently 'a position from which *something else* can be determined as reality' (Luhmann 2000: 142). And, differently from religion, the art system realizes this possibility in the realm of perception, with the result that playing with perceptible forms is central to the way in which works of art deal with reality.

To social systems that are distinctly different from each other (such as the economic, the religious, the political or the art system), Luhmann applies the concept of the binary code, the system's basic structure, which knows only two opposite values, distinctive from each other in the system concerned. This binary code expresses the central value of all operations in the system and makes it, in the case of art, possible to differentiate aesthetic utterances as a specific type of observation. For science the binary code is true/false; for the economic system owning/not owning property; for the legal system right/wrong. But Luhmann has real problems formulating a binary code for the art system. He tries art/non-art and beautiful/ugly, but neither of these is satisfactory, if only because the first means nothing and the meaning of the second is too (historically) strict. In Laermans's reading of Luhmann, operations in the art system are based on the distinction between fitting/not fitting, which can be considered the binary code of the art system. Indeed, Luhmann pays much attention to this couple, but it can only be understood as the art system's binary code if it is connected to more specific characteristics of aesthetic communications, for operations in each social system are based on the selection of fitting communications. The art system, however, is for Luhmann a play with *forms*:

> Forms play with forms, but the play remains formal. It never arrives at 'matter', it never serves as a sign for something else. Each formal determination functions simultaneously as an irritation that leaves room for subsequent decisions, and advancing from one form to the next is an experiment that either succeeds or fails. This is why ... a 'code' emerges in art, a continuously maintained binary orientation concerning the 'fit' or 'lack of fit' *of forms*. (2000: 118; italics HvM)

It becomes clear from this quote that, if fitting/not fitting should be the code that distinguishes the art system from other social systems, it would be better called 'fitting/not fitting of form'. And perhaps another essential feature Luhmann discusses should be expressed in the binary code as well. As we have seen, he states that 'art splits the world into a real world and an imaginary world' (2000: 142). The imaginative character of artistic communications is fundamental for Luhmann's idea about the function of art, demonstrated in the extensive quote below;

> Only within a differentiated distinction between a real and a fictional, imagined reality can a specific relationship to reality emerge, for which art seeks different forms – whether to 'imitate' what reality does not show (its essential forms, its Ideas, its divine perfection), to 'criticize' reality for what it does not want to admit (its shortcomings, its 'class rule', its commercial orientation), or to affirm reality by showing that its representation succeeds, in fact, succeeds so well that creating the work of art and looking at it is a delight. The concepts imitation/critique/affirmation do not exhaust the possibilities. Another intent might address the observer as an individual and contrive a situation in which he faces reality (and ultimately himself) and learns how to observe it in ways he could never learn in real life. (2000: 143)

Indeed, this is a brief but comprehensive view of the function and possible functioning of art, which, incidentally, does not differ greatly from the best known approaches in the philosophy of art, as will be shown later in this study. For now the question before us is: what does the fact that imagination is fundamental to the art system mean for determining the system's binary code? This code typifies all operations within the system and, in so doing, distinguishes it from other social systems. For that reason, in order to express Luhmann's ideas about the particularity of the art system, it would be better to call its binary code *fitting/not fitting of imaginative forms*.

5.6 How the art system generates the societal functioning of art

Like functionally oriented authors, as well as Heinich and Latour, Luhmann emphasizes that communications do something, bring something about. An utterance only exists as a communication when it generates an adequate reaction and, in so doing, gains a place in a series of communications: a system.

The core type of communications in the art system are works of art, paintings, poems, performances, concerts, films and so on. They react directly or indirectly

to each other within a whole discourse of 'commenting communications', struc-
tured by expectations and roles, referred to by Luhmann as the social structure of
the system. As shown before, Bourdieu in particular has worked out how, in his
view, this structure of expectations (illusio, ortho- and heterodoxy, nomos, etc.)
and roles (positions, occupation of positions, habitus, etc.) functions. The most
important new view Luhmann introduces is that the system is not a structure (of
relations) of organizations and other actors, but a socially (expectation-based)
structured set of communications. In a sense, the symbolic interaction approach
used by Becker can be considered a (not very well thought out) predecessor
of Luhmann's thinking. In the latter's approach, however, a severely materialist
point of view predominates, in that social systems (among them the art system),
systems of meaning in communications, are based on form. Communications
are in the first place utterances in which the form determines the observation,
neither more nor less, with the result that the set of possible forms (languages)
are the material basis, the medium in a material sense, of a communication sys-
tem. The fact that communication only *becomes possible* through joined horizons
of expectations (*Sinn*, or 'meaning', which can be linked to the symbolic side of
symbolic interactionism), is another aspect, that, partly, explains why such a big
part of communication within a social system occurs in so-called interaction
systems, sets of communications uttered by people who are physically together
in a situation.

When speaking about *what* communications in the art system *do*, we can dis-
cern three important types: works of art, communications about art and, as a part
of the latter group, utterances about the experience a work of art has produced.
There is a strong connection between these three, particularly between the first
and the last one. In the first place, works of art generate, of course, the enormous
range of activities Becker and Heinich have summed up: from people travelling
to a place to see a production (and to be seen there) to the making of frames for
paintings, and from making money out of insurance activities to the founding of
a festival. In the end, though, all these types of activities are based on the possible
reactions works of art are able to bring about. Luhmann devotes a lot of attention
to what he considers the typical function of artworks as artistic communications,
but his approach does not make it easy to incorporate the direct reactions to
works of art as parts of the art system, because these reactions take place within
the psychic system of the art users. Communication is not continued until the
outcomes of the psychic system have generated communicative utterances as reac-
tions to the works of art.

As we have seen, Luhmann's view on what artworks do, although coherent and
therefore convincing as well, is not very surprising. Because of the fundamental
role of form in communication in general, and in artistic communication in par-

ticular, works of art create a 'unity of distinction' between information (*what* is observed) and utterance (*how* things are observed). At the same time this opens up the opportunity to play with forms, on or over the borders of reality, and so in the domain of imagination, in other words to take a position on the side of 'not-reality', from where works of art can produce their different types of relationship with reality, such as the confirming, criticizing and imitating approaches. And finally, despite the operative closedness of different systems, but thanks to the structural coupling between them, works of art make outcomes of the perception system available for the communication system, because works of art are indeed perceptions in material form.

The most interesting question for this study is whether or not this availability for communication is limited to reacting to artistic communications (other works of art) and to utterances in the discourse around works of art. This also holds true for communications in which users, being ordinary spectators, listeners or readers, express their artistic experience; for, as Luhmann says, artistic communications generate intensities of experience in the psychic system of people. And, to repeat a part of the final quote of the last section:

> Another intent might address the observer as an individual and contrive a situation in which he faces reality (and ultimately himself) and learns how to observe it in ways he could never learn in real life. (2000: 143)

So the question is whether and how this artistic experience in the psychic system will find a continuation in a communicative system, be it in the art system or outside, in the educational system or perhaps in the system of everyday-life communications.[8] The closest thing to this can be found in what Luhmann calls interaction systems or, in his 1984 book, *Einfaches Sozialsystem* (simple social system). These types of systems, as we have seen, are marked by the fact that people are physically present in a situation, such as at a dinner, a party, on the street or in the marketplace, in other words, in ordinary 'social' situations. The fact is that many of the communications in these types of systems are not about the interaction situation as such but can be about all possible items which form the core of the functionally differentiated systems mentioned. In that sense, many interaction systems are not differentiated at all, but are rather collecting different types of communications. Whether the theoretical construction of a functionally differentiated social system of *social* communications, for instance with a binary code, 'being part of/not being part of', will be useful, is discussed in the next section. For now it is sufficient to note that communications based on the psychic processing of artistic communications, and contextualized in systems other than the art system itself,

probably should help the arts to function in a society. This can happen in different ways. In the first place, all types of comments can be presented in all types of media in different systems and do their job in relation to the binary code of those systems. But in the second place, interaction systems within the art system are situations in which communications can be exchanged socially and as a result may turn in several directions, across the boundaries of the art system as well. Communications concerning works of art and the experiences they brought about can, conversely, do their work in interaction systems of another social system (especially the social system of social communication), since these interaction systems have the same lack of differentiation. In both cases it is certainly imaginable that a communication based on artistic perception that acquires a place in such a chain of communications (in other words, becoming a real communication) will influence the original psychic outcome, and its place in the communicator's mental system as a whole, in a kind of feedback loop to the psychic system. Along these lines, the dissemination of artistic effects and hence the functioning of art in society can be thought of in Luhmann's system-theoretical terms.

Notes

1 However, in so far as the art system consists of communications in the form of aesthetic utterances, a communication between several artworks of no more than one artist participating in this system is imaginable.

2 Luhmann discerns four types of 'internal' differentiation which can operate in all types of social systems, but insofar as society is at stake they can be traced back as successive kinds of differentiation over the course of history. Archaic societies had a *segmental differentiation*, based on clans and/or geographical factors; during high cultures, like the Roman Empire or the European Middle Ages, the geographical segmentation took the form of a *centre-periphery differentiation* as well as of a *stratification differentiation* organizing social hierarchies. Finally, in modern society, *functional differentiation* divides the super-social system 'society' into several autopoietic subsystems, such as the economic, the political, the educational and the art systems.

3 Beckett's plays are, in this sense, also good examples of artistic observations that, with the actualization of one side of the 'referent' (in this case the impossibility of communicating perceptions), always show traces of the other side (the possibility of it) as well.

4 This view does not differ very much from Peirce's concept of a sign.

5 It will be clear that this difference is very similar to the concept of distance, understood as distance from reality, considered essential for aesthetic experiences since the eighteenth century, which appears in Bourdieu's notion of aesthetic disposition as well.

6 Luhmann uses the term 'unmarked space' for the field that is not entered by producing distinctions or forms in it, so that it remains 'the other side'.

7 This contingency can be seen as a productive force in the art system, more than in most

other social systems, because artistic communications principally stem from autonomous possibilities of choice sought by the artists, and from their aim to refer to 'the other side', as will become clear in the second part of this study.

8 Luhmann, just like the other authors, has problems with indicating a system of communications on social life. He states that society as a whole is the umbrella system encompassing all other social systems, and pays attention to the legal, the economic, the religious, the political and the educational system, but does not discern a particular social system of 'social communication'.

6 How Art Worlds Help the Arts to Function

The main goal of the first part – which will be completed by this chapter – was to discover what the different authors have contributed to the understanding of how the organization of art worlds serve the arts to fulfil their functions. At the end of the introduction a schema was introduced to present the various aspects of functioning in the art world, varying from the organizational structure of the different domains and their mutual relationships, via the question of which processes are going on in these domains, to – what may be the main question – which types of outcomes are generated by these processes. For the moment, the last question can only be answered in a provisional way, since the philosophy of art has to have its say about it, which will happen in part two. But some conclusions can already be drawn, partly on the basis of a sort of consensus among the approaches discussed, partly concerning the differences among them.

6.1 What the authors agree about

6.1.1 *That works of art **do** something*

One first remarkable result of the expedition undertaken here is that all authors agree that studying the art world from a sociological point of view has to deliver an understanding of what the arts *do*.

Beardsley, as a functionalist, was totally clear on this point and very well paraphrased by Dickie, who admitted that his own pure institutional thinking on art could produce a definition, but not a full understanding, of the art's characteristics. What Dickie also brought about, in relation to the question of what the arts do, albeit in a purely abstract way, was that they can only function for prepared audiences, for whom works of art, in one way or another, can have meaning. The same view was worked out by Howard Becker, whose concept of cooperative activity not only makes everybody in the production of art dependent on the con-

tribution of the others, but determines an interdependence between artists and audiences as well. Unfortunately, Becker remains unclear about what artworks *do* with people who use them, due to his uncertainty about the role of the market in distributing aesthetic values on the one hand, and the task of the artists to produce new views on the other. Strangely enough, his reflection on the central category in his work, the role of conventions, is not exhaustive in studying the exact relationship between the use of and the play with conventions. Becker's own reservation with regard to art philosophical approaches plays tricks on him in this respect, a reservation that is thematized by Heinich fifteen years later when she criticizes sociologists for their activities in other domains such as art history or philosophy of art. But the same holds true for her as well, and in the end, she will need art philosophical insights to answer her sociological question: 'our sociology will be a *"pragmatique"* of contemporary art – a description of what it does, of the ways in which it works', including influencing people's mindsets. Whereas Heinich and ANT make it clear that actors – among them works of art – make other actors do something and, in doing so, network themselves again and again, they seem to need the help of philosophers or art historians to understand what these other actors, being artworks or other types of actors, are doing when 'addressed' by works of art.

In Luhmann's way of thinking as well, the basic entities – works of art among other communications – are characterized by what they do. Utterances become communications by gaining a place in a system of communications and, even more importantly, communications can be called artistic because they contribute to a system with its own binary code, formulated by Luhmann as 'fitting/not fitting (as forms)'. Hence, it is not surprising that Luhmann devotes large parts of his book on the art system to finding the typical features of artistic communication, thus coming very close to the art philosophical question of what art does and, for that reason, is.

The only one who is not very explicit on this point, at least not in his field theory, is Bourdieu. In that part of his work he does not explore what the arts do, but under which conditions different forms of art (can) do their job, giving much more attention to the former than to the latter aspect. His summary of the three fundamental operations of the 'science of cultural works' sounds like this:

> First, one must analyze the position of the literary (etc.) field within the field of power, and its evolution in time. Second, one must analyze the internal structure of the literary (etc.) field ... , meaning the structure of objective relations between positions ... And, finally, the analysis involves the genesis of the habitus of occupants of these positions... (1996: 214)

No word about what works of art do. As we know, the word 'position' refers to types of artistic work and a relation between the field of power and the field of art does suggest an influence by actors from both fields upon each other. And, yes, Bourdieu discusses this links extensively, exploring particularly the autonomy-heteronomy relationship and the 'space of possibles'. But his thinking on the working of art takes place in the other part of his oeuvre, about 'the social critique of the judgement of taste', his theory of distinction. In this part of his work, Bourdieu has developed and made use of a theoretical construct of different forms of aesthetic experience, which is really about what artworks do. To show how strongly, although implicitly, this part of Bourdieu's thinking is connected with his theory of the artistic field, it will be enough to refer to the important part cultural capital plays in participation in the field, or to the different types of audiences mentioned in figure 3.4 on the French literary field (p. 63).

6.1.2 That production and reception are inextricably bound to each other

Again, all the authors agree that aesthetic production and reception are interdependent. But this does not mean that they pay the same attention to both domains or work out this relationship thoroughly. On the contrary, especially on the organizational level, the domains of reception and distribution are quite poorly discussed. That is not entirely true for the reception on the level of outcomes; as we saw in the former section, Bourdieu (in his distinction theory) and Luhmann explore the features of aesthetic experiences, produced by people confronted with works of art. Luhmann even says a great deal about the types of processes generating aesthetic perceptions and communications, particularly about how the systems of perception and communication are operatively closed, but open for each other's outcomes – not to include them, but to be stimulated by them. As shown in the third column of figure 0.2, these reception processes, seen as executed by individuals, are based on the organization of the individual's perception and communication system (including embodied cultural capital). To make the functioning of art possible in the domain of reception on a societal level, however, not only do communications (works of art in this case) have to stimulate perceptions, but, conversely, perceptions particularly need to stimulate the production of communications (produced by the art users in this case), since on that level a kind of shared experience or experience of something shared, has to be brought about. Neither the types of processes of participation and reception, nor the organization of attendance, which are the conditions for this communication to come into being, are worked out by the authors.

To understand what art does and what makes art do something, it should be known how different types of art events – not in terms of discipline or genre, but

in typically sociological terms, those of organization – are conditioning different types of experience.[1] Because of the nature of the sociological approaches presented here, the lack of this kind of knowledge is not surprising. For the elaboration of the ways in which the organizational forms of events serve the functioning of works of art, one needs thorough insight into the organizational forms in which an art discipline has been historically developed and is developing nowadays. Although it can be very helpful for an art sociologist to be at home in an art discipline as well (like Heinich in the visual arts, for instance, or Becker in music and photography), it cannot be expected that elaborations on this topic will be presented in general studies. But what could be expected from the sociology of art is that it formulates the significance of the organizational character of art events for the societal functioning of the arts presented, and that by doing so it also points to the importance of the domain of distribution which shapes these conditions for the functioning of works of art. Heinich also seems to stress this when she distinguishes a sociology of works, a sociology of reception and a sociology of mediation, all of which have to be linked to each other 'to reconstruct the logic of the movements'; she describes the third form of sociology as 'the analysis of the mediations carried out by the different categories of specialists, from the collectors and dealers to the critics, exhibition organizers, curators and agents of the state'.[2] And, indeed, the third part of *Le triple jeu de l'art contemporain* is largely devoted to the roles of mediating institutions and experts (pp. 264-326). Yet, in general, the entire domain of distribution is neglected and the focus is instead placed on the production domain; the distribution domain is discussed by the authors as a sideline, whereas it should be considered the centre of an art world.[3]

This poor attention to the fields of distribution and the organization of reception does not mean that nothing valuable is offered. Becker, for instance, sees conventions as the cement that binds artists and audiences together. And he works that out by listing the 'basic workings' of the art market; among the items on this list are 'effective demand is generated by people who will spend money for art' and 'what they demand is what they have learned to enjoy and want, and that is the result of their education and experience'.[4] Becker even discerns three types of audiences: 'well-socialized people', who have little acquaintance with and experience in art but seem to be part of the audience; 'serious and experienced audience members', who are able to enjoy the 'manipulation of standard elements in the vocabulary of the medium'; and '(former) art students', who know the profession and can function as gatekeepers for both other groups. Strangely enough, Becker calls the first group the backbone of the art world, because it provides most of the money, whereas the second sort of audience should be the one most wanted by artists, because they can communicate with them in an artistic way. There is

something ambiguous – an ambiguity present throughout Becker's entire book – in saying that the backbone of the art world is formed by people who cannot participate in an artistic communication and are only pleased by standardized operations, whereas the distinctive feature of artistic work is formulated by Becker himself as work that 'invites us into a world defined in part by the use of materials hitherto unknown and therefore not at first completely understandable'.[5] The first group could instead be called the economic basis of the art world, at least in poorly subsidized systems where the existence of art forms appreciated by the second group of users – who deserve to be considered the backbone of an art world more – depends on the incomes earned by aesthetic entertaining. In terms of the functioning of the arts in society, it can be supposed that the bigger the group of experienced users is in proportion to the inexperienced audiences, the more art can play a role in society.

Becker is not the only one who is struggling with the question whether the term 'art' can be used in such a broad sense that all types of utterances that make use of aesthetic media and languages are included, fully conventional communications as well.[6] Bourdieu, too, has problems with defining the borders of an art world, particularly concerning the place of the audiences and the institutions that serve them. In his sketch of the French literary field in the second half of the nineteenth century (figure 3.4 in the present book), he places different types of audiences around the field itself: intellectual audience, bourgeois audience, mass audience, no audience. First it can be said that Bourdieu's intellectual audience will be more or less the same group as Becker's experienced public, that a bourgeois audience will be divided over the experienced group and the well-socialized people, and that Becker's audience of professionally trained artists forms a part of the field of production itself. The place of what Bourdieu calls a mass audience, loving industrial art, does not get a real place in Becker's approach. The reason why will probably be that a big part of what the latter calls art is industrial in nature and produced for bigger and smaller masses, without being considered by Becker as less valuable in terms of art than not industrialized forms. Partly he is right, indeed, because the twentieth century has experienced the development of mass media as producers or distributors of aesthetic utterances of all sorts, among them strongly consecrated works of art for 'small masses', as well as the most standardized types of work for real masses. This development has expressed itself obviously in confusing terms like mass culture, industrial culture, low and high art, and the debate around them, which, for the time being, has ended up in a tendency not to make any distinction at all between different forms of culture. Acceptance of this tendency, however, will make it impossible to discover anything about the functioning of the arts in a society. Hence the debate will be taken up in the second part of this study.

Not only in the figure mentioned do the audiences find themselves back out-
side the field of literary (etc.) production, but in his texts, Bourdieu places them
in heteronomous spheres as well. As ticket buyers they are part of the economic
field; as students they are part of the educational field, as decision makers they
can be part of the field of power. In all cases, however, they do influence the fields
of aesthetic production, particularly at times when the structure of a field (based
on the distribution of specific capital) is out of balance, or all the more when the
autonomy of the field is weakening. In that case the struggle for dominance be-
tween the doxa of the field and those of fields around (which never stops, because
the cultural field is dominated by other parts of the field of power) will intensify.
This was very well illustrated by what happened in Europe between the end of
the 1980s and now: after a period of a relatively strong autonomy on the part of
the field of artistic production, the increase of heteronomous influences from
inside the aesthetic field (struggle for a broader concept of art), as well as from
the economic field (a bigger role for what the market demanded) and the politi-
cal field (social legitimization of subsidies), ran parallel with shifts in the field of
power, where the economic field took over the dominance from the political field,
and within the political field, neo-liberal parties strengthened their position in
the European Union as well as in a number of European countries.

So, in Bourdieu's view, audiences are important, but particularly as a factor in
the struggle for power in the field of production. There is almost no attention to
the other direction, about how the arts can help audiences to be a factor of power
in the fields they participate in as well. For instance, how theatrical events de-
construct political discourses, or how pop or other concerts (re-)define social or
ideological life. It is neither discussed on the level of the arts themselves, nor on
the level of the organization of the events in which art can be experienced. Yet, if
there is a space of possibilities within the field and if there is a homology between
changes in the field of production and changes in the mutual position of audi-
ences (as Bourdieu states), then the domain of distribution is the place where the
connection between both developments is organized. In other words: if the arts
do something, it is in the domain of distribution that their 'doing' is organized.

There is, finally, a particular group of listeners, spectators and readers, called
the critics, about whom somewhat more is said. Becker devotes an entire chapter
to aestheticians and critics, using it for a large part, however, to explain his own
position in relation to the art philosophical views of Danto and Dickie, among
others. Becker sees critics as actors in an aesthetic system, meant as a set of aes-
thetic theories and artistic programmes. Critics take positions in such a system
by supporting some programmes or by showing why and how a work of art or
an oeuvre relates to a certain aesthetic genre. By doing so, critics play a role, of
course, in an art world, because, in the words of Bourdieu, they help actors in the

field to collect specific symbolic capital in the form of prestige. On the side of distribution and reception they help both programmers and audiences to find their way in the jungle of what is produced, not only by mentioning and evaluating certain works and not others, but also by relating them to what is already known.

A specific question is where in the different systems, networks, worlds or fields the critics have to be placed. In the Actor Network Theory as well as in Becker's approach, no theoretical difficulties arise. In the first case, critics are, just as other actors of all sorts, present in the network as soon as they make other actors do something. It would be interesting to understand how they make audience members communicate with each other or make audiences use their experiences in other systems, but that is not what is described. Heinich especially shows how critics help artistic work to become part of a network of art distributors. In Becker's approach, critics participate of course in the cooperative activity of art production, as do audiences. For the model gives everybody a place who is contributing something. Luhmann's system theory also gives space to the type of communications critics contribute. Critics are typically participants who deliver communications, because their utterances obviously have a material form and position themselves in a series of communications, reacting to artworks or other communications about art such as catalogues, interviews or reviews, which are materials to be answered by new communications in their turn.

What is the position, however, of critics in an aesthetic field? Are they in fact functioning *within* the field, or are they working from the outside? Of course they contribute heavily to the division of specific symbolic capital, the reason why Dorleijn and Van Rees give them such a prominent place in their model of the literary field. They distinguish three domains in the twentieth-century literary field: the domain of material production, inhabited by authors, publishers and literary journals; the domain of distribution, filled with bookshops and libraries; and, finally, the domain of symbolic production, where literary critique and education in literature are the main institutions. Bourdieu himself is less clear on this point. Following his early written features of a field, it can only be said that the activities of biographers, and maybe critics as well, *indicate* the presence of a field. In his later work, critics do not appear in sketches of fields, although they show up now and then, as do publishers and gallery owners. Because of Bourdieu's practice of alternating the terms 'literary field' and 'field of literary production', without defining them, it remains possible to give distributing institutions as well as aesthetic critique a place in his concept of fields, as a kind of extension of what is produced and which, in the end, gains its real presence only through these institutions. In this sense, critics are part of the field of artistic production, more so at any rate than general audiences, which are located on the outside, as Van Rees and Dorleijn (2006) also argue.

6.1.3 *That art worlds are autonomous, but open*

While emphasizing the autonomy of art worlds, fields, systems or networks, all authors are happy to note that these worlds are also porous, or open. What is more, this openness is in fact studied more intensively than the closedness. Particularly in the Actor Network Theory, openness is the basic principle. Networks are not, in that approach, existing systems of relationships between actors, but sets of relationships coming into being, changing and disappearing because of the acts of actors that make other actors do something. This process is quite comparable to the way in which communication comes into being in Luhmann's view, as a series of communicative reactions. This should be called 'internal openness', as it will become clear that this openness will be restricted by structures of expectations in Luhmann's theory, or by the power of conventions in Becker's approach and by the state of the division of capital in Bourdieu's view. Although ANT appears to need some notions such as 'underlying structures', 'rules' or 'institutions' as well, the restrictive working of these on the rhizomizing process is not strongly stressed by Latour or Heinich.[7]

'External openness', concerning the relationship *between* (sub)systems, is something else. Translation centres are the places where ANT actors, being persons, organizations or objects, pass from one net into another, by tying themselves to other types of actors. In ANT there is a great freedom for actors to travel from network to network, changing themselves as well as the networks, but at the same time, translation centres impose certain field characteristics on the actors during their passage.

Both Bourdieu and Luhmann stress the 'external closedness', the autonomy, or the 'difference' of fields or systems much more than ANT does.

The autonomy of art can be studied on the level of the artist, of the artwork and of the art world. In Bourdieu's work the artist is autonomous within certain boundaries. Internally there is the restriction of the *illusio*, the stake of the game that is called art and that has a more or less open set of rules. As soon as an artist crosses the line of *illusio* he stops being part of the field. Besides that, there are boundaries defined by the state of relations between the positions within the field. Artists occupy positions on the basis of the homology between their habitus and the requirements of the position concerned. This relationship always knows a certain space for the artist to play, but this will become bigger when the relationship between the positions in the field is out of balance, which is not infrequently linked to a disturbance of the balance in other parts of the field of power. Concerning the autonomy of artists with respect to the powers outside their own field, it is particularly their capacity for refraction that determines their autonomy; however, this is not done apart from the amount of symbolic capital

they have at their disposal and insofar as this is of any significance outside the aesthetic field.

In Luhmann's approach the artist is autonomous as long as he or she is producing artistic communications, which includes the fact that reacting communications take place, so that an art system comes into being. As we saw before, shared expectations condition such a system of communications.

The autonomy of the artistic utterance as such is a much more problematic question, because in fact this refers to the functioning of a work in the reception by users. The consumer produces a more or less adequate, but always specific, mental image based on the work of art that, strictly speaking, is left over to the mental activity of the user. So the autonomy of the artistic utterance is not obvious at all: it has to realize itself in a struggle with the consumer, supposing that a communicative reaction will be there.

On this point the field or the system can play a protecting role for the work of art through its institutional structure of relationships, within which art utterances are given a place, as long as the artist respects the illusio. Users of art have to take this place into account when they try to produce a meaningful perception of a work of art. And Luhmann's system does more or less the same thing: as a result of the general functional differentiation in society and particularly the historically developed structures of expectations and roles, the art system can easily recognize communications as artistic ones and let them function within the system. These structures do not mean that works of art cannot have any significance outside their own field or system. In Luhmann's thinking this depends entirely on the effects of structural coupling with other social systems, just like the relation with psychic systems determines the working of artistic utterances for individuals. Bourdieu has made clear from the beginning that the cultural field is part of the field of power, but is dominated there by the fields of politics and economics. In addition it can be said that the economic field has started to dominate the political field again since the late 1980s, and that within the field of culture the subfields of science and media are dominating the aesthetic field. These dominances are exercised through direct influences by the fields mentioned on the power relations (divisions of capital) among the positions within the aesthetic field, whereas, in addition, external actors can present themselves within this field.

In a sense, Luhmann's social systems are fully autonomous because of their operative closedness, but the question is what exactly this means for the influence of other systems, such as the political or the economic, on the aesthetic. Particularly complex systems are open to impulses from outside, which they then, however, process in fully operative closedness. It seems that thinking about the autonomy of the art world on the basis of the clear concepts of autopoiesis and operative

closedness is less fruitful than using the concept of structural coupling between systems, because this is how the way in which the art world is influenced by the environment has to be understood.

Going one step further, it has to be asked whether and how, conversely, the art world can influence its environment. Although Bourdieu does not discuss this possibility, the homologies he sees between habituses of agents within different fields (e.g. the aesthetic and the economic or educational field) at least suggest the possibility that changes of habitus in one field (e.g. the educational one) can be influenced by changes of habitus in another field (e.g. the cultural one). These processes can be imagined most easily on the level of individual mental and material activity in the free space between requirements of positions on the one hand and habituses of position-occupiers on the other. But this influence can take place on a more societal level as well; in that case particularly the mediating institutes, such as museums, theatre venues, libraries, and aesthetic critique play an important, not to say essential role, because they can, as mediators, connect two different fields by bringing people together in aesthetic events. In Luhmannian terms: at these events, people perceive and communicate in the aesthetic languages provided, and according to the structures of expectations belonging to this system. If, for instance, a school class visits a theatre to see O'Neill's *Mourning becomes Electra*, the students not only have to pass the translation centre, that is, a theatre venue, to behave according to the structures of expectations of the theatre and prepare themselves as spectators, but a structural coupling is also made between the educational and the aesthetic system. Before and after the play the first is active, using communications about the importance of O'Neill in theatre history, American history of the period after the Civil War, and the structure of the play in relation to Greek tragedy. But during the play, the art system is active in the form of the performance as a set of aesthetic utterances and the reaction to them, based on the aesthetic experiences of the spectators and the audience as a whole, as well as on the expectations built up in the educational system. After the play this process can go on and turn into a continuous alternation of communications in the one and in the other system. In the end, of course, in the educational system the students are tested according to a binary code of knowing/ not knowing, but even then a link can be found. A certain knowledge is needed to produce an aesthetic experience and, conversely, experiencing art increases the aesthetic competence.

6.2 What the authors do *not* agree about

Two main questions that are of particular importance for the present research arise directly from the comparison of the different approaches: a) which place the concept of 'the social' has in the various theories; and, inevitably, b) what the difference is between the concepts of world, field, actor-network and social system.

6.2.1 *What is 'social' in a world, a field, an actor-network or a system*

Latour as well as Luhmann are very clear in their opinions that 'the social' does not exist but is something to be shaped by the production of links between actors, or the succession of communications, respectively. Latour called his last book *Reassembling the Social* and criticizes the 'sociologists of the social' for understanding society as an existing order and 'the social' as the type of relationships that meet this order. For the sociologists of associations, on the other hand,

> there exists no society to begin with, no reservoir of ties, no big reassuring pot of glue to keep all these groups together. If you don't have the festival now or print the newspaper today, you simply lose the grouping, which is not a building in need of restoration, but a movement in need of continuation. (Latour 2005: 37)

One of the categories of this sociology of associations is what Heinich calls the realm of singularity, as opposed to the realm of community favoured by the sociologists of the social. In the realm of singularity the peculiar, authentic and differently acting counts, and this holds true for the world of arts in the first place. As became clear, however, this type of acting is not performed in a vacuum, but is bound to rules – like those of a game – which, in the view of ANT sociologists, are overestimated by sociologists of the social, who should see them as (societal) structures that define the doing of actors. In fact this conflict refers to the classical debate on the relationship between the role of structures and the role of agents in dynamics and changes of cultures; a debate that Latour tries to get around by understanding both aspects as positions that different groups of sociologists take, instead of building blocks of reality as such. 'The social possesses the bizarre property of not being made of agency and structure at all, but rather of being a circulating entity' (2004: 17). This type of thinking gives the impression that a certain fear makes Latour himself circle around the problem of the social he formulates, instead of resolving it. For is there any reason to understand this 'circulating entity' as based on anything else than activities of agents on the one

hand and structures that frame these activities on the other, be it in the form of demands from translations centres, or, in Luhmann's terms, in the form of expectations (of expectations)? In other words, is Latour's circulating entity not just another expression for the dialectic of agency and structure? Latour is entirely right if he states that the importance contributed to agency or structure is a question of positions of sociologists, but his effort to neutralize this opposition seems to stem from a fear of the dominance of the one position, the (post)structuralist, over the other, the individualist way of thinking. He may even be trying to control a fear that agency is indeed structured in reality by denying this fact.

If something like the social can be reassembled, there is nothing wrong with calling the result of this assembling something social, in the sense in which Luhmann understands the expectations that structure communication. They are social in the sense that they help actors to connect and they are structures in the sense that they do this in a more or less institutionalized way. During periods in which institutional patterns are changing very strongly and broadly, it is always tempting to understand reality as something principally not-understandable and this feeling became stronger in the last quarter of the twentieth century, when mediatization of reality and commercial globalization sidelined the possibility of interpreting reality in terms of a society.

Luhmann takes a particular position in this debate, discerning specific types of systems built out of communications, calling them social but also stating that 'the Social' does not exist, although society does. Society is considered by Luhmann the most general system of communications, in which something like 'the Social' does not exist, because the link between communicative utterances has to be produced each time anew in order to generate a social system (consisting of two or more communications). If structures of expectations organize these processes of linking, it should not be strange to understand them as social(izing) structures (or institutions); when they are thought of on the level of society, then as societal structures. It can be questioned whether, as in Luhmann's thought, structures of expectations and roles can be used as notions to understand society as a system. They work instead on the lower level of sub- and sub-subsystems, because, as Luhmann underlines, expectations are always and only active in the present time, connecting the past and the future in the here and now. More than that, he is of the opinion that most communication runs on the level of interaction systems, in which participants are together at the same time at the same place. As we have seen, he also used the term 'simple social system' for this, to distinguish it from a social system as a whole. Conversely, when Luhmann speaks of the relationship between interaction and society, he seems to use the latter term for parts of society as well, because subsystems, such as the art system or the economic system, are of course not only social, but also societal.

Other authors, like Becker and Bourdieu, do not worry as much about the use of the term 'social'; the latter particularly not in the way in which he discerns various fields (based on the type of capital, whereas Luhmann makes use of binary codes), and so the question arises whether one or more social fields should be defined. Neither Bourdieu nor Luhmann refers to that type of field in the summing-ups they present now and then, and Becker seems to see different worlds, such as the art world or the political world, as social worlds, just as Luhmann sees them as social systems. In terms of the latter, is a *social* social system imaginable, or, following Bourdieu's idea, a social field? In *The Rules of Art*, Bourdieu uses the term 'social space', whereas in his 'Field of Cultural Production' (originally from 1983) the notion of a 'field of class relations' is used for the same space, both meaning something like 'society as a whole'. Within that society, fields are distinguished, but not all on the same level. There is a literary field and an artistic field, the former being part of the latter and the latter, in its turn, part of the cultural field. Besides the cultural field, there is also an economic and a political field, as well as a field of law, all characterized by the type of profit that can be made by activities in the field concerned. Related to these, a field of power is imagined, although not clearly defined. Does it enclose the other fields mentioned, or do only certain actors of all types of fields participate in the field of power, where they struggle for dominance of their (sub)fields? The latter idea seems to be the most logical one within Bourdieu's thinking. But the main question is whether a field exists in which the relationships are not primarily educational, political, economic, and the like but 'social'. Of course, Bourdieu uses the notion of social capital, but should that be considered a by-product of gaining other forms of capital, or is it the capital at stake in a specific field of social relationships, with its own subfields, each of them defined by the porous borders of the social class concerned? Such a field should consist of family life, pub life, club life, community activities, and so on, in short, all types of relationships referring to the benefit of 'being part of', in Cultural Studies partly covered by the Notion of 'Everday life'. Although activities or communications of this type are realized in other fields or systems as well, there is such a vast area of specific social relationships in which people participate and in which they are also collecting specific social capital, that within Bourdieu's social space, a social *field* should be defined. This should certainly make sense with respect to the present study, because it is precisely in social subfields that artistic experiences can get a second life. Even more than in other fields, communication in the social field takes place in interaction systems. And it is especially interaction systems within the field of social communication that accept many types of communicative utterances and help to distribute them to various types of other systems. In this sense, a field or a system of 'social life' could be considered the cement of a community and it

is precisely the disintegration of traditional social subfields during the last half century that has weakened the position of art in society for the time being. New social fields and systems are needed to give works of art, and the possible experience of them, a place in society. Whereas the traditional social fields and systems were and are mainly functioning on a local scale, new types will emerge that will be of a more globalized and 'cyberspaced' nature.

6.2.2 Art world, field of art, aesthetic actor-network or art system?

The most furious reaction of one of the authors to the concept of one of the others is Bourdieu's comment on Becker, already quoted in chapter four. Bourdieu accuses Becker of doing no more than enumerating and describing elements in the art world, whereas the search for 'objective relationships' is necessary to make understandable what is going on in that world. The notion of field makes, in his view, the difference between the most neutral term, 'art world', and a specific scholarly approach to the world meant by that term. As we have seen, Bourdieu is the only one who makes the 'objective relationships' into the core aspects of research and who studies the structure of these relationships as well as the types of powers and dynamics that produce such a structure in the first place. And that is exactly the basic element in his theory for which other sociologists of art like Heinich, Laermans or Gielen, inspired by the ANT approach, criticize Bourdieu. In my opinion they go a bit too far in doing so, for three reasons. In the first place, they often depict him as a structuralist, whereas he should be considered a poststructuralist, taking up structuralist achievements in his efforts to make cultural changes understandable. In the second place, Bourdieu is exploring different things than his critics are. As mentioned, his research is aimed at studying the powers and dynamics that generate a historically existing and changing system of relationships within the aesthetic field and between this field and its environment, albeit the impact of the latter on the former is explored more extensively than the other way around. The main fear of ANT scholars is that such conceptual structures will strongly and falsely influence the search for what really happens in a culture. And the latter is exactly one of the two things they try to describe: what happens (or is done) when actors (organizations, individuals, objects) do something. Another question is how passages (going through a translation centre) change an actor in his, her or its doing. In a sense ANT scholars have and give the feeling that the societal changes during the final quarter of the twentieth century made them leave the search for patterns, structures or laws aside and go back to the concrete occurrences in a culture. Hence Latour's utterance that the ANT practice is 'the summing up of interactions through various kinds of devices, inscriptions, forms and formulae, into a very local, practical, very

tiny locus'.[8] In the third place, however, these authors do not remain as far from Bourdieu in this respect as they suggest, because they appear to arrive at a point where they need to speak in more general terms, varying from the *rules* that limit the freedom felt by artists, to a *hidden coherence* Heinich tries to find, or 'the new institutions, procedures, concepts able to collect and to reconnect the social', as Latour proposes to attempt.

Seen from a certain distance it would not be unwise to study whether and to what extent Bourdieu's (as well as DiMaggio's) field laws and dynamics could be related to the factual interactions found by ANT studies in the art domain and which, as a result, may or may not be seen as elaborations of the 'rules', 'hidden coherence' or 'concepts able to collect and reconnect the social'.

What is said above makes it possible to formulate the essential differences between a world, a field, an actor network and a system. Whereas traditionally networks are considered to be existing structures of elements related to each other through interests and/or rules, ANT stresses that an actor network is something that comes into being each time an actor, by doing something, makes a link to another actor. There is no given network of interrelated actors into which new ones fit themselves, nor a given social structure that exists and organizes the behaviour of actors. Rather, the act of linking means something social is happening. The basic elements of an actor network are the acts that make other actors doing something, and the connections made in doing so. For Bourdieu a field is not a set of interrelated actors, but a structure of relationships between *positions*. The basic elements of study are not the actors, but the positions (artistic places in the field) and their relationships. The essential distinction is that in the field theory, artistic positions (being concepts, based on constructed relationships) precede the occupation of them by actors. It is this very point that marks the (post)structuralist thinking by Bourdieu as well as the gap between a field and an actor network. As soon as a field should be studied on the level of the occupiers of positions, the difference with network theories should be not very great, because the relationships ought to exist between concrete actors (organizations or individuals) instead of between positions. In this sense a theory of fields and an (actor) network theory can be seen as approaches with their starting points on opposite sides.

Luhmann differs from Bourdieu, and from the actor network approach, in another way as well. A social system is not a set of relations between positions of actors or of actors as such; it is nothing other than a set of communications. The smallest entity consists of two utterances, the biggest is society as a whole, functionally split up into subsystems such as religion, economics, education, politics and art, each with its own binary code to which the communications refer. Thus the basic elements Luhmann studies are the communications in a particular sys-

tem and their typical nature. Although he stresses that with each communication a system comes into being, which is comparable with the actor-network approach, his way of thinking at the same time demonstrates a strong (post)structuralist tendency. For placing actors (people, organizations) in the environment of the communication system, he provides the system as such – let's say the historically developed discourses within a system – with maybe not an overwhelming but still a structuring power. People, not being part of the system, but participating in it, can be considered to fit their communications into the system according to the rules of the system, which is not far away from how thinkers such as Lacan, Althusser and Foucault describe the ways in which people get their place in an existing world.

Having no actors in a system, Luhmann's approach is not easily comparable with Bourdieu's, Becker's or Heinich's. Nevertheless, seen from a certain distance, the approaches are perhaps in a sense compatible. The symbolic interactionism of Becker and the ANT of Latour and Heinich share the method of describing the concrete activities of actors, and in that sense provide the material layers on which the 'nature' of the world or the actor network concerned can be studied. Although they stress the role of activity and keep a more analytical approach, formulating structures or institutional patterns in the background, these elements are still there. Becker discusses the role of conventions extensively, although not taking the step to the search for institutional patterns; and the ANT scholars, as we saw, indicate that rules or concepts could be found in the way activities are carried out. Translation centres in particular ask or force passersby to behave according to the network they enter. Bourdieu's field theory can be seen as an effort to describe just these rules, institutional patterns or even structures, although what he found on the basis of his empirical research during the 1960s has to be checked and revised for the ways in which participants in the field act since the 1980s, how they relate to each other, and which types of artistic and hierarchical positions can be determined, if at all possible, nowadays.

What Luhmann states, finally, is that activities in a social system exist only in the form of communications. So the things done by actors in an actor network should be, in his view, nothing other than communications, with the result that what actors do is strongly determined by the rules of communication, or in Luhmann's words by expectations (of expectations) and the roles of people based on them. To make the combination of ANT and field theory compatible with Luhmann's approach, one of the views has to be included in the other. Either a system of communications is part of a system of relations between (positions of) actors; or the latter is the result of a system of communications that organizes and more and less determines the relationships between actors; in other words, either a

field, world or network creates a system of communications, or a system of communications creates a field, world or network. In the first case, the fundamental question is whether other entities than communications – and, if so, which ones – can be imagined organizing an art world, a field of art, or an aesthetic actor network, with a communication system within it as one of the results. Bourdieu can imagine this possibility very well: the division of cultural capital, which in the end can be considered economic capital as well, determines the structure of the cultural field. In addition, the nature and division of the means of production, in general, probably determines the structure of a society. The second solution – a system of communications creates an art world – does not raise a comparable question and is imaginable as well: Luhmann sketches out how in a communication system expectations and roles come into being, which can be considered to provide the structure not only of communication, but also of sets of relationships in an art world. [9] What will arise from that, is, of course, a dialectic between structures and communications. And it is precisely the dominance in that dialectic relationship that is the crucial point in this debate. Starting from communication, a social system will, at a certain point in its history, have developed expectations, structures of expectations and roles based on them. If and when these structures are going to be institutionalized, they start not only to regulate communications, but to constrain them as well. At that moment it becomes possible to think of a dominance of a structure over communication, although structures cannot exist apart from communications and the social system (of communications) remains the 'universal' entity.

The consequence of this is that, to understand the working of art worlds, we must study the dialectic between utterances made by actors and institutionalized patterns that exist within the communication system but appear to be an entity in their own right. This also means that neither the term 'field', nor the term 'actor network' can be used as the general concept in this study, although the notions behind them have delivered productive entrances. Of course, 'field' could be used in a general sense, but strictly speaking not after Bourdieu's attack on Becker or bearing in mind the whole theoretical apparatus of field theory, which favours the institutionalized and institutionalizing aspects in studying art worlds. 'Actor network' is not the desired term for the opposite reason: the combination of words can, indeed, refer to the dialectic mentioned above, albeit in ANT in a very specific way, but the term does not sound general at all. That leaves 'art system' and 'art world'. The latter should have the best credentials, because it is the most general term of the four used. Its disadvantage is, however, that it does not add anything, at least not in a sociological way, to understanding the world of arts. It is too heavily marked by the time of its origin, partly in a productive art philosophical way, partly as a first general notion in the sociological domain. 'Art System', finally,

sounds general in the first instance, if linked to the General System Theory which states that all entities of related elements can be studied as systems. This well developed general theory can help to define the nature and borders of art worlds and to name various types of internal and external relationships. But Luhmann has elaborated the theory of *social* systems in such an advanced way that nowadays the art system will be understood primarily in Luhmann's terms, with the accent possibly on the autopoietic character of social systems and the exclusion of actors as parts of them. Because of the general background of the term as well as the general value of Luhmann's elaboration, 'art system' will nonetheless be used in the following parts of the present study to indicate the entire organization of artistic communication within a culture, with a certain accent on the institutional patterns, referred to by Luhmann as structures of the social system. In short: the art world will be studied as a system.

6.3 How to study what the arts do

If the main sociological question on art is what the arts do, the lack of research in the domain of reception and how this is organized by distribution is the most remarkable outcome of the investigation till now. The first aspect to consider regarding the 'doing of works of art' is their impact on human perception in a double sense: as what happens in the act of perceiving and as the result of this in the form of possibly changed perception schemata. To be honest, at least the latter aspect has been discussed by all the authors, although by some of them quite poorly, but what is not discussed at all is how, in organizational terms, the working of art is made possible. In figure 6.1 (a simplified upside down version of the schemata as used in the introduction) three essential stages are shown on which conditions for the working of art can be studied: 1) where organizational patterns condition typical forms of production, distribution, reception and contextualization of art; 2) where production and reception meet in the domain of distribution; 3) where aesthetic experience relates to other systems. The process shown in this figure can be studied on an individual, a community and a societal level. When studied on an individual level, stages 1 and 3 in particular have to be approached from a psychological point of view; this falls outside the frame of reference of the present book, but is an indispensable basis for the understanding of how aesthetic experiences come into being and how art education proceeds. Attention will mainly be paid to the ways in which these stages can be discussed on the levels of communities (in the most broad sense of the word) and societies.

Figure 6.1 What works of art do, mediated by distribution

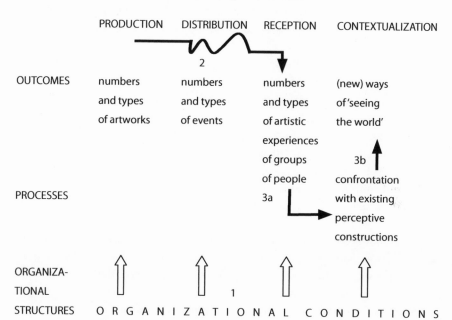

As said several times before, works of art cannot do anything, and do not even exist without the mediating role of the distribution domain; mediating is not meant as passing something on, but having the character of a real passage. Distributing institutes do work as translation centres, for works of art as well as for potential spectators. They give the artworks a place in an aesthetic event in which they are tied in with a lot of certain other actors, such as space, other works maybe, spectators and so on. These connections are determined by the type of the institute and its own place in the system, so that the work of art will play its role according to the nature of the event. But the spectators are changing as well: as soon as they become a participant in the event, they become part of an audience, put through the rules and conventions of the organizing institute and in a specific way focussed on the work presented.

So, the domain of distribution *makes the work of art available* – by using it in a particular way and in that sense changing it – *creates* the audience for it, and *brings both together*, three aspects to be studied by sociologists of art in detail. And by doing this, distributing organizations give art a place in a community or society, a specific place based on the type of events they provide.

It can be questioned whether or not the participants, going back through the passage to their normal life, are still the same people as before. According to ANT

this should not be possible, but in reality the differences between before and after are often so small that they can be considered negligible in terms of personal or social development. This brings us to the second main question, extensively discussed before, concerning the relationship between the various (sub)systems. In particular, the possibility of works of art being useful in other systems has to be investigated here. On a psychological level the question can be asked how cognitive concepts are used in aesthetic perception, but also how, conversely, artistic perception, by actualizing existing cognitive concepts in specific ways, at the same time challenges them. By so doing, it helps the spectator to develop new cognitive schemata, which in their turn make (new) types of perception possible, and so on. This whole process takes place in the psychic system, albeit on the basis of a structural coupling with the art system and a structural coupling between the subsystems of perception, imagination and cognition within the psychic system as well.

On a community or societal level, however, the phase called 3a in the figure is food for sociologists, because here the question under discussion is how types of aesthetic events, including the works of art they make use of, relate to and possibly impact on social identities, conventions, expectation structures and even ideologies, and especially how this relationship and possible impact is organized. Spectators, listeners, readers, and visitors to art events in general, participate in various social systems such as the educational system, the 'social life' system and the art system. In all these systems, conventions, expectations, roles, institutional patterns, norms, views and so on are implicitly or explicitly communicated and form the ideological structure of each system. There is, however, a kind of overlap between these ideological structures, because the matters or themes they concern (e.g. love, death, money, war, sexuality, friendship, historical and political events, etc.) can be the same, although they are approached in different ways (in the end based on the binary code of each system) and get different forms in the communications about them. So, the second question arising in the sociology of art is whether the ways in which these themes are artistically communicated can be made useful for (communication in) other systems and then, how this structural coupling is or can be organized. It goes without saying that the distribution domain once again plays an essential part in the organization of this type of process.

Finally, the third investigation from the sociology of art concerns how art systems are organizationally structured, not because of the structuring as such, but in the light of the question whether and how different types of organization condition what the arts do (and hence their 'doing'). This question is a bit difficult to think about in Luhmann's terms, but if structures of expectations can be seen as institutions, including rules and roles, organizational structures can be studied according to his theory as well. In general, these structures have to be

considered the abstract outcome of the study of institutionalized relationships between actors, as based on the typical and different forms of communications between them.[10] As the schemas in the introductory chapter have made clear, these relationships exist among the three different domains (production, distribution and reception) as well as between the art system and other systems (such as the political or the economic). More than that, organizational structures also form the basis of the domains themselves, and, as a result, the question has to be asked what their impact is on the specific types of processes of respectively making, allocating and using art.

The search for the conditioning impact of organizational structures, within as well as between the domains, on what the arts do and how artistic communication is related to other types of communication can be considered the most important and challenging task for the sociology of art today.

Notes

1 'Event' is used here in a purely general way, as something happening around a work of art, as is the case in theatre performances, exhibitions or pop concerts, each of which has various types of organization in its own field. See also Van Maanen 2004: 247-248.

2 See p. 99 of this book.

3 As stated before, in this approach the functioning of an art world includes the use of art by people outside the field of artistic production as such; the possibility to limit an art world to the field of artistic production in a strict sense, at the very most including professional critics and aestheticians but excluding the ordinary public, is rejected here. Later on in this section the different authors' relationships to this question will be discussed.

4 See p. 39 of this book.

5 See p. 40 of this book

6 The question will be discussed further in part two, in relation to the terms 'aesthetic' and 'artistic' and to the debate on the disappearance of the distinction between 'high' and 'low' forms of art.

7 Except in the comparison of the artist with a chess player.

8 See p. 85 in this book.

9 An escape from this solution might be that human beings are seen as the creators of communications.

10 Bourdieu's relationships between positions concern in the first place the description of the domain of production on the level of the results: the types of aesthetic production provided by the field and their mutual relationships.

PART TWO

On Values and Functions

of the Arts

7 What Philosophers Say that the Arts Do

7.1 Introduction

As has become clear from part one, the most important task of the sociology of art is to explore how the internal and external organization of art worlds makes the functioning of art possible in a society. At the core of this study is the answer to the question: 'What does art *do*?' In the first part of this study, the question was introduced and discussed, but certainly not conclusively answered. In the second part, this subject will be examined more closely, albeit without attempting to write a short philosophy of art or even to try to do justice to the various positions and arguments that play a significant role within the field. Rather, a line of thought is pursued in the attempt to answer the question what the arts do, to bring the aim and the purpose of this book into focus, namely to develop models that can be useful for examining how the organization of art worlds contributes to the functioning of art. In this connection, the central concepts of the philosophy of art – among them the difference between aesthetic and artistic experience, distance and disinterestedness – can be applied and critically examined on the basis of their legitimacy at the present time.

Much of what the arts effect is understood under the heading of 'values and functions'. These terms are often used interchangeably, but in an attempt to look at how the arts function, they must be kept distinct. As has already been said in the introductory chapter, the term *the value of art* will be used here to describe the typical experiences art is able to generate in the act of reception. This description makes it possible to distinguish between the objective and subjective aspects of the value of art, because on the one hand a work of art, as an object, must make something possible, which on the other hand must be realised by the user(s) as subject(s). Aesthetic experience, commonly viewed as the 'central value' intrinsic to art and works of art, is now a topic of further investigation, based on the queries that Shusterman (2000), Carroll (1999 and 2001) and Davies (2006), among others, raise about this concept.

Nevertheless, a large portion of the activities produced by art has little to do with what may be called the *intrinsic value* of art, that which is realised as a *direct* effect of the mental engagement with artistic communications and which emanates from the typical character of these utterances as well. The most common intrinsic value of art is undoubtedly the capacity to evoke an aesthetic experience (whatever that might mean) in the reader, listener or viewer (provided the right conditions are present). *Extrinsic values* can be realised in both direct and indirect contact with art, but are not the result of a mental working through of specific aesthetic characteristics of artistic utterances. They can have to do, for example, with the economic value of artworks that is realised through trade, with the social value that is realised through contact with visitors at performances, concerts or expositions (often referred to by the term 'networking', so rightly loathed in this context by Latour), or with a physical/psychological 'restorative value' by means of a temporary escape from everyday reality, initiated by *presence at* an aesthetic event (at which *participation in* the aesthetic communication per se need not occur). This type of extrinsic value can also be realised in a situation in which art plays no role whatsoever.

Finally, we can also distinguish *semi-intrinsic* values. Like extrinsic values, these, too, can be realised in situations that are completely different from aesthetic events, but if they *are* actualised in aesthetic events, then, just as with an intrinsic value, this is the direct effect of the mental contact with the artistic expression in question. This may involve, for example, acquiring technical or historical information which is provided in a novel (good for general education), or affecting the emotional system (good for crucial mental release) or it may generate social communication through common experience (good for the development of social identity and/or cohesion). Stecker (1997) and Kieran (2002) also distinguish these types of activities, which can be labelled partly intrinsic and partly extrinsic, because they bear fruit that, on the one hand, is not independent from the nature of the activity (for example reading a book or viewing a sports match), but on the other hand is rather general in its nature and can be realised through a variety of activities. Reading books and watching sports can give rise to comparable forms of excitement and relaxation which, upon closer inspection, are quite different. The boundary between semi-intrinsic and intrinsic values is narrow: information, emotion and communication can move from having semi-intrinsic to truly intrinsic value as art if they are necessary to *aesthetic* experience, which comes into being through interaction with the artistic utterance.

In the investigation of all that art does, it is, as has been mentioned, important to distinguish between value and function. In principle, value serves function, of which the importance to the recipient must be understood in a wider context. To put it another way: the description of function offers a response to the question

of what the *use* of the realised value is. This would be true even if the 'useless-ness' of art were an aspect of its value, because uselessness, often considered a characteristic of the artistic experience, can also have a function. The intrinsic, semi-intrinsic and extrinsic values of artistic communications have functions, that is, they put artworks and art in a position to fulfil functions or to contribute to their fulfilment. The economic value of artistic utterances makes it possible, for example, for art to contribute to an accumulation of capital; several examples of functions that are supported by semi-intrinsic value have already been given (furthering general knowledge, development of social cohesion), while with the intrinsic value of art, one may think especially of the development of the power of the imagination, that consequently can be thought of as serving a greater 'open-ness to the world of possibles'.

In order to examine how the functioning of art *as art* is or can be organized, it is particularly important to start with the intrinsic values of art. Semi-intrinsic value can be derived therefrom, and on that basis one can establish which func-tions are or are not served by specific features of art, and thus whether or not one can speak of art-specific functions. This is important not only for thinking about art and its significance in a culture, but especially for understanding the position occupied by the art world and its relationships with other social systems (in par-ticular politics, education and economy), a position that is perhaps more often than not determined by extrinsic aspects of art. The question as to which features of art, artworks and artistic experience in contemporary times can be regarded as intrinsic to art or even specific to art nonetheless has yet to be answered. In the following sections, an attempt is made to that effect.

7.2 Art and reality

One can discuss the values of art on various levels: 1) on the level of art and the arts in general, as regards the role they play in a culture or in a society; 2) on the level of artistic utterance, looking at the significance of the arts for users, individu-als as well as (population) groups; 3) on the level of artistic utterance, albeit in this case exclusively with regard to whether or not a work can be called artistic. This last question will not be addressed here, as solely the first two levels are discussed. Theoretically, there should be an obvious connection between these two levels, be-cause it is difficult to imagine that art could play a certain role or function within a society as a whole without playing a part in the way in which individuals and groups in society actually interact with works of art. On this second, more opera-tional aspect more will be said in section 7.3.

7.2.1 Art and 'aboutness'

The philosophy of art provides us with a broad range of possibilities with which to think about the value of art in and for society. In earlier chapters, several examples have already been given. Luhmann was the most clear in this regard: 'art splits the world into a real world and an imaginary world' (2000: 142) and the latter offers 'a position from which *something else* can be determined as reality' (ibid.). According to Luhmann, language and religion, like art, make it possible to experience the existence of reality; without fictional realities 'the world would simply be the way it is' (142). Art, as something that is made in perceptible objects, offers the possibility of 'duplicating' every reality via the imagination. This duplication can be idealised, or it can be affirming or critical in nature, depending partly on the communicative use that recipients make of works of art. Thus the transition from the first level of value to the second has already been set in motion:

> Another intent might address the observer as an individual and contrive a situation in which he faces reality (and ultimately himself) and learns how to observe it in ways he could never learn in real life. (2000: 143)

The manner in which art makes the world appear in the world has, according to Luhmann, developed in three phases. During antiquity and the Middle Ages art was symbolically oriented, and from the time of the Renaissance works of art functioned as symbolic systems that bound artists and consumers together; with the growing autonomy of art in modern times, works of art had to be viewed primarily as combinations of form. This latter manifestation also has a function: 'to broaden one's understanding of the forms that are possible in the world' (151).

Even though the blockage of hetero-references – which is not part of the symbolic (ritual) phase but increases during the 'meaningful' communication phase – is typical of the development of an autonomous system of art, this does not mean that the world is completely excluded from that system. Connections with other systems are constantly made, for example in the form of ticket sales, subsidies, censorship or as artistic utterances in public spaces. But what is involved first and foremost aside from that is the self-referential, artistically minded act as such; the latter is subject at the same time to the partially hetero-referential constraints of the material used, but the unmarked hetero-referential element is always present as the obverse of the self-referential form.

The blockage of the hetero-referential semiosis of art should not be confused with what Luhmann also saw as the necessary 'uselessness' of works of art. In this connection Plato ('The beautiful is the antidote to utility; it is that what is liberated from utility'), Kant ('[A]n end in itself without purpose') and Schiller

('There is no path from aesthetic pleasure to other pursuits') are reviewed. Rendering works of art useful on the basis of extrinsic objectives interferes with the realization of their artistic value. In contrast, hetero-references actually acquire their function 'qua *hetero*-references precisely within the protected differentiation of a unique domain for creating and elaborating information' (155).

Art carries within itself a relationship to reality. Apart from pure institutionalists, who make no pronouncements on this subject, and the pure aesthetes for whom the value of art lies in playing with forms *tout court*, apart from every indication of another reality than that of art itself, virtually everyone is in agreement that art not only distinguishes itself from other reality, but also occupies itself with reality.[1] Danto dubbed this 'aboutness', a term applicable also to purely abstract art, which is either about art (its development or position) as such, or about the contact with the material of the medium, as the most pure form of artistry. 'Aboutness' posits that works of art maintain a relationship with something other than themselves, that traces of this relationship will be evident in the artworks in question, and that with the help of these traces the relationship can be 'experienced'. The extremely short description by Richard Eldridge – 'art provides the evidence of things not seen' (2003: 263) – immediately indicates how since the time of Hegel, through modernism to structuralism and the improved version of structuralism, post-structuralism, the 'appearance' of the spirit, of being, of a reality or a truth *in* art, can still be understood as the 'distinctive value' of art. In the words of Frank Vande Veire: 'For them [the philosophers he discusses in his book, HvM] art is not just an *aesthetic* matter, a matter of perception or affect. With art, *truth* is at stake' (2002: 334). And what is more: in *Als in een donkere spiegel* (*As in a Mirror Darkly*), the author deals with art in modern philosophy from Kant through Hegel to Nietzsche and from Heidegger to Derrida (by way of Benjamin and Adorno, among others), reaching the conclusion that art 'brings truth into focus in a specific way'.

> It is not just about the fact that truth can 'also' manifest itself in art; in art the not yet imagined *truth about truth* comes to the surface. (335)

It is Kant above all who brings the philosophy of art to this insight, for not only does he consider truth to be present, in the form of the sublime, but also grants an important role to the experience of that truth. In his understanding that aesthetic reception is characterised by free play between the understanding and the imagination, the relationship between known reality and the (experienced or self-constructed) other also receives expression. For the understanding contains more or less universal concepts whereby realities can be known, while the imagination makes it possible to diverge from these. Moreover, Vande Veire points out once

again that in Kant (in the *Critique of Pure Reason*) the imagination is dependent on, and functions primarily in the service of the understanding. For the imagination, via perception, makes possible the development of concepts by which the world can be understood. People perceive the world in the first instance in the form of images. Only in his study of the faculty of judgment does Kant grant the power of the imagination the autonomous value that plays such an important role in the aesthetic experience, so well characterised by Vande Veire:

> The experience of beauty is that an object stimulates the formative activity of the imagination without the imagination aiming for any understanding of the object as such. (336)

How this plays out and whether aesthetic experience works in this way is more closely examined in section 7.3; the concern for now is the more general question of what relationship between artistic imagination and reality can be taken as a starting point for discussing the operations that take place in artistic communication. This question thrusts itself upon us since in current thinking about the position of the artistic imagination vis-à-vis reality, art is increasingly viewed as a form of presentation instead of *re*presentation. Although Luhmann also goes along with this idea to a considerable degree, as he accentuates the form and materiality of artistic expression and observes that in postmodern art, 'information' disappears in favour of the form of artworks as such, he concludes that the other side of what is 'per-formed' always remains present as 'unmarked' in the artistic expression. Hidden, out of necessity, in these unmarked parts of communication are references to realities – or images thereof – other than those created in the here and now of the particular aesthetic event. Given that Richard Shusterman offers his 'aesthetic alternatives for the ends of art' (in *Performing Live*, 2000) and that Hans Thies Lehmann concludes that presence takes the place of representation and that 'the real becomes an object ... of the theatrical design itself' (in *Postdramatic Theatre*, 2006: 100), their most valuable studies cannot ultimately lead to the conclusion that the existent reality of an artistic communication, such as those given form in a performance or installation, completely excludes the imagined reality. An actor can go so far as to transfer the fictitious reality into an existent reality by wearing himself out almost completely, by setting himself on fire or jumping from a great height, but in all these dangers the spectator experiences *not only* the actual reality of the here and now, but also the imagined reference to other realties. This is situated, on the one hand, at the base level of denotation that, with the help of references, makes recognition of the event possible; on the other hand, with help from the performative frame, it occurs on the connotative level where significance is sought in relation to known realities.

On the basis of the distinction Luhmann makes between marked and un-marked components of an aesthetic communication, it can be concluded that however one twists and turns, artistic utterances are about more than themselves, even if this 'more' is not always present in the marked part of the artwork. Danto's observation that works of art evince 'aboutness' need not be dismissed as a modernistic relic, but can also be interpreted as a postmodern assimilation of insights developed in modernism.

7.2.2 Beauty and truth in Hans-Georg Gadamer

The line of thinking we have dealt with above offers the opportunity to consider Hans-Georg Gadamer's thought about the relationship between art and reality. He, too, views the form of artworks as decisive for their function, without, however, completely losing sight of the relationship to the attribution of meaning. In *The Relevance of the Beautiful* he poses the question: 'What is actually mediated by the experience of the beautiful and particularly the beautiful in art?' (32). For Gadamer, the fundamental insight into this question is that the meaning experienced in artistic communications should not be conceived as a reference to a reality that exists or can be thought of elsewhere in a more universal or purer form (as in Hegel's sensory glimmer of an idea); rather, it is precisely in art that the truth appears in all its distinctiveness, without being an image of a more general, intellectually comprehensible meaning. Gadamer follows this line until he eventually reaches a positive decision about what he sees as a general feature of art:

> In the representation that constitutes the work of art, there is no question of the work representing something that it is not, that is, it is not allegory in the sense that it says one thing and give us to understand something else. On the contrary, what the work has to say can only be found within itself. This is a universal claim and not simply a necessary condition of what we call modernity. (1986: 37-38)

This statement is possible because Gadamer reconsidered his concept of the symbolic in art as presented earlier in *Truth and Method* (*Wahrheit und Methode*). In his later work, the symbolic is understood in a more concrete way, in the sense that the symbol represents something directly or makes it present, rather than simply pointing to something. Here Gadamer harks back to the Greek origin of the significance of the *sumbolon*, the pottery fragment of which two families each had half, so that when they visited, the hospitable relationship was immediately visible. What is more, by means of this symbol the relationship was expressed in the most adequate and unique manner. Similarly, art does indeed refer to some-

thing, but that to which it refers is even 'more truly' present in the artwork. 'We could say', writes Gadamer, 'that the work of art signifies an increase in being' (1986: 35). As symbol, art therefore does not merely expose a meaning already attributed, but rather gives form to that meaning. The latter statement makes it clear that the 'general structural reference' of art formulated by Gadamer can also apply to works of art that are intended to be viewed more as presentation than as representation. Moreover, the assertion that art is a formation of meaning refers directly to the principle of 'Aesthetic non-differentiation' (*ästhetische Nichtunterscheidung*), whereby Gadamer in *Truth and Method* rejected Kant's view that the aesthetic characteristics of an artistic expression could and should be distinguished from the work as such; for ultimately it is the aesthetic consciousness of the reader, listener or viewer that determines the value of the work. Gadamer places more emphasis than Kant on the nature of the artwork as such, but it must be acknowledged that in *The Relevance of the Beautiful* he does solidly build on Kant. This he does on the basis of two points: Kant's idea of the universal character of the aesthetic experience, and his understanding of 'play' as the essence of this experience.

To begin with the last point, Kant is, of course, the one who views both the making and the reception of art as a form of play – the free play of the understanding and the imagination (or imaginative powers). The mind offers concepts (cognitive schemata) as 'labels' under which perceptions can be placed and therefore 'understood'. The power of the imagination provides the opportunity to extend the boundaries of these concepts, and to be able to 'perceive' even those things that are not in the first instance named. In the experience of the sublime this leads to a temporary dismissal of cognitive concepts; in the experience of the beautiful (or the non-sublime aesthetic) it is a question of playing with these concepts. This process can also go hand in hand with forms of mental disturbance.

Gadamer views play as a basic activity of life – in which living beings represent themselves – and considers the peculiarity of the human drama

> To involve our reason, that uniquely human capacity, which allows us to set ourselves aims and pursue them consciously, and to *outplay* this capacity for purposive rationality. (1986: 23; italics HvM)

Play is self-regulating, as if there were objectives, such as when a schoolchild tries to kick a ball as often as possible: a textbook case of purposeful behaviour without purpose. This is a form of non-purposive activity, notes Gadamer, but this activity is itself intended, for 'in the end, play is thus the self-representation of its own movement' (1986: 23).

The play that is called art is communicative in nature (who wants to be involved, has to play) and above all liberates the representation, that is, it emancipates itself from a ritual bond and imposes its own rules of the game on participants. The rules differ, of course, for various historical periods, but from the early modern era onwards they increasingly regulate, as we have seen earlier, a play of 'forms'. That sounds clearer than it is, because the question remains: is it indeed about a game with forms or, as Gadamer seems to imply in connection with modern art, a 'play[ing] around with the content so that our expectations are constantly frustrated' (1986: 22)? Do artists and the public play with forms or 'contents'? Gadamer considers playing purely with forms to be decoration, not art, because in artistic play meanings are generated. Playing with contents seems a rather inaccurate expression, for what are the contents of art? It would seem more likely that playing with meaning, with concepts, or perhaps even with representations, would be more appropriate. The last option in particular ties in with Gadamer's idea of 'aesthetic non-differentiation', where the signified (concept) and the signifier (form) are inextricably linked. A play with forms becomes a play with forms *of something*, namely perceptual schemata, and *within* those, active concepts. Perhaps artists and consumers of art take a different position here: the artistic presentation (the work) is the result of a game with forms (in material) that the artist plays, while for the art consumer this presentation as form is the starting point of a game with his or her perception (including the cognitive concepts activated in the process). In any case such a distinction has the advantage that artists do not give a material form to already existing mental images, as is suggested in primitive forms of the theory of expression, and that the aesthetic experience of art consumers is guided to a certain extent by the artistic utterance. This last point is precisely what Gadamer wishes to emphasise, because it gives him the opportunity to examine the relationship between art and 'truth'. To this end he departs from Kant's idea of the universal character of aesthetic experience in order, ultimately, to make more explicit than Kant did the domination of the artwork in aesthetic communication.

'What is this truth that is encountered in the beautiful and can come to be shared?' Gadamer asks himself and the reader (1986: 18). And he responds that it is certainly not a truth that can be understood in the general sense of the concept, but neither is it a subjective truth. Paraphrasing Kant, he suggests that an experience with beauty that is seen only as subjective surrenders any claim to legitimacy, accuracy or truth. 'When I find something beautiful, I think that it 'is' beautiful' (ibid.), and that the expression 'it is beautiful' is true. In fact this does not affect the relationship between art and reality, but only the validity of communication about a work of art. There is nevertheless a connection between the two, because the universality claim of the expression 'beautiful' does not originate solely in the

strength of subjective experience, but also in the fundamental *uniqueness* of the work, from what Gadamer terms 'identity' and, when referring to its realization in aesthetic experience, 'hermeneutic identity'. The identity of a work consists in the way in which it is the form of perceptions (in this respect Gadamer's and Luhmann's interpretations are similar) and therefore makes meaning possible. For Gadamer, meaning is an important concept (in which the relationship between art and reality immediately appears centre stage). Those who participate in aesthetic communication are players in the game of form in search of meaning:

> Someone who, on admiring a famous Titian or Velazquez depicting some mounted Habsburg ruler or other, thinks, 'Oh, yes that's Charles V,' has not really seen anything of the picture at all. Rather, it is a question of constructing it, reading it word for word as it were, so that after this necessary construction it comes together as a picture resonant with meaning. It portrays a world ruler upon whose empire the sun never sets. (1986: 27-28)

An artwork allows the consumer a certain amount of room to play, where one's own perceptual schemata can be applied and challenged, but the identity of the work in turn limits this space. This means that, to a great extent, aesthetic experience is determined by the way in which a work of art plays with the perception of the observer. In the participatory interaction with one's perception, the consumer experiences the artwork as true (to life). On the basis of Gadamer's concept of aesthetic non-differentiation, Kant's universalist claim as situated in the expression 'this is beautiful', can also be understood as 'this is true' (i.e. in this form).

7.2.3 *The Return of the real*

We have already established that Luhmann's concept of communications as unities of marked and unmarked sides makes it possible to attribute a certain hetero-referentiality to works of art that present themselves more than they represent anything else. Paradoxically, hetero-referentiality appears most clearly as a problem in works of art which are scarcely if at all distinguishable from 'normal' objects or occurrences in reality. Although they have a direct relation with these in terms of formal similarity, that relation is not referential in nature, and neither does the artwork have to contain any indication of the way in which the work, precisely *because* of its commonality of form, might refer to other realities. In *Return to the Real* (1996) Hal Foster discusses this question with reference to pop art and forms of superrealism that have surfaced since the 1960s, and in which the problem of the relationship between art and reality does indeed appear in its purest form.

Foster contends that neither of the two common views of the relationship between art and reality is able to describe pop art. The position that art is tied to referents too easily disregards the fact that these are difficult to discover in works of art since 1970; but the view that images can do nothing more than represent other images, which in turn represent other images and so on, also limits the possibility of examining the real significance of pop art, according to Foster. The latter approach is strongly linked to post-structuralist thinkers, who see in pop art a decline of meaning in favour of a 'simulacral surface', where the artist is no longer present in or behind the work. Roland Barthes could still regard this as an avant-garde attempt to break through referential thought, and Baudrillard goes too far – in Foster's opinion – when he asserts that with pop art, art creates a distance from its subversive potential by joining the 'political economy of the commodity sign' (Foster 1996: 128). Along with others, Thomas Crow described the referential standpoint in his study of the early Andy Warhol. He sees 'underneath the glamorous surface of commodity fetishes and media stars..."the reality of suffering and death"' and is of the opinion that 'the tragedies of Marilyn, Liz and Jackie ... prompt "straightforward expressions of feelings"' (130), thus betraying not only a referential, but even an expression-theoretical perspective. Understood in this way, 'Warhol belongs to the popular American tradition of "Truth telling"' (ibid.). Foster views both approaches as reductionist projections and searches for a third way:

> Can we read the 'Death in America' images as referential *and* simulacral, connected *and* disconnected, affective *and* affectless, critical *and* complacent? I think we must, and we can if we read them in a third way, in terms of *traumatic realism*. (Ibid.)

By 'traumatic realism', Foster means the way in which the real reveals itself in pop art. He bases his position on the thought of Lacan, who defined the traumatic as 'a missed encounter with the real' (idem: 132). Because the real is missing from experience, it cannot be represented but only repeated. In Warhol's work in particular, repetition plays a fundamental role in a variety of ways. Not only does the artist constantly repeat the same image, but he also legitimises the concept of repetition in his personal comments: 'I want to be a machine'; 'I like boring things' and:

> I don't want it to be essentially the same – I want it to be exactly the same. Because the more you look at the same exact thing, the more the meaning goes away, and the better and emptier you feel. (Foster 1996: 131)

Foster emphasizes that repetition in Warhol's work is not a question of re-pro-ducing in the sense of representation or simulation, but rather that repetition serves 'to *screen* the real understood as traumatic' (idem: 132). But precisely be-cause repetition is effective in providing protection from the real, the real is also made present and in a certain sense breaks through the screen of repetitions, a process that Luhmann would point to as a relationship between the marked and unmarked sides of communication. In this sense something is *produced* through repetition, namely 'a traumatic effect' in the form of a rift between perception and consciousness. According to Foster, this rupture presents itself especially to those who are touched by a work of art.

An essential aspect of repetitive forms of pop art is that the shock made possi-ble in the first instance by the nature of the illustration or depiction (of reality) is shielded by the repetition, yet the technique of this shielding repetition forces 'the real to poke through' (idem: 136). This dual role of repetition renders the images both affective and affectless, and viewers are neither integrated nor dissolved.

Reality, according to Foster, is present not only in the repetition of the image, but also in the repetition of reality, as is the case in superrealism. Based on Lacan and his concept of 'the gaze' as a way of seeing that precedes the subject, he con-siders the trompe-l'oeil as a dialogue between the artist and reality, a dialogue fol-lowed by the spectator because he too is interested in what lies beyond the image: 'the gaze, the object, the real' (idem: 141). Thus he comes to the conclusion that

> [a] perfect illusion is not possible, and even if it were possible it would not
> answer the question of the real, which always remains, behind and beyond,
> to lure us. This is so because the real cannot be represented; indeed it is
> defined as such, as the negative of the symbolic, a missed encounter, a lost
> object. (Idem: 141)

This applies not only to traditional forms of trompe-l'oeil, but even more so to postmodern forms of superrealism 'pledged not only to pacify the real, but to seal it behind surfaces, to embalm it in appearances' (ibid.). Because reality is 'repressed' in superrealism, it reappears in and through the latter. The illusion of superrealism does not succeed in protecting the viewer from the 'traumatic real'; it reminds him of the real, in a 'traumatic illusionism' (144).

There need be no doubt, therefore, about the fact that one way or another art cannot avoid relating to what it is not, that is, reality, or an image of a reality that does not exist as such. Even in art which repeats reality – and thereby shields it – this reality forces itself on the consumer, albeit differently than in art which is referential, or art that first and foremost *is*, such as performance art.

7.2.4 Aesthetics and ethics

The fact that art bears any relationship to reality, and especially the view that art makes it possible to experience realities in a specific way, makes it tempting to suppose that art can offer a contribution to the moral level of a society or of individuals. Indeed, so many works of art, particularly those with a narrative character such as film, literature and theatre, take human behaviour as their theme and implicitly ask readers, listeners and viewers to consider the nature of that behaviour in their ethical judgment. Two questions arise: a) how can the relationship between art and ethics be conceptualised? and b) Can this relationship be viewed as a generally applicable specification of the relationship between art and reality?

Martha Nussbaum may be considered the champion of thinking about the moral significance of art. In 'Form and Content, Philosophy and Literature' (1990), she takes moral philosophy as her starting point in the quest for the moral value of literature, in particular of the novel, which, given its referential character, offers a relatively wide range of possibilities. The very title of the article to some extent limits her quest, for the concept of 'content' cannot lead to sufficient insight into the relations under examination. That is a problem common to many authors (for example Gaut, 1997, 2002 and Carroll 2001). Content is an empty notion, and generally speaking authors have not determined its meaning in reference to art. When she describes content as 'certain thoughts and ideas, a certain sense of life', Nussbaum naturally also feels this difficulty and shifts to speaking of the combination of 'conception and form' or 'conception and expression' (2002 [1990]: 202). The problem is, however, that this gives rise to a certain suggestion that conception precedes the creation of the work, as if a 'packaging' were needed for what has been thought of (a common erroneous metaphor, for that matter) or as Gaut writes: 'cognitive content (including moral content) is essentially connected to the aesthetic features of the vehicle which carries that content' (2002: 350). Looking for this relationship in terms of content and something else – to which, according to Gaut, the aesthetic characteristics of a work are connected – is still emphasizing a distinction that, as we have seen, has already been overcome by Gadamer.

Nussbaum sees literature as an extension of life, in which normal life, experienced but not much studied, is presented and described with greater precision. Reading can broaden and deepen experience, precisely because the reader is not identical to the characters in the novel. This brings Nussbaum to her famous observation that 'the (ethically concerned) aesthetic attitude shows us the way' (207). Literature helps people to live humanely by means of investigation and practice in an imaginary world, one whose structure is literary, and therefore aesthetic.

In his crusade against autonomist views of art, Noël Carroll attempts to discover how it can be that an aesthetic construction helps one look at one's own world in new ways. This approach yields two lines of thought which follow upon each other quite naturally. In the first place the viewer, listener or reader must employ a mental schema with which he has learned to observe and to understand the world:

> To understand a literary work, for instance, generally requires not only that one use one's knowledge of ordinary language and verbal associations, drawn from every realm of social activity and valuation, but also most frequently, that audiences deploy many kinds of everyday reasoning, including moral reasoning, simply to understand the text. (Carroll 2001: 278)

In the second place, however, it is typical of works of art that they are 'incomplete'; 'understanding' an aesthetic text consists not only of decoding and following a sequence of signs, but also of 'filling' the gaps that characterize an artistic utterance. 'Every narrative makes an indeterminate number of presuppositions that the audience must bring, so to speak, to the text' (idem: 280). And, to go one step further, when the empty spaces in the artistic communication are filled in, the given work of art requires the recipient to reorganize the mental concepts and schemata he or she has deployed. That is what Carroll claims, at any rate, precisely with reference to moral concepts:

> In the course of engaging a given narrative we may need to reorganize the hierarchical orderings of our moral categories and premises, or to reinterpret those categories and premises in the light of new paradigm instances and hard cases, or to reclassify barely acknowledged phenomena afresh. (Idem: 283)

Perhaps it is not redundant to emphasize here that these changes in moral or cognitive concepts are indeed, to begin with, re-*visions* – and are situated in the domain of perception and imagination, specifically during artistic communication. Only later might these concepts take on the new structure in their 'home domains' as well. Carroll does not emphasize this sequence and uses terms that do not refer either to the role of perception or to the emotions which may accompany the process of a forced review of mental schemata (although he does point to the necessity of an audience to mobilize the emotions a piece of art demands). He calls this conception of the relationship between art and morality the 'clarificationist view', and the capacity of the consumer of art to celebrate the process of artistic communication his or her 'understanding':

> the capacity to manipulate what we know and to apply it with a sense of
> intelligibility...A person with understanding has the ability to find her way
> around in the mental geography of her own cognitive stock. (idem: 284)

It should be clear that what Carroll is describing with regards to artistic treat-
ment of moral concepts also applies to other mental concepts that are invoked,
tested and drawn upon in artistic communication. Given the way in which Car-
roll portrays this phenomenon, there is no reason to assume that the interaction
with *ethic* concepts in artistic communication is an impediment to the *aesthetic*
character of the latter. Rather, he has made it clear that the typical character of
artistic communication in fact makes possible a specific interaction with moral
and other mental concepts. Nevertheless, in both the theory and the practice of
art there is a certain fear that artistic skill and ethics will hinder one another.
Berys Gaut has immersed himself in this issue and will be followed here for a
while, because of the nature of his arguments.

Gaut (2002) distinguishes three positions: autonomists think that 'ethical as-
sessment is irrelevant to aesthetic assessment'; immoralists assert that works of
art can be aesthetically good, precisely on account of their moral reprehensibility;
and moralists (or ethicists), by contrast, find that ethical flaws reduce the aesthet-
ic value of art. Gaut attempts to demonstrate that only the third perspective is
viable because there are plausible arguments in favour of this position, while none
exist for the other two standpoints. He identifies three arguments for a moralist
(or ethicist) viewpoint: the best-fit argument, the merited response argument,
and the cognitivist argument. The first suggests that the ethical aspects in the
tradition of western art criticism have always played an important role and that
this is less true for aspects related to the other two views. Quite apart from the
question whether this is true, this argument holds little validity, if only because
the arts change, and in the last half century especially have undergone fundamen-
tal changes. According to the second argument, works of art prescribe a kind of
response to viewers, listeners or readers, or invite them to respond (for example,
to sadistic pleasure), without meriting these types of response. 'Now one ground
for holding a response to be unmerited is that it is unethical' (Gaut 2001: 351). In
that case one can speak of an *aesthetic* flaw in the work, because the work is not
in a position to realize the response it demands, owing to its structure and form.
In other words, the unethical character of the work is impeding the aesthetic
experience. But what if the work is sufficiently strong to bring recipients to an
unethical attitude, so that they do enjoy the evil? Much contemporary art lends
itself to such types of aesthetic investigation of subjectivity, and in such cases
Gaut's reasoning does not hold true. The third argument ties in with Nussbaum's
position that works of art can teach consumers something on a moral plane, but it

goes further. Citing Beardsmore, Carroll rightly emphasises that 'what art teaches us is essentially connected with how it teaches us' (idem: 350). He concludes that 'the aesthetic relevance of cognition in those cases is established' (ibid.). This is undoubtedly correct, but what exactly does it contribute to the ethicist perspective that ethical flaws reduce the aesthetic value of art? One could just as easily, or perhaps even more readily, draw the conclusion that the aesthetic value of works of art cannot be determined by the concepts, ethical or otherwise, that are introduced in an artistic manner, but rather by the manner in which these are put forward artistically, namely in a way that challenges the consumer to play along with these concepts on the perceptual level. If recipients reject this on ethical grounds, this does not mean that unethical elements run counter to aesthetic value, but that an artistic utterance as such does not fit with the set of conditions and mental capabilities and attitudes on the part of the consumer.

When Gaut investigates the autonomist perspective, he logically arrives at formalism, as it is touched on in the underdeveloped theory of Clive Bell and the functionalist approach of Monroe Beardsley. Certainly the latter does not exclude the possibility that works of art not only draw attention to 'colors and lines, but also [to] how the artwork presents a certain subject matter: the ideas and attitudes it manifests towards its subject' (idem: 344). In other words, since the general consensus is that if works of art have an 'aboutness', this consists in the form of observations, therefore artistic communication can play with all possible concepts – moral, immoral, amoral or totally other ones – in artistic communication. The artistic semiosis – how a work interacts with the perceptual schemata of the viewer, listener or reader – is determined by the nature of the concepts it introduces into the work of art only to the extent that the recipient considers it of any interest. The fact that many consumers keep a distance from certain forms of art for ethical reasons tells us nothing about the potential artistic value, the more, however, about the ethical value of those forms of art. But that is a completely different problem, namely the problem of the manner in which a work of art relates in matter and form to a reality, expressed in the answer to the question of what responsibility a work of art assumes in the world. The positive or negative value attributed to this ethical position is, of course, entirely dependent on the question of which set of norms the attribution stems from. The same ethical question and the same finding can be linked to works and in a certain sense also to artists: what is their primary concern (insofar as that comes to expression in their work)? What do people think of it? By posing the question thus, two issues immediately become clear; first, that artistic utterances can be contemplated and judged both in the artistic and in the ethical sense, but in their function as art both aspects form one unified whole; secondly, that the ethical aspect of the relationship of a work of art to reality – the relationship examined in this section – is located

in the nature of the responsibility that the work (or the artist) assumes for the reality, and that this aspect is therefore always present in artistic communication.

7.3 The value of aesthetic utterances: what is aesthetic experience?

In the previous section the relationship into which art enters with realities has been examined, in an abstract sense, apart from the question of how that particular relationship develops in what is generally called aesthetic experience. As we shall see, this is, alas, not a neutral term with a set of unambiguous characteristics. 'The aesthetic' can have a very broad general meaning, in the sense of 'concerning the arts', but it can also refer specifically to aspects of form in works of art or even to elements arising from experiences with beauty. The term 'experience' requires an attitude of the art consumer that makes this experience possible and that is based on the Kantian notions of disinterest and distance and the resulting contemplation. It is precisely these aspects that make the term 'aesthetic experience' suspect in postmodern thinking, not least because of the changing position of popular art forms.

The following paragraphs will examine to what extent and in what sense the terms aesthetic and artistic experience can be used to describe what is typical of artistic communication. The terms 'aesthetic' and 'artistic' will be compared and the concepts 'disinterest' and 'distance' will be subjected to closer study. Further, the criticism of the Kantian interpretation of aesthetic experience by Noël Carroll, Richard Shusterman and Jean-Marie Schaeffer will be discussed.

7.3.1 The aesthetic experience under fire

Around the turn of the millennium there was, among writers on the philosophy of art, a heightened awareness of the term aesthetic experience, partly because contemporary forms of aesthetic communication challenge the existing descriptions, and partly because definitions are no longer considered desirable. Before a few conflicts that have resulted from this shift will be discussed, Arthur Danto will get one more opportunity to encourage the reader with a considered and personal perspective:

> As an essentialist in philosophy, I am committed to the view that art is eternally the same – that there are conditions necessary and sufficient for something to be an art work, regardless of time and space – ... But as a historicist I am also committed to the view that what is a work of art at one time cannot be one at another, and in particular that there is a history, en-

acted through the history of art, in which the essence of art – the necessary and sufficient conditions – are painfully brought to consciousness. (Danto, 1997: 95)

Noël Carroll's research findings (2001) on the status of the concept of aesthetic experience stand in stark contrast to the views of Danto; although Carroll may be attempting to track down essential facets of this experience, ultimately he opts for what he calls a 'deflationary account' in which a diversity of experiences can be labelled 'aesthetic'. This result is reached after the partial rejection of three approaches: the traditional, pragmatic and allegorical accounts. According to Carroll, the first and the third have much in common, because Marcuse and Adorno (who represent the allegorical account) derive the autonomy of art – essential to breaking away from the force of market value – from Kant's view that the aesthetic experience is characterized by disinterestedness (the traditional account). In this regard, Carroll emphasises the distinction between the freedom made possible by disinterestedness (free from interests) and the free play of the imagination and understanding (free from concepts). Both are necessary in an approach (the allegorical) in which Marcuse and Adorno assign a role to aesthetic experience in a greater conflict between this experience on one side and the instrumental reasons and market rationality which dominates capitalist society on the other:

> In the Kantian system, aesthetic experience or aesthetic judgement occupies a niche in a static architectonic schema. What the allegorical account does is to dynamize that schema, thematizing the parts and turning it into a story. (Carroll 2001: 56)

Carroll considers this account and the freedom it suggests to be false, because Kant as well as Marcuse and Adorno would attribute no role to concepts in aesthetic contemplation. If they would have recognized that role, the cognitive free play and the conflict between aesthetic experience and instrumental reason (which in any case relies entirely on the use of concepts and categories) would be a non-issue, according to Carroll, and the allegorical account could be discarded. This way of thinking is, however, too simple, for Kant had in fact made room for cognitive concepts in his play of imagination and understanding, even if these had to do with independent beauty, without endangering the imaginative play (as does happen in a society that is controlled by the instrumental reason). In addition, Kant's view of disinterestedness cannot be so easily set aside, as Carroll and others assume. What is the argument that leads to this point? That 'aesthetic experiences are said to be valuable for their own sake' and that 'this [belief] is false' (2001: 47-48). According to Carroll, this idea is false because a) aesthetic

experience can be important to people, for example, from an evolutionary view-point; b) because people engage with art for various reasons, one of which is the pleasure of the aesthetic experience itself; and c) because two visitors to a concert, for example, would have the same aesthetic experience, in spite of the fact that one is there for the aesthetic experience as such and the other because he thinks that it is good for him to have the experience.

None of these arguments hold much water. The fact that gaining aesthetic experiences has a function for individuals or for humanity says nothing about the nature of the experience itself; neither does it matter if the recipients realize whether or not they have an interest in such an experience. In order to determine whether it is true that the aesthetic experience is characterised by disinterest, we need to study what is meant by disinterest within the context of the aesthetic experience, particularly in today's world, dominated by images as it is. Carroll has a tendency to confuse disinterestedness *within* (as a characteristic of) an aesthetic experience with the disinterestedness nature *of* (having) an aesthetic experience.

Where Carroll reproaches the traditionalists because they 'define aesthetic experience in terms of the agent's belief' (idem: 49), he is of the opinion that the pragmatists focus on the 'content' (whatever that may be) of the experience. He bases his position on John Dewey's view that the 'aesthetic' is present in every experience, because an experience exists only when it is completed, and a sense of completion, union, harmony and so on are typical of the aesthetic. Nor does Carroll handle this problem particularly well, with the result that his paragraph on the pragmatic account generates little insight. Of course he also shortchanges other representatives of the pragmatic philosophy of art, including Shusterman (whose work will be highlighted in the following pages).

On the basis of a pragmatic approach, Carroll does, however, opt for the 'deflationary' approach to aesthetic experience. Thus he starts out from the question 'what goes on during the aesthetic experience?' (idem: 55) and goes on to note two sorts of activities as typical: a) 'that we attend to the structure or form of the artwork', which he calls 'design appreciation' and b) 'the detection of the aesthetic and expressive qualities of an artwork', which he calls 'quality detection' (idem: 59-60). Although the two mental activities often appear together in an aesthetic experience, they do not take each other for granted according to Carroll, but 'independently or together, they provide sufficient conditions for classifying an experience as aesthetic' (60). That is not to say that they also form a necessary condition, because 'the formulation also allows that there may be other kinds of experience that also deserve the label "aesthetic experience"' (ibid.).

With this last point, Carroll seems to express himself somewhat imprecisely. Perhaps he means that there are other, equally legitimate experiences of artworks besides the aesthetic, such as the political or the moral. Somewhat later he refers

to such an experience as 'simply an art-appropriate response that is different from aesthetic experience'(61). For the latter, either design appreciation or quality detection is a requirement. In this approach there are ultimately two elements that play an important role in traditional views of the aesthetic experience; these are set up in such a way that no closed definition exists and yet it remains possible to speak of the aesthetic experience.

Stephen Davies struggles with the same problem of the alleged limitation of the term aesthetic experience, which he couples in the first instance with the well-known lists of 'aesthetic qualities' such as harmony, dynamics, elegance etc., in short, assessments of form or even beauty. He also argues that 'an aesthetic interest in something as an end in itself excludes all thought or knowledge of it as a means to the perceiver's or anyone's ends' (2006: 59). Davies links what he calls this limited view of the aesthetic position with the conviction of formalists, who with their plea of art for art's sake would dismiss the relevance of associations, interpretation and analysis for the true appreciation of art. This somewhat caricatural, or at least one-dimensional image that Davies gives to formalism here, fits well with his strategy to introduce first a rigid distinction between terms and views, 'because this should help us keep clear about where the crux of the disagreement falls' (2006: 55), from which he can then argue that they do actually relate to each other. So, too, regarding the relationship between aesthetic theory and the philosophy of art:

> The former maintains that consideration of the aesthetic in art is adequate for art's appreciation as art. Reflection on a work's artistic properties is not relevant to its proper reception. The latter view denies this. Indeed, it maintains that awareness of a works' artistic properties is crucial not only to understanding it but also to identifying it as the artwork it is. (2006: 55)

It is evident that Davies has given himself a perfect opening, which he announces with the words: 'What is needed for art's appreciation is attention to the work's artistic as well as its aesthetic properties' (2006: 61), and so he establishes the importance of Carroll's core ideas of design appreciation and quality detection. This principle is later elaborated on in an elegant way with help from the 'art for its own sake' principle. For Davies questions what 'its' stands for in this phrase. Does it refer to an artwork apart from the context in which it originates and functions (what Bourdieu calls the 'naive gaze'), or does this 'its' imply that

> to identify an artwork, and to locate the properties that belong to it as an artwork, it must be seen in relation to those things outside its boundaries that contribute relationally to making it what and how it is. (2006: 71)

This last view (which ties in relatively well with Bourdieu's position that in the 'pure gaze', knowledge is provided) was already defended by Davies in his *Definitions of Art*, on the grounds that this way of listening and viewing offers a *richer* experience of the work than when the intended knowledge is lacking or is present in applied form (1991: 185). In this sense 'it is true that art is typically to be appreciated "for its own sake"', according to Davies; and he is right. Davies's view of the aesthetic and artistic does not diverge widely from that of Gadamer, who elaborates much more on the relationship between both sides, and shows that to understand the artistic experience, they must not be thought of as parallel, but connected.

Even Richard Shusterman does not wish to exclude the notion of aesthetic experience, but takes the traditional view and subjects it to heavy fire. Already in the opening sentence of his foreword he communicates that *Performing Live Aesthetic Alternatives for the Ends of Art* (2000)

> advocates the value of aesthetic experience by exploring its different roles, methods and meanings, especially in areas that were marginal to traditional aesthetics but that now seem most vibrantly alive in today's culture of democracy. (2000: ix)

It is a powerful introductory statement replete with terms and assumptions that call for commentary. For instance, what do the words 'marginal' and 'traditional aesthetics' mean here, and what precisely is meant by 'vibrantly alive'? A few things come together in the questions about the expression 'today's culture of democracy', a phrase that since the 1970s in European countries has so often been juxtaposed to the 'democratization of culture'.[2] Shusterman discusses several forms of popular culture, such as rap, urban dance, and country musicals, which in contemporary cultural democracy have apparently attained a position alongside the 'highbrow' culture that was traditionally enjoyed as *art* by a well turned-out elite.

Indeed it is impossible to distinguish between popular and elite forms of aesthetic expression using the archaic distinctions 'low' and 'high', according to which one usually spoke of 'low *culture*' and 'high *art*', a usage that itself reveals the shortcomings of this terminology. It is precisely the industrialization of the culture that has made the popularity of new aesthetic disciplines such as film, photography, comic strips and pop music possible, without everything produced within these disciplines being popular in the sense of familiar, accessible, and so on. Within both the new and the old media (theatre, classical music, literature, dance) of aesthetic utterance, there are certain forms of expression that stimulate the perceptual schemata of participants and others that do not; forms, to echo Scitovsky, are either provocative or comfortable. The (rhetorical) question is

whether a cultural democracy that grants as much (and the same kind of) artistic value to aesthetic production intended to provide comfortable experiences as it does to aesthetic production that challenges the perceptual and imaginative powers can be called a cultural democracy. The latter forms of expression contribute more to developing the power of imagination and thus competencies that offer individuals and populations opportunities to participate more (self-)consciously in society. Therefore one should not so readily label a culture democratic if it attributes the same value to popular forms of expression as to less popular ones. But if a culture regards as equal and encourages all those forms of communication within the various aesthetic disciplines that challenge the perceptual schemata of the participants, then it can rightfully be called democratic.

On this point, Shusterman is not very convincing. In one of his reactions to the reasons given by philosophers of art as to why popular aesthetics cannot be art (among other things because it is characterised by superficiality and a lack of complexity), he remarks that 'Certainly many mass-media products are boringly simple and painfully devoid of intelligent complexity. But cultural critics wrongly conclude that all of them must be that way' (2000: 48).

However, he decides not to actually use this stance as a crowbar to break up the massive block of opponents. Instead, he sums up all the objections against popular aesthetic forms of expression that are presented from a traditional aesthetic perspective and then proceeds to try to refute them. This produces a list of six types of charge regularly made against 'popular art':

a) that it fails to provide any *real aesthetic satisfaction*
b) that it is not providing any *aesthetic challenge*
c) that it is too superficial to be *intellectually satisfying*
d) that it is not *original and unique*
e) that it has a lack of *formal complexity*
f) that it has a lack of *aesthetic autonomy and resistance*

With sufficient goodwill toward the non-traditional, it is indeed possible simply to establish that the presence or absence of the six aspects listed here cannot be linked to the popularity of the media (in the sense of disciplines and sub-disciplines) in which artists express themselves. No one need doubt that these 'values' *can* be present or absent in pop music as well as in classical music, theatre and film, in what is called literature and in video games. But due to the fact that aesthetic communications in popular disciplines are suited to raising money (in part because of their enormous influence), it follows that the majority of them are market oriented and are possibly characterised by many of the six objections just mentioned.

Thus it is no longer really necessary to attempt to refute these objections to popular art (as Shusterman still does in 2000), because they have, theoretically speaking, been superseded by a distinction between comfortable and challenging aesthetic communication (in whatever discipline).[3] Shusterman does, however, bring a number of interesting arguments to this discussion. In the first place this relates to his reaction to the objection that popular art does not offer any aesthetic challenges. He is prepared to suggest that each aesthetic pleasure demands a certain level of activity in which a particular resistance is overcome, but raises objections to the view that this activity must be cognitive per se. Rock and roll songs are, for instance,

> Typically enjoyed through moving, dancing and singing along with the music, often with such vigorous efforts that one breaks into a sweat and eventually becomes exhausted. And such efforts, as Dewey realized, involve overcoming resistances like 'embarrassment ... awkwardness, self-consciousness [and] lack of vitality'. (2000: 44)

On these grounds, Shusterman establishes that popular art such as rock music has an aesthetic dimension based not on a cognitive but on a somatic involvement, 'which idealist philosophy has long repressed to preserve its own hegemony (through that of the intellect) in all realms of human value' (ibid.). Here Shusterman announces his most important contribution to the study of the nature of aesthetic experience in a postmodern environment: his view that this experience must be understood in terms of a 'somatic turn'.

A second commentary by Shusterman on the reputed deficiencies of popular art involves a presumed lack of formal complexity. On this point he enters into discussion with Bourdieu and the latter's concept of aesthetic disposition, the capacity to regard things as form, rather than function. In the first place he correctly observes that formal complexity can be present as much in popular as in elitist aesthetic media; in the second place he examines Bourdieu's idea of a 'basic opposition between form and substance' (54, Bourdieu 1986: 197). Here Shusterman cites a discussion about form and function in relation to the appreciation of food and restaurants; hence the interesting term 'substance', with which Bourdieu refers to food as such. In connection with art, Shusterman brings this back to the conflict between form and content, which he subsequently does not accept, because this antithesis would assume that 'we cannot experience ... a work properly unless we distance ourselves from any interest in content' (Shusterman 2000: 54). Later in this chapter the relationship between a disinterested and an interested view will be further examined, but this phrase by Shusterman calls for comment at this stage. Bourdieu's stance that there is a fundamental conflict between form

and substance (or perhaps better: matter) is not so extraordinary if one under-stands that artistic utterances derive their character from the way they give form (this particular form) to matter, thereby altering the matter or at any rate chang-ing the way it is experienced. In Luhmann's terminology, there is a unity of dif-ference between utterance and information. Postulating a 'struggle' between form and matter does not in any way assume a lack of interest in the latter; rather, it is precisely the form that creates (the attention for or experience of) the distance from the matter which is required in order to experience it differently.

The question remains whether this understanding of 'distance' stands in the way of the immediacy which Shusterman finds so characteristic of popular art. Perhaps there is also a contrast between form and matter that can be experienced *within* the 'more immediate and enthusiastic bodily investment' in aesthetic com-munication and which creates a certain distance from matter. This is much more conceivable where the above-mentioned examples of immediate physical involve-ment with music, such as through movement, singing and dancing, involve in the first place an absorption in the *form* of the work, through which a mediated relationship to matter remains perfectly possible. Shusterman remarks, however, that '...rappers urge an aesthetic of deeply embodied participatory involvement – *with content as well as form*' (2000: 75, italics are the author's). What does this mean? He points out that hip hop artists criticize and challenge accepted repre-sentations of social structure, violence, commercialism or political hypocrisy in their texts. This relates to the subject matters to which they give specific forms in music and text. Strictly speaking, here too the medium and the form given to the matter create a distance from accepted concepts. But the question is whether and to what extent this distance, or better, this rift with the ordinary must be consciously experienced in order to be effective, in other words, in order to be considered an artistic experience. This is in fact about two forms of distance. On the one hand the distance from accepted concepts that is forcibly imposed by the form of artworks, better denoted as discrepancy; on the other hand, the distance from the work of art that, according to traditional theory (but not according to Shusterman in the light of the somatic turn) is necessary in order to endow the thus created discrepancy with meaning.

Bourdieu sees a lack of distance from a work of art as the tendency to a direct, 'initial' affective reaction to it (a tendency that shows no signs of an aesthetic disposition), which is precisely the reaction Shusterman so values. By way of contrast, he posits a more distantiated reaction, in which the artistic utterance's play of forms becomes the subject of the contemplative attention (an attention that does reveal an aesthetic disposition). The distance from the work is thus supposed to avoid the former attitude and make possible the latter. But what is meant here by 'distance from the work'? Is this the same thing as what Kant means

by the absence of interest in *the existence* of the object (see more on this below), which alone allows the artwork to fulfil its aesthetic functions, or does it refer to maintaining a distance from its possible direct effects, by placing the formal elements of the work first of all in relation to those of other works, an activity to which Bourdieu attached so much importance? His description of the aesthetic disposition does indeed seem to move easily in the direction of an 'art historical' or 'art analytical' gaze, *as the condition* of an aesthetic experience. But it is not at all clear what the true nature of artistic experience *is*, in the sense of a communicative confrontation between concepts that are given and those that are 'played' out at the level of perception, and what role the 'art connoisseur's gaze' in fact plays in that process. Naturally, a certain familiarity with artistic language used in aesthetic communication is a precondition for such communication, and various sorts of artistic utterances will make demands on various levels and amounts of knowledge, but that does not mean that the ability to deploy aesthetic language is the same thing as the experience for which it constitutes a precondition.

Pursuing this idea further, neither does it seem tenable that the affective experience of a work, which Bourdieu so easily gives up on, should be regarded as necessarily non-artistic. Vande Veire points out, for example, that even while Kant 'insists on the distance maintained by the "pure" aesthetic experience from the direct immediacy of the affect, he himself renders this *internal distance in the affect itself* obscure' (2002: 351, italics are the author's):

> The significance of Kant's concept of imagination lies in the idea that already at the 'passive' level of sense perception, of affect, creativity comes into play. Aesthesis as being affected in the senses is not simply feeling a stimulus; even at this affective level, the world is structured, given form. (2002: 337)

Given the very fact that in perception as well as in imagination, cognitive concepts necessarily 'follow along' from the outset, one can speak already at this level of mental activity not only of operations in which the world, or at least the image of it, is constructed, but also of a possible confrontation between form and concept, and of the interplay whereby they challenge each other, with all the possible affects that this produces.

It is for this reason, too, that Van Stokkom can argue that 'absorption', giving oneself over completely to a work of art, need not stand in the way of artistic experience at all, but can instead be enriching, since the recipient's own judgment is thereby temporarily suspended 'in order to be able to experience the field of vision of others' (1995: 333). He does not regard this 'sinking' into a work of art as the core of the artistic experience, but as one possible condition for it:

In a more contemplative stage, which follows such experiences, the newly
acquired impressions and discoveries can impel one to further investiga-
tion. Loss of self and self-conscious reflection are not opposite poles, there-
fore, but complement each other. (Ibid.)

Ultimately, Van Stokkom is interested in 'interventions in comfortable experi-
ences', and absorption can play an interesting role therein. For Shusterman, by
contrast, this interpretive activity after the fact does not seem necessary in order
to be able to speak of aesthetic enjoyment. In 'Beneath Interpretation', he rejects
the view, defended by Gadamer, among others, that 'all understanding is inter-
pretation' (Gadamer 1982: 350). Although Shusterman agrees that reality can-
not be thought of 'without the mediation of human structuring' (2000:116), he
nevertheless insists that interpretation should not be considered the only form of
such structuring. That activity is preceded by the experience which he calls '(un-
interpreted) understanding'. Relying on Heidegger – 'any interpretation which
is to contribute understanding must already have understood what is to be in-
terpreted' (1962: 194) – Shusterman observes that understanding grounds and
guides interpretation. Interpretation is necessary, however, in order to assess the
value of understandings; the hermeneutical circle is thus a cycle of understanding
and interpretation, in which the former concept represents direct experience, and
the latter the process of shaping meaning.

Schaeffer (1998) adopts a similar stance. He, too, makes a distinction between
interpretation and understanding, in which the latter is considered an important
aspect of the experience of the work: 'the interpretation of artworks is the inter-
pretation of what is already understood – of what has already been experienced as
an artwork' (1998: 49). But he goes one step further: because aesthetic experiences
in the modern and postmodern eras do not occur primarily in 'the sphere of active
life' but help to organize leisure time, it is nearly certain, says Schaeffer, that their
social function is of an aesthetic nature. This means that 'an aesthetic experience
is a cognitive experience which is regulated by the intrinsic degree of satisfaction
or dissatisfaction it induces' (idem: 50). A cognitive experience, such as occurs in
the encounter with art, is for Schaeffer an operation in which concepts and imagi-
native reactions are as important as 'pure' visual or auditory perception. The aes-
thetic functioning of these cognitive faculties receive their value from the degree
to which the effect of this faculty intrinsically bestows fulfilment, and does so not
afterwards but during the experience itself. Schaeffer seems therefore, theoreti-
cally speaking, to be building a bridge between Shusterman and Kant, although, as
will become clear later, he tries to resist the central concepts of the latter.

In order to make clear the distinction between 'understanding' and 'interpre-
tation', Shusterman moves further in precisely the opposite direction. He is of

the opinion that interpretation is aimed at solving problems and uses linguistic constructions in order to do so, while understanding 'can be unreflectively blind to the existence or possibility of alternative understandings' and 'does not require linguistic articulation' (2000: 135). It has to be emphasized here that, for Shusterman, this 'blindness for alternatives' only postulates on the level of 'understanding'. If he should consider such a form of blindness applicable on the interpretative level of experience as well (during or following the process of understanding), he should immediately find himself in conflict with Luhmann and numerous other philosophers who argue that the typical value of art is that it creates the opportunity to experience 'the other', or as Van der Schoot has expressed it so elegantly:

> [beauty] refers to the possibility of an alternative ... That is precisely what ordinary things do not do, they are thus-and-such, but do not reveal anything of the tension between the 'thus' and the 'such'... Each work of art says: 'It ain't necessarily so'. (Van der Schoot 1993: 48)

The immediate experience of art, which according to Shusterman appears primarily in popular disciplines and is characterised by 'understanding', can be held onto in two ways only: either by noticing that this process of understanding also offers the possibility of experiencing a dialogue between form and matter, and thus of experiencing 'the other'; or else by stretching the concept of art in such a way that there is no longer any distinction between comfortable and challenging aesthetic experiences. The second possibility, though widely used, is in both a theoretical and a social sense all too easy a solution, for it is precisely the distinction under discussion here that makes it possible to understand the different values produced by the social system of aesthetic communication and to enable them to fulfil a social function. Not choosing the former option means that all direct, bodily, unmediated experiences which Shusterman has in mind must be consigned to the realm of the *non-artistic* aesthetic communication, which would be a shame. Van der Schoot seems to consider this unnecessary in any case, given that in the text cited above he makes explicit use of the famous *and* at the time popular song from *Porgy and Bess*, 'It ain't necessarily so'.

With this, we are back to what has already been discussed in terms of play: play with forms, with perception, with concepts. The artist playing with *forms* can easily bring about a direct, bodily reaction at the level of perception, in which the discrepancy between known forms (of music, image, movement, etc.) and their manipulation can be experienced, without this discrepancy being simultaneously interpreted: the artist plays with the listening or viewing conventions of his or her audience, which have a role at the perceptual level. Playing with *cognitive concepts* by disrupting their habitual forms (in other words, by creating a gap between sig-

nifier and signified) calls more explicitly for an interpretive 'understanding', which is to say a manner of understanding in which the recipient follows the artwork, and perhaps even loses himself within it, but in which an ongoing interpretive effort goes hand in hand with the perception. In this sense, bodily immediacy does not stand in the way of artistic experience; on the contrary, one may even ask whether the interpretive activity that follows afterwards, which Van Stokkom found so important, is even necessary in order to be able to speak of an artistic experience. This train of thought does imply that in an artistic conception in which form and meaning, and the relationship between them, play a role, there is always an interpretive process under way, even if it involves an 'immediate understanding'.

Finally, closely linked to the problem of distance is Shusterman's third attack on the traditional philosophy of art. This he directs at the alleged autonomy of art, which serves as a pretext for it to distance itself from its surroundings. Popular art eliminates this autonomy by treating life and art as one whole and by serving functions other than the strictly aesthetic. Shusterman does not see, therefore, why 'the dogma of autonomy' should still be considered valid.[4]

While the doctrine of autonomy can refer to three different aspects, namely, the autonomy of the artist, that of the art world, and that of artworks, Shusterman here directs his barbs at the last of these: 'popular art forfeits aesthetic legitimacy simply by having more than purely artistic functions, by serving also other needs of life' (2000: 55).

As we have seen earlier in the discussion of the work of Bourdieu and Luhmann, the autonomy that is so fiercely defended is at the same time so relative in nature, that is, to a large extent dependent on users and the influence of adjoining fields or systems. The reason why they nonetheless place such great emphasis on autonomy (in contrast to heteronomy) is that they are looking for what is unique in art. Art and artworks can, of course, fulfil very diverse functions and serve many needs in life, but the question is what they can deliver *as art*, or to put it the other way round, what are the typical values that they share with each other but not with other types of communication. As regards the autonomy of art – the boundaries of which are determined by their users, among others – the question is ultimately not whether works of art can serve *other* functions as well as the artistic one, but *which* functions are served by the values that are realised through artistic experiences. This question can of course be asked just as legitimately about traditional or elitist forms of art as about popular art, understood as artistic communication in popular aesthetic media.

Schaeffer, who shares Shusterman's view that art is not there to be explained or judged, but to be experienced, goes more deeply into this question by distinguishing two different ways in which art can be experienced: a) as a sign for something else, for example, social status or skill; b) as an operating structure. Only in the

latter case does the artwork function *as* an artwork, which means, according to Schaeffer, that 'the experience it elicits is an experience that is induced by its own operating structure' (1998: 49). This 'operating structure' can take various forms, such as a sign structure, a perceptual structure or an imaginative pattern, but it may not be confused with the interpretation of the work.

Aesthetic experience – even if this is in no way contemplative or interpretive in nature – thus does involve, according to Schaeffer, an apparently inevitable inter*play* of perceptions, cognitive concepts and imaginative activity, as a result of which a certain tension between these elements is at least a possibility as soon as the imagination comes into play. He likewise rightly observes that this intrinsic valuing of aesthetic experience does not mean that whoever has such an experience can have no vested interest in it:

> What attracts us in artworks we experience aesthetically is, on the contrary, the hope that we'll be able to relate them to our lives. And to relate them to our lives means to relate them to very specific interests which depend of course on the person and on the moment (1998: 53).

From this perspective, aesthetic experiences have a merely instrumental character, since cognition sustains the relationship with reality – a relationship that must continually be trained – and 'aesthetic experience induces us to indulge in this activity' (idem: 53).

Precisely on the basis of this observation, Schaeffer comes to the conclusion that Kant's notion that aesthetic experience is 'disinterested' is incorrect, because Kantian theory in no way makes it impossible to combine an 'aesthetic (disinterested) vision' with a response to the question of the purpose of an aesthetic vision, or the function which the aesthetic experience of that vision fulfils for those concerned. On the other hand, Schaeffer himself stresses that artworks can function in various ways, but can do so *as* an artwork only if its experience 'is regulated by the intrinsic degree of satisfaction or dissatisfaction it induces'. That does mean that the experience can be called an aesthetic one on the basis of the satisfaction that is felt as a result of the uniqueness of its aesthetic quality. As Schaeffer acknowledges, more clearly than Shusterman, although perhaps still not clearly enough, this unique quality of aesthetic reception lies in

> The collaboration of our senses, of our mental conceptual frameworks and of multiple imaginative activities induced by the encounter of the perceptual data with our conceptual classifications. (1998: 50)

Kant cannot be very far away.

7.3.2 Disinterestedness

So back to the source – to Immanuel Kant, not in order to dig up once again his 'Analytic of the Beautiful' ('Analytik des Schönen'), which is included in the first part of *Critique of the Power of Judgement* (*Kritik der Urteilskraft*) (1790), and certainly not in order to devote further study to the problem of the difference between the pleasurable and the beautiful or the question of the universality of judgments of taste, but simply in order to determine whether a focused rereading of Kant can help us grasp the significance of the notion of 'disinterested pleasure' for popular forms of art.

Kant, too, notes that in his quest it does not matter *why* someone views art, in other words, what importance a subject has for a pure judgment of taste, but that with the question whether 'I find something beautiful', we mean

> whether the mere presentation of the object is accompanied with satisfaction in me, however indifferent I might be with regard to the existence of the object of this representation. (Kant 2000 [1790]: 90-91)

It is worth noting that the title of the section in question is 'The satisfaction that determines the judgment of taste is without any interest' (90), which captures in its full glory the central proposition, one that a number of philosophers of art have challenged. Three questions play a fundamental role in understanding this position: What is a judgment of taste? What is understood here by satisfaction? And what is the meaning of disinterested? Regarding the last of these, Kant provides a direct clarification: 'The satisfaction that we combine with the representation of the *existence* of an object is called interest' (ibid. italics HvM). What precisely is meant by satisfaction will be addressed shortly, but we can already state here that it is a certain type of mental state, which in this case is linked to the experience of something that exists. In other words, the subject experiences in the form of a representation (a mental image) the existence of a certain object (a work of art in this case), and that bestows a sense of 'satisfaction'. The fundamental aspect here is that this pleasure is connected not to a 'judgment of taste' about the object, but to nothing other than the awareness that the object is there. The 'pleasure' which the subject enjoys in this existence as such is what Kant calls the interest that the subject has in this object. The example he gives here is the satisfaction generated by the existence of a palace, seen as a place to live, or a space-taking elitist building. In such a case there is simply an object that, by looking at it, is mentally represented. But things become more complex if it is not the satisfaction of the existence of a typical functional object such as a building that is at stake, but the existence of a work of art that takes its values in the first

place from how it presents or represents something. Also in this case, 'the representation of the *existence* of an object', refers to the image the perceiver forms of the existence of the work of art itself (including possible functions of it), and not to the mental representation of the objects represented within the work of art. Whereas the first activity is interested in nature, the onlooker's representation of the latter objects is part of the aesthetic experience which is the result of the free play of imagination and understanding.

Since interest is defined by Kant as satisfaction in (the representation of) the *existence* of an object, therefore the experience of beauty, which is precisely *not* based on the existence of the object, can without any difficulty be called disinterested. This distinction is, according to Kant, extremely important, because 'a judgment about beauty in which there is mixed the least interest is very partial and not a pure judgment of taste' (91).

The question whether the *consciousness* one has of the interest in a disinterested judgement of taste, obstructs a disinterested perception, will be discussed later in this section.

What, then, is this famous judgment of taste? It is in any case completely indifferent to the existence of the artwork in its functional existence and 'merely connects its constitution together with the feeling of pleasure and displeasure' (95). Because it is indifferent towards the existence of the object, Kant calls the judgment of taste 'purely *contemplative*' (ibid.), which has also helped dispel the misunderstanding that contemplative in this context must be regarded as 'viewing from a distance or interpreting'. The only distance Kant recognises in this regard is the one separating the viewer from any interest in the existence of the object:

> Taste is the faculty for judging an object or a kind of representation through a satisfaction or dissatisfaction *without any interest*. The object of such a satisfaction is called *beautiful*. (96)

A judgment of taste is a judgment that is based on this faculty and that makes possible an experience of beauty, for beauty is not a characteristic of the object, but an experience connected to the object. Judging something as beautiful happens through a free play of the cognitive faculties, that is, imagination and understanding. Freedom here means, as De Visscher remarks in his introduction to Kant, what is 'independent of the particular and participates in the universal' (13). In order to clarify what is meant here, it is necessary to go briefly into Kant's conception of the phenomenal (the way things appear) and the noumenal (the way things in essence are). In this Platonic distinction, things as they are in essence remain unknown to human beings, but through their understanding, subjects, being confronted with phenomena, can think of the relationship of them with the

noumenal world. Because, according to Kant, taste belongs to the essence of the human being, and thus precedes his particular existence, his judgments of taste are connected to the universal and essential dimension of the noumenal world, and thus are free of the particular. This freedom, which moreover also forms the foundation of Kant's notion that a judgment of taste claims general validity (since it is not based on particular concepts, but on the relationship with the supra-individual, noumenal world), makes it possible for the cognitive faculties to allow themselves to be led, in judgments of taste, by the way something is represented, rather than by their own perceptual schemata.

The fact that Kant deduces the free play of imagination and understand-ing from the existence of a noumenal world calls for a contemporary testing of this very attractive characterization of the aesthetic experience. What is certain is that both imagination and understanding are active in this process; under-standing in the form of given concepts by which the subject knows the world and which are necessary in order to recognize the (general) characteristics of the world being represented, or, in other words, in order to perceive objects as meaningful. The imagination, however, is engaged in order to unpack the con-cepts given within the domain of perception. In this way, this free play can be understood as a (temporary) letting go of given concepts, whether or not these are particular, with the help of the imaginative powers, without necessarily pos-iting a noumenal world.

With this, we come to the answer to the third question: what does Kant un-derstand by 'satisfaction that determines the judgement of taste'? It is the feel-ing which accompanies the free play of imagination and understanding, which is engaged in judgments of taste, and is in fact a very special feeling, for it has to do with 'the pleasure in the harmony of the faculties of cognition' (101). According to Kant, the judgment that 'this is beautiful' precedes pleasure, which he regards as a feeling of enjoyment of the harmonious operation of the cognitive faculty in making the judgment. 'Pleasure in this judgment', writes De Visscher, 'is the sub-ject's consciousness of his own state of contentment in which the harmony of the free play of the imaginative power is realised' (2002: 14). Naturally, the question then arises whether Kant's disinterested pleasure can still apply to representa-tions in which the harmony of the cognitive faculty is hard to find. The majority of artistic utterances in the twentieth century could more easily be characterised as communications in which understanding (given concepts) and imagination are not at all in agreement with each other. And yet it is quite possible to affirm that the Kantian judgment of taste applies not only to the experience of beauty, but also to aesthetic experience in general. For upon closer examination it becomes clear that in the free play of imagination and understanding, the imaginative pow-ers of the subject are harnessed in order to link together the concepts represented

in an artistic communication and those which the reader, listener or viewer bring to them. If this confrontation produces a meaningful sensation, then one can in a sense speak of a 'harmony of the free play of the cognitive faculty', even if the aesthetic experience itself may be painful or unsettling.

To sum up, it can be stated that it is not necessary to dismiss Kant's conception of the disinterestedness of the satisfaction determined by the judgment of taste as irrelevant for contemporary forms of art, popular or otherwise. His theory does not stand in the way of Shusterman's view that artistic communications can have many different functions, as long as not all these functions are automatically regarded as 'intrinsic aesthetic'. Nor can it be said, on the basis of Kant's theory, that experiences would lose their aesthetic character if they were of an immediate nature, could more appropriately be described as understanding than as interpretation, or called for no contemplative, 'distanced' attention.

The notion of the free character of the play of imagination and understanding does, however, have to be updated in a sense, if one does not wish to become overly dependent on the world of the noumenal; the harmony experienced in this interplay calls for the type of explanation chosen above.

But above all it is clear that the disinterested, aesthetic, experience does not mean that this experience holds no interest, nor that the object which is seen as beautiful cannot in some way also be useful, but only that these useful aspects cannot, according to Kant, play any role in the free play of imagination and understanding, that is to say, in the aesthetic experience of the work.

A final attempt to test this interpretation of Kant's insights will be undertaken with the help of a text by Peggy Zeglin Brand, 'Disinterestedness and Political Art' (2003). Zeglin Brand rightly points to the fact that the notion of disinterestedness was developed in the eighteenth century in order simply to formulate the difference between valuing objects because of what can be done with them, and valuing them because of the pleasure of the encounter with them, and particularly the encounter of the senses with them – in sum, in order to postulate what is typical of aesthetic pleasure from the perspective of the instrumental enjoyment of objects.

The way in which the disinterested gaze was interpreted in the art theory of the nineteenth and twentieth centuries is regarded by Zeglin Brand, along with a number of other feminist authors, as typically masculine, for it betrays an attitude 'that seeks mastery even over one's own bodily responses', whereas 'a feminine stance encourages interest in, identification with and nurturing of awareness' (2003; 159). But at the same time she calls for 'a bit of gender treason' (163) by accepting that in order to enjoy art, both positions are not only possible but even necessary. She speaks of 'interested attention' (IA) and 'disinterested attention' (DA), which cannot be active simultaneously, but must take turns in viewing or

listening to art. The IA often appears in the first encounter with a work, since the viewer or listener is seeking a way to allow the work to speak to her, but it can also appear (again) later in the communication. In the encounter with art, an alternation between these manners of seeing is inevitable, according to Zeglin Brand, if only because every perception is to some extent constructed on the basis of a relationship between the organization of what is observed, on the one hand, and that of the experiences and expectations of the user on the other. Perhaps it is therefore better to speak, taking a cue from Zeglin Brand, of moments of attention in which one interest dominates, that is to say, in which the personal 'lens' comes to the fore, and moments in which disinterestedness, that is to say, the organization of the artistic utterance, becomes dominant.

The involvement of *disinterested* attention is self-evident, and offers the user the opportunity to allow himself/herself to be led, or seduced, by the work and its colours, forms and constructions, and for his or her imaginative powers to be engaged. Although *interested* attention is often active for only a short time, and would make the free play of imagination and understanding impossible if it were to dominate during the reading, viewing or listening period, turning it off completely would in fact exclude certain important possibilities of the work's meaning. For the direction of the recipient's gaze opens up the opportunities for aesthetic communication to react in a playful way to existing perceptual schemata. In Zeglin Brand's approach, interested attention may indeed have to do with what an aesthetic utterance offers a user, but the experience thereof is realised at the level of the meaning the work has for a recipient. Therefore the question arises whether this form of attention is related to *the existence* of a work of art and its use, as is the case in Kantian theory. It would seem to be more a matter of attention being given to *elements in* the work in which the recipient is 'interested', that is, matter and theme. If this interest is decisive in the communication, then DA and thus the free play and artistic experience become impossible, but if this interest simply serves to give direction to that communication (which is inevitable) and the play that is launched by the work is not impeded, then it opens up specific spaces in which new representations and meanings can be created.

To conclude this limited exegesis of Kant, we can establish with confidence that there is no reason to give up the Kantian notion of disinterestedness in order to be able to regard as art aesthetic utterances in popular disciplines. For this notion simply affirms that an artwork cannot do its work as art if it is received in the context of an interest linked with the existence of the object as such. The fact that the work is in the first instance – and perhaps even thereafter – necessarily regarded from specific perspectives, as Zeglin Brand and Vande Veire make evident, in no way detracts from this. For in such communication it is always precisely the disinterested attention which the work demands of the viewer, listener

or reader, and in which the work urges itself upon the user, that makes it possible to perform its task: to bring the user to engage his or her imaginative powers in the service of a play with existing perceptual schemata.

7.3.3 Aesthetic or artistic experience?

Meanwhile, there is in any case one area of confusion in thinking about art that has not yet been dispelled. In this book, too, the terms aesthetic and artistic are to some extent used interchangeably, as is customary above all in the English-speaking tradition. This confusion is partly the result of the history of the term aesthetic, and partly due to the increasing uncertainty in the formulation of the typical working of art and the declining inclination to attempt to provide such a formulation. These two developments are of course a result of a theoretical reaction to modernistic ways of thinking and of resistance against this thinking in the postmodern cultural discourse (including the economic and the political).

Yet there is reason enough to continue investigating and formulating the nature of artistic experience. Not only is aesthetic experience silently conceived of in large parts of the theoretical discourse as an experience that bears the marks of what is considered artistic. But in addition, an answer must be given to the question whether aesthetic forms of communication, insofar as they exhibit qualities of an artistic nature, generate different values for users and societies than do other forms of aesthetic communication, and whether these values are sufficiently important to pay attention to. In the discussion above, material has been provided to answer these questions, on the basis of which the conclusions in section 7.4 will be formulated. But before that, first a decision regarding the use of the terms aesthetic and artistic experience will be proposed.

The concept 'aesthetic' can be approached both from an etymological and from a science historical perspective, if its meaning for the present has to be understood. The result of the first approach will soon be seen to form the basis for the relationship between the aesthetic and the artistic that is used in this study, while the second is of use in refining our understanding of that relationship.

The meaning of the Greek term *Aisthesis* belongs to a family of words centred on the concepts of sense perception, observation, taste and experience. It refers first of all to experience on the basis of sense perception. This experience can relate to all sorts of objects – artefacts as well as actions or natural phenomena – and can be of various types. Seen etymologically, *aisthesis* need not be considered necessarily as an experience of beauty. Much more essential is that the 'aesthetic experience' should be capable of being understood – and, in this study, will be further understood – as a sense experience, which is to say as an experience in which the senses are addressed. As was noted earlier, cognitive concepts (in the sense of

notions) inevitably 'accompany' this experience, but in the aesthetic communication these play a subordinate or servile role in and with regard to the perceptual schemata. On the one hand, this means that all possible communications which are aimed in the first place at sense perception or the power of imagination – from the new circus to the opera, from soaps to cult films and from gothic novels to minimal poetry – can be regarded as aesthetic, as long as the 'accompanying' notions and conceptions do not become dominant, as is the case, for instance, in *certain* forms of politically engaged art. On the other hand, within this conception of aesthetic communication, it is possible to specify the distinction between what Shusterman sees as the immediate sense experience and the more Kantian view that a certain distance from direct experience is necessary in order to be able to speak of an aesthetic experience. In fact, both sorts of experience are present in aesthetic communication, as just defined, but in the second view, the cognitive concepts play a somewhat greater role, albeit one that is primarily a subordinate one.

Since Baumgarten developed the concept of 'aesthetics' in the eighteenth century within scientific thought about art, this notion has come increasingly to refer to a specific area of sense experience, namely that of beauty, both of natural phenomena and of manmade objects. This conception of the aesthetic also underlies the thought of Kant, who could therefore consider art as that which is made by humans *and* which makes the experience of beauty possible. It is immediately clear from this that the experience of the sublime, which Kant linked more to natural beauty than to the results of human activity, including art, transcends aesthetic experience, that is, the experience of beauty. This has to do with the fact that beauty is related to harmony. In Kant this does not refer primarily (at least not in a theoretical sense) to the harmony among elements within a work of art, but the harmony of the cognitive faculties: imagination and understanding. The experience of the sublime lies precisely in breaking through that harmony at the cognitive level: anyone who experiences the sublime, is shocked in his perception, because it is beyond his understanding.

In order to be able to understand the developments in art during the twentieth century in the area of aesthetics, one must understand the concepts of harmony and/or beauty quite differently than it was in the eighteenth and nineteenth centuries. As showed above, the harmony of the cognitive faculty can also be understood in such a way that the confrontation of the senses between the representations contained in an artistic expression, and the resulting mental schemata in the mind of a recipient, can, through the effort of the latter's cognitive faculty, become a meaningful perception. If that process is painful, or perhaps traumatic in nature, then the aesthetic experience can no longer be easily understood as an experience of beauty, even if one can speak of a certain harmony in the operation of the cognitive faculty. Rather, one will more likely experience an artistic

utterance as 'beautiful' or 'lovely' if the representations offered, through the interplay of imagination and understanding, can be integrated relatively easily with the recipient's existing perceptual schemata. It is therefore better, if only for this reason, to conceive of aesthetic experience as the result of a communication that addresses the level of the senses in general, rather than as an experience of beauty. Should one nevertheless wish to define aesthetic experience as an experience of beauty, then one must, like Kant, understand this as the result of the interplay of imagination and understanding; and with the consideration, moreover, that even 'ugly' art can lead to such an activity of the cognitive faculty and thus evoke an aesthetic experience. This then makes it easier to approach twentieth-century art, which seeks truth rather than beauty, by means of Kant's frame of reference.

The relationship between beauty and harmony used to be understood differently. For there is a long tradition of thinking about beauty in terms of harmony *in* the work (as this is expressed, for instance, in the 'golden section' in the visual arts and architecture, the theory of harmony in music, or rhyme schemes in literature) and a similarity *between* the work and what it represents ('so beautiful, so realistic!'). Barend van Heusden, approaching art from an evolutionary perspective, also emphasised that the need for beauty is a need for known forms, for symmetry: 'We witness a strong tendency toward the establishment of order' (2004: 120). For disorder causes uncertainty, and uncertainty stands in the way of action. 'No wonder the discovery of order (of form, meaning and structure) generates a strong sense of satisfaction (as every critic of art will acknowledge' (ibid.). Apart from the fact that in this form of the experience of beauty, the order of similarity in question can exceed all expectations so that an entirely new experience can indeed come into existence which itself may be called sublime, the core of this experience lies in the act of re-cognition.[5] That aesthetic satisfaction can be based on recognition, harmony and even symmetry is also supported by neurological research. Ramachandran and Hirstein (1999) seek – and in part find – a demonstrable evolutionary link between brain activity in the area of perception, and recognised elements of aesthetic pleasure. Recognition of forms as belonging to a known category is one of the activities involved in that process:

> The discovery of similarities and the linking of superficially dissimilar events would lead to a limbic activation – in order to ensure that the process is rewarding. It is this basic mechanism that one taps into, whether with puns, poetry or visual art. (1999: 31)

And the attention to symmetry, according to these authors, appears very early in the visual process, because it works as 'an early-warning-system to grab our attention to facilitate further processing of the symmetrical entity until it is fully rec-

ognized' (ibid. 27). By extension, they cite research that shows that both animals and humans prefer symmetrical 'versions' in their choice of partners.[6]

Recognition, repetition of the known, can lay the foundations for an artistic experience, but in the Western philosophy of art it is certainly not understood to be characteristic of this experience. The emphasis in the latter is on the experience of the other, and possibly on the recognition of representations that once were lost. Precisely for this reason, Van Heusden also makes a distinction between art and beauty. In his semiotic theory, artistic communications are a form of second-order semiosis at the level of perception: 'Art ... exemplifies life by mimetically representing the structure and contents of the semiotic process' (2004: 119). And because life and its meaning do not always unfold in an orderly and harmonious form, 'a tension arises between beauty and art' (idem: 121).

Theoreticians who have linked aesthetic experience with developmental psychology in order to be able to develop a cognitive psychology of the aesthetic faculty have noted a need for similarity among users of art. But in the succession of the stages of which developmental psychologists customarily speak, the ability to value aesthetic experience based on what is known or repeated is generally situated at a relatively early phase. Michael Parsons, for instance, distinguishes five stages in the cognitive development of aesthetic experiences, of which the second is called 'beauty and realism' and 'is organized around the idea of representation' (1987: 22). At this stage, artworks are more appreciated and judged to be better when the representation is realistic: 'style is appreciated only as realism. Skill, patience, care are admirable. Beauty, realism, and skill are objective grounds for judgements' (ibid.). Gerrit Breeuwsma, too, observes that this stage is dominant around the age of eight, so much so that many children, through an inability to satisfy adequately the demand for realistic representation, put an end to their own aesthetic activities (Breeuwsma 1993: 332). Many adults also appear to judge artworks on the basis of categories that dominate in the second stage, although Parsons goes on to describe three more stages in the development of the aesthetic faculty. The third stage involves the expressive power of the work, and not before the fourth stage do formal and stylistic features play an important role: 'it places the emphasis on the way the medium itself is handled, on texture, color, form, space, because these are what are publicly there to see' (Parsons 1987: 24).

It should be clear that these psychological approaches offer a great deal of room for conceiving of aesthetic experience as more than just an experience of harmony. But in philosophy, too, there has been a shift, since the beginning of the twentieth century, in the meaning of the term 'aesthetic'. Far from being understood exclusively in connection with beauty and harmony, the concept is at any rate increasingly linked to form in a general sense. For also harmony, and beauty in the sense

of harmony, are elements of an aesthetic utterance that manifest themselves only in and through form.

As has been noted earlier, above all on the basis of the theories of Luhmann and Gadamer, aesthetic communication consists only of form, and there is no such thing as content that might be opposed thereto. But given that form must always be the form of something – both of material and of matter – or perhaps rather 'the form of matter in the material[7] – one can distinguish among various layers of aesthetic communications, which Luhmann for instance refers to as 'utterance and information' and which is present in Gadamer in the relationship between form and meaning. Meaning is, in this sense, a difficult but interesting concept. It is something that the recipient of art links to a communication on the basis of the relationship between the signified and the signifier of the work, on the one hand, and of the user's actualised perceptual schemata on the other. Because of this relationship, a work can only be said to have one or more *possible* meanings, which may be realised in its reception. If one wishes to speak of the meaning *of a work*, this can best be understood, therefore, as the specific relationship between the signified and the signifier – or, to use somewhat more neutral terms, between matter and form – which makes it possible to engage someone's perceptual schemata and the interplay in which these engage.[8] Gadamer is certainly of the opinion that in order for a work to be called art, it must 'have' meaning in the sense outlined above. Works that are marked by a play of forms in which there is *no* relationship with matter (in order that meaning may be created) he refers to as 'decorative'. Such utterances have only a formal aspect, and for this reason, although they are certainly aesthetic in nature, they are not artistic; this distinction is very close to everyday usage: one speaks of an aesthetically pleasing design of a room, or of the aesthetic aspect of a design when one is referring to the formal elements as such, apart from any matter and thus free of any meaning – a 'form of nothing' (apart from the material shape), in a manner of speaking. Decorative *art* is in this sense a contradiction in terms.

Finally, one may ask how Bourdieu's concept of 'aesthetic disposition' is related to this sense of the aesthetic. Both Gadamer and Bourdieu see form as decisive for aesthetic and artistic judgment, but in Bourdieu, it is precisely the *aesthetic* disposition that makes an *artistic* judgment possible, because it makes the recipient able to judge a work by its form (rather than by its function), while an *aesthetic* judgment in Gadamer would mean that the *artistic* experience is left behind. Much of the uncertainty may be attributed to Bourdieu's fairly unsystematic use of certain concepts. His concept of 'function' seems in some cases to overlap with the 'use' of the work (for instance, in the question whether a painting fits in with the furniture, which in Gadamer's terms would be a purely aesthetic,

'decorative' consideration of a work), while at other times with the meaning of the work, where the attraction a work holds for the user lies in the matter or theme (which comes close to Zeglin Brand's notion of interested attention). In general, Bourdieu uses terms such as aesthetic disposition and pure gaze in order to refer to a way of seeing, listening or reading that excludes forms of interest; this is, indeed, most readily done by concentrating as fully as possible on the form. For Bourdieu, too, moreover, forms *of* or *in* artworks are forms of something, and it is as such that they are given their meaning, although he pays very little attention to that aspect. What he calls the aesthetic disposition is in fact the disinterested attitude to a work, through which, as we have seen earlier, the work can realize its own meaning as a work of art. Partly because of the multiplicity of possible meanings the term 'aesthetic' can have, it would be better to refer to this attitude as 'artistic disposition'.

And so we come back to the question that formed the basis of this section, namely, whether to refer to the experience that one gains through communication with certain utterances as aesthetic or artistic.[9] It should be evident that the large number of meanings that can be attached to the term 'aesthetic' makes it unsuited to a specific usage. The etymological background of the word does mean that it lends itself to designating the sensual nature of communication with artworks in general: aesthetic refers to a communication where an artefact speaks to the user *at the perceptual level* and where the experience takes place at that level as well. The interplay of the cognitive faculty with perceptual schemata in this process, and the cognitive concepts thereby actualised, need not *per se* be characterised by contradictions: for affirmative aesthetic communications are also possible. On the whole, it is assumed in the philosophy of art that this interplay produces representations of truths, realities or meanings that hold a certain degree of 'strangeness' for users, and lead them to rearrange their perceptual schemata. *Artistic* pleasure is, then, understood first and foremost as the successful effort to deal with these 'foreign' perceptions.

Following upon the discussion of the terms aesthetic and artistic, we can thus distinguish three different types of aesthetic experience: a) the experience of the form that does not seek a meaning: 'decorative' aesthetic communication; b) the experience of form that can be understood by means of familiar perceptual schemata: affirmative, or comfortable aesthetic communication; c) the experience of form that calls for a reassessment of one's perceptual schemata: challenging (artistic-) aesthetic communication. Although the term 'aesthetic' thus fully covers all that can take place in the encounter with art, it is nonetheless worthwhile – partly since too limited a conception of the aesthetic can easily be generalised – to carve out a special place, within the totality of aesthetic communication, for what may be called the *artistic* experience. If we take as a starting point the view that

forms which demand meaning at the level of perception transcend a purely deco-
rative aesthetic, they therefore fall within categories b or c. However, if one takes
as one's point of departure the values and attendant functions that the philosophy
of art attributes to aesthetic communication, then the term 'artistic' ought to be
reserved for challenging forms of artistic use, in other words, for category c alone.
In the rest of this study, the emphasis will be on those communications that are
marked by a discrepancy between form and matter, and in which the participants
are thus asked to engage with *foreign* perceptions. One might expect that it is
precisely these types of communication that hold interest for an investigation
into the specific values and functions that the arts may have for their users and
the society in which they live.

7.4 Conclusion: values and functions of the arts

The task undertaken in this part of the book was to investigate what the arts
do in terms of the values that are produced in the course of their use. Since aes-
thetic experience is regarded, at least by functionalists, as a typical feature of the
encounter with art, it was necessary to look more closely at the possible forms
this experience may take. In doing so, differences certainly emerged between the
conceptions of the authors discussed – especially with regard to the role of disin-
terestedness and distance in aesthetic reception. More careful examination and a
certain reformulation of classical concepts also pointed to the existence of greater
consensus than was previously assumed to be the case.
 First, it was determined that by making a transition from representation to
presentation, the relationship between artistic utterances and reality did not
disappear, but was transformed. Represented reality is, in presentational art,
scarcely if at all present in the marked portion of the communication, but it is to
be found in the unmarked part, and can certainly never disappear completely.[10]
In other words: postmodern art can also be understood as a form of matter in
material. The two-in-one unity of form and matter emerges in myriad variants
in aesthetic theory, in which form is linked mainly with the aesthetic and matter
more with the artistic. But ultimately everyone is more or less in agreement that
the relationship between the two is essential if we are to be able to speak of art. In
order to formulate the specific values of aesthetic communication, this relation-
ship was investigated still further, making good use of Gadamer's notion of play
(with that of Kant in the background). In the arts, the forms of something are
communicated and the play with forms includes the play with concepts (except in
decorative aesthetics, in which forms do not call for meaning). What Nussbaum
and Carroll regard as characteristic of the moral value of art, namely the possibil-

ity of *revising* moral concepts, is true for the arts in general: in artistic experience, one plays with perceptual schemata (in which cognitive aspects are also engaged) on the basis of the communication of forms which the recipient partly already knows, but partly finds foreign. Art, moreover, not only endows this play with form and concept with the ability to interfere with moral patterns, but, with a bit of good will, one can say that art has a moral value as such, since it demands that one pay attention to 'the other'. That this other may in itself be seen as immoral within certain value systems, or the fact that art can be used in immoral ways, does not significantly detract from that observation.

A second important result of the exercise carried out in this part is that the disinterested gaze retains a core aspect of aesthetic experience. In the absence of this gaze, an artwork would lose its typical communicative power that resides in its specific form, for an 'interested' gaze would itself go in search of specific meanings and leave little room for allowing oneself to be led by the artistic utterance. In a sense, users of art *must* have an interest in aesthetic (even disinterested) communication in order to be willing to take part in it.[11] Within aesthetic communication as such, the disinterested gaze in the Kantian sense prevails, although, as Gadamer, Vande Veire and Zetlin Brand demonstrate, it does afford considerable room for realizing a certain interest in the matters to which the work gives form and thereby also for the existence of what is represented in the work.

Shusterman's concern that by maintaining a disinterested attitude, a mental distance from the artwork remains essential in order for aesthetic experience to be possible, as a result of which more somatically oriented disciplines could have no aesthetic value, appears to be more or less unfounded. Of the two different sorts of distance that can be identified, the most important one can, in any case, appear in all forms of aesthetic communication: the discrepancy between the form and matter of a work of art which creates a distance from the ordinary concepts whereby reality is perceived and understood. For this reason, and because of the role of the interested gaze in aesthetic communication, the other form of distance, that which separates one from the artistic utterance as such and which is allegedly necessary for an adequate reception thereof, is in any case debatable. At most, the question may be asked whether cognitive reflection *resulting from* aesthetic communication is necessary in order to be able to speak of an aesthetic experience, as Van Stokkom claims. What happens in certain types of communication may instead be characterised by the opposite: the first form of distance, that between form and matter, is experienced so powerfully, at a more or less physical level, that intellectual reflection during or after the communication in question cannot be absent. Such a reflection can strengthen the usefulness of the aesthetic experience, and may in due course endow it with a function, but cannot be considered a precondition for this function.

In the above discussion we have chosen to reserve a special place within the totality of aesthetic experiences for artistic experiences, in which, based on a discrepancy between form and matter, a game is played at the level of perception with these two components: the imaginative powers play a mediating role in the encounter with this discrepancy. The value of art can, on the basis thereof, be defined as the ability to generate communication in which this type of experience can be obtained. The value that is thus realised by the recipient is the pleasure of the use of the power of imagination in playing with the relationship between form and matter. The imagination does not per se have to start in the cerebral domain; the play can also be entered perfectly well through physical behaviour.[12]

If this discrepancy is not present, one can still speak of a comfortable aesthetic experience, in which the recipient can limit himself to an engagement with existing perceptual schemata, including the cognitive concepts which these actualise. The value realised in this sort of communication lies above all in the enjoyment of the reuse of existing schemata. The distinction between comfortable and challenging experiences is important, given the various types of value that they produce, but the boundary between the two is sometimes difficult to draw. That is the case, for instance, where earlier experiences 'disappear' in an endless series of ordinary communications, and suddenly reappear in the confrontation with an artistic utterance; or where the meaning of already functioning cognitive concepts are confirmed in the perception of the representation. Many artistic experiences would thus appear in the zone where comfortable and challenging aesthetic communication overlap, or where the two share common traits. This does not mean, however, that the former will always bring with it the value of the latter. Many concerts, books, films and plays are interchangeable because their forms always address the same perceptual schemata and attendant existing concepts in the minds of the recipients. In these cases, the power of imagination is engaged in only a rudimentary way, namely, to recognise a form as a form of something.

In section 7.1, the distinction among intrinsic, semi-intrinsic and extrinsic values was introduced. The intrinsic value of art is understood as the direct effect of the mental encounter with artistic utterances as described above. Extrinsic values can be realised in both direct and indirect encounters with art; they do not came about, however, on the basis of a mental reaction to specific characteristics of artistic communications, but can also be realised in situations in which art does not play a role. Finally, semi-intrinsic values were identified, which like extrinsic values, can also be realised in situations other than aesthetic events; but if they do and come about through aesthetic events, then they are a direct effect of the mental encounter with the artistic utterances in question.

In figure 7.1 the findings relating to the values of aesthetic communication are linked to this classification. Two aspects that come to the fore in this figure call for particular attention: a) the role of emotions in artistic experience, and b) the 'sharing' of experiences.

In daily usage the encounter with art is often linked with the rise of emotions, and artworks are considered good if the viewer, listener or reader is moved by them. In the philosophy of art, there seem to be few arguments available to support this notion. The discussion in this chapter nuances and criticises this widely held view, and calls for a distinction among types of emotions. Generally speaking, the use of the emotional system in aesthetic communication is semi-intrinsic in nature, because this communication does not per se appeal to the emotional system and, moreover, because the same emotional effects can come about from non-aesthetic communication. This does not, of course, mean that there is no room for emotions in aesthetic communication. First of all, the experience of feeling can indeed be linked with other situations, be these real or fictitious: for example, feelings of sorrow, joy, anger, and so on, that are evoked by a work of art, either because the characters on stage, in film or in a novel experience these feelings, which the viewers or readers enter into, or because such emotions are evoked in the recipient by what the work represents. These emotions (type C-comfortable 1), if they appear, are typical of a comfortable aesthetic communication, since they engage the emotional system without, however, challenging it. As known, the more or less predictable tears of rage, sorrow or joy yield a certain pleasure, which in turn is also not unknown to or undesired by the recipient (emotion type C2). In artistic experiences (the challenging forms of aesthetic communication), it is possible, in addition to these types C1 and C2, for new and (to the recipient) unfamiliar forms of emotion to manifest themselves (type U-unfamiliar 1), and for an unfamiliar form of pleasure to result from this new use of the emotional system (type U2). One can, for instance, be pleasantly or unpleasantly surprised by a sense of happiness in a confrontation with death or by feelings of hatred towards characters that one thought one loved. In this case as well, we are dealing with semi-intrinsic values of art, for reasons already mentioned. However, if this sort of emotion comes into play in an artistic communication, the emotional system is challenged and new kinds of emotion are produced. And in this way they approach the only two truly intrinsic artistic emotions (for they alone are always present in artistic communication): A1) the pleasure of the experience of new perceptions and A2) the pleasure of the engagement of the imaginative powers in order to unite form and matter in a new, meaningful perception.

Sharing aesthetic experiences with others has long been considered an essential aspect of the theatrical arts. Peter Brook stated, for example, in 1989:

Figure 7.1 Intrinsic and extrinsic values in aesthetic communication

AESTHETIC COMMUNI-CATION POSSIBLE VALUES	Decorative aesthetic communication	Comfortable aesthetic communication	Challenging (artistic) aesthetic communication
Intrinsic values	– Enjoyment of perception of forms without the need to give meaning to them	– Activation of existing perceptual schemata – Reliving and enjoyment (of the reliving) of known representations (recognition) – Production of existing representation	– Challenge of perceptual schemata – Use and enjoyment (of the use) of the imaginative powers in dealing with the discrepancy between form and matter – Production of new representations
Semi-intrinsic values	– Enjoyment of the relationship between decoration and surroundings	– Use (and enjoyment of the use) of the emotional system – Acquiring information – Experience and enjoyment (of the experience) of sharing known emotions, representations and concepts with others	– Use (and enjoyment of the use) of the emotional system – Acquiring information – Experience and enjoyment (of the experience) of sharing new representations, emotions and concepts with others
Extrinsic values	Experience of relaxation value Experience of social value Experience of economic value Experience of informative value	} apart from the typical aesthetic value characteristics of artistic utterances	

The aim of any show is to unite an audience ... This is the very basis of the theatrical experience, its deep meaning: the desire to become one with others, and for a second to hear what it's like to belong to a single human body. (cited in Eversmann 1996: 9)

Apart from the fact that it would be difficult to apply this to literary experience or to viewing paintings, the question remains whether the collective nature of the

experience can still be considered an essential quality of theatre itself. Not only have theatrical performances increasingly evolved into more and more conceptual systems of signs, which ask for an individual 'understanding' and/or 'interpretation', but besides this, it cannot be easily stated that a performance does not exist if it is not received by more than one viewer: theatrical communication remains possible. For music, the situation is somewhat different; pop concerts and dance events seem to have more to do with collective experience. Whether this always goes hand in hand with an experience of collectivity remains an open question. But that is what this semi-intrinsic value is all about: the feeling that the familiar or new perception is shared with others, thus making the experience not only more true, but also more valuable, namely, in the social relations among the participants. In many cases such a feeling can come about in a roundabout way, either in the social interaction in which, afterwards, whether accidentally or not, people communicate about the aesthetic experiences, or in a more abstract sense, when people follow the reports and comments on the artistic expression in question in the media and compare their own experiences with what is said there. Both situations make it possible for the encounter with art to contribute to the (development of the) social identity of the participants. In light of what has been said above, it is evident that sharing aesthetic experience with others, and the pleasure derived from doing so, cannot be regarded as intrinsic to the art, although it can of course take place at the level of specific artistic utterances, and may be an essential part of the aesthetic communication.

Speaking of the contribution which aesthetic communication can make to the social identity of participants in the communication marks the transition from values to functions, for, as has been remarked several times, the description of a function constitutes the answer to the question as to the *use* of the value that has been realised, in other words, why the realization of the value in question for the user or society is important. In figure 7.2, the values and functions are first of all related to each other at the level of the aesthetic communication. Values and functions at the societal level are introduced at a later point.

This figure indicates that, while the values of non-artistic (comfortable) aesthetic communication serve to *strengthen* the competencies and identity of the user, the values of artistic communication are useful for *developing* competencies and identity. The use of the term identity calls for further elaboration. In figure 7.2, a distinction is made between personal and social identity. Both refer to individuals, for we are dealing here with values and functions at the level of the experience. Personal identity is understood here as the totality of one's physical and mental traits, that which makes him or her into this person. None of this is, of course, separate from the social identity, which may be summed up as the totality of connections that a person maintains with others, on the basis of these traits (while these traits of course develop partly through these connections).

Figure 7.2 Values and functions of aesthetic communication at the personal level

	Comfortable		Challenging (artistic)	
	Values	**Functions**	**Values**	**Functions**
Intrinsic	– Activation of existing perceptual schemata	– **Confirmation** of the value of existing perceptual schemata	– Challenge to perceptual schemata	– **Possible development** of new perceptual schemata
	– Reliving and enjoyment (of the reliving) of known perceptions (recognition)	– **Using** the imaginative powers	– Use and enjoyment (of the use) of the imaginative powers in dealing with the discrepancy between form and matter	– **Development** of the imaginative powers
	– Production of existing representations	– **Confirmation** of personal identity	– Production of new represen-tations	– **Development** of personal identity
Semi-intrinsic	– Use (and enjoyment of the use) of the emotional system	– **Regulating** emotions	– Use (and enjoyment of the use) of the emotional system	– **Regulating and developing** the emotional system
	– Acquiring information	– Developing knowledge and insight	– Acquiring information	– Developing knowledge and insight
	– Experience and enjoyment (of the experience) of sharing known emotions, representations and concepts with others	– **Strengthen-ing** social identity	– Experience and enjoyment (of the experience) of sharing new representations, emotions and concepts with others	– **Developing** social identity
Extrinsic	Experience of relaxation value Experience of social value Experience of economic value Experience of the informative value		apart from the specifically aesthetic value characteristics of artistic utterances	

One could also speak of the sum total of roles and positions within the social network, or as Latour puts it, of the set of linkages by which an actor makes him- or herself into a network. In this regard, one is reminded immediately of the fact that the social identity of a person can change, including through the actual encounter with other participants in aesthetic communication, and the more or less conscious sharing of related experiences. In comfortable experiences, this involves a confirmation, and potentially a strengthening, of existing 'linkages'; artistic experiences, however, can challenge not only personal but also social identity.[13]

Furthermore, in connection with what might be called the 'regulation of the emotional system', some additional explanation is necessary. It is a collective term which can designate various aspects of the emotional life of the users of art. In general terms, the pleasure of both comfortable and challenging emotions can help the user of art to relax. Abbing distinguishes here between two specific effects: that of tempering the affect, and of releasing the affect (1989: 65ff.). Both have to do with the satisfaction of sublimated needs. Art, like sport, helps in the first instance to sublimate needs, so that these can subsequently be satisfied to some degree through the encounter with art. This satisfaction takes place in the form of affect tempering or affect release. In the first case, which is most common and is typical of the process whereby societies are civilised, the sublimated needs are released in a controlled, tempered manner. For instance, within the conventions of film, theatre or the novel, this can occur as little by little one shares what the characters are doing or undergoing; or by reading a poem, the feelings it expresses are processed in a strengthened, but restrained manner as a result of the typical formal structure of poetry. Affect release is, according to Abbing, less typical of the civilizing function of art, but is nonetheless most necessary. On the one hand, this can involve unrestrained physical activity (in song or dance, for instance, or in roaring laughter or uncontrollable fits of weeping), but on the other hand, a complete and unrestricted release is also possible, according to Abbing, in circumstances of extreme quiet:

> A distanced manner of listening cannot be compared with Beethoven's Fifth Symphony. And even if the pornographic drawings of Keith Haring – white screwing black – hang in an oh so decent museum, entering into the work is indispensable in order to gain true understanding. So they must stimulate or at least summon up sexual associations or defence. (1989: 69)

Why these should be examples of unrestrained affect release and not of controlled release of sublimated needs is not clear. There is little reason to suppose that entering into an artistic communication ensures that feelings are released in an unrestrained or untempered manner. It would seem, instead, that even in what

Abbing calls tempering of the affects, there is a degree of release, in a controlled form. In any case, it is clear that aesthetic communication can help users of art to maintain or bring their emotional management in order, a capacity that it shares, moreover, with various forms of sport and games.

Finally, a few remarks on the extrinsic values and functions, which until now have received scarce attention. We are dealing here still with values at the level of personal experience, that which one receives in return for an investment of time, and possibly of money and effort, in the aesthetic communication. These are, in fact, by-products (which can, however, be core products for the consumer) which can be obtained in other situations as well, and sometimes even better. Simple information about the history of Norodom Sihanouk as king of Cambodia can be obtained more efficiently from other sources than from the play about him which the Théâtre du Soleil performed in 1985 (*L'histoire terrible mais inachevée de Norodom Sihanouk, roi du Cambodge*). This does not, of course, mean that the way in which this company told the story was not informative as well as artistic, or rather, made an artistic use of information, but that involves a semi-intrinsic value, included in figure 7.2 as 'acquiring information'. A similar distinction applies to the social and relaxation values, which already appear above at the intrinsic and semi-intrinsic levels, but that can also be realised as extrinsic values. A feeling of relaxation, especially as a feeling of escape from daily reality, can also be gained simply from the fact that one is out for the evening, in a different environment, without it making much of a difference what is being offered in terms of possible aesthetic experience. And the same situation can make possible numerous forms of social interaction, which contain as many different forms of social value, such as the feeling of having friends and belonging somewhere. In this case, as well, it has little to do with what is being played or shown. And here, too, it is true that as soon as the mutual contacts between visitors to events are related to the type of aesthetic communication, one can speak of semi-intrinsic values. The functions of social and relaxation values in the lives of consumers are evident. Social values help people to (re)discover or reinforce their place in a smaller or larger community;[14] the extrinsic value of relaxation helps people to be able to face life (again).

Economic values have a slightly different character; they do not appear in the semi-intrinsic domain, except very exceptionally, for instance, when an aspect of an installation involves visitors being able to take home objects that play a role in the event. If these objects have an economic value as well as an aesthetic one, one may speak of a semi-intrinsic economic value of artworks. But in general, as mentioned earlier, the economic value of artistic utterances is extrinsic to the art itself. Moreover, it lies in marketable objects in the first place, in particular in the worlds of the visual arts and of literature, but also as regards the bearers of particular types of artworks, such as manuscripts in music and theatre, or films

and videos of historical importance. The function served by this economic value is immediately obvious: the realization of such value makes a person richer, not in a figurative but in a purely economic sense; an increase in social status in certain cultural circles can be a further side effect. Besides this type of economic value of works of art, there are other ones which are extensively discussed in the field of cultural economics, and which have got a significant place in debates on the legitimization of cultural subsidies. It concerns typical questions in the economic field, such as employment in the sector and extra spending around the visits to aesthetic events. These aspects will not worked out here further, because they are too extrinsic to the aesthetic character of works of art.[15]

In the first part of this chapter, the value of art is sought at the societal level. On the basis of Luhmann's statements that art offers the opportunity to 'duplicate' every reality via representation, and moreover to make perception available for communication, we have gone in greater detail into the relationship between art and reality. Danto's notion that artworks always have a form of 'aboutness' in them seems to hold up, partly with the assistance of Luhmann's appeal for recognition of the fact that what is not marked may well be present, in communication, on the obverse of the marked, in the unmarked part of utterances. As a result, one can also speak of artworks that do not represent a reality, but present or 'merely' repeat (because of the traumatic absence of reality in experience) as referring implicitly to a reality. Finally, both Gadamer's concept of play and the discussion of the moral nature of aesthetic communication led, in the end, to the insight that art makes 'truth statements' about reality, or at least makes it possible to test the extent of truth of experienced reality (or of experience from which reality remains absent) by making the 'other possible' conceivable.

In this brief summary, values and functions are interwoven; in figure 7.3, however, the necessary distinction is made, at least on the societal level.

Figure 7.3 Intrinsic societal values and functions of art

Values	Functions
Art duplicates reality in the realm of the imaginary	Offers a community the possibility of imagining a reality and to reflect upon it
Art makes the 'possible other' imaginable through a play with forms	Helps a community to test its 'vision' against reality and to be open to the unknown
Art makes perception available for communication	Makes the exchange or re-adjustment of perceptions possible within a community

Finally, the values and functions at the personal and societal levels can be related to each other. This is done in the figure below, which covers both the intrinsic and the semi-intrinsic domains. Societal values and functions are printed in bold; below them are the personal values and functions that are directly related to them. The realization of certain values is a condition for fulfilling the functions, and this is expressed in the arrows pointing from left to right. In addition, there are links among the three societal functions. The first is a condition for the second, and, just like the second and third functions, the first and the third presupposes each other. The reason for this is the fact that exchange of perceptions is necessary in order for representations to function in a community. At the level of societal *values*, such bonds are weaker; there we see values on the personal level that are primarily preconditions for the societal ones. That is true, in any case, for the first two categories. Where we are dealing with the capacity of art to make perception available for communication, this can be seen as a condition for the personal enjoyment of sharing representations, and so on.

Figure 7.4 Links between the intrinsic societal and personal values and functions of art

VALUES	FUNCTIONS
Art duplicates reality in the realm of the imaginary →	**Offers a community the possibility of imagining a reality and reflecting upon it**
Personal value Dealing with the relationship between matter and form through the imaginative powers	Personal function Development of the reflective faculty Development of the imaginative powers
Art makes 'the other possibility' conceivable, through a play with forms →	**Helps a community test its 'vision' against reality and be open to the unknown**
Personal value Possible development of new perceptual schemata (in combination with obtaining information)	Personal function Production of adequate representations and confirmation or development of personal identity
Art makes perception available for communication →	**Makes the exchange or re-adjustment of perceptions within a community possible**
Personal value Enjoyment of sharing representations, concepts and/or emotions with others	Personal function Strengthening or development of social identity

Bringing together the values and functions at the personal and social level at once makes it clear that the most important intrinsic value of art is the engagement of the imaginative powers, and that this engagement serves primarily the development of the societal power of imagination. The development of this faculty among individuals and groups in society in turn makes a contribution to the intellectual openness of a community. In addition, art can, through its ability to make perceptions available for communication, be significant for the development of social webs at the level of people's representations of reality. In a certain sense, this can be regarded as a contribution to social cohesion, but that certainly does not always mean that existing shared representations are confirmed in aesthetic communication. It is precisely when no distinction is made between comfortable and artistic forms of aesthetic communication that it becomes too easy to expect art to serve social cohesion by confirming shared representations. Maybe more often the opposite will be true that artistic communication causes a rupture in existing representations and social relations, thereby making new bonds possible.

Communities can grow stronger through such critical processes. There is another aspect that can play a role here, although noticeably absent in figure 7.4: the regulation and development of the emotional system. What is at stake is a non-intrinsic aspect of art that manifests itself at the personal level, and appears as a by-product or side effect of aesthetic communication, but which can play an important social role. It does so in two ways: first, it is evident that emotional release through aesthetic communication can help prevent an overload of emotional energy, which necessarily seeks an outlet in reality. But secondly, art, through its capacity to confer an experience of a certain distance from reality in the realm of the imaginary, and to create a certain openness to 'the possible other', can make a contribution to reducing the influence of what is often called 'gut feelings' or 'cheap sentiments'. For emotions of various sorts are constantly being tested through aesthetic communication, that is, in the artistic forms thereof, to determine their value.

Building on the overview provided in this chapter of the values and functions that can be attributed to art and aesthetic communication, the third part of this book will proceed to try to realize the central purpose of this study: to develop models which can be used to investigate how the organization of art worlds serves the functioning of the arts in society.

Notes

1 Perhaps an exception should be made here for non-programmed and text-free music, for which the question is whether it expresses or represents anything, in whatever mode. Such music could appeal to something in its listeners, without any reference; that's why Scruton

(1974) can interrelate music with the imagination on the part of the listeners.

2 Augustin Girard's *Cultural Development: Experience and Politics* (Paris 1972) has had a strong influence on this development, particularly in Scandinavia. See Van Maanen and Wilmer 1998.

3 If popular art is viewed as art in popular media, then Bourdieu's statement that popular art does not exist does not hold up. For that view is based on the idea that art breaks through the common (popular) on the basis of a distance from the common that is created by form.

4 In this regard he has been inspired by, among others, a dubious distinction between the ways in which the US (customarily abbreviated as America) and Europe look askance at 'culture'. He describes the social structure of 'America' as 'more flexible and decentered' and considers that there is more cultural freedom there than in Europe. An important reason for this is that 'Americans take neither philosophy nor the cultural hegemony of intellectuals as seriously as do the French and other Europeans' (2000: 57). As a result, awards such as the Oscars, Emmys and Grammys 'confer, in the eyes of most Americans, not only aesthetic legitimation but a degree of artistic prestige' (ibid.).

5 Which can sometimes lead to the strange reaction that, upon seeing something beautiful in reality, one exclaims 'as lovely as a picture'.

6 Moreover, there were other elements which Ramachandran and Hirstein related to the role of brain activity and the evolutionary process besides those that are primarily connected with harmony. Contrast and the attractiveness of a strengthening of essential formal qualities are perhaps the most important of these.

7 Matter and material can sometimes appear to coincide, since the form which is given to the material (clay, body, language) can also be the matter of the artwork, in other words if the 'aboutness' of the work concerns the material and the way is it is treated.

8 It would be better to call this specific capacity of a work of art to touch someone the ability of a work to 'speak', and to reserve the concept of meaning for that which comes about in the communication.

9 Aesthetic aspects and experiences of nature will not be given further consideration here. The following refers exclusively to responses to human expressions.

10 Reality as such, however, is fully present in presentational art.

11 The types of interest which come into play in this communication arise from what Luhmann calls the structure of expectations.

12 Although the public which asked to do so, for instance during performances, often has great difficulty with this.

13 This fact is not unimportant in the cultural-political system, in which one often starts from the assumption that the identity of social groups benefits from comfortable aesthetic experiences, since it helps strengthen social cohesion. Social cohesion, like social identity, should be viewed in relation to the type of connecting factors and the degree to which the development of new connections at both individual and group level, may or may not hamper this.

14 On the basis of a mistaken interpretation of Bourdieu, the confirmation of social status as a motive for participation in aesthetic events is seriously overestimated, at least in a European context.

15 And for the same reason they are a bit risky if used as the most important legitimatization of art subsidies or other forms of governmental intervention in the art world.

PART THREE

How to Study Art Worlds

Introduction

At the end of the first part of this study, the two most important and challenging tasks for the sociology of art today were defined as 1) to investigate the conditioning impact of organizational structures – within and between the domains of production, distribution and reception – on what the arts do in society and 2) how aesthetic communication is related to other types of communication. What the arts do was expressed in the values of art formulated in the second part and summed up in figures 7.1 and 7.2. The functioning of art can simply be defined as the realization of these values.[1]

As supposed previously, the impact of art on human perception appears to be at stake in a dual sense: as in what happens in the act of perceiving and as the result of this in the form of possibly changed perception schemata. The question remains, under which conditions does this impact come into being? This is discussed in the present part, mainly on the societal level. The most important places where answers to this question might be found were marked in figure 6.1 (reproduced on the next page).

Besides the general question of the presence and working of conditioning structures (1), the working of the domain of distribution (2) – where aesthetic utterances and their users meet and the aesthetic system actually takes shape in aesthetic events – as well as the relationship of aesthetic experiences with other mental, particularly conceptual and moral schemata (3a and b), appear to be of particular importance. These three issues will be discussed in chapters 8, 9 and 10, respectively.

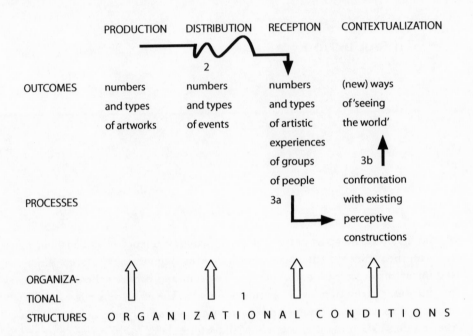

PRODUCTION DISTRIBUTION RECEPTION CONTEXTUALIZATION

OUTCOMES numbers numbers numbers (new) ways
 and types and types and types of 'seeing
 of artworks of events of artistic the world'
 experiences
 of groups 3b
 of people confrontation
PROCESSES 3a with existing
 perceptive
 constructions

ORGANIZA-
TIONAL 1
STRUCTURES O R G A N I Z A T I O N A L C O N D I T I O N S

8 Foundations for the Functioning of Art Systems

8.1 Introduction

Referring to the foundations of the functioning of an art system leads us back to a broader meaning of the term 'functioning' than used in the second part, in which particularly the functioning of aesthetic utterances, or art as such, was under discussion. The title of the first matrix in the introductory chapter was 'Fields and relationships to be studied concerning the functioning of an art world on the societal level'. The same matrix might also be called '87 ways to study the functioning of an art world', which means that possible outcomes of the various processes can be studied not only on the level of the effects but throughout the whole system, its internal functioning – the way it works, so to speak – as well. In the first place sets of structural (historically developed and more or less durable) patterns can be identified. They play a conditioning role because they determine the nature of the processes, apart from the extent to which these are intrinsically determined by the typical and historically developed character of the aesthetic languages at stake.

As soon as the most important factors that condition the processes of production, distribution and reception in an art system are listed, it becomes clear that despite the increased autonomy of the art system itself, these factors stem largely from the social systems in its environment: the economic, political-judicial, educational and social life systems, in particular. They not only condition the processes *within* the different domains but partly the relationships *between* the domains as well; the latter aspect concerns the educational and social life systems in particular and will be discussed more extensively in the concluding chapter 10.

In a sense, the technological system can also be considered a social system, as far as technological renewals are not only outcomes of activities carried out by machines but certainly based on technological communications. Although developments in this system can definitely be seen as the most determining ones in

how societies change as a whole, as well as in the art worlds, technology is only
mentioned here as a conditioning system of aesthetic processes and not discussed
further. This is because the description and analysis of the role played by these
developments in the art system would ask for a study of technological revolutions
in art, including the digital one in the present time, which is not the topic of this
book. Nevertheless, it is important to realize that electronic technology in general
and digital developments in particular have changed the processes of production,
distribution and reception of the arts and, as a consequence, strongly influence
the structures that condition these processes as well. The latter is most visible in
the central role the distribution domain plays. Electronic and digital media have
taken over a big part of the distribution of aesthetic utterances from the tradi-
tional venues such as museums, theatres and concert halls, and even cinemas.
The word media has to be understood here in two interrelated ways; in the first
place medium has to be considered literally as something that mediates between
production and reception, but at the same time it refers to the type of material in
which aesthetic communications express themselves. The latter meaning includes
the digital medium as a new material in which new forms of art can be made. And
that is indeed what has happened: web poetry, digital music and even theatre in
cyberspace have changed the landscape.[2] These new forms of art differ on the
essential point of materiality from traditional forms of art merely distributed by
electronic and digital media – showing the work of a painter, broadcasting a con-
cert or a classical film as well as typical forms of theatre products such as reality
TV or TV-based cabaret. Television and internet as distributors of more or less
traditional aesthetic utterances (the border with electronic and digital art forms
can be rather thin) function in fact as translation centres and actually change
these utterances as well as their types of reception by audiences. But they do
more; as a central domain they largely *organize* the making and watching of aes-
thetic communications. Film makers are going to work for television; YouTube
offers everybody the opportunity to present his or her work; actors try to en-
hance their status in the theatre field by getting parts in TV drama; audiences can
choose *when* they want to watch a film or look at a digital exhibition, and do both
at home. In other words, technological developments are changing not only the
arts themselves but the organization of the art world and hence the conditions for
societal functioning of art as well. This is happening in a far-reaching way indeed
because a typical characteristic of technology is that their utilization is largely in
the hands of the economic powers-that-be. These powers directly shape (via their
financial control of the media) the specific conditions for the making of art (e.g.
types of programmes to be made) and for the aesthetic communication (e.g. on an
individual and remote basis).

8.2 Economic conditions

As discussed in chapter 2, Howard Becker has highlighted the relationship between artists and their economic environment and formulated some clear statements about this relationship, among which the following:

> Fully developed art worlds [...] provide distribution systems that integrate artists into their society's economy, bringing art works to publics who appreciate them and will pay enough so that the work can proceed. (1982: 93)

Besides the fact that these sort of views landed Becker in some trouble, because they confirm the importance of conventions in a 'fully developed art world' whereas artists are expected to break through conventional patterns, this quote makes at least the financial basis of art production more than clear, as well as the economic relationship between art production, distribution and reception in a market-driven system.

To make something, even a work of art, one needs at least to stay alive, which means to be fed, clothed and housed or to have the financial means to buy required products and services. Artists mostly need extra money as well to buy materials or pay colleagues or 'supporting personnel' for their parts in the making of a work. In Becker's view, these financial means come from buyers and visitors who appreciate the types of aesthetic utterances strongly enough to pay money for the possession of them or participation in them. In such a system types of art that do not meet a sufficiently large group of paying users will not be made at all. In history as well as in our own time we can find various types of sub-subsystems that arrange the financing of such aesthetic production; to name the most important solutions in a from personal to societal order: side income, family support, patronage, sponsorship and subsidy.

If aesthetic utterances do not yield enough to live on, the most common way of earning a living is to do work other than making art (or to make work for other tastes than the artist's own) and to create works of art in the time left. Very many beginning artists in all disciplines combine jobs like teaching, washing dishes or making websites with their work as artists. This happens particularly in the fields where doxas were or are not strongly determined by schools of professional education, such as pop music or creative writing. In those fields people have to practise and profile themselves year after year before they attain sufficient recognition. This does not mean that graduates of art schools are guaranteed an easy path. In the Netherlands, for instance, no more than ten per cent of graduates from drama schools starting their career in what are known as 'theatre labs' (*theaterwerkplaatsen*) are still visible in the

field after five years (Vom Bruch 2007). No more than the same percentage
of visual artists earn a full income from making and selling works of art (Ab-
bing 1989: 113-123). Most of them – and the same holds for artists in other
disciplines – have a job on the side or are supported by family or partners
who bring in a substantial part of the household budget. The first type of
artist especially suffers the direct consequences of this financial condition
in having 1) less time to devote to their creative work and 2) less means at
their disposal to make use of optimal materials, new technical processes or
adequate spaces. This often leads to the creation of works on smaller scales
(fewer actors on smaller stages or thinner books) than the artists hope and
dream of working on. However, as soon as market recognition of the value
of the artist's work increases, then the process described by Becker begins:
artists start earning the production costs of their works back through sell-
ing their works until they reach the stage at which their sales deliver enough
money for them to live on and make the type of art they really want to make;
in short, the stage typical of a 'fully developed art world', in Becker's words,
that is characterized by an economic circle, so to speak. There are various
reasons why many artists do not reach this wonderful stage. The least in-
teresting is that the standard of their work is not good enough in terms of
attractiveness or artistic appeal to find an audience big enough to keep the
artist alive and kicking. But there is another more important and well-known
reason why artists find it difficult to get their work fully market-based. This
is because the renewals they insert in existing aesthetic languages can only
be appreciated by people who are quite familiar with those languages. This
means that the presence of a relatively huge and educated population in the
more or less direct environment of artists can be seen as a basic economic
condition for the production of the more challenging forms of art that many
artists prefer to produce. New types of performances, video installations or
concerts will find fewer buyers and visitors in smaller provincial towns than
in cities as New York, London or Berlin which, by the way, is one of the rea-
sons why most artists choose these bigger cities to live in (with consequently
a smaller market share per individual artist). It has to be noted here that new
forms of art produced and distributed in mass media can in principle easily
find a (worldwide) audience but this encounter can be negatively influenced
if the distributing organization – a television, film or music company – pri-
marily aims to make money.

A lack of sufficient audience demand is a more serious problem for those
forms of art that cannot be multiplied (reproduced) without an important loss
of artistic appeal, such as painting or performing art. The production costs of
the original mostly cannot be recouped by a certain number of copies, as is

indeed the case for film or literature. Besides this, the time required to produce and present the originals, especially in the case of the performing arts, has remained the same over the centuries whereas living costs have risen in the industrialized world. This is because in most cases the amount of production time generally required has dramatically decreased and as a result wages and the standard of living have increased. Baumol and Bowen concluded in the 1960s that the performing arts in particular suffer from this 'disease' because a certain number of persons has to be present on stage (and off) at every performance and be paid for it (Baumol and Bowen, 1966). Only big, full houses can provide these artists with sufficient income. For artists who do not like to search for anything else than market income there are in principle only two ways to tackle this problem: they can make more popular work, or they can try to reduce their production costs by, for example, using fewer personnel on and off stage. Both possibilities show how market-oriented financing *can* condition the human and material input in production processes and hence their outcomes in the form of types of aesthetic utterances. Hans Abbing, an economist and visual artist himself, puts it thus:

> My work has also been shaped by the government and there is nothing wrong with that. My unsubsidized colleagues need money as well. And independently of where it comes from, from the market, from a job on the side or from a partner, it always influences the work. (2005: 30)[3]

If circumstances are bad – if the potential audience of a place is too small in relation to the costs of the type of work – this generates two negative effects, one at the start and one at the end of the complete process of production, distribution and reception of art. 1) The 'research costs' an artist or a discipline as a whole has to recoup to realize interesting work in the future cannot be made through earnings, with the result that this research cannot be done. On the other hand, 2) the danger arises that some typical values of aesthetic experience cannot be realized in a community because the concerning utterances are not delivered or only to a very small audience that can and will pay the real price. Seen on a societal scale, the first aspect does not need to be disastrous if other places in the country provide sufficient possibilities to make and sell the work. The second problem is more difficult to tackle.[4] Large parts of a population will find themselves in the vicious circle of not being related to the arts, subsequently not developing their aesthetic competence and consequently not buying works of art or visiting aesthetic events.

As a matter of course we arrive now at the other types of economic or financial conditions for the making, distribution and use of aesthetic utterances; types

which have in common that the artists in particular (but also distributing venues) are financially supported without being compelled to earn the money (fully) back: patronage, sponsorship and subsidies.

Patronage is mostly used to describe the relationship between artists and rulers or merchants who supported them in the period before capitalism came into being as the dominant economic organization of society, although the same type of support can occur nowadays.

Becker as well as Abbing likes to see modern government as the successor of the classical Maecenas or the early-modern patron. It may be clear that Becker thinks and writes from an American background, stating that

> The patron may be a government, which commissions paintings or sculptures for specific public spaces or puts the artist on a permanent salary in return for specific services to be performed from time to time, as with a poet laureate. (1982: 99)

He also describes the role of corporations as modern patrons of the arts as 'paying for works which decorate their headquarters ... or can be displayed publicly as part of their effort at image building' (idem: 100).

To understand what is going on and how financial support influences the making, distribution and reception of art, more distinctions than Becker's have to be made. In the second quote, the activity of corporations preferably should be understood as buying works of art, be they commissioned or not, and the same holds true for the first part of the first quote; in those cases, the government pays for works that are already, or are yet to be, made. Both situations are based on the supply-demand dynamics of the modern marketplace. That is not the case in the second example Becker gives, that of a poet laureate who receives a permanent salary in exchange for his or her services. This is indeed a form of patronage but at the same time it is not the most usual practice in the relationship between governments and artists. Nowadays it is also true that some cities or even nation states employ a 'city' or 'national' poet laureate to compose poems on the occasion of special events for a year, or longer. But the common type of relationship between both parties is based on giving and gaining subsidies, which is a totally different concept from patronage, as will become clear in the next sections. A government can simultaneously act as a buyer of art on the market, as a patron and as a subsidizer; all three of these different forms of financing art life have three different outcomes. In the first manner of acting, the government, often a specific governmental department, is an ordinary client searching for a specific type of work to celebrate someone or something or to 'beautify' a space, or is trying to build a collection of contemporary art. In the latter case the government is

still a buyer – albeit more a 'buyer of services' than of the works themselves – one, however, that makes its choices depend on the development of the artist's work, just like galleries, museums, collectors and theatre labs do. But authorities do not become patrons by acting like this, not even if they commission artists to write, perform or create a visual art work. This is because the patronage system is based on an archaic form of an employer-employee relationship in which the artist was part of the patron's entourage and received a stipend to make works in his service. While not only the patron, but sometimes an entire population as well, could profit from the works of art, it will be clear that patronage involves a certain balance between the aesthetic autonomy of the artist and the goals a patron is trying to reach. In former times the latter part of this balance was strengthened by various forms of censorship. In our time, national or local authorities can be considered patrons in certain situations, in particular if an orchestra or theatre company consists of people who are formally contracted as civil servants, as is the case in a number of city theatres for instance. More and more, however, this type of relationship has been influenced and actually replaced by the subsidy system, in which private companies are financially supported by the government, often based on competition between several applicants. In scholarly terms it is not very productive to categorize this system under the same name as what in former times was understood as patronage, because both forms of funding condition the making of art in entirely different ways. The same holds true, albeit on a much smaller scale, for the distinction that can be made – and is, indeed made by Abbing – between a Maecenas and a patron, for the first commissions an artist to make work or to play more or less regularly, whereas the second employs the artist. The latter form gives the patron, in principle, more opportunities to restrict artists in their aesthetic freedom. Finally, sponsorship as well differs clearly from patronage. Sponsorship is a way of supporting the production, distribution or reception of art by giving money, goods or personal help without influencing the characteristics of the works of art or aesthetic events. Nonetheless, sponsors, mostly businesses, have interests in sponsoring and base the selection of what they choose to support on the extent to which the chosen institutions, works or events are able to serve those interests, such as expanding product recognition or company familiarity, positive image-building or reaching particular groups of potential buyers. Sponsorship can be seen as a market-oriented, and hence a specific successor to, patronage because it is based on the sponsor's choices related to his interests.

In this sense sponsorship and patronage strongly differ from a dominant art financing system in highly developed democracies: the subsidy system. The authors mentioned in the first part of this book do not have much to say about the subsidy system although it plays a vital role in the functioning of art worlds and

particularly in the debates surrounding it. One of the most noteworthy authors to discuss the subsidy system in depth is Hans Abbing. He seems to have a kind of 'love-hate' relationship with state subsidies, as appears from his various publications. Above we have seen how Abbing, as a visual artist, benefitted from the opportunity to receive state subsidies. In his first substantial book, *Een economie van de kunsten* (1989, *An Economy of the Arts*) he defended state intervention in the art market by stating that because artists and art organizations cannot earn back their research costs with patents as business companies do, they need outside help to finance their experiments. Without these experiments, aesthetic languages cannot develop and renew themselves. In the light of what is said above, it can be questioned whether this also holds true for artists living in a metropolis, but it is certainly true that in many situations subsidy is a condition under which artists from all disciplines can renew their language and hence their aesthetic communication.

Strangely enough, in his well-known book *Why Are Artists Poor* (2002) Abbing takes a radically different position on state subsidy:

> Arguments stating that art subsidies serve the general interest and those arguments that refer to the special merits of the arts, to equity and to the collective goods and external effects in the arts are largely false. In this respect, providing subsidies is unnecessary, ineffective, or counterproductive in the long run. [...] Instead of correcting market failure, subsidies actually induce market failure because they cause unfair competition. (2002: 230)

Although, or perhaps because, Abbing's argumentation is not fully developed and tends to be outcome-oriented, he can conclude that the state is not serving the arts by giving subsidies, but, the other way round, that the arts receive subsidies because they serve the government. This happens, according to Abbing, in two ways: art helps the government to be seen as impressive, at home and abroad (the function of display); and the arts 'contribute to the education of people and, consequently, to social coherence' (ibid. 254). If the latter is true, however, Abbing enters the domain of values and functions of art so that what he sees as an overlap between the interests of the government and those of the field of art can better be described as a causal relationship. For, if a government supports the arts financially to make the production or reception of specific aesthetic values possible because these values serve a function the government likes to be realized in society, there is no reason to say that this government does not serve the arts. It serves the arts, especially their functioning, perhaps aiming to help attain something other than aesthetic communication. This definitely does not mean, as

became clear in the second part, that only extrinsic values of art might be financed by governments. In describing and analysing the subsidy relationship between governments and art worlds one of the main topics is precisely the proportion of intrinsic and extrinsic values in this relationship. In a subsidy-based relationship the autonomy of the field of art, expressed in the production of intrinsic values, determines the borders of freedom that governments have to formulate their subsidy motives and criteria.

Referring to the European part of the world, Abbing correctly states that 'art has changed and so has its patronage. The new patronage is one of democratic governments...' (ibid. 240). It goes without saying that Abbing's inclination to use the same word for both phenomena is caused by his effort to show that the arts serve a government rather than the other way round, but precisely because of the essential differences between the forms of patronage and forms of subsidy, using the old term is misleading. Marking the differences is important because it has to be investigated how they condition different processes in art-making and viewing. The typical character of subsidy is that the subsidizer has no *personal relationship* with the artist or art institute, as does a buyer, a Maecenas or a patron. A subsidy system is a model in which artists and art institutions can apply for money on the basis of a match between their aesthetic plans and a public set of criteria the subsidizer makes use of in the process of granting. The central aspects are that a) the judgement of the planned work and its values are predominant over the relation with the person of the artist; b) applicants have time and again equal chances, given the quality of the work they have planned; c) the process of offering the opportunity to apply, as well as the assessment process and the final judgement are open, transparent and as objective as possible; d) criteria applied in these processes are based on the subsidizer's opinion that the subsidized works or events have a certain value for society that cannot be realized via the market mechanism. In this respect, subsidies are a specific (governmental) form of arts funding.

If, for instance, a country or a city maintains a national or municipal theatre or its own orchestra, there is actually not a subsidy relationship but a relationship based on employment. Principally, subsidy as a system supposes a transparent relationship between the subsidizer on the one hand and a group of legally autonomous persons or organizations on the other. This typical aspect of legal autonomy of the applicants stems from the fact that in highly developed democracies the art system as such has reached a certain level of autonomy, as discussed previously.

Many complaints about a system's lack of transparency, or about an excessive application of a subsidizer's or their adviser's own tastes are possible and, indeed, always pour in, but those aspects have to do with the ways in which a subsidy

system is organized: are the judgements and criteria used for them made public? Are there independent judges, or do civil servants evaluate the applications themselves? How much influence does the political decision-making have? Are the evaluators replaced after a certain period? Perhaps the most important question is what type of criteria are used, purely because these criteria represent the values of art a subsidizer recognizes and the functions of art he prefers being realized. It is this set of criteria, partly based on political preferences, that can make a subsidizer be seen as a patron that distributes funds according to its own needs. But even if this set is 'coloured' by tastes, or unclear in its description of terms such as quality or artistic appeal, the typically 'neutral' process of applying, competing, being evaluated and receiving money (or not) continues to exist because the subsidy process is based on the public availability of an amount of money to provide a society with certain values.

What all forms of financing have in common is that they would like the values for which they stand to be realized. Hence, it is extremely important to understand which regimes of values and the functions served by them govern the various financing processes. Not only do the values on which patrons, market parties or governments base their strategies and activities need to be discerned, the detailed differences within these positions and those based on combinations of them also have to be mapped out. Abbing's idea that fifteenth-century patronage and twentieth-century subsidy systems are more or less similar, because in both cases the display of the qualities of the paying authority is the primary goal, completely passes over the key role of values of art as discussed in part two. It also passes over the fact that democratic societies, by subsidizing the perception of the possibility of otherness, feed their own opponents. By doing so, the authorities present themselves as civilized, but that is more a side effect than the central goal of granting subsidies. If countries or cities wish to use the arts to display their identity, the easiest way is to act as a buyer or commissioner, not as a subsidizer, because artists might produce things and generate experiences that are completely different from what a subsidizer would like. On the other hand, if local authorities reserve a subsidy for the making and distributing of art that strengthens the local economy and they formulate real targets to be reached in that direction, it can be expected that only specific forms of art will be made under these conditions.

A final question is in which domain the arts are financially supported. In general, jobs on the side, family support and patronage directly help artists make their own work; sponsorship can do that, too, but it is more often related to distribution than to production, for audiences are met in that domain. This sometimes leads to sponsorship in the domain of reception, for instance when schools are supported in visiting aesthetic events.

Based on the working of the market, the main financing system always functions through the distribution domain because what is created, be it paintings, performances, books or films, always has to be allocated to potential audiences. Even when a sculptor invites potential buyers to her studio, or a musician gives a concert at home, this is a way of distributing works. Often there is a more multi-stage process going on; touring companies, for instance, sell performances of their productions to theatre or music venues, which in their turn try to recoup the price or more back by selling tickets. And authors, providing a publisher with a manuscript, earn royalties per sold copy of the book. In these cases, earning income from aesthetic production is highly mediated by the distribution organizations and the more artists depend on them, the more they *can* be hindered in their creative freedom, particularly if the interests of the distributors differ from those of the artists. Generally speaking, the closer the relationship between the domains of production and distribution, the easier it is to realize the values of the works offered and consequently to provide the artists with income based on the properties of his or her work.

The subsidy system works in all three domains. Artists and art organizations get subsidies to develop their work or provide society with forms of art not funded via the market but considered valuable by the subsidizer. Distributing organizations, such as museums, libraries and theatre venues, get money from the authorities precisely to let the arts function in society; in other words, to help the values of art to be realized. In some cases, an art system does not function well because authorities subsidize distribution organizations on the basis of values other than the production the subsidy is based upon. Something like this happens in the field of performing arts in the Netherlands where, to put it rather bluntly, the national government subsidizes the production of art more or less for art's sake and where many cities pay for the venues to offer the public what it likes. The result is that, in total, no more than 15 per cent of all performances on subsidized stages is actually subsidized theatre, dance or music and no more than four per cent of the adult population visits a professional subsidized theatre performance at least once a year. Just as in the market-based financing of the arts, a close connection between values used in the domains of production and distribution is of great importance if aesthetic values are to be realized. Finally, subsidies are also provided in the reception domain, particularly to schools to enable (cheaper) visits to aesthetic events. Clearly, the direction of subsidy flows cannot always be determined precisely; think of money going to a company to educate its audience, or a subsidy allocated to a venue for discounts on tickets for youngsters and elderly people.

Each type of funding for the functioning of art throughout the three domains has its own effect, although we do not as yet fully understand the differences be-

tween them. The various systems of arts financing in the US on the one hand and on the European continent on the other do show in general how a market-based system generates a broad supply of comfortable forms of art, except in the biggest cities where a potential audience is available to finance the renewals. However, a subsidy system as on the European continent supports the production of challenging forms of art and brings about a situation wherein only a proportionally small part of a population makes use of the arts. The latter cannot easily be corrected by changing over to a market system but rather asks for a stronger connection between the different domains.

In summary it can be said that three parameters help to describe how ways of financing the arts help them functioning. The first has to do with the *values* at stake in various forms of this system. In principle, all types of values elaborated upon in part two can play a role in all types of financing but there is a tendency in patronage and market systems that intrinsic values of art have a weaker position than extrinsic values and the functions they serve. Intrinsic values are best guaranteed in the simplest form of financing, by jobs on the side and familial support, but some subsidy systems are fully focused on the intrinsic quality of art and its development. In other cases, state support is based on a mix of intrinsic and extrinsic values, legitimated by the functions served by them, or strongly oriented to help art realize extrinsic functions such as economic growth, or the increase of social coherence or local identity building.

Thus the first opportunity to understand the conditioning role of a financing system is always to determine the values it works with, not only in its discourse, but in its measures and means as well. It goes without saying that the question of values is strongly connected with the second parameter, the extent of *aesthetic freedom* a system offers. On this point as well, although all types of financing can deliver optimal freedom, we have seen previously that jobs on the side and familial support indeed leave the artist totally free to do what he or she likes to do, but mostly do not deliver the means to use this freedom optimally. Patronage and sponsorship are typically forms in which the aesthetic freedom is an issue to be negotiated. Sometimes the aims of both parties match completely but in many other cases one of the parties, or both, have to compromise. It is often said, especially by artists who do not benefit from subsidies – but, for instance, by Abbing as well – that the same holds for the subsidy systems. Theoretically speaking, this is not the case because the basis of arts financing by subsidy is the recognition of those values of art which, determined by the autonomous art system itself, cannot be realized via the market. Fortunately, of course, these values can often be linked to the interests of the subsidizing authorities but that is not the same as what happens if the subsidy system is corrupted by a predominance of the extrinsic interests of these authorities. In those cases, the subsidy system

as a sub-subsystem of arts financing does not function according to its usual dynamics.

The market system, finally, is seen by many people to offer freedom. Apart from the question of how free people can be in a fully market-based environment and its predominant sets of values – luckily just artists belong to the group capable of escaping in part from this predominance – this is indeed true as long as the market offers the artists enough of an audience to pay for their work and living expenses by buying or visiting the work artists like to make or show. If not, artists have to change their work, which means dealing with their aesthetic freedom, or to find other forms of income, or to stop working.

The third parameter concerns the way in and the extent to which a financing system helps the arts to *realize their values*, which has a quantitative and a qualitative component. The first concerns the number of participants of various social groups that are involved in aesthetic communications as well as the frequency of their aesthetic activities. The qualitative aspect describes the type of communications in which people participate, the use they make of it in their lives and the role they play in their social environment. A decisive shift from subsidizing the production of art to the distribution and reception of art can be imagined here, although in many countries and/or disciplines, the distinction between both domains cannot easily be made. But subsidizing galleries, schools or factories to buy and display artworks or to employ visual artists, musicians or theatre companies to make and show their work regularly in and around their buildings is an entirely other system, with indeed outcomes other than granting subsidies to the artists themselves to make their work. What plays an important role in this distinction is that subsidizing the production of art does not guarantee its societal use in any way; and that, the other way round, subsidizing distribution does not say anything about which types of aesthetic values will be distributed and realized. The latter becomes clear if one knows that sponsorship and market-based financing mostly take place in the domain of distribution, where the demand of potential audiences has at least the same (but often more) influence than the aesthetic values on hand. Because the realization of aesthetic values, however, always goes through distribution processes, systems that finance these have in principle a bigger chance to help art realize its values (albeit often only specific ones) than systems that are especially oriented to the financing of art production. Financing combined production and distribution processes, theoretically, will give the best results, because in that situation the three parameters – *type of values produced*, *aesthetic freedom* and the *realization of the values concerned* – can best be related to each other.

Figure 8.1 shows an effort to compare some conditioning differences of various financing systems.

Figure 8.1 Conditioning factors in different financing systems in terms of aesthetic freedom and societal distribution of aesthetic values

	Freedom of aesthetic production	Types of values produced	Realizing aesthetic values in society
Jobs on the side and family support	No other restrictions than lack of time or means.	What the artists are interested in	Difficult access to audiences other than inner circles of friends and colleagues.
Patron or Maecenas-based financing	The patron only pays for the production of values he likes and in doing so possibly restricts the aesthetic freedom.	What the patron and artists agree about.	A patron determines whether and how the values can be used publicly.
Sponsorship	In principle the contribution is only a part of the costs the art organization has to make. So, this organization is free to choose for this support.	What artists look for (except fully sponsored situations but those can better be considered commissioning or buying).	The sponsor pays for reaching public in such a way that his name or image is communicated in a positive way. Good public access is guaranteed.
Market-based financing	Aesthetic freedom only reigns in an environment of big, well-monied and well-educated audiences.	Experimentation is threatened (except in bigger cities with enough well-educated and well-monied audiences).	Building up an audience for contemporary forms of art can be difficult.
Subsidy	Artists and companies are set fully free to develop their aesthetic languages, within the variable frames of cultural-political criteria	Artists are supported in their playing with form and in shifting the borders of imagination. Venues can be subsidized to serve a specific aesthetic taste or the needs of many different parts of a population.	Artists seldom actually need an audience to survive and work. Subsidized venues are supported to help aesthetic values be realized in the community and to build up audiences for the artistic work offered.

8.3 Political-juridical conditions

Because the judicial system generates types of communications (based on the binary code of what is right and what is wrong) other than the political system, in which communications are related to power, Niklas Luhmann considers both systems fully separated, although necessarily structurally coupled.[5] This coupling is indeed continuously happening because in democratic countries the parliament is the legislative power, whereas laws are maintained and enforced by the judicial or legal system. Hence the question of how a political system conditions the production, distribution and reception of art has to be answered in political-juridical terms, or in other words: the political conditioning is organized in juridical communications.

The three categories that help characterize various economic conditions – freedom of the artist to observe; types of values produced; and types of values realized in society – are also at stake in the political-juridical conditioning of art production and reception. The first of these categories, and in legal terms the most fundamental, has been laid down in constitutions of democratic political systems in the form of 'freedom of speech'. Although censorship is abolished in this type of system, serious restrictions are built into most constitutions through another fundamental right that regulates the protection against insult, especially to prevent people or organizations from being offended against in their basic rights of equality of gender, religion, race and sexual orientation.

It is especially the balance between freedom of art – or, better, of artists to produce their observations – and the injunction against insult that is not always found and probably cannot be found automatically by all parties concerned. Moreover, this balance is not clearly guaranteed by the law itself, so it is up to the judiciary system to find it time after time, as became very clear in recent debates on aesthetic utterances felt by believers to be insults to their religious values. Here again, the coupling between the political and judicial systems demonstrates itself as inevitable, for instance in the struggle surrounding the permissibility of wearing headscarves in Turkish universities in 2007 and 2008. Something similar happened when the former president of Pakistan, Pervez Musharraf, dismissed a group of judges, who promptly returned to their seats after Musharraf lost the election of 2008. In these types of cases, political decision-making and constitutional judging compete for priority and show the limits of the democratic separation of powers – the legislative, the judicial and the executive. A strict separation between religion and state appears to be an even more necessary condition to guarantee the freedom of aesthetic production; this freedom has particularly suffered and sometimes still suffers, even in democratic countries, from religious dominance within a culture. That is not only the case in countries with an official

state religion, but also where cultures are strongly riddled with religious values and conventions. For instance, in historical terms, Calvinistic-influenced cultures have problems with the performance of plays, which is still observable today in the proportionally smaller distribution of children's theatre in Protestant schools than in others, at least in the Netherlands.

In general it may be said that the greater the separation between the three mutually independent state powers on the one hand, and a similar separation between religion and these powers on the other, the more the freedom of aesthetic production and distribution is guaranteed.

The judicial system provides the artist with a second broad set of rights, based on the concept of 'intellectual ownership'. Artists are the owners of the aesthetic concepts realized in their works. This means that their works may not be copied without their permission. In this way artists are protected against misuse of their work by others, but in the first place intellectual ownership helps them to earn money; in many cases – in literature, theatre, music or film – artists want their works to be copied or replayed as often as possible, not only because of the distribution of their aesthetic values but certainly because of the royalties they receive in exchange. This part of the judicial system is more linked to the economic system than the political system and has been extended in various directions over the last decade, particularly due to the increasing cultural predominance of image over text on the one hand and the digitalizing of communication on the other. Especially musicians, and theatre and film actors have, at least in Europe, achieved the goal of getting a fee each time a concert, performance or film they play in is broadcasted (known as 'resale rights'). In the same decade, a comparable achievement was reached by visual artists, who receive a percentage of the sale price each time one of their works is retraded.

Intellectual ownership and resale rights primarily serve economic goals. They are political-juridical regulations that help artists and other creative people earn money under the economic conditions of the free market as discussed in the previous section. Conversely, the fact that, and the ways in which, these financing systems are regulated also condition the production and distribution of aesthetic utterances. Protected by a set of legal rules, the artist in principle becomes a more independent and equal party in the economic discourse with producers, buyers, audiences, distributors, each with their own interests. In addition, aesthetic freedom grows as soon as more ways of making money out of an aesthetic practice come into being. However, a certain economization of aesthetic practice occurs, a kind of merging of the artist in the economic domain, with the possible result that the most powerful parties in this domain 'automatically' gain more influence on aesthetic production and distribution. This holds all the more true if artists are dependent on the workings of the

free market, which brings us to the most important political-juridical condition of aesthetic production, distribution and reception: the presence and nature of a politics of art.

Whereas the freedom of aesthetic production is protected by the judicial system in the first place, and the societal realization of aesthetic values is organized through the art system's links with the education and the social life systems – as will be discussed in chapter 10 – the political system conditions the production of aesthetic values in particular, through the presence or absence of support for the arts by governmental or other authorities and their ideological backgrounds. A political system that gives no support to the arts whatsoever leaves production and reception simply to the dynamics of the free market, but it will be clear that those types of political systems are not found in economically and culturally developed countries. All these countries maintain at least a national museum or gallery, often a theatre or a concert hall, and most have an elaborate subsidy system as well.

The most important questions are a) which types of production and/or reception values are supported and b) which types of subsystems organize this support? To help answer the first question three distinctions need further investigation: a1) between art that generates comfortable aesthetic experiences and art that generates challenging aesthetic experiences; a2) between intrinsic and extrinsic values; and a3) between the value of the arts for the arts on the one hand and the value of the arts for users and society on the other. To find answers to which types of subsystems condition the production and reception of which types of values, three additional topics must be studied: b1) the distance between supporting authorities and the supported field; b2) the advisory system; and b3) the form and extent of decentralization.

8.3.1 Types of values

Since the 1970s a certain fear has crept into policy documents against use of the term 'art'. Instead, the notion of 'culture' became very popular and often in the space of one document, authors shifted from art to culture as soon as an explanation of the first was needed but was too difficult to provide. Art was often hard to define since it was identified with the elite and politicians felt that all social groups had their own forms of aesthetic expression and experience which, however, could not all be called 'artistic' in the sense in which they usually understood this word. The solution found was to use the terms culture and cultural policy and often in one and the same breath 'art & culture', which seemed to make an understanding of distinctions unnecessary: distinctions between culture in a broad or narrow sense; between aesthetic and other cultural utterances; or between ar-

tistic and other aesthetic values. Specific features of different types of cultural values and their functions in people's lives disappeared in the melting pot of cultural democracy. Undoubtedly this development was part of and supported the emancipation of social classes and groups, but probably it did not automatically lead to democratization in the cultural domain. What did happen by the substitution of the notion of art and its specific values for the term culture, was that the *power of imagination*, as used in artistic communication, was deprived of its societal functioning. Typically cultural behaviour and identities of emancipating sections of the population were indeed recognized, but at the expense of a loss of the necessity to develop the imaginative powers that 'makes the possible other imaginable through a play with forms'. To give aesthetic production and experience a better role in the distribution of democratic power, the notion of art should not be extended to culture but should instead focus on what challenges perception and develops imaginative capacity.

With regard to what has been discussed in the second part of this study, the distinction between comfortable and challenging aesthetic experiences in particular has disappeared from political discourse, whereas in theoretical discourse the old-fashioned concept of high and low art has been overcome by the insight that every aesthetic discipline is able to generate more comfortable or more challenging aesthetic experiences. In the same way cultural policy can vanquish the antithesis between cultural democracy and the democratization of culture by supporting the production, distribution and reception of those aesthetic forms that generate *artistic* values for various parts of a population. Clearly this is not the same as a 'something-for-everyone' policy or as a 'true-art-is-recognized-by-all' idea. Cultural democracy asks for differentiated and specified *artistic* programmes, which of course have to be developed in the field and supported by cultural policy. A policy that expresses itself in the general sense of culture supports the cultural status quo, which means the use of art and imaginative capacities by the well-educated and the awareness of their own cultural identity (which often means a re-experiencing of traditional values) by the less educated.

A second tendency in cultural policy, particularly after 2000, is the legitimization of state support for the arts with the help of extrinsic functions, of which social cohesion on the one hand and economic benefits on the other, are the most striking ones. The latter cannot be seen separately from the publications by Richard Florida who has convinced politicians all over the world that there is a highly causal relationship between the presence of a creative class and economic flourishing. Apart from the fact that a certain size of population and degree of economic production in a city or region is required to realize this relationship, the notion of 'creative' as used by Florida is many times broader than the term 'artistic'.

It more or less corresponds to all the activities of people working in branches where they have to make use of their brains in not such a conventional or standard way but more in a developing and flexible way (thinking 'outside the box'). These branches include the aesthetic and the educational fields but are spread largely over the various service industries in which more than 40 per cent of the population of industrial countries finds a job nowadays. So, legitimization of cultural policy on the basis of economic benefits generated by the presence of a creative class does not necessarily meet the development of artistic activities, although, of course, the need for artistic experiences among 'creative workers' in the sense Florida means is greater than among people who are trained in (and enjoy) standardized patterns.

Other economic motives, such as employment and economic spin-off of cultural investments, have been used since the 1980s to stress the significance of culture and its governmental support. But these approaches also suffer from an overly generalized character, and more than that, if they indeed hold out in comparison with other branches, especially in times of a flourishing economic situation, employment and economic benefits particularly increase in the field of comfortable forms of aesthetic production and reception. This does not mean, however, that the production and distribution of artistic communications cannot match any economic benefits. Any place that establishes an art museum, a theatre company, or a poetry or film festival with a strong artistic reputation can profit from a public that comes from everywhere to experience the artistic values on offer. And of course local authorities can support this relationship, but it has to be said again that most cultural tourism policies do not distinguish between the economic benefits of comfortable and challenging aesthetic supply or, to put it in another way, the extrinsic and intrinsic values of art are usually not coupled.

Something similar, although to a lesser extent, holds true for the other group of extrinsic values, or functions, brought up in cultural policy documents: social cohesion, inclusion, identity building and so forth. Of course these types of social benefits can be attained with the help of many other values besides aesthetic ones, such as by participating in sports; playing all types of games as long as they require more than one player; membership in clubs and meetings in pubs. But there is something in aesthetic communication that offers a special value indeed: its 'aboutness' in the first place, and, in the case of artistic communication, the play with forms that changes the perception of what the communication is about. The aboutness of aesthetic communication helps people be more or less aware of themselves or experience themselves as 'participants' in something on a thematic level, not just because the matters in question are of any importance for them and their environment, but also because the form of these matters fits with the way in which the participants like perceiving them. If, however, this

aesthetic communication acquires an artistic character, which means that the play with form brings the user to unfamiliar fields of perception, social cohesion or inclusion and social-identity building seem to be threatened rather than supported. At this point of distinction, most writers of cultural policy documents and politicians themselves simply give up. Their focus is on strengthening what people already have in common, often based on cultural-historical backgrounds, whereas artistic communication in principle challenges what is known, the conventional, the familiar. Nevertheless, if politicians are to take the role of art in society seriously, they should at least recognize the possible connection between its intrinsic values and the social extrinsic functions they like to ascribe to it. In other words, they should appreciate that the challenge of familiar perception schemata through artistic communications can contribute to the investigation of social identities, strengthen social cohesion or generate new social formations. So, in this sense, the core value of artistic communication – making use of and developing imaginative power – can in its characteristic way contribute to what usually is considered an extrinsic function, namely the *investigation* of social cohesion and identities. The best results on this point can be realized in aesthetic events with a strong collective character, such as concerts and particularly theatrical events. In the latter type, matters play an important and often quite central role, at least in the audience's opinion, and spectators are more or less explicitly linked to one another in the theatrical communication. Although it has to be said that contemporary performances in conventional theatres increasingly focus on the individual reception of the play, other types of events, such as target-group or site-specific theatre, offer circumstances in which the social and spatial factors can work more adequately in this respect. This is most clear in forms of theatre in which the audience 'participates' in the production of a performance, as is the case in Brecht's *Lehrstücke* ('learning plays'), but can also be found in Augusto Boal's forum theatre and in all types of community-based theatre. These forms of art show that serious art politics have to be based on detailed insights in how diverse values and functions have to be realized through various types of art used in different types of aesthetic events. The more politics are formulated in general terms, the fewer conditions it offers for new types of production and reception of *art* and for new ways of helping the arts function in society.

Finally a third and very rough distinction can be made between art politics that focus on the art world itself, and politics that look after the role of art in society. The first policy supports *artists* in the first place and in particular the continuous development of their language. In the second case it is not the artists themselves who earn the primary attention of the authorities but rather the functioning of their works for audiences. The strange thing is that both attitudes are felt as contradictory and this is precisely because a distinction be-

tween comfortable and artistic communication is not made. In the artist-based policy authenticity, quality and originality are the key terms, whereas in the society-based policy participation, art education, and cultural diversity are at stake, one-by-one all terms clearly not inconsistent with the first group of notions. To bring both ways of thinking together requires an understanding of the different values of various forms of aesthetic communication. Then conclusions can be drawn for the production and reception of the values desired in creating conditions for supporting the artists, or for organizing the reception of the art, or for the integration of both. Only then can the next step be taken: to look for adequate systems to condition the production and realization of the values considered worthwhile.

In fact, all these different values supported by aesthetic politics can also be found in juridical communication. Dutch jurist Frans Hoefnagel wrote a study for the Scientific Council for Governmental Policy (*Wetenschappelijke Raad voor het Regeringsbeleid*, WRR) in the Netherlands about the juridical basis of cultural politics entitled *Cultuurpolitiek: het mogen en het moeten (Cultural Politics: What Is Allowed and Required)*. He discerned five fundamental 'rights' upon which the politics should be based: freedom, equality, multiformity, development of personal abilities, and quality. The two first aspects can easily be linked to freedom of speech and the prohibition against discrimination and hate speech, as discussed above. In addition, equality also means that all people have the same right to participate in cultural communication. As will become clear, a contradiction can occur regarding the aspect of quality. The next two elements, multiformity and personal development, concern the *use of art* in the first place and are strongly related: 'a multiform culture enlarges the possibilities to learn from each other' (Hoefnagel 1992: 46). Figure 8.2 presents an overview of choices found on the level of values in the political-juridical domain.

These elements can be understood as the juridical expression of an society-oriented aesthetic policy in which *artistic* values have to be realized. Finally, as stated earlier, quality can be in conflict with equality because it is linked to the typical character of an art work in the first place and an important aspect of an art(ist)-oriented aesthetic policy. Such an art(ist)-based policy can easily bring the multiform character of cultural life in danger but, according to Hoefnagel, these can 'be reconciled with one another, if the government installs different systems of quality judgement in different domains' (1992: 52). He is right, on the condition that the type of quality – in the terminology of the present study, the types of values – is formulated as precisely as possible.

Figure 8.2 Main choices to be made in art politics as conditions for the production of different values

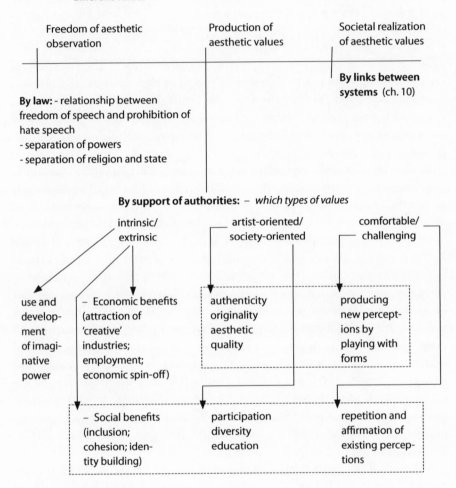

8.3.2 Types of supporting (sub-)systems

Only formulating choices in what values, goals and functions of art will be supported is not enough to realize them as well. For that, the specific working of the supporting systems is needed. The four key aspects mentioned above can help to discern the differences in such subsystems: the distance between authorities and the aesthetic field(s); the way in which the judgement of the work to be supported is organized; the form and extent of decentralization in the system; and the relationship between the authorities and various domains in the field. As far

as the realization of aesthetic values in society is concerned, the ways in which the links with surrounding social systems are organized is fundamental, and this will be discussed in chapter 10.

THE 'ARM'S LENGTH' PRINCIPLE

In most democratic countries, a form of the 'arm's length' principle exists, which means that the supporting authorities maintain a certain distance from the field that they support. The arts council model is the best-known example, albeit rather variable. In this model, the government makes a sum of money available to a body that, for its part, divides this money autonomously among applicants. This means that the political authorities cannot intervene in the decisions the council makes, at least not directly. However, it is very possible – and is indeed what they do – for the authorities to formulate a framework of goals and criteria that the council has to make use of in the process of allocating the money. Afterwards, the functioning of a council can be evaluated in the political arena on the basis of this framework. In this sense, the differences in support systems can be found in the typical values and functions formulated in such frameworks on the one hand, and in the extent of strictness of the frameworks and their maintenance on the other. These politically based frameworks are for many governments the most important means of executing their policy in the field of arts. Josh Edelman (2009) shows very clearly and thoroughly how this happens by taking Ireland as an example. For instance, the Arts Council was expected to execute the Irish government's arts plans from 1993-2004 but even so, during elections, political parties can promise to support certain arts institutions via the council, should they come into power (2009). Edelman is right in questioning the autonomy of the council, despite the formal arm's length distance between the arts and the political field, as created by an arts council model.

The delicate relationship between governmental politics on the arts and arts council activities reflects the common conflicts between designing a system and making it work but, besides this, the delicacy is based on the different position that can be occupied on a scale from autonomy of the arts to their societal functioning. As we have seen, neither contradicts the other – rather, a real functioning of art can be based only on its autonomous way of observing reality – but supporting systems can accentuate or be directed to 1) the development of artistic languages; 2) the development of a population by means of artistic communication; 3) something in the middle or a combination of both. Usually it is the council that has to watch over the space for artists and arts organizations to produce autonomous communications, whereas the government often feels responsible not only for the working conditions of artists, but for the use of art in society as well. In principle both positions can fit in quite well, but in practice, the support

of artistic production as such has come under more pressure since governmental arts policies use more extrinsic values and functions to legitimize their financial support. Of course, the same 'conflict' does not need to exist between council and government; it can also arise in the bosom of the council itself, or does not exist at all, if a correct balance exists between the production and realization of values on the basis of a cultural policy. The council model is in principle meant to guard the balance but the aspects built in a system that disrupts this balance can help increase a societal use and functioning of aesthetic but non-artistic communication (with a lower degree of autonomy of the council). Alternatively, other organizational aspects can help the production of new artistic perceptions to be used by a relatively small inner circle (with a higher degree of autonomy of the council). One of the aspects is the proportion of money spent, on the one hand, on art institutions with a guaranteed position in the field (such as national theatres, museums, or orchestras), often financially supported for more years or, on the other hand, on new projects and artists, often financed for the duration of the project. It is not totally illogical that a shorter period of financing and a smaller proportion of the available amount is connected with what is relatively new in the field because from a governmental point of view this 'small money' is an acceptable risk. Especially the *total amount spent* on new developments in art, in proportion to what is allocated to the established institutes, says something about the hierarchy of values fostered by a government or council.

In periods of big cultural change, as happened at the end of the 1960s in Western Europe, or around 1989 in the eastern part of Europe, this type of aesthetic value conflict came to the fore. It concentrated on the relationship between national or local institutions and independent groups or artists who all wanted a slice of the cake. By that time the bigger institutions in many countries were not subjected to anything such as a council judgement, but were state or city organizations or institutions that often employed numerous artists and other people. Various developments rose from these historical moments, which evidently changed the relationship between the political and the aesthetic field. In the first place most countries in such circumstances installed a new form of subsidy for the newcomers – a specific fund, just as autonomous as the independents who applied. The amount of money available is always a fraction of what is spent on the established institutes. In fact the financial support system unfolded itself in several forms: Still present is a (big) part of the aesthetic institutes that are 'owned' by the authorities; a second part consists of private organizations subsidized directly by the state or a city (maybe advised by a council); and a third group of organizations or individuals is indirectly supported by the authorities through a fund (often called a council as well). A certain shift from the first to both other forms has taken place in Western Europe since the 1970s and in Eastern Europe

since the 1990s, which is important to note, because the government or city-based institutions demonstrated a kind of tendency to become more or less rigid, in an aesthetic as well as in an organizational sense, in times that asked for renewals. This 'fossilization' was caused by, among other things, the large amount of permanent (meaning lifelong) contracts with artistic personnel, the long, often bureaucratic lines of decision making and the influence of established 'public taste', represented by audience organizations or the authorities running the institutions.[6]

An important aspect of the relationship between the political and the aesthetic fields is the way in which the authorities like to have themselves represented in the institutes they support. In some systems it is definitely not acceptable to have the authorities represented on the board of subsidized organizations by politicians or civil servants. This is based on a strong tendency to keep the subsidizing and the subsidized bodies separated. The opposite takes place, however, in systems where the competent authorities of state or city-owned organizations are automatically fully responsible for the aesthetic policy of the institute. And in directly subsidized organizations, finally, various forms of representation of authorities can exist. In some systems the authorities deliver members of the board, sometimes the majority of them, sometimes as observers, sometimes as fully responsible members. These factors determine the extent of influence the political field can exert on aesthetic practice through their presence on the board of aesthetic institutions. Also the form of governance plays a role in this. Political authorities can be represented on the board of a subsidized organization and in that position be responsible for its aesthetic policy. But in a model that is gaining ground, particularly for bigger organizations, a supervisory board looks over the shoulder of the board that is the competent authority and has the juridical relationship with the subsidizers. It makes a real difference whether the political field is represented on the level of the competent authorities of an organization or on the level of the supervisory board that only has the power to control.

Besides the change in financial and judicial conditions, a change *within* the established institutions occurred, particularly in theatre. In Sweden, for instance, the number of permanent contracts with actors was limited, and in Germany the independent groups (*Die Freie Grupe*) were increasingly considered a breeding ground for artistic talents, who indeed took over the leadership of the city theatres from the 1970s onwards. Nowadays, as a result, important artistic renewals can very well come from established institutions, as is the case in, for example, the Nordic countries, the German-speaking countries and the Low Countries. For instance, the Netherlands is a country where until 2008 the authorities did not operate at a full arm's length, nor did they act as owners of the aesthetic institutions. Almost all art organizations were autonomous foundations and many of them were awarded subsidies from the state, the provinces, or the cities, *based on*

the advice of an art council, which in essence did not distribute money, but advised the authorities on how much money they should allocate to which organizations. In this system the government also provided the arts council with a political framework for the arts to be used by the council in its advisory work. In principle the authorities might deviate from the advice given, relying on other aesthetic considerations (something definitely 'not done' in the Dutch political tradition), or they might correct the direction of the advice according to their political arts framework. So, besides the concepts of state ownership or arm's length funding, here we see a third type of relationship between the political and the aesthetic field characterized by direct financial support from the authorities with the help of advisory bodies. It has to be said that the Dutch system is in transition today, precisely because of the rather high extent of direct intervention by the state in the art world. From 2009 onwards, the government's direct financing system will only be used for cornerstone institutes of Dutch cultural performance or those that form part of what is being termed the 'basic infrastructure'. If these do not function well, they will not lose their position, only their artistic management. In addition to this part of the system, however, the national support system has various funds (for film, visual arts, performing arts, writing, etc.) that autonomously distribute money among applying artists and art organizations. The total amount of all these funds is about 25 per cent of what the Department of Culture spends directly on structurally subsidized organizations, advised by the Arts Council. The other way round, the Council serves no more than 25 per cent of all subsidized professional art organizations.

As said above, the financing of art through subsidies instead of ownership (or patronage) is becoming dominant in democratic cultures; it reflects the autonomy the aesthetic field has achieved in the process of functional differentiation. This autonomy is always of a relative kind and it can be questioned whether direct financial state support to the arts on the basis of council advice strengthens the heteronomous powers more than subsidization through autonomous funds does. In both forms, the money-providing authorities have the option to intervene in the appointment of the advisory council or fund management; in addition, they formulate policy documents as frameworks for decision-making on councils and funds. These frameworks can be either very open or very strict and shift with the political climate. Nevertheless, it can be expected that political influence and hence the influence of extrinsic motives are stronger in the case of advice-based direct subsidization, because in the end the decisions are made in the political field, whereas in the other case the 'independent' council or fund can operate more autonomously. Much depends on how the relationship between councils, funds and the aesthetic field is organized.

THE ORGANIZATION OF THE AESTHETIC JUDGEMENT

In almost all support systems in democratic countries something like the judgement of aesthetic work has to be done. As we saw above, this can happen in the subsidizing authorities whose civil servants decide which organizations will or won't be supported. Often a council, a committee or a fund is installed to advise or to decide on this. Three aspects play an important part. In the first place, the proportion between different criteria – to be distinguished in aesthetic and functional ones; in the second place, the composition of the judging instances; and third, the public nature of judging, concerning the criteria, the structure of the process, the composition of a committee and the judgement itself.

Figures 7.2, 7.3 and 8.2 show the various values and functions the arts can have for users and communities. In judging aesthetic communications – mostly plans and concepts for them – the criteria are based on these types of values and functions. This holds for the level of cultural political frameworks authorities deliver, as well as for the level of the judging process itself. And it will be clear that the choices made on both levels determine strongly, even fundamentally, the influence political support has on aesthetic communication in a city or a country. Key to this is *the choice between aesthetic and functional criteria*. The first group concerns the intrinsic values of aesthetic communications and is often linked to the notion of quality. What is meant is the aesthetic, more precisely artistic, quality, although this notion is rarely made explicit. As stated before, in recent decades in particular, politicians and even scholars tend to avoid making a distinction between aesthetic communications in general and artistic communications as a subset of them. One of the reasons is that the nature of aesthetic quality, in the sense of the *qualitas* of experiences based on aesthetic communications, not only depends on the aesthetic utterance, but certainly to a great extent on the activity of the recipient as well.[7] Precisely this has raised the barrier too high for many politicians and scholars to be willing to understand the specific values of artistic communication, which can only be understood, indeed, in the light of differences between tastes and competences of people on the one hand and the possible values of specific aesthetic (sub)disciplines and their utterances on the other. Nevertheless, as became clear in the second part of this study, a distinction between the values of different types of communication on the level of experience is not superfluous, if the role of art in the life of people or in a community has to be formulated, which is the case in art politics. So, speaking about aesthetic criteria in the judging of plans, concepts of works, their specific *qualitas* has to be understood and the quality level on which the works deal with this *qualitas* has to de defined.

In addition, judging committees have to deal with functional criteria. Those are not exactly the same as extrinsic ones. Rather, these criteria involve the ways in which possible aesthetic values of works of art are (planned to be)

realized in the reception, on an individual level, but in light of the relation-
ship between the political and the aesthetic field, on a societal level in the first
place. In other words: how are the aesthetic utterances organized so that they
do what they are expected to do? Important aspects in this area are the reach-
ing and building up of audiences and the embedding of aesthetic communica-
tion in the life of people and communities. Indeed, this can easily be confused
with the demand for extrinsic values and functions especially, such as social
cohesion and inclusion of people, or social education as such. The difference
is that extrinsic criteria are not bound with intrinsic aesthetic values, whereas
functional criteria are. It is conceivable that a support system develops in the
direction of dominant functional, or even extrinsic, criteria – as is true at the
moment in the UK, for instance, where museums are strongly monitored re-
garding their contributions to social cohesion – or that aesthetic criteria nearly
have hegemony in the judging process – as was the case in the Netherlands
until recently. Support systems can try to develop criteria which help to create
a social-aesthetic balance. This balance cannot be based on compromise, for
example by asking artists to be a bit less artistic, so that more people can enjoy
the work. No, artists have to do their work as artists, and be set free to create
new perceptions. It is the distribution domain that has to organize the events
based on this work through which the artistic values derive social existence, as
will be dealt with in chapter 9.

Based on the aspects discussed above, some guidelines and questions can be
formulated for the judging of aesthetic communication in the light of a search for
a social-aesthetic balanced support system:

1) The possibility for artists to autonomously create artistic perceptions has to be
 guaranteed;
2) How far may politics and politicians be involved in the assessment of the artis-
 tic quality of aesthetic utterances?
3) The values artists and art institutions have to realize in society and the func-
 tions they have to fulfil have to be determined as precisely and verifiably as
 possible;
4) The core of this determination is the type of relationship between the cre-
 ation of aesthetic values on the one hand and the realization of this value for
 a community on the other. An art system as a whole has to be balanced in this
 respect; parts of a system can be 'unbalanced' on purpose;
5) The various responsibilities and roles of artists, art institutions and support-
 ing institutions have in an art system have to be determined and formulated;
6) An art system that enables art to function in society needs to organize a quan-
 titative and qualitative proportion between free production of art and the in-
 stitutionalized use of it.

It will be clear that, in the judging of aesthetic communication, criteria related to the production of art and to its distribution must go hand in hand. This relationship is not automatically present in all types of support systems, which is partly connected with *how judging organizations are composed.* Three types of members can be discerned in general and the proportion between them is related to the quantitative power of kinds of criteria in the judging process. At one pole is adjudication by peer artists. Advisory committees consist of artists who know (the history of) the field very well and have a strong reputation so that their judgement can be accepted by their judged colleagues. This group almost always concentrates on aesthetic criteria formulated in terms of artistic quality, in which professional skills, originality and expressive power fight for priority. At the other pole we find politicians or their representatives, who can be very respectful towards these aesthetic criteria, but have a certain interest in the societal outcomes of the whole system, rather than in the aesthetic output as such. In between, a mixed group of 'mediators' can play a role, consisting of people who work in other domains of the aesthetic field than that of production, such as managers of venues (who are especially interested in relationships with audiences), critics (partly very familiar with and interested in the art forms as such, partly taking the position of less-informed audiences) or very experienced representatives of audiences (who walk easily among artists because they cannot compete with them on the basis of their own specific expertise). Although the aesthetic point of view has a 'natural' dominant position in such committees, because all members share a respectful attitude towards the arts and the specific knowledge artists have of them, it will be fully clear that the composition of advisory or deciding teams has a serious influence on what is supported, how that happens and hence which type of aesthetic output the support systems helps generate.

Finally something can be said about *the public nature of judging* aesthetic plans and works. It goes without saying that applicants for governmental support have the right to know on which criteria their work will be judged and how that will be done, although these criteria are not always publicly distributed or are formulated so vaguely that it is not clear what is going on behind the scenes. These criteria can be made public in policy documents or application guidelines, as is also the case for the names of the committee members. At the end of the process, applicants receive a written report, which contains the findings and conclusions of the judging organization. Particularly if the judgement is negative, financing organizations tend to formulate their motives with great care, since laws on public administration favour the artist in a dispute of the judgement. This leads in some countries to a 'juridification' of the entire judging process and hence to insubstantial reports lacking in detail.

Why should the public nature of judgement have any influence on the output of the judging process and hence on the aesthetic outcomes of the support system? Because the aesthetic field – actually artists and other people active in the field – is a party involved in the societal debate on the role of the arts, a party that brings in an indispensable type of expertise. This party cannot be excluded from the debate on the role that judging the arts has to play in the functioning of the arts in society. For this reason, one of the main questions is which role artists and their organizations should play in the whole subsystem of judging. Additional questions are whether artists should be excluded from the decision-making information on the concrete level of allocating money to aesthetic institutions and projects or, more generally, at the very least, the democratic quality of the system could be seriously undermined if there should be no public control on how judging committees or officials come to their results. Maybe the decisions should not differ directly, but with the disappearance of public control on favouritism, political deals, improper forms of the use of power, and so forth, the decisions might end up being very different.

Figure 8.3 Parameters concerning the organization of political support for the arts

Art institutions owned by authorities	Art institutions directly subsidised by authorities based on advice	Art institutions indirectly subsidised by authorities via autonomous fund (or council)
directed more at functional and/or extrinsic values (development of population)	*search for social-aesthetic balance (but at risk of too much political influence)*	*directed more at artistic and intrinsic values (development of the arts)*

But the proportion of values depends on:
- Framing criteria laid down by the authorities in policy documents and guidelines and their evaluation
- Presence of authorities in boards of institutions
- Organisation of advice processes

– *in supervisory board to control the management of the institution*	– *composition of judging instances*
– *competent authority in executive board as:*	• *artists (aesthetic criteria)*
• *normal member(s)*	• *mediators*
• *observing member(s) having a majority or not*	• *political representatives (functional criteria)*
	– *public nature*
	• *composition committees*
	• *processes and criteria*
	• *advice*

CENTRALIZATION AND DECENTRALIZATION

Annoyed by the inaccurate way the notion of decentralization is used in the po-
litical arena, Nobuko Kawashima tried to categorize the 'unsolved problems' con-
cerning this issue (2001). The first thing she did is to discern three types of decen-
tralization (cultural, political and fiscal) and to determine what the fundamental
differences are, with figure 8.4 as a result.

Figure 8.4 Three types of decentralization (source: Kawashima 2001:110)

Type of decentralization	Cultural	Political	Fiscal
1) *what to decentralize*	cultural opportunities	decision-making power	resources for the cultural sector
2) *with whom to be concerned*	consumers, but also cultural producers	public authorities	funders, funded institutions
3) *policy goal or measure?*	policy goal	policy measure, but also a goal	policy measure

The most typical aspect that makes the three types distinctive is the answer to
the question of what is decentralized: access to culture, the power to make deci-
sions or the funding of culture. These three do not go hand in hand automatically.
Cultural institutions can be spread all over a country, whereas the decision about
their functioning can still be taken on a central level. And, the other way around,
local authorities can determine what institutions in their cities should do or be
the legal owners of venues, without providing the biggest part of the funding.

Kawashima tries to link the different types of decentralization with the vari-
ous political values that have to be served by them. The most fundamental is
the search for equality, which means in this case that as many people as possi-
ble should have the same access to 'culture'. Unfortunately Kawashima does not
make an adequate distinction between culture and art, which particularly when
she starts talking about 'culture accommodating [...] different cultures into its
mainstream' or 'diverse cultures have been "domesticated" by the dominant cul-
ture'(2001: 113) makes her views somewhat less precise. If the notion of culture
is used in a very broad sense, it becomes difficult to imagine how some people
should have less access to culture than others, and even if the notion includes
amateur and popular aesthetic utterances, a community centre, television and
internet will be enough to provide everybody with an equal access to 'culture'.

Culture can best be considered here as aesthetic communication so that the underlying thought of cultural decentralization will be that everyone should have an equal access to opportunities to participate in this type of communication. And Kawashima's views will be even more important if related to the question of which types of values of aesthetic communication people should be given an equal opportunity to realize. If, for instance, everyone should have an equal chance to develop his imaginative capacities by participating in artistic communication, much more cultural policy has to be committed than the distribution of artists and institutions all over a country. These changes depend, as Kawashima emphasizes, on 'consumption skills' in order to enjoy the arts and culture, which one acquires through family socialization and formal education (ibid.). It has to be said that the presence of art organizations and artists will be a necessary condition for a population to develop the capacities mentioned. In this sense, cultural decentralization can be considered a condition, albeit an insufficient one, to realize aesthetic values within a community. And in this context it can be questioned whether a system that concentrates aesthetic life in one or several metropolitan areas, hosting 70 per cent or more of all the artists together, creates sufficient opportunities for the rest of the population living outside the cities (maybe more than 70 per cent of the total) to realize art's typical values by participating in artistic communication. Kawashima, as well, notes that it is a 'typical accusation [...] that the centre is spending too much in the capital city' (2001: 112).

This brings us to another often-discussed aspect, this time particularly connected with *political* decentralization. It has to do with the question whether cultural decision-making is in the best hands at the central, regional or local level. Opinions differ seriously on this point. Local politicians in particular hold the view that their knowledge of the local situation gives them a better position to determine what the community needs. Artists, however, are afraid that just this type of knowledge will be used to decide to support more-demanded forms of art rather than the originality artists are oriented towards. Whereas a more or less equal spread of artists, venues and art organizations over a population (i.e. physical decentralization) seems to serve the opportunities to participate in artistic communication, indeed, the decentralization of decision-making power in cultural matters does not necessarily do this. It is possible that decentralization of political power causes a reduction of artistic communications, in favour of other types of aesthetic communication, just because the smaller a population is, the smaller the autonomy of the aesthetic system will be as well and hence, the bigger the influence of the political system. In the end the scale of a city or region will be decisive, for two reasons: a) at a certain point the number of inhabitants is big enough to develop a sufficient demand for artistic communications;

b) possibly a situation has been reached at the same point wherein principles of democracy require a certain degree of political autonomy for regional or local authorities, in cultural matters as well. Only on this level will the local knowledge that politicians and civil servants are equipped with serve the organization of artistic communication.

Centralization of culture, in the sense of a containment – a lack of spreading – of artists and art organizations over a country seems to have at least three possible consequences for the functioning of the art system; in the first place, on the level of the artists themselves. Because of the concentration of many, maybe the majority, of artists within one bigger city, most will orient themselves easily to the (development of) the arts as such, rather than to their functioning in society. Second, this orientation, combined with the stronger autonomy of the aesthetic system, accepted by the political one, will easily result in specific types of aesthetic output, particularly appreciated by a well-informed circle. And third, on the level of outcomes, the realization of artistic values will be distributed unequally among the population and maybe this realization as such will be relatively limited in quantitative terms.

With the exception of the question whether an art system is more centralized or decentralized, the ways in which different aspects of a politically based funding system support the production and realization of various aesthetic values is summarized in figure 8.3. Key to this is the degree of explicitness with which the authorities formulate the values they would like to have realized. At the same time they have a say in this through their positions on the boards of institutions as well as in the judging instances. On top of that the authorities can appoint people to the boards and committees or approve the appointments of others. This is why the judging and funding organizations needed a certain autonomy as a counterbalance, as is the case with indirect support via a fund (often called a council) that operates autonomously on the basis of a framework of politically assessed and in general terms formulated values and criteria.

Notes

1 A distinction might be made between the functioning of art in a strict sense (the realization of its values) and in a broad sense (the realisation of its intrinsic functions).

2 Theatre scholars are discussing whether one can still speak of 'theatre' if audiences and players are not present in the same physical space at the same time. Cf. e.g. Nelson (2004) and Chapple & Kattenbelt (2006).

3 Speaking about his own career, he asks 'Did my course change because of the money the government had to offer? To answer promptly: Now I'm absolutely certain of that. Without this opportunity of subsidy, probably I should not have started photographing

seriously or my pictures would have looked differently. The same holds for my drawings. Should I have been a better, a more original or autonomous artist? I do not think so.' Abburg 2005: 30.

4 In practice, a market-based financing of art production can easily make a shift to a commercially based production, which means that the activity of artists is used to make (as much) money (as possible), so that the space for doing artistic research will become smaller and the genuine talents of artists may remain unused.

5 In *Soziale Systeme* (1984: 626-628) Luhmann puts this binary code of having power/not having power in perspective. On the one hand, he states that power is related to various types of communications in other systems as well. On the other hand, it is not always power that is at stake in the political system; rather it is an accompanying aspect of all communications in this system.

6 See Saro 2009 and Van Maanen & Wilmer 1998.

7 The notion *qualitas* is used here to describe the typical nature of aesthetic communications, particularly in terms of the intrinsic values they offer to be realised. The *quality* of aesthetic utterances refers to the level on which they offer these values, related to other works of art in the same subfield.

9 How Distribution Conditions the Functioning of Art

9.1 Introduction

Precisely because aesthetic utterances and users of them meet in the domain of distribution, for a clear understanding of this encounter and the conditions it places on the functioning of art, it will be necessary not only to investigate the organization of this encounter as such, but also to answer two other questions: a) what types of aesthetic communication are brought in by the artists, and b) who are the participants in the communication taking place. When these questions relate to the domains of the art world as a whole – including the domain of contextualization in which realized values are placed in systems other than the aesthetic one – a matrix as presented in figure 9.1 can be drawn. It will be clear that what happens in the first two domains – the making of art and the programming – conditions what occurs in the third domain: the realization of aesthetic values by audiences, resulting in the arts functioning in society. In the fourth domain this can lead to brief or lasting effects on mental, ideological or social structures. Figure 9.1 depicts a condition-result relationship, presented from top left to bottom right, in which the distribution domain plays the central role.

For that matter, the reverse relationship also plays a role. From bottom right to top left successful actions have a positive effect on a renewed cycle. The realization of aesthetic values requires a follow-up supply, for example, both from the distributor and the artist to be able to repeat or renew the experience. Furthermore, as figures 0.1 and 0.2 showed, all the domains to a certain extent presume the existence of one another. They are described in the figures as systems, which generate processes on the basis of organizational structures, which in turn generate output, be it in the form of an aesthetic utterance or an event or experience. The following section considers the realization of aesthetic values (in relation to the fulfilment of intrinsic art functions) as the intended result of what is organized in the distribution domain. This is why in this chapter the essence of an

art world is viewed from the perspective of the organizational structure and the processes in this domain.

Figure 9.1 Core questions concerning the conditions for the functioning of art in relation
 to the three domains of an aesthetic system and its context

	Production	Distribution	Reception	Contextualization
What	*What is made?* - matter-form rela- tionship - aesthetic position in the field	What is selected? *How is it offered?* - in time, space and context	--------------------►------►	
Who	Who are the artists? - characteristics of their education -oeuvre - generation - position in the field	*Who are the users?* - age - gender - education and competence - social background and function - mutual relation- ships	-----------------------►----►	
How		*How is the aesthetic event organized?* - the contact bet- ween audience and work of art - the contact bet- ween the audience and the artists - the mutual contact among recipients	*How does the au- dience participate in the aesthetic event?* - how does the au- dience make use of the aesthetic event - how does the audience interact with the artists - how do the reci- pients interact with the others	*Do the participants relate their aesthetic experience to other 'systems'?*
Effect			*Are aesthetic values realized?* - play with matter and form - production of new schemata of perception - sharing imaginati- ons with others	*Are functions of aesthetic values realized?* - development of power of imagina- tion and reflection - testing and deve- lopment of identity

9.2 The environment of the distribution domain

Distribution is defined here as the process of bringing potential users into contact with aesthetic utterances. The term distribution arises from the works of art which are offered or presented; viewed from the standpoint of the recipients this could also be described as the reception domain. There are two reasons why this is not done here. In the first place, a separate space has to be created for the organization of the reception. At the psychological level this relates to the type of 'mindset' which a potential art user could adopt in receiving the work. At a sociological level there may be said to be a level of aesthetic competence within certain population groups, distribution of aesthetic capital or imaginative capacity, which operate as conditions under which these groups take part in aesthetic communication. The distribution domain has no control over these conditions, but is affected by them and they have to be taken into account. In the second place, or viewed from a different perspective, given its central position in the system, it is necessary to distinguish the distribution domain from other domains, not least on a terminological level. Besides this, it has to be understood in a rather broader sense than as merely being concerned with making works of art available to an audience. What takes place in this domain is the societal distribution and allocation of opportunities to participate in aesthetic communication and, as a result, the realization by the participants and groups of participants addressed of possible values of an event.

Let us begin by placing the distribution in its context (fig. 9.2), in which, of course, the production and reception domains are most immediately apparent. But other institutions too have a stake in what may here be termed the *direct context* of the distribution domain: subsidizers and sponsors, advisory bodies, agencies, service suppliers and the media; the last to some extent more remote from the institutions which organize the distribution (e.g. theatres, concert halls, museums, galleries, booksellers, libraries, etc.) because although reviews and other forms of commentary by the media can have a direct influence on the production and reception of art, it is only in relation to these two domains that it has significance in terms of the distribution.

In the *indirect context*, in which no direct influence is exercised over the primary processes which take place in the distribution domain, there are, on the one hand, myriad suppliers of competing, or, from the point of view of the potential audience, replacement supply available; while on the other, there are also organizations into which people or bodies active in the sector have organized themselves, such as unions or umbrella organizations within the sector (e.g. theatre, museum or orchestra associations). Alongside them there are other institutions which provide for the training of the various types of professionals for the distribution domain.

Finally, there is also the wide area in which changes in society take place which naturally also have an impact on the aesthetic social system. The significance of developments in judicial, political, technological, educational, social and cultural subsystems can easily be imagined. Usually the influence of these systems is mediated by institutions which are found in the direct or indirect environment of the distribution domain. Changes in the political system, for example, have an effect on those receiving subsidies, whose relationship with distributors is in turn affected. The influence of important economic or social and cultural changes is often expressed through the reception domain, but the development of technology also has a direct impact on the production domain as well as on distribution organizations, which then have to ensure that their technical apparatus meets the demands of the producer as well as what competing suppliers have to offer.

Figure 9.2 The environment of the distribution domain

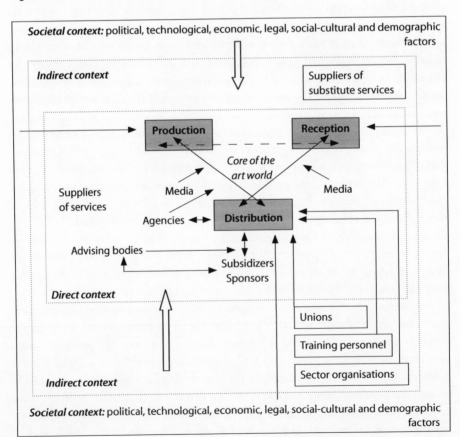

Before investigating the distribution system further, some details in figure 9.2 require some explanation. First of all, the arrows between the three domains which intersect where they meet show that the core processes in each of the three domains are, to a certain extent, based on the input of the other two. The degree to which this applies varies, of course; in parts of the production domain, artistic autonomy will at least keep the degree of outside influence in check, while in the distribution domain, the influence from the reception domain (the demand) will be significant in some cases. Furthermore, the domains of production and reception are connected by a dotted line; this is to indicate that, in any event, the output of the production (the artistic utterances) is never direct, that is, can never be received separately from any form of distribution. This would seem to be unlikely in situations where the production and distribution processes take place within a single organization (e.g. city theatres, studio-gallery combinations or self-published poetry), but in these cases too, different processes take place in both domains which, although carried out in concert, each have their own connections with other actors. The block arrows in figure 9.2 indicate the overall impact of the one context on the other with only the influence from outside in shown, because of the fact that what is being investigated here is the way in which these contexts exercise influence on the core of the aesthetic system. The dotted lines between various contexts just show that there is an open connection between them. Finally, it should be noted in this figure that numerous actors have links with the distribution domain but not with the other two domains, although they are active in the area around it. This has been done for the sake of clarity and because this chapter is essentially about the distribution aspect.

9.3 The primary process in the domain of distribution

Independent of the scale on which the function of the distribution domain is being studied (e.g. on the level of a museum department, one city theatre or on an institutional level, when the role of pop music stages or cinemas as a whole is concerned), there will always be the necessity to deal with the input of artists' work, on the one hand, and what the possible spectators are looking for, on the other. It is remarkable that artists and their agencies tend to supply their products and services far more empathetically than demanded by audiences. Although the latter make their preferences clear by attending some types of events and not others (or not attending aesthetic events at all), their choices are based on what is known and on offer, and not on a directed search to meet a specific 'aesthetic deficiency'. Almost nothing of the values and functions discussed in part two

plays a role on a conscious level when spectators choose to visit a play, a concert or a film. However, the questions of when and where something to someone's liking can be experienced play important roles in spectators' choices. And the 'when' and 'where' are precisely two of the core elements in the offer that not the artist but the distributing organization decides. This organization, which is responsible for the societal allocation of possibilities to participate in aesthetic communication creates its own offer based on its relationship with artists (or their representatives), and with the possible participants. The offer can be described as an aesthetic event within which people make use of an aesthetic utterance. The organization of events, in such a way that aesthetic values will be realized, can be seen as the primary process in the domain of distribution. The processes and its sub-processes museums, theatres or festivals carry out to produce aesthetic events, are fed by four different types of input: 1) the material, personel and facilitating conditions; 2) the supply of (types of) aesthetic utterances; 3) the presence of potential audiences in the environment; 4) the habitus of whoever is artistically responsible. These inputs, as presented in figure 9.3, will be discussed in the next four subsections.

Figure 9.3 The primary process of art distribution

9.3.1 Habitus and the primary process

The last of the four input factors is fundamental to the way in which the other three categories are assessed and deployed. Because, as Bourdieu made clear, it is the habitus which depends on (but does not coincide with) the artistic position of the organization in question that, apart from the totality of opinions on art and society, more specifically encompasses the intentions the (artistically) responsible person has with art and artists on the one hand, and with the potential audiences on the other.[1] The term 'intentions' refers in a direct and specific way to the question which every distributor of aesthetic forms of communication finds themselves faced with: 'am I here to support the development of art and artist or to serve the public, and, if the latter, to please them in a way which is comfortable or to have them enjoy themselves through the use and development of their imaginative powers?'[2] The answer most definitely needs to be found, but is not of such an absolute nature as the question suggests. It is indeed possible to support art and artists and to challenge the audience at the same time. But only, as indicated, provided that there are clear insights into and opinions on both aspects. It is clear that the task of having art function in society gives the second aspect (use of the arts by the public) a dominant position. But the development of aesthetic utterances is, of course, a prerequisite for this, not only because these utterances have to be there, but also because due to the nature of their substance-form relationships they are able to set in motion and direct an aesthetic, possibly artistic form of communication. On this basis, the strong reactions in some artistic circles when not the production, but the distribution domain is presented as the *centre* of the arts world will be greatly tempered by understanding that the production of art is the *basis* of aesthetic communication.

Essentially in bringing together the interests of artists and audience when organizing theatrical events it is a matter of fine tuning the needs of both, not just by presenting the right art to the right audience, but by doing it in such a way that the 'interests' of the art work and that of the public also serve one another. In this respect, the aesthetic distributors will in all seriousness find themselves faced with the matter of the value and functions of art, in particular by having to address the anything but comfortable question of whether the aesthetic event(s) to be organized should provide challenging or comfortable aesthetic communication processes. The relationship with any sponsor or grant provider will play an important part in answering this question, but here it will be a matter for the distributor, having a set of material and personnel resources to be able to conceive an aesthetic event which provides the optimum conditions under which to create the intended type of communication. This will logically take place on the basis

of the nature of the aesthetic productions offered and the nature of the audience. These aspects will later be considered in more detail.

9.3.2 The use of material and personnel possibilities

Material and personnel possibilities refer to those elements which a museum, a concert hall or a festival have at their disposal for the creation of a situation in which visitors come into contact with aesthetic utterances. In some cases specific services can be utilized for this, such as musical support, catering, intermission acts; in most cases personnel input plays a particular role, but the factors which a distribution organization can never get away from, because they provide the necessary framework for an aesthetic event, are time and space.

By utilizing all these factors in a specific manner, to conceive an aesthetic event, the distribution organization creates the right conditions for the optimum aesthetic communication process, given the supply selected and the right audience to go with it.

One of the four 'instruments' is the supply or use of other services. These are referred to as 'other' here because the opportunity which is offered to the visitors to be in contact with the selected work, can also be interpreted as a service. In arts marketing theory this concept is generally referred to as a core service.[3] But a distinction is also made between facility and supporting services. The first is seen as largely necessary to be able to provide a core service (which generally includes ticket sales, space, lighting, etc.). The supporting services are more interesting in this context because they provide additional opportunities for creating an optimum distribution situation. Van Maanen (1997) proposes making a distinction within them between value-enhancing and value-extending supporting services. The first group covers all the resources utilized to support the process of bringing about the intended aesthetic communication and to achieve its intrinsic values. These resources range from providing information to offering aesthetic utterances in media other than those of the core service, and from providing the opportunity for the participants to develop their own activities, to being introduced to the artists. In all cases these services must always maintain a direct relationship with the core service, the aesthetic utterance at hand. This will not be the case with value-extending supporting services. This covers extras, such as food before or after a performance, catering in general, city walks or accommodation arrangements, and so on, essentially, all conceivable services which can be offered in combination with the core service without actually being connected with it in any way.[4] Value-extending services are often used, and are even often offered as a standard arrangement, and can tempt people to come to a performance despite

a limited interest in the aesthetic production itself. As indicated, in principle, these services have no direct influence on the realization of the intrinsic aesthetic values of the event, at least, not in a qualitative sense. But what they can do is contribute to the attractiveness of the event, so that more people attend and therefore have the opportunity to take part in the aesthetic communication. Furthermore, such value-extending activities can in an indirect manner make the participants more receptive to the core of the event; for example, because a trip by boat or by bus gives the audience the chance to free themselves from their everyday cares and worries.

The use of personnel takes place, at least partly, in the context of the facility and supporting services, such that the question that can be put once again is: to what extent will their specific use contribute to the optimum functioning of the distribution situation? And here too, there is an abundance of possibilities, ranging from the uniforms of ushers to the personnel's interest in and knowledge about the work of art presented, and from the presentation of staff as 'parts of the building', as puppets or pillars, to making visible the excitement about what is going on, in which they in fact express the link between the works of art and the audience. The way in which personnel act in distribution situations is closely related to conventions and the habitus of the organization. In the venue of Théâtre du Soleil in Paris, the Cartoucherie, there are no ushers or doormen, but everyone, including the artistic director, Arianne Mnouchkine, is there to warmly welcome guests and to see them to their seat as a member of the 'family' for the evening. Why? Because the intention of this theatre is to let visitors share something, both with each other and with the creators of the performance. The personnel have that passion. This is something quite different than the men and women, dressed in costumes which don't entirely fit them, possibly chewing gum, who tear off ticket stubs for performances about which they know neither the name nor what they are about or who created them. Then the apron-attired elderly ladies of the Royal Albert Hall or of the great theatres of St. Petersburg, are preferable, who are indeed proud of every performance for which they sell programmes and who always visibly share in the festive spirit of the evening. Anyway, it has been said that there is a great deal to be decided and that there are many choices to be made when it comes to the use of personnel. This is the more important with respect to personnel who form part of the core service, the aesthetic utterance as such. That is the case in the performing arts, where Sartre's adagium that musicians have to disappear behind the music and actors behind the text of the play, is no longer always true – more than that, it cannot be taken seriously in the era of television and Internet, because precisely the presence and presentation of the playing artist have become prominent in the aesthetic utterance and the communication based on it. How much more interesting it

is nowadays to hear each of the violinists labouring, sweating and enjoying, re-
ally working at full tilt in the performance of a Tchaikovsky symphony, than to
know them present behind their giant music stands, trying to produce the same
sound as people hear on a CD. But in fact, this is not a matter of organization of
distribution, but the nature of the works of art selected. It reveals, however, how
closely the responsibility of the distribution organization is connected with that
of the production organization, because the first, in his attempt to have the audi-
ence experience what can be experienced in the encounter with art is dependent
on what the second offers, not simply to be accepted without question, but to
be used as part of what the venue offers to the potential audience; an important
reason for viewing the dividing line between both domains as a limiting factor in
the functioning of art in society.

The two other areas in which choices can and have to be made if the distribu-
tion situation is to function to the optimum – that is, aimed as far as possible at
the realization of the aesthetic values which are considered to be attainable in the
communication between the selected work and the selected audience – are time
and space. The aspect of time relates to the time of day and the length of time,
in relation to the actual time in which the user of the art lives and within which
he has to create space to be able to take part in an aesthetic event. The questions
of when it takes place and how long it takes play a role which should not be un-
derestimated. Performances at unusual times, for example, during the night, will
often only be interesting to an audience of students, theatre professionals and
theatre enthusiasts, as will productions lasting more than two-and-a-half hours.
This doesn't mean that it isn't sometimes necessary and a good thing still to use
strange times and longer time slots. In such cases, additional attention will need
to be devoted to dealing with other input factors, that is, the audience selection,
the use of the services discussed above and marketing methods. Because what in
fact takes place is that the organizer of aesthetic events offers to organize a part
of the potential users' time for them, and that must then be done in such a way
that it is not perceived afterwards as a waste of time, or not the best use of time;
on the contrary, after taking part in an event, audiences should be looking for-
ward to the next time that the organization of their time can be contracted out to
this distributor. Particularly in the visual art sector, people can choose when they
would like to visit a museum or an exhibition and how much time they would like
to spend; musical and theatrical performances, however, generally begin and end
at set times and are sometimes not organized more than once in any particular
town or city. Here it is crucial for a distributing institution to organize the use of
time extremely carefully, from the point of view of the values to be achieved by
the selected production and from the point of view of the importance which the
audience attaches to its use of time.

Finally, there is the matter of dealing with space, which is perhaps the most physical material factor which can be utilized, but also the most complex. Space can refer to the place where something is performed (1), or the way in which that space is given form (2). This form may relate to the style of the building or the landscape (2a), or the way in which the space is used or constructed in the aesthetic event (2b). And 'place' can, in turn, refer to a place in an urban or other landscape (1a) or the social perception of that place (1b). A theatre can, for example, be found on a square in the centre of the town (1a) and be perceived by visitors as 'easy to find', 'centrally situated at a top location', or as a 'blot on the landscape' when shopping, etc. (1b); its style may be perceived as grand, closed, accessible, contemporary, or classical, and so on (2a), but anything can be done with the space inside and outside to make it suitable for the intended communication (2b). The development of performing arts in public spaces, in particular, forms of site-specific theatre which since the 1980s have come to occupy such an important place in the international theatre scene, is based mainly on the need to be able to communicate with the audience in more suitable settings than is possible in conventional theatre spaces. In the world of contemporary visual arts a similar development took place: in the 1990s a strong trend to build new museums occurred; museums to which a visit is a real treat, even if no works of art would have been exhibited. And besides the experience of their own values, these types of museums, such as KIASMA in Helsinki or MACBA in Barcelona, show up the values of the art works optimum through the spatial context they offer.

Anyone who has seen the *Summerhouse trilogy*, based on Goldoni's plays and performed by theatre company De Appel in its water-filled theatre in The Hague, or Ibsen's *Rosmersholm* played in the rural landscape of Groningen, the Netherlands, in a nineteenth-century country house, will ask themselves why so much is still performed and presented in ordinary theatres.[5] There are possible reasons for this: the buildings are there for that purpose, more people can usually be accommodated, some of the buildings are also beautiful and people are used to or fond of them, but none of these arguments says anything about the suitability of the venues for the creation of contemporary theatrical communication processes. They can, however, be used in attempts to give existing spaces more significance in an aesthetic event than just that of a framework. When it comes to the space, there are, therefore, plenty of decisions to be made by a distributor: in what space, situated where, and in what form, will the specific aesthetic communication system best be served?

The space is of such importance to the success of the aesthetic communication because this is where all encounters take place, and encounters form the basis of aesthetic communication processes. These go beyond simply the encounter between the visitor and the work of art, and also include those between the users

themselves and possibly between the artists and audience members. The aesthetic event is thus primarily a slice in time and space out of the life of the visitor and it is the distributor's task to make sure that this slice has sufficient meaning for the life from which it is taken.

Figure 9.4 Types of possible encounters in a theatrical event

Figure 9.4 shows, as an example, what types of relationships occur in a theatrical event, bearing in mind that for each relationship it is necessary to ask under what spatial conditions this one will best be served in terms of realizing the aesthetic values. The organizer of an aesthetic event therefore must find an answer to all these questions. As can be seen in this figure, multiple encounters take place simultaneously. The most concrete are the coming together of spectators (1) and the one of performers and spectators (2). In a more abstract and certainly in a more aesthetic way, spectators meet the performance (3), and can meet, in a conceptual sense, through the performance, an author and/or a director (4). In this sense, also, the performers can meet (parts of) the performance over and over again, playing it (5) and in so doing, they can meet the author, the director and their colleagues repeatedly (6). Finally, spectators can meet each other in a way organized by the event, which is mostly mentioned as 'becoming an audience' (7) and which can continue afterwards in social communication between people in connection with the event (8).

It is now possible to define the input of 'other material and personnel resources' a little more precisely in relation to the processes in figure 9.4. When these processes are examined separately in relation to the input, it appears that the possibilities set out above can be used as instruments for the *conception* of the theatrical event, as shown in figure 9.5.

Figure 9.5 Inputs in the conception of an aesthetic event

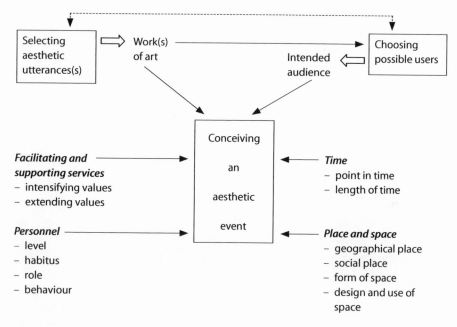

9.3.3 Selecting aesthetic utterances

As stated, a distribution organization is dependent on what artists make and offer. This is because a selection must be made from this offer, which will be presented to the public in a reception situation. Sometimes the boundary between distribution and production is somewhat blurred and a distinction has to be made between production in the sense of 'making' art and production in the sense of organizing the creation and distribution process. Gallery owners and publishers are, for example, distributors who are also involved in production in this second sense. Publishers produce books, and in that sense they support, advise and encourage authors; they also handle the material aspects of the book production and survey the market. Such arrangements are also regularly found in the theatre world. Major dance theatres in Europe act together as producers for the distribution of international performances by Pina Bausch or Jan Fabre. This means that they co-finance the production (including by buying performances). They sometimes also make rehearsal space available and handle the financial and organizational aspects. In the performing arts it is the case in many countries that a large part of the production and distribution is arranged within one organization; city theatres who perform in their own venues being an example of this. Within this type of institution the internal relationships between the two

domains determines what type of event is being organized. The theatre program-
mer of the Salzburg Festspiele 2007, Thomas Oberender, expressed a view often
heard that the 'radical and reckless' theatre created by the Dutch and Flemish
could never have evolved in Germany:

> They [the Dutch and Flemish theatre makers] set up their own production
> collectives and the political authorities also provide for that. As a result
> unusual ensembles have been able to develop. That would never have been
> possible in Germany: the resident companies are not capable of doing any-
> thing like that without finding themselves faced with a myriad of regula-
> tions. (de Volkskrant newspaper 22-8-07: 14)

What Oberender is referring to here, apart from the bureaucratic rules (which
are also to a large degree found in the theatre world in the Netherlands and Flan-
ders), is the assumed independence of companies in the Low Countries. The
directors he refers to, however, also generally work in large companies with their
own venues. The difference is that, as Oberender correctly observes: 'The Ger-
man theatre system is focused on institutions, that of the Dutch on the makers'.
And apart from the fact that these institutions are often housed in traditional
theatres which must put on work, in the German system there is an organized
demand for certain types of performances on the one hand (Hofmann 1998: 223
ff.) and by the political powers on the other. Conversely, in the Dutch situation,
companies (of which by far the most do not have a regular venue but tour), re-
ceive subsidies to make art and, to some extent, quite apart from the question
of how and by whom the results are received, are evaluated in terms of quality;
which creates an entirely different kind of relationship with the distribution
domain and in relation to the attendant question of how the work functions in
society.[6]

 To the extent that there are no fixed arrangements between production and
distribution, relationships may be said to be governed by conventions between
the two domains. Boorsma comments that relationships between actors operat-
ing in the art world take three forms: transaction (or exchange), transformation,
and communication (2001: 99). By the latter, she means something other than the
exchange of information to be able to arrive at a transaction; based on Habermas's
Theorie des kommunikatieven Handelns (1981; Theory of Communicative Action)
she considers communicative actions to be 'not primarily directed towards the
realization of goals but towards giving room to the intersubjective forming of
opinions, judgements and meanings and coming to a mutual understanding of
the situation' (2001: 98). Boorsma notes that communication in this sense plays a
very fundamental role in the arts world where, she believes, cooperation occupies

a more important place than competition. The question here is whether that is always the case and whether her view is not partly coloured by the situation in the subsidized Dutch art world. It is clear that this communicative activity of distributors is closely related to their habitus and its development and, in that sense, also has a major impact on the selection processes at work in the distribution domain. In particular, people's intentions for work which is or is not selected, play an important part in this communication.

This is not the place to discuss extensively the different types of art appreciated by different types of distribution organizations that choose some of them to prepare their own aesthetic event. The attention Bourdieu gave to differences between artistic positions, and to the question of how those differences are connected with the division of capital inside and outside the fields and sub-fields concerned, has at least produced the possibility to think about aesthetic communications in terms of their differences, their values and their functioning. Several sociologists of art express this way of thinking in the question of *what the arts do*, a question that is worked out in the present study into a distinction between decorative, comfortable and artistic forms of aesthetical production, each of which generates their own types of value.

When it comes to selecting aesthetic utterances, distributors should thus first establish which types of values they wish to help realize and what works of art will actually contribute to this. These quality judgements, which say something not only about how good a work in a particular genre is, but more particularly about what the possible value of the genre is and how this is specified by the work in question, should, if done correctly, be at the centre of the selection process. At the same time it should be noted that this 'value judgement' is to a certain extent relative, specifically in that the ability of a work to realize its values also depends on the ability of the user. In other words, a work of art can have an entirely different value for one viewer than another, or rather, where a work challenges the perceptions of one it comfortably pleases another. It is up to the distributor to take this into account in his considerations.

Although this study cannot provide a broader insight into the diversity of types of aesthetic utterances which distributors have at their disposal, it can provide such insight into the selection process. Apart from the nature of the decisions to be made, which have already been discussed above, and the role of the habitus, which provides the basis for and is formed by the communicative action, there are also the transaction and transformation processes. An exchange takes place in the first; that which is exchanged is then turned into something else in the second. Much has already been said about transformation in the discussion of the utilization of material resources, which essentially defines the distributor's supply on the basis of the production or productions selected. The work

itself will generally not be affected; it will be included as part of a larger supply and thus lose its independence, although it can express its dominance within the service as a whole in such a way that its potential values can be realized; at least that is the intention. In terms of the Actor Network Theory, the selection can be described as a passage through which the work of art passes, so that it ends up as part of a new fabric of actors, networks itself in a new fashion and in this sense therefore changes (Latour, 2005).[7] The term 'translation' expresses this process a bit better than the term 'transformation', and will be used further for this reason. This translation process casts its shadow in advance of the selection process: the distributor makes a selection while bearing in mind the question of whether the work will have meaning in a publicly offered service and what that service should then look like.

In general, the envisaged translation processes by which an aesthetic utterance is allocated a place in the distributor's service is largely a standardized process based on convention. This can be explained, among other things, by the fact that distributors sometimes take an entirely different approach to the selection process than that proposed here. They opt for the artist and not for the public, in other words, for the work or the oeuvre itself, rather than how it functions in a society. This position has been accurately described and documented in Gielen's *Kunst in Netwerken* (*Arts in Networks*, 2003), in which an analysis is made of artistic selections in contemporary Flemish dance and fine arts. In this study, Gielen examines how the efforts of venues, museums and galleries support the careers of the artists and their work and enable them to move from a regional to a national network, and finally to acquire a position in international networks. Naturally, this process can have an impact on the functioning of the artworks in certain circles of users, but the distributors' intention with the art and artists (which is based in the habitus as an input factor) is not in this case primarily concerned with how society uses art; they focus, certainly in the later stages of this process, on the symbolic position of the work in the field in question, doing so with the knowledge that among the higher echelons, there is an audience of specialists ready and waiting to confirm, grant or deny a position. This does not alter the fact, by the way, that particularly in the beginning of these selection processes it is, also for distributors who choose to help artists on their way, the most important task to make their work available to people, even though they are only experienced colleagues, collectors, teachers and critics.

Although, theoretically speaking, the artwork also forms part of a service supplied by the distributor, and the communication has a place in the context of a specific reception situation and so there is also a translation in the sense outlined above. The processes Gielen describes, are first and foremost about the autonomous meaning and authenticity of the work, whatever that may mean in

the context of an always organized way of viewing. What that demands is not primarily a concept in which aesthetic production can function at its optimum in relation to the way in which population groups and individuals make use of it to perceive the world, but rather a 'neutral' environment, which unfortunately is all too often interpreted as a conventional environment.

As commented above, both these positions adopted by distributing institutes do not necessarily obviate one another; they can complement and support one another. This also happens with many important artists and art. The new sites which Ariane Mnouchkine, Peter Brook or Robert Wilson sought for their work and to communicate with the public attracted not only the audience that they had in mind, but, because of the artistically sound match between theatrical communication and the environment, they also greatly contributed to the accumulation of their specific symbolic capital in their sector.

Finally, the most standard form of transaction processes are those in which the selection of aesthetic utterances is ultimately arrived at for the purpose of the distribution. These centre on the exchange and the necessary conditions for this. Distribution organizations offer artists an opportunity to show their work under the appropriate conditions for this and artists or their agents supply work from which the distributing organization can create an aesthetic event, so that it can fulfil its role, for instance, to create circumstances in which the imaginative power of the community in the area it serves is used and developed as a result. Often this exchange is accompanied by financial transactions, which may assume very different forms per discipline and subdiscipline. These types of transaction processes do not occur in systems where artists have their own venues, but may present themselves as communication processes between departments. The artistic director, for example, wants to put on Heiner Müller's *Hamletmachine*, while the managing director wants to know what type of people (and particularly how many) will come. Meanwhile, the dramaturge wants to know what the play may mean to whom and under what conditions, and the marketing department is faced with the question of how to attract the right people in the right numbers to a performance and to induce the visitors to buy a ticket for a later performance.

Although the term transaction can easily refer to financial activities, in the art world it mainly relates to agreements made about products and services to be supplied. In fact, to assess the quality of transaction processes it is necessary to answer the questions of what intentions of the artist, agent, or distribution organization are or could be served by the agreement. As shown in figure 9.6, these intentions come into being at different points in the process, initially as potential or an option, later as an agreement.

Figure 9.6 Phases and input during the selection of productions for theatrical events

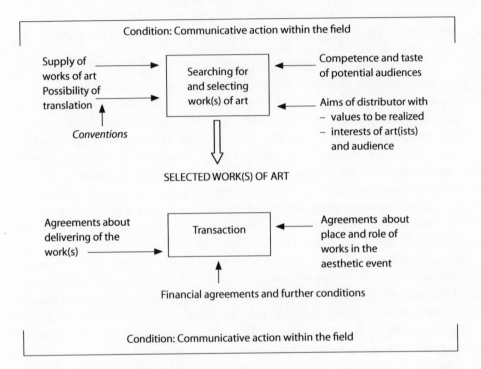

SELECTED WORK(S) OF ART

9.3.4 *Audience and marketing*

With the selection of an audience, the distributor soon ends up in the field of arts marketing, because marketing can best be seen as the organization of the exchange of values, in this case the values of a theatrical event in exchange for effort, time and possibly money from the audience. Boorsma, who further developed the pioneering work of Kotler (1972) and Leeflang's commentary on that work (1978 and 1994), defines marketing, particularly in relation to the arts world, as follows:

> Marketing concerns the activities an organization undertakes which are aimed at influencing the interaction between one or more stakeholders to promote the exchange of values...between one or more target groups (1998: 19).

And she emphasizes that these new developments in thinking about marketing, in which more emphasis is placed on 'building relationships' and 'taking future-

oriented initiatives', have created sufficient room also to be able to work with marketing concepts in the arts world (Boorsma, 2002).

The time when marketing was considered as simply the application of a number of P's (product, packaging, place, price, etc.) as instruments to sell a service to buyers, with or without the aid of sales tools, is far behind us, at least in the *theory* of arts marketing. While instrumental marketing has been overtaken by the conceptual, which in turn provided the basis for customer relationship marketing and the recently developed customer value approach (Boorsma, 2006), the result of these developments is that the elements which were initially considered as instruments (specifically to earn money), such as product, place (of sale) and packaging, have taken on a conceptual meaning. They are now largely considered as part of the value package on offer. It goes without saying that when a customer value approach is adopted in the distribution domain, the selection of an audience will be fundamental, but it also immediately raises the question of whether the audience should be selected on the basis of the values of the aesthetic product which will be transformed into an aesthetic event, or, conversely, whether events should be developed on the basis of audience preferences. The choice depends entirely on what the intentions of the distribution organization are in relation to art, artists and the audience, that is, the question of what goals the aesthetic event is intended to achieve. In all cases, a value analysis of the specific work of art and the event as a whole will, however, play a decisive role in the selection of an audience. A second important factor in the selection process will be the answer to the question of what the position of the intended target group in relation to this is, in terms of competence and need, because the intended participants must be able to realize the values of the event on the basis of their competence and need. If the distributor focuses on the realization of a *comfortable* experience it can generally be assumed that an audience with the right level of competence and need will turn these two elements into a market demand. Need will in this case be equated with demand, but this is not entirely correct, because the need for a comfortable experience can often be satisfied by various types of supply and the competition between suppliers of both aesthetic and other services mainly induces them to deploy resources which transform the needs of potential audiences into a demand for the specific aesthetic service which a distributor has to offer. This will be different for the supplier of *artistic* (i.e. challenging) events, because the intrinsic values of these can, in principle, only be realized by participation in these types of events. It is not necessary to enter into competition with sporting events, eating out or family visits; in this case the competition will be about the difference compared with the artistic events of other distributors. Here, too, it is the case that turning need into demand will only automatically take place for an informed (and committed) audience. In other cases, the mar-

keting effort must be specifically directed toward the development of a desire
– and the action arising from it – among potential visitors to meet their need by
attending a particular event. Only then may it be said that there is a *demand* for
this service.

The organization of this demand requires an analysis beforehand of what is
to be offered, as well as of the potential audience in four areas: presence and size,
competence and need, 'reachability' and 'organisability', and interest.

Distributing organizations operate in a social and geographical context and
have a place in that context. They can opt to function at a local or an interna-
tional level and at levels in between, that is, regional or national. Combinations
are possible, but often what is offered at one of the levels dominates in the ar-
tistic position of a distributor. This will be associated with a specific audience
found at the level in question. The Salzburg Festspiele, for example, which is
aimed at an international audience of informed people, also attracts spectators
at national and local level who, in terms of competence, largely belong to the
same group.

Knowing at what level demand may be expected is important not only to
achieve a match between the values of the aesthetic event and the competences
and needs of the audience, but also to know how large is the potential audience
for the selected range on offer and the events based on this. Institutions that
operate at local or regional level in particular, will rapidly find that there is lit-
tle demand for their artistic services and therefore will need to know how large
that potential demand is, based on the competences and needs of the residents
of the area served. Given the volume of a great variety of competing produc-
tions on offer, there will generally be quite a gap between the potential and
the actual demand and therefore it is well worth optimizing the quality of an
aesthetic event as well as the use of specific marketing strategies. If the poten-
tial demand is small, or too small, it may be necessary to ask whether what has
been selected for offer is suitable for the institution in question. It is usually
not possible to obtain a direct and clear answer to this. For 'taste minorities'
are also entitled to a certain social enjoyment and the development of their
imaginative powers (which should also be considered from the perspective of
the relationship between the aesthetic and the political systems). Furthermore,
an aesthetic event can serve as a catalyst within a community, although this is
more likely to happen in a situation where the actual demand is much smaller
than the potential. Institutions, finally, which adopt a pluriform aesthetic posi-
tion, that is, which offer a range of reasonably varied aesthetic events to par-
tially differing types of audiences, will benefit from an overall analysis of the
population of the area they serve in terms of competences and needs, 'reach-
ability' and 'organisability'.

As stated, after an analysis of a distributor's own potential and actual aesthetic services offered, an analysis of the competence and need of the potential audience is the most important factor in the selection of an audience. In the first instance, the presence of these factors can be derived from age, gender, profession, education and patterns of leisure time use. Sometimes all these elements may be clustered in one postal code area, because the population of a town to some extent segments itself on the basis of the properties built.

In general, there will be a degree of agreement between competences and needs, in the sense that the first are a pre-requisite for the second. Someone will not readily be inclined to enjoy the work of Sarah Kane if they have difficulty with abstract or vile use of language; and the artistic value of the boat Romuald Hazoumé built with oil cans without lids, giving it the name *Dream*, cannot be realized by people who do not know, that 'canisters are the most widespread utensils in Benin' and who are not able to see a connection with 'the transports of death' to the rich western and northern parts of the world (Dokumenta Kassel 2007: 258).[8] Conversely, competences generally demand to be used or, in other words, people have the feeling that they are not functioning at an optimum level if they cannot use and develop their competences.

Although an aesthetic utterance can generate many different values in different users and at different levels, it is primarily the power of the imagination, in the sense that someone can be caught up in the representation of something, and a certain command of the language in which an artist expresses him or herself, that are the necessary prerequisites for the enjoyment and value realization of aesthetic communications. Given that these conditions are necessary, the organization of an aesthetic event is intended to give viewers the chance to apply their competences to the optimum in perceiving the aesthetic utterance (figure 9.7). The presence of competences, however, does not necessarily mean that the need for aesthetic enjoyment is constantly present; competences must be addressed to be activated, so that a need can arise which can ultimately be turned into demand. Only then can a distributor have selected productions function in the community in which he operates.

This may well be possible in theory, but apart from the fact that there must be a competent audience of sufficient size available, they must also have an interest in or benefit from the interaction with art. This ultimately centres on the pivotal question of what the reception of art adds to the life that a person leads, that is, *the relationship between values and functions*.

Thus, even where there is ample *potential* audience available, a distributor who is not capable of making this relationship perceptible and cannot give potential visitors a sense that taking part has a certain significance for their lives, will not succeed in his mission, despite the potential audience on hand.

Figure 9.7 Competences used by participants in an aesthetic event

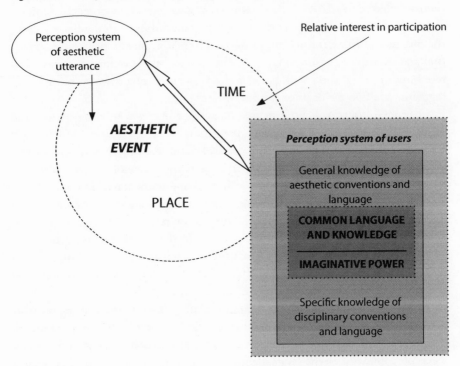

The potential audience has a number of competences, of which only a part will be used during the participation in an aesthetic event. And not all competences that people have at their disposal have to be addressed constantly to give them the feeling that they are fully functioning. More than that, if too many faculties are appealed to during a longer time or too often, enjoyment can easily change into an experience of stress. For Maas, this explains why people whose competences are appealed to on a high level during working hours feel a need for activities with a lower level of stimulation in their leisure time (1990: 46). This is, however, mainly a problem of making people interested in an aesthetic event. By the time that visitors pass from their everyday lives into the aesthetic environment, the problem has already largely been dealt with, because the nature of the communication (imaginary or otherwise) also liberates them from these everyday lives. It is therefore important in the organization of an aesthetic event to make it possible for potential viewers to perceive their relative benefit in advance of taking part (i.e. in relation to other possible activities). This can be arranged for many potential users via two aspects: the matter covered in the aesthetic communication (generally referred to as the theme or subject matter) and the place it occupies in their

social subsystems, which in terms of Niklas Luhmann largely consist of interaction systems. The second is directly related to the fourth factor in the analysis of the potential audience: its 'reachability' and 'organisability'.

The more comfortable the intended experience in the interaction with art is, the easier it will be to reach an audience and tempt them to make the necessary investments that will make it possible for them to experience these events. In the first place, because the mental investment will be smaller; secondly – and more importantly – because what is offered is known and therefore also what one can generally expect in exchange for one's money, effort and use of time. This is why in the case of this type of aesthetic communication, mainly – and often only – instruments in the area of information and publicity are used to find a public, through channels which the intended audience knows and uses. But when it comes to aesthetic events which centre on artistic communication, these resources will generally not be sufficient, particularly as a new audience must be addressed. In this case the potential audience has to overcome something and this generally takes place, as commented above, through the realization that an interest will be served by attending a performance. The matter, or, in more abstract terms, the theme of the communication and its place in the social context of the audience member, play an important role in this. This is why the trend discussed above towards marketing concepts which focus on building lasting relationships with audiences is so important in the distribution of art. These concepts make it possible to give the typical theatrical events which a distributor creates and offers a more fixed place in the life of users, including the extreme variant in which signs of addiction start to occur. As with the care of addicts, it is only natural that the people around them must also become involved, and because artistic communications challenge the perceptions, aesthetic events which are shared with a social network may put that network at risk. In other words, new links in new networks may be made at the expense of the functioning of existing networks of individuals. Given the fact that the functioning of art in society also requires a social context for aesthetic values, that is, communication between audience members inside or outside the event, customer relationship marketing can have a two-fold effect: the development of ongoing relationships between audience members and the distributing institution on the one hand and among audience members themselves, on the other. Once these relationships have reached a certain level, the reachability of the groups in question is also increased and a distributor of artistic events no longer has to put out such enormous volumes of publicity material which are in no way in proportion to the number of people who will be attracted as a result. The problem of the distribution organization changes from one of reachability to a matter of how to organize the audience: What groups or types of groups can be segmented on the basis of their identity and addressability as a group? The

tradition in this area ended in Western Europe in the 1960s, when the individu-alization of art reception began.[9] Only in education is organized reception still a prevalent phenomenon: where groups of schoolchildren attend performances and discuss their experience afterwards. Given their role in society, distributors not only can play a specific role in this, but they can also apply this model of organ-ized reception to other groups of potential users, although they may not always fit together as neatly as schoolchildren.

Apart from the two factors referred to earlier (matter and place in social envi-ronment), the place which participating in aesthetic events can occupy in people's lives is also to a large extent determined by the place itself, in the literal sense, the space in which the communication takes place; and finally, increasingly by the other people who take part, these being the performers, musicians, administrators and possibly writers, and so on, on the one hand, and other audience members, on the other. They in turn form a community to which the audience member belongs and which will lend something to the development of his of her identity. In these aspects of customer relationship marketing in the arts, it is not difficult to see the personnel and spatial dimensions reflected in the conception of aesthetic events, not least to support the various encounters as shown above in figure 9.4.

Figure 9.8 Phases and input during the process of audience selection

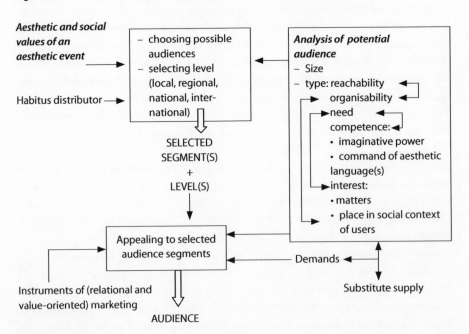

This completes the cycle of the distribution process, because a cycle, or rather a process of continual feedback and feed-forward loops, is most definitely what it is. The output of this can now be discussed, but first the phases and input in the search for audience and the marketing of aesthetic events are shown in figure 9.8.

9.3.5 Output and outcomes

The organization of the distribution domain is described above in relation to the processes involved and the input which is used for them. The advantage of this is that it provides a reasonably clear overview of the factors that play a role in the domain. The drawback is that it hardly shows how *the relationships between the factors* affect the results of the processes in terms of conditions; in other words, their relative influence is not made visible. The factors which play a key role in this conditioning process will be further considered later in this section. Another consequence of deciding to describe the organization in terms of processes is that this could create the impression that the production of specific aesthetic events is being discussed, rather than an institutional approach. And indeed, on the basis of the above, the first area about which statements can be made concerning the output of the distribution process is that which relates to the specific situation. This output, the aesthetic event, is a communication process organized in time and space, on the basis of an aesthetic utterance. But when we talk about the artistic position of a distribution organization then this refers to the totality of its events, 'the annual programme', or rather the *type* of events which determine the artistic nature of the distributor. And to take this one step further, an aesthetic field or subfield in a particular culture, say Dutch, North American or German, is also to a certain extent characterized by a specific type of aesthetic events, at least by the dominance of this type over others. In other words, distribution domains may be set up and function differently in different cultural regions and also present different types of events, which in turn generate different types of reception and experience among the people of these cultural regions. In this way we are, indeed, further removed from the level at which the processes in the distribution domain were first outlined here, but we do find ourselves at our destination, that is, the point at which we can study how the organization of the distribution domain can contribute to the functioning of the arts in a society (the outcomes). This is because this takes place through the types of aesthetic events provided to the society.

In terms of the functioning of arts, events can be characterized by the answers to three interrelated questions: what opportunities do they provide for the selected works to realize their values, with whom do they do this, and how? In other words, *how* are aesthetic events organized, so that they bring about *what*, among *whom?* Seen in the light of the terms values (what), potential audience (who), and

material and personnel resources (how), it became clear in the previous sections that each of these three aspects is made up of a conglomeration of sub-aspects. But this does not obviate the fact that these three coordinates make it possible to classify aesthetic events in relation to one another.

Figure 9.9 Coordinates of types of aesthetic events

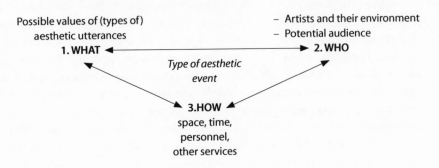

I. WHAT?

Aesthetic utterances come in a variety of shapes and sizes, and users can also realize a variety of intrinsic and extrinsic values in their encounters with each of these works. Nevertheless, a certain degree of categorization can be made. First, there is of course the distinction between disciplines. Listening to music delivers other experiences than attending the theatre or reading a book. One reason for this is that these disciplines make use of different materials, which for their part evoke different processes of perception and representation; another reason is that in the use of the different materials, the matters (directly or indirectly experienced reality) are transformed in a different way, with the consequence that finally the same matter will not only not be perceived in the same way, but that it will even be changed in itself through the perception.

The difference between a reading process and a watching process is a good example of the first aspect. With the aid of her knowledge of language and remembered experience, based on arbitrary signs (letters and words), a reader creates for herself a mental image which she can then play with; the viewer, by contrast, is confronted with a physical representation which directly enables him to play with remembered experience. And people listening to music? Strictly speaking, they hear material which is different from matter. Within the disciplines in which matter is given material form, a distinction can be made between static and dynamic media. Film, theatre, dance and literature can give form to matter in proc-

esses or, in other words, the matter which is observed in these disciplines is of a process nature, while those in the visual arts are of a momentary nature. There are, of course, various related areas in mediaeval storytelling triptychs, for example, or areas of overlap, as in performance art or installations, or interdisciplinary art forms, such as musical theatre or dance/text combinations, but this does not take away from the fact that one type of material is more suitable for the transformation of certain types of matter than another.

A third distinction that can be made between aesthetic disciplines or their utterances is based on the 'distance' between matter and form, or rather the degree of abstraction of the work. What happens here is that the perceivable matter changes due to the form it assumes – in the perception of the artist – and therefore in the observation the artwork is. 'Love', 'power' or 'death' can be perceived and presented in forms which differ little from the physical forms in which these phenomena actually occur in reality, or in forms which to a large degree are abstractions of these physical experiences: love, power or death in their conceptual forms. In this latter case, the observer must in essence bridge two gaps: that between matter and form in the aesthetic utterance, and that between his own experience and the matter given form in the work of art. Besides this, as highlighted earlier, aesthetic utterances are able to stand out to the degree that the relationship between form and matter challenges the perceptive schemata of potential audience members and gets them to use their imagination to realize a perception that makes sense. This concerns the most typical nature of the game that is played in giving form to a matter. This nature can be expressed in the degree of artistic appeal, or put conversely, in the degree of comfort that characterizes the perception process. As will already be clear, this last distinction can only be found in relation to the coordinates of the potential audiences, to which we will turn shortly, however not before emphasizing once more that all four sub-coordinates which can be used to categorize aesthetic utterances – logically, but still pretty remarkably – bear a relationship with the matter-form relationship which constitutes each aesthetic utterance.

The material of the aesthetic discipline (verbal language, wood, the body) first of all determines what type of perception and reception process must be performed by those participating in the performance, which is nothing else than taking part in a particular type of a matter-form play on the basis of the type of material used and the way in which it is used (sub-coordinate P_1, use of materials). Because the material of a discipline determines the forms which matter can take, this also determines what types of representation of these matters can be communicated and therefore, strictly speaking, also about what matter can be aesthetically communicated, because the matter changes with the form given to it. The simple question 'what is it about?', which a general audience most often asks, can, therefore, paradoxically enough, only be answered in terms of the form (in

which the matter exists). Nevertheless, the matter (and its nature), is the second
sub-coordinate of the aesthetic production (P2, matter).

The third and fourth relate more specifically to the form; the first sub-coordinate
to the gap between matter and form in terms of abstraction, that is, the degree to
which aesthetic utterances are different from the forms matters take in the per-
ception of everyday reality (P3, abstraction).[10] The fourth sub-coordinate relates
to the degree to which a performance is capable of involving the audience in the
interplay of form and matter (P4, artistic appeal). This is about the relationship
between matter and form in the most tangible sense, because the form given to the
matter is what makes the play and specifically *this* playing with the matter (for the
audience member: with the own perception of his or her reality) possible. It is this
sub-coordinate in particular which makes the essential link, with the description of
one of the two other coordinates of types of aesthetic events: the audience, the 'who'.

2. WHO?

Becker (1982) defined, as we saw in the first part of this study, three types of audi-
ences or spectators for art: 1) Well-socialized people, 'who have little or no formal
acquaintance with or training in the art to participate as audience members' (46);
2) Serious and experienced audience members, who 'have the ability to respond
emotionally and cognitively to the manipulation of standard elements in the vo-
cabulary of the medium' (48); 3) Present and former art students, who know 'the
technical problems of the craft… and [how] to provoke an emotional and aesthetic
response from an audience' (54). The last group may be seen as the inner circle of
the field, the audience which comprises colleagues and other professionals in the
sector. They watch with an expert eye, are particularly interested in technique and
form and see the creation process reflected in the work which, by taking part in
an aesthetic event, they are probably also looking for. In some smaller venues, this
group constitutes most of the audience, which can be annoying for others who do
not always understand why some audience members laugh so loudly (i.e. because
a certain actor they know on stage does something in particular), or applaud so
long and hard at the end. These professional audience members stand out from
the other two groups, not only because of their behaviour (sometimes), but most
of all, because of their interest (sub-coordinate A1). Their interest in taking part
in the aesthetic event lies primarily in seeing and understanding how their con-
temporary or former colleagues carry out their profession, that is, give form to
the subject matter in the material with which they themselves are also so familiar.
In this form of understanding, it is how the form is handled that is predominant.
And indeed, this form of reception, motivated by interest, can easily become a
particular interest of the artists themselves, which, among certain groups of art
historians, for example, is quite common, but in theatres can take on the form

described above[11]. The perceptions of the other two groups will, of course, also be motivated by interest. Becker's second group, the well-informed users of art, are primarily looking for an opportunity to have an exceptional artistic experience. This audience too, because of its competence, will devote a lot of attention to the form, and specifically in relation to how it serves the perception of the matter. People look for a communication which reflects their own perception of reality and where they can apply their own competences to experience the beauty or truth of what is communicated. This is why it may be said that the backbone of an art world is more likely to be formed by these well-informed audience members than by the well-socialized people to whom Becker assigns this role. The interests which bring this last group to the art venues are of a highly varied nature. People may be attracted by the beauty of the design in a decorative sense,[12] by highly developed professional skills in this area (in the physical sense, as well as the ability to be able to perform so much from memory or imitate reality so precisely), by the social context and effectiveness of an event, by the matter (in this context usually formulated slightly more abstractly as themes), or by a combination of all these things. A lot of what these users are looking for can be found in aesthetic events which primarily present comfortable aesthetic values, but this does not mean that audiences who have little command of aesthetic languages cannot have artistic experiences. Firstly, it should be remembered that what is commonplace for one person in terms of the form-matter relationship may be new, surprising, challenging and worthwhile for someone else, but the interest which is attached to the theme (matter) when reading books, watching theatre, or visiting museums also generates a way of perceiving which makes an artistic experience possible, as long as a certain imaginative power enables someone to be open to new matter-form relationships. This brings us to the second sub-coordinate of the audience dimension of aesthetic events, namely aesthetic competence (A2). This can again be further subdivided into imaginative power and command of the aesthetic language in question. In psychology, various phases are discerned in the development of the aesthetic competence, based on which it may be assumed that some groups in the population will be among the potential users of certain forms of art and others will not (e.g. Parsons, 1987). But at the same time, such classifications imply that there will be transition areas between phases, as a result of which aesthetic events make it possible to encounter new types of art and develop aesthetic competence. A similar approach can also be found in the work of authors such as Erwin Panofsky and Bourdieu, who, for example, make a distinction between 'the most naive beholder [who] first of all distinguishes the "primary or natural subject matter or meaning which we can apprehend from our practical experience"' (Bourdieu, 1993: 219), on the one hand, and recipients who reach the 'sphere of the meaning of the signified' on the other. And within the second group of recipients,

Panofsky sees a further difference between the ability to make use of conventional symbolic language in the interpretation of meaning and the ability to assign intrinsic meaning to a communication based on a command of the specific artistic language. In these ways of thinking, the development of imaginative power and the command of aesthetic language seem to meet. In the first instance, a basic form of imagination is used which enables a recipient to consider a perception as a representation (instead of seeing it as the real thing it is a representation of) followed by the capacity to appreciate the image *as* representation. The next step can be taken on the basis of a development of a general power of abstraction, by which certain forms can be understood as symbols. A rudimentary knowledge of an aesthetic language renders good services to this, as far as symbols that are conventional in the language concerned have to be understood.

The phase in the development of the aesthetic ability which, according to Parsons, is characterized by an appreciation of the expressive encompasses a wide area in which a better command of the art language will contribute to a fuller use of the imagination, because more types of forms can be seen as possibly useful forms of matter, as a result of which the imaginative powers will be asked to make this connection. After this phase, both Parsons and Bourdieu appear to present a reversal: knowledge of the art language begins to dominate over the imaginative power; that is, appreciation of art becomes more and more based on a comparison of form elements in aesthetic utterances (style, composition, technique, method of expression), with the current status in the discipline, with other works from the artist's oeuvre or the work of other artists. In other words: the ability to appreciate aesthetic utterances and the enjoyment that goes with this becomes increasingly based on the use of one's knowledge of the language as such, rather than on playing with one's own set of perceptions using the imaginative powers. Clearly there will be an area of transition between these phases; this is apparent in Parsons in particular, because he notes that respondents in what he refers to as the 'fourth phase of aesthetic development', deploy their fuller knowledge of an art language in the process of assigning meaning to the aesthetic utterances with which they are faced. Just this process of assigning meaning is less apparent in Bourdieu.

The third sub-coordinate relates to the size of the audience, their demographic background and the relationships between them (A3, sociographic position). The size of the audience for certain types of aesthetic events can, of course, be measured on various levels: how many people take part in a specific event, how many of the events are organized by a particular distributor and how many people make use of certain types of aesthetic events in a town, region or society. If we take the relationships between users (which can also be described at all levels), it can be determined whether the audience members know one another, take part

in the event as a group or are viewed by the organizers as a group (e.g. a professional group, or a specific population group, such as refugees or single people). This coordinate has nothing to do with the question of whether an event turns the participants into a group for a while or not, which Peter Brook considers to be essential for theatre: the viewers who become united to create an audience (Eversmann, 1996: 9). This question plays a part in the third main coordinate, which essentially relates to the way in which the personnel and material resources are used to organize the encounters within an aesthetic event.

The demographic backgrounds of audience members have been studied the most, for the purposes of cultural policy, the academic study of art and culture, and its marketing. Comparisons between art users have been made at national and international levels based on age, gender, education, profession and leisure activities. These are indeed the first aspects which can be used to describe an audience relatively simply, but besides this a great deal can be derived from this type of data which may be significant to the above areas. In cultural policy considerations, for example, it is important to know which social strata make use of art, whether subsidized or not.[13] Art marketers make use of this information to segment potential audiences, in particular of anything that can inform them about people's preferences in the use of their leisure time, including participation in all kinds of aesthetic activities. It may be said in general that the possible or likely presence of competences (primarily based on education and profession) and preferences (partly determined by gender, age and leisure time use) of population groups can be linked to this data, from which a potential need to interact with the arts may be derived, which is essential to know, given that this is an important input factor in the demand to be organized. It is this relationship between demographic factors, on the one hand, and the need based on competences, on the other, which makes the sociographic position so important as a coordinate for an audience and thus a sub-coordinate for types of aesthetic events.

3. HOW?

Four aspects have been listed which can act as sub-coordinates, within which a hierarchy can be made. Space (M_1), in all its facets, and supporting services (M_2), are, as a category, more important than personnel (M_3) and time (M_4), mainly because the use of personnel is already expressed in the use of the space and the nature of the facility and supporting services, as a result of which this part can more readily be seen as an aspect or possible requirement for the other two sub-coordinates. The geographic and social position of a space, the use made of it and how it is laid out determine to a large degree the nature of an aesthetic event, because they can have so much influence (which may be positive or negative) on the realization of the aesthetic values of the works presented in that space. Venues,

through their isolating effect (e.g. theatre in a bus or on the beach, visual arts on a square or an airport), can have the effect not only of having viewers watch in a more concentrated fashion, but also reinforce the sense that something is being shared with others. The space in which an event is organized can also help audience members to establish a relationship between the work and their own perception of reality. The place where this takes place can, quite simply, make it easy or even possible to take part, which has the effect of directly influencing one of the other coordinates, that of the audience. And finally, while time can be viewed as an abstract factor (although it doesn't have to be, it can be turned into a theme or specifically used) the space is always subject to a specific use, even if conventions give the impression (which is what conventions do) that this is not so. Even conventional use of space is specific and thus contributes to the nature of certain types of events and the nature of the experiences which can take place within them.

Strictly speaking, almost all the various services which are provided as part of an aesthetic event occupy a place in selected spaces and form part of the use of that space. This applies, in the first place, to the core services, the presentation of the aesthetic utterance which is indeed, to a large extent, determined by the space. Spatial aspects can, in many cases, even be seen as parts of the core service. Facility and supporting services can also largely be provided in the spaces in question, in the form of ticket sales, catering, audience facilities, musical accompaniment or support, supporting aesthetic or other sources of information. However, there are a few exceptions to this. Outside the performance space, there may be a ticket ordering and reservation system with which people can communicate by telephone or Internet for ticket sales, and visitors can be provided with information (sent beforehand or afterwards) to support adequate reception. In such cases personnel will be deployed outside the space where the aesthetic event takes place. It may be said in general, as will be clear from the foregoing, that the space will be the most important aspect under the M (means) coordinate.

The nice thing about coordinates is that by describing them, the objects for which they are the coordinates can be located. Coordinates only have meaning in relation to one another, and if even one is missing then it is impossible to find what one is looking for. This also applies to the coordinates for aesthetic events: by describing all three of these the type of event will be determined and the more that sub-coordinates are used (specifications), the more precisely a type will be revealed, so that a distinction can also be made from other types of events taking place in the area. To distinguish an exhibition from a concert or a ballet a very specified description of coordinates is mostly not needed, but to discern various forms within a specific discipline or genre, in other words to determine different aesthetic positions, a simple use of the main coordinates will mostly not be suffi-

cient, certainly not if the type of values to be realized by participation in the event have to be mapped. The fact that the coordinates are only significant in relation to one another, moreover, means that by describing one coordinate, a relationship is always found with another. In the context of the present study, it is particularly important here that in describing the various coordinates and sub-coordinates a link is made with the values of the aesthetic utterance on the one hand, and the interest and competence of the audience on the other. To conclude this section, the PAM Triangle presented below can serve as an aid in this.[14]

Figure 9.10 The PAM Triangle describes aesthetic events on the basis of their coordinates

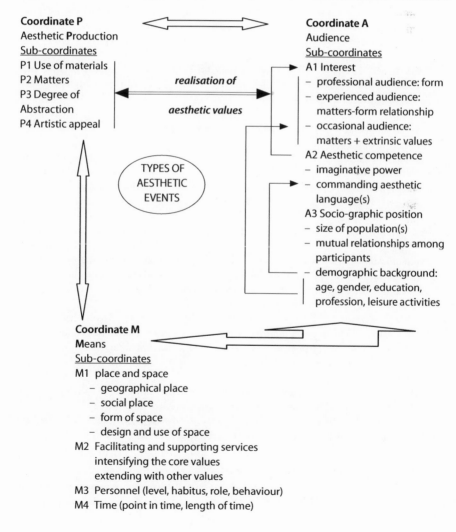

Notes

1 In this context the term 'artistic' is used rather than the more general 'aesthetic' because in practice a distinction is often made in the management of art institutions between the artistic and organisational part. The term is given here between quotes because factors other than those which directly affect the aesthetic communication can play a large or even dominant role in the habitus of an organisation. Sometimes this takes a form in which the marketing or commercial management of an institution actually 'takes over' responsibility for the core process.

2 The reason why these types of questions are not always asked very explicitly is that within the habitus dispositions, among them intentions, are implicitly and largely unconsciously present.

3 Cf. Van Maanen, 1995 and 1997; Boorsma, 1998 and 2001.

4 Many of these resources, for that matter, can also be applied in the value-enhancing sense.

5 Anne Marit Waade specifically raised this question in her challenging article 'When Art Becomes Culture. Contemporary Theatre and New Patterns of Reception' (*Nordic Theatre Studies*, vol. 14, 2001).

6 Furthermore, the situation in the Netherlands differs in this respect quite a bit from that in Flanders, where the relationship between both domains and with the public is stronger.

7 For further details, see also Gielen, 2003.

8 This work, consisting of a fifteen-metre-long boat in front of an even longer picture of a heavenly landscape of sea, sun, beaches and playing children, was exhibited in the twelfth Documenta at Kassel (2007).

9 In the US, attending charitable performances may still be designated as organised reception; in the former Eastern Bloc countries, performances were attended per factory or school. Nowadays, organised reception takes place as various forms of community art. Collectively organised reception of children's theatre is also still quite common.

10 What must be taken into account here is that also in social systems other than that of art, observations and communications are realized to a greater or lesser extent at a conceptual level and that aesthetic perceptions of these (economic, political, social and interactive) communications, may operate at the same level of abstraction as the original forms of communication. If these economic, political or aesthetic communications are included as such as material in new or existing aesthetic communications, they may become abstracted once again, but this is not necessarily so.

11 See Hadjinicolaou, *Art History and Class Struggle*. London (1978): Pluton Press.

12 With regard to a Dutch performance in 2007 about life in the Dutch East Indies just before Indonesia gained independence, in response to the question what they thought of the performance, various members of the audience responded: 'Wonderful, wonderful, those dresses....'

13 Although here more importance should be attached to the nature of the use, or rather the nature of the values which various population groups realise from the use of theatre.

14 Furthermore the PAM-triangle can be used not only to determine relations between aesthetic positions, but also between fields of aesthetic production.

10 How Aesthetic Values Become Contextualized

10.1 Introduction

In the third part of this book, and particularly in this final chapter, the question asked was how the values of art obtain a function in society. Chapter eight was principally about the ways in which financial and economic, as well as political and legal, factors condition the production and realization of aesthetic values. Chapter nine investigated how the distribution domain, which had already been shown to be the central domain within an aesthetic system, brings together the production and use of art in aesthetic events and thus organizes the aesthetic communication in a society. This resulted in the PAM Triangle which can be used to describe the nature of aesthetic communication forms within a culture, in particular at the level of disciplines and sub-disciplines.

Within this model, and during its construction, the possibility of contextualizing was mentioned here and there. Sub-coordinate A3 shows, among other things, the mutual relationships between participants and in the section on audience selection, various parameters were mentioned which implicitly refer to conditions under which values which, once realized, can take on a second life beyond the aesthetic event itself: organisability, need, interest and the place an event occupies in the social context of the participants.

The reception of art in the broadest sense takes on a double meaning when it comes to the functioning of art in society. This relates to the participation of population groups in aesthetic events which can be formulated and studied both quantitatively and qualitatively, on the one hand, and *the use* of the values outside the events in which they were initially realized, on the other. From a theoretical point of view, this contextual use of the perceived aesthetic value is difficult to grasp under theories which emphasize system separation and field autonomy. Bourdieu's field theory also does not offer much scope for this, while Luhmann's

communicative systems and the concept of passage in the Actor Network Theory certainly do. As with Luhmann, communication depends on perceptions (or social systems are structurally coupled with psychic systems), and one can easily imagine that aesthetic perceptions and the communications based on them feed other social systems, such as the political, legal or social life systems, even though these systems have their own types of communication. Recent politically sensitive aesthetic utterances about Islam being the most obvious examples of such a coupling. The observation of them leads to communications in religious, political, legal, educational and social life systems. In the first place these communications are even fed by the specific form-matter relationships of the aesthetic works concerned (how does what matter assume form and therefore what meaning?) and the questions raised as a result. In the second place, the straightjacket of the binary code of the 'receiving' systems is imposed and the aesthetic utterances are then only viewed and discussed in terms of their political, legal, and possibly economic meaning. This is due to the operative closure of communication systems and certainly not least of all due to the predominance of the economic and political systems over the cultural system, in what Bourdieu refers to as the field of power. And whether the aesthetic communications are as such 'picked up' by other systems depends on the dominant system within the cultural field itself, that is, that of the media. In terms of ANT, this sort of aesthetic communication goes through two passages. They are first taken up in the media system, as a result of which they largely lose their aesthetic meaning in favour of a certain news and/or entertainment value; then, through various mutations, they become part of new networks of communication in which they become politically, legally, economically and so on 'networked' and 'loaded'. A central question, which will be addressed shortly, is to what extent aesthetic utterances can still retain something of their intrinsic value once they become coupled with other networks. Could it be that there is something such as the 'unmarked aesthetic part' within political and other communications? Another question is whether (and, if so, how) aesthetic communications which less easily gain entry into adjoining systems through the media system (because the matter to which they give form is less interesting to the media, for example), can still play a role in society outside the aesthetic system.

For *artistic* utterances in particular, it is always the case that they must overcome a certain resistance. Because they generate not comfortable but challenging perceptions, what that means is that at the individual reception level the prevailing perceptive senses are turned upside down and that at the level of societal reception this takes place with collective perception or ideologies (in the neutral and partly material sense which Althusser assigns to them). Ways of perception at both levels are assigned a place in consciousness through the interaction sys-

tems (in the family, at work and at school, in clubs and societies, the neighbourhood or community, and night life) which is where people actually interact with one another. It is, however, the question whether and to what extent within these systems of interaction there is room, or room can be created, for new perceptions, given the fact that in a mediatized society, perception of reality is greatly influenced and controlled by the media.

This media system, and television in particular, under the yoke of the economic system, has a strong tendency to turn all information into entertainment. 'Entertaining/not entertaining' could well serve as the binary code of the TV system. The Dutch film critic François Stienen links to this the far-reaching consequence that engaging art can be shown on television but it cannot work there. A 'confronting documentary', for example, 'will lead at most to applause but not to critical reflection' (2005: 34), and Stienen further says that the maker of *Fahrenheit 9/11*, Michael Moore, can 'film whatever he wants, he will simply have no influence in a TV culture' (ibid.). It is a present-day echo of what Walter Benjamin noted in the 1930s, that 'we are confronted with the fact (...) that the bourgeois production and publication apparatus is able to absorb appalling amounts of revolutionary themes, even to propagate them, without questioning its own survival (...)' (Benjamin 1966 [1934]: 104-105). And not only 'without questioning its own survival', but also without even having to *doubt* its own survival. Benjamin's suggestion for dealing with this disturbing power of the mass culture production apparatus was to supply nothing that, once accepted, would attack the production conditions of the apparatus. And his example of this was Bertolt Brecht, who lured the film industry into lurid legal court battles during the filming of the *Threepenny Opera*, but who, during his exile in the US, had very little say in the American film industry.

Perhaps even more than in the period analysed by Benjamin, the present media are capable of taking up and publicizing all possible artistic perceptions, specifically because it also tempers their appealing powers. For, these perceptions are always in the minority compared with the popularly held view, and at the same time their effect can be reduced to minimal proportions by chat shows and commentators. This has to do with the fact that perceptions only become dangerous if the prevailing concepts which initially go unnoticed but which are necessarily part of the play, change in the perception of a work of art and in such a way that also outside the artistic communication they can no longer retain their former meaning in the cognitive system. It is commentators and chat shows in particular which make use of the spoken word and are therefore capable of taking on board changes in cognitive concepts at the level of meaning.

In this sense, *making use* of artistic experiences can be interpreted as creating the space to be able to change the concepts involved through which the world

is 'interpreted' or 'known'; a transition from observation to consideration, so to speak. This then raises the question again of where and under what conditions this space can be found, also specifically when artistic observations which operate in the perception domain are operatively separate from conceptual observations produced in the thinking domain. Or, formulated at a societal level of aggregation: the production of experience in artistic practices is operatively separate from the production of knowledge, understanding and insight in educational and informative practices.

10.2 Structural coupling between different social systems

The operative separation between the production of artistic experience and the production of knowledge, understanding and insight as formulated above does not exclude the possibility of a structural coupling between both psychic systems; more than that, notions and opinions play an implicit part in the production of perceptions, and conversely, perceptions can play a role in the renewal of concepts and the generation of insights. In other words, although the systems of perception and thought may produce their own elements, they are also open for those of the other system. For art to function in a society, it is important not only that people, many people, take part in artistic communication systems, but also that the perceptions produced in them *can* be related to concepts which organize insights into and notions about reality. If this is not the case, the artistic experience may well receive mental applause, but it further evaporates into nothing. For this relationship to actually come into being, some space has to be found in the mental system as a whole, or perhaps an opening created by cracks in the normal way of seeing things (in the sense of both perceiving as well as understanding), similar to what Bourdieu refers to at the field level as 'a space of possibles', which is created when 'structural lacunas' which demand to be filled occur in a field. In a similar way, the desire for new insights should provide space for changes in cognitive concepts like those offered by artistic perceptions.

In addition, however, these types of cognitive concepts and insights have, in turn, to be further used to maintain themselves. This can take place in continually evolving perceptive schemata on the one hand, while there is a need for embedding them in the social systems in which people take part, that is, in communications, on the other. At this level, too, we may speak of perceptions in a sense, but now in a materialized form, in art or other utterances in which the world is presented in forms rather than thought of in concepts. And indeed, here, too, the same space of possibles may be revealed in the production of views about the world, influenced by the way in which commonly held views are played with in

artistic communications, even if this only takes place implicitly in works of art and within the frame of production of perceptions. Here we enter the area in which possible structural couplings between different social systems can occur, in particular the coupling between the artistic system and another.

According to Luhmann, social systems consist of communications. They may be operatively closed but open to outside impulses, thereby making structural coupling possible. A large part of the communication takes place in interactive systems which are part of social systems where communications respond to one another in the presence of the people taking part in the communication. For the sake of clarity it is important to note that it is not the people which form the systems but that an interaction system is also a system of communications. What Luhmann did not point out, but which is typical of interaction systems, is that they, because of the presence of the participants, are to a greater extent open to different types of communications, simply because those present are able to 'hop' from one thing to another, or in other words, they can continually interrupt a communication process in order to set another type in motion, even if a specific type of utterance does not require it. Everyone has been to parties or meetings where one can't make out what people are talking about because the communications are not what might be expected in view of what was previously said. But in the serious business of artistic communication too, the system can regularly change its nature. Let's say for example, that some art critics in a panel discussion are discussing artistic aspects of a certain work of art in relation to other works and that one of them makes a connection with the legal problem of its similarity to another work, to which the other panellists then respond in legal terms; in this case the artistic interaction system changes from one moment to the next into a legal interaction system, unless the critics concerned are not at all well versed in the law and the second part of the discussion is actually nothing more than idle chit-chat, which is an interaction system of social life communications. Such shifts from one system to another constantly occur in interaction situations – and particularly in social life interactions – and this can only happen because elements within the one communication system refer to elements in another. Although communications in the artistic system cannot as such serve as building blocks in another system (political, economic, social life, etc.), it cannot be ruled out that *elements in* these communications can play a role in another system. We have seen something similar in the implicitly involved concepts which are renewed in artistic communication, so that they can no longer function in their old form in the creation of insight, but must also be renewed in that domain. Thus it cannot be ruled out that communications about art, for example, about a particular way of dancing or playing music, contain elements which are picked up in a political or economic communication where they even have a certain impact; or, conversely, that a politi-

cal debate contains elements which critics see as theatrical. These possible transitions are always based on the fact that an explicit concept has an unmarked size in the one system which remains implicit, but which then becomes marked by the other system and related to the relevant binary code. Someone speaking about the artistic value of a painting, for example, is not talking about its economic value, but this meaning certainly has an unmarked presence and can easily be made explicit in the economic (interaction) system of an auction house which has to review its valuation on the basis of what has been explicitly communicated in the artistic system. The same applies to theatrical elements which have an unmarked presence in political communication but which can become marked by art critics, as a result of which the nature of political communications can be seen in a very different light. Thus it could be said that the unmarked parts of a communication mediate in the transition from the one communication system to the other.

In fact, this is still about the role cognitive concepts and insights (instead of perceptions) can play in the relationship between different communication systems. And besides this, for the time being we have left aside the fact that there are differences in dominance between these systems and that these become immediately apparent as soon as interaction, particularly social life interaction occurs. Of course, many of the legal, political, educational and other communications take place within interaction systems but, in principle, in these cases it will be clear what the dominant binary code is and therefore which system is dominant, even though from time to time this can easily be set aside for the purposes of a discussion, or a joke in an entirely different area. Such alternative communications, such as painting collections in business corporations will not have much impact on the dominant system, for example, unless the system is completely out of balance and therefore an ocean of possibles is created. In social life communications which, by definition, largely take place within interaction systems, varying dominances can occur more easily, however. As this system is essentially about 'belonging/not belonging', results can be achieved through communications in all sorts of different areas, even if only because the people taking part in the system must be able to join in with the discussion in all kinds of different areas and need to have views, also because of the significance of these interaction systems in terms of the forming of personal and group identities. It could be said that social life communication is over-determined, which also directly implies that there is a mutual hierarchy between the various determining systems.

Besides the question which Benjamin – and to a certain extent Stienen also – asks, that is, how can one intervene in the media production of common representations, the question which presents itself is to what extent is it possible to escape this dominance *in interaction systems?* It is clear that interaction systems, in particular those in social life systems, essentially offer the best opportunities

to escape from the dominance of prevailing cognitive concepts and ideas, because they, in any event, make it possible to test them in different sorts of communications. The foregoing also partly answers the question of whether this also applies to representations, and artistic perceptions in particular: artistic communications bring unmarked concepts with them which can start to play an explicit role in other communications. But there is more to this: 'Art makes perceptions available for communication', which means that also at the level of the representations of a reality, communication can take place, between artworks on the one hand, but also through the reactions to aesthetic utterances, on the other, in the form of calling out, fits of laughter or tears, meaningful silences, understanding looks or looks of dismay, comments or actions about what has been seen or heard, possibly resulting in an 'artistic discussion'. The more that such a communication system develops, the more that aesthetic perceptions can also play a role in interaction systems, can validate themselves and acquire a (challenging) position within the system of representations which a community cherishes. In other words, the artistic value of a work acquires significance in society in the communication it generates, first on the level of perceptions, and second as soon as the cognitive concepts involved in the artistic perception are then used in other types of communication systems.

10.3 How to organize the realization of artistic values?

The foregoing means that the realization of artistic values in a society not only requires that the right conditions be created under which people can partake in aesthetic experiences, but also the conditions under which those experiences can take root and gain meaning in a societal context. How that works will be considered here from two different angles: based on the guidelines proposed by Brecht in 1935 in his essay 'Writing the Truth', the possible contribution of the artist to this will be discussed; thereafter the possibilities for structural coupling between the various social systems will be considered, in particular, between the artistic, the educational and the social life systems.

10.3.1 On the representation of 'the truth'

The term 'truth' plays a fundamental role in the modern history of the arts.[1] Two of the most important modern playwrights, Ibsen and Brecht, for example, fully deploy this concept and it is of critical importance also in the arts philosophy. This is entirely due to the fact that art is seen as a way of knowing, a way of grasping reality and, still in the manner of Hegel, revealing what is hidden. Almost all

of Ibsen's plays are about discovering the truth, both at the plot level, in which it is revealed step-by-step what has happened in the past and can serve as an explanation for the present situation, and at the level of the society in which the hypocritical behaviour according to Ibsen is based on 'the eternal lie' of the bourgeoisie. Truth often also means honesty and openness here. He ends his *Pillars of Society* (1877), for example, with the following lesson which the characters have learned and which is now passed on to the audience:

> BERNICK:...I have learned this too, in these last few days; you women
> it is you women that are the pillars of society.
> LONA:You have learned a poor sort of wisdom, then,
> Karsten. No, my friend; the spirit of truth and the
> spirit of freedom – they are the pillars of society.

Brecht sees his theatre as 'scientific', theatre in the form of an experiment in which it is attempted to understand reality and thus also at least establish what is not right in the way in which that reality is understood or what is not 'true' in its representation. This approach is probably most clear in Brecht's *Der gute Mensch von Sezuan* (*The Good Person of Sezuan*, 1939-1941), in which he begins an experiment by bestowing a divine gift of 'more than a thousand silver dollars' on Shen Te, who may use it to create a life but at the same time she must try to remain as good as she is. Brecht allows her to investigate all the possibilities for this and when she finally reaches the conclusion that it is impossible to live a good life in a bad world, Brecht then asks the spectators, after they have followed this experimental search for 'the truth', if they can think of a solution:

> How could a better ending be arranged?
> Could one change people? Can the world be changed?
> Would new gods do the trick? Will atheism?
>
> *You* write the happy ending to the play!
> There must, there must, there's got to be a way![2]

The message is: find out what is true, although the search for truth here tends more towards the search and desire for 'the other possible'. While Ibsen sees truth mainly as a moral matter, in Brecht it appears to be more a question of 'what is theoretically reliable', what can be scientifically counted on as 'true' and he adopts the materialistic dialectic method for this. But in his 1935 essay 'Writing the Truth: Five Difficulties' he uses this notion also in Ibsen's sense, as that which is hidden by a lie,

'Nowadays anyone who wishes to combat lies and ignorance and to write the truth must overcome at least five difficulties', Brecht explains to German writers when he points out to them their responsibility to offer resistance to the fascist ideology (1973 [1935]: 228). They must have the courage to write the truth, the keenness to recognize it, the skill to wield it as a weapon; the judgment to select those in whose hands it will be effective; and the cunning to spread the truth among such persons.

Although in the present time reality itself is understood to be a set of constructions and 'the' truth, waiting to be revealed, hiding behind an apparent reality, therefore no longer exists, a distinction between true and untrue representations is certainly still of importance. And in that sense, Brecht's essay can have some useful lessons for the artist who wants to ensure that her 'truths' gain meaning in society, or in other words, who wants to ensure that the way in which she betokens or represents reality, functions in society. This then is not first and foremost about having the courage (although given present-day threats, it may be necessary), or the keenness or shrewdness (let's assume that artists have their own methods for analysing the world), but rather the other three requirements in a modern form. The skill of being able to wield the truth like a weapon means in Brecht's terms that the artist should not view fascism as a natural disaster but as something which could have been prevented and can be combated.

> The man who does not know the truth expresses himself in lofty, general, and imprecise terms. He shouts about 'the' German, he complains about Evil in general, and whoever hears him cannot make out what to do. Shall he decide not to be a German? Will hell vanish if he himself is good? ... All this is put in general terms; it is not meant to be a guide to action and is in reality addressed to no one. (Ibid.)

'Not meant to be a guide to action....'. That sounds as though an artwork must of necessity lead to political or other action, just as Augusto Boal, for example, also referred to his theatre as an 'exercise for the revolution'. But in the light of this study it can also be taken in a more general sense. Artists who want the challenging way in which they represent the world (challenging relative to the prevailing representation of 'truth'), to have significance also beyond that of its immediate reception should, according to this guideline, ensure that the artistic observation and the concepts that it 'encompasses' are *useable*; what this means is that they can be applied in the perception and understanding of, and in dealing with the world in which the people using art must live. Because images and concepts which are not used vanish without trace: 'the product [in this case the representation constructed in the reception, HvM] only attains its final consummation in consumption. A railway on

which no one travels... is potentially but not actually a railway', to repeat an old but still true quote from Karl Marx (1973 [1857]: 85). Or: a new representation which plays no part in other social systems than the aesthetic will have no societal impact.

To make this impact achievable, Brecht imposes a second condition on the artist:

> 'Writing for someone' has been transformed into merely 'writing'. But the truth cannot merely be written; it must be written for someone, someone who can do something with it. The process of recognizing truth is the same for writers and readers. In order to say good things, one's hearing must be good and one must hear good things. The truth must be spoken deliberately and listened to deliberately. And for us writers it is important to whom we tell the truth and who tells it to us. ... And the audience is continually changing. Even the hangmen can be addressed when the payment for hanging stops, or when the work becomes too dangerous. (Id.: 230)

The realization of this second task, the finding and addressing of the right audience, an audience that is open to the challenge, not only in terms of form but also in terms of matter, is in fact a necessary condition to achieve the first task, because only this audience can indeed make use of the uncommon representation. In this respect artists are, of course, largely dependent on actors in the distribution domain which, however, is too often based on the general and public offering of works and events *in the hope* that people will make use of them and in the belief that these are the people (and also as many people as possible) that the artist wishes to address and, indeed, that they can and will use their experience of the work in their communications.

Finally, Brecht speaks of the cunning that is necessary to reach this audience. The most interesting aspect of this is what he says about dealing with language. The use of words in a different way than they are usually used is considered by Brecht as cunning, but is, in fact, the typical work of the writer, whether cunning or not. Anyone who writes investigates reality through the written word; no meaning is self-evident and no word has a fixed meaning. Therefore, playing with words has nothing to do with cunning, but as such with artistry. Nevertheless, Brecht has some words worth considering on this point:

> In our times anyone who says *population* in place of people or race...is, by that simple act, withdrawing his support from a great many lies. He is taking away from these words their rotten, mystical implications. The word *people* (Volk) implies... certain common interests. ... The population of a given territory may have a good many different and even opposed interests – and this is a truth that is being suppressed. (Id.: 231)[3]

The way in which Brecht speaks of the cunning which is needed in situations where censorship prevails, is not of any great relevance to the present-day situation in Europe. Where there is censorship, wrongdoings in a country can be denounced by performing plays or writing books in which these misdemeanours take place in the enemy's country. Writing in a specific genre can help when it comes to addressing certain matters. Detective novels and TV thrillers, for example, offer the opportunity to draw attention to police corruption or forms of class injustice. Conversely, high-quality artistic language falling beyond all suspicion of a political agenda, can help to protect challenging observations. These are examples of how artists behave in situations which make it difficult to communicate certain material, which in the Germany of 1935 was much more the case than in Europe today.

In the present time it is, in large parts of the world at least, not so much the problem that the matter cannot or may not be addressed but that the specific, challenging perceptions of such work do not gain a sufficient position in aesthetic and thereafter other communication. What is required to achieve this is not so much cunning, but rather the typical matter-form relationships which can turn an artistic observation into a weapon and, besides that, the search for an audience which can do something with it, must be coupled with the underlying links between the various social systems and the way in which the aesthetic distribution domain operates within these relationships.

10.3.2 *Possible couplings between the aesthetic and other social systems*

Representations of and ideas about reality are developed in all social systems and play a part in all interaction systems, but it is the education system and that part of the social life system known as family life, which specialize in this. The binary code of the education system is 'knowing/not knowing' in the double sense of capability on the one hand and knowing and understanding on the other. The binary code of the art system has been formulated as 'fitting/not fitting of imaginative forms', forms which represent something in a way which either rings true or does not; forms which make reality 'known' in a specific and different way. In that respect it is therefore certainly not strange that the art system and the education system are coupled together. One of the difficulties here is that by far the largest part of the education system is dedicated to the development of knowledge and skills which make it possible for people to take on a role within a social reality, while aesthetic communication seeks a reflective and often inquiring distance from this reality. Artistic and educational communications can therefore quite easily collide with one another. Nevertheless it may be expected of educational systems that they enter into a structural coupling with aesthetic systems, specifi-

cally because the latter makes other perceptions possible and thus increases the knowing and the ability to know.

It is not only the educational system which can benefit from this coupling (a benefit which it itself does not always seem to recognize), the art system too, as was already made clear above, has an interest in an organized relationship with the education system, specifically to realize in society the values which it creates. This coupling is generally organized at a subject level, and then in the discipline of 'arts education', which in any case makes the connection immediately apparent from the name. But what does this mean? Art education can be interpreted as all forms of education in which art serves as a goal or as a tool, but the courses and curricula are generally set up such that students develop their active, receptive and reflective aesthetic capabilities. They learn to act, sing, and draw, besides this they learn how to watch and listen to aesthetic expressions of their own and others and gain a command of the language in which they can communicate about this. This is extremely important, but apart from the fact that much of this education is only provided to a handful of students, specifically those who wish to use their competences in this area and thus satisfy a need, two other problems can arise: a) the educational goals are formulated entirely on an individual basis; b) the interaction with art is not integrated in the wider context of the educational perception of reality. What the first implies is that the use of aesthetic observation within a system of aesthetic communication is going to be difficult to achieve. The second means that neither artistic perceptions as such nor the implicit cognitive concepts contained within them can be tested against other types of observations or in anything other than aesthetic communications. Even though both forms of embedding of aesthetic perceptions are necessary to be able to provide their values with a context which gives them meaning and thus keeps them alive.

Like all types of processes, these types are based on organizational structures which make them possible and even force them. In this case these are the structures in which the relationships between educational and aesthetic institutions are organized. If the system of aesthetic communication must enable students to increase their capabilities within the educational system to imagine different realities and not the other way round, the educational system has only to help increase the aesthetic communication ability (a distinction that, as has become apparent, is made at the expense of both capabilities) the conditions for this can only be created by coupling the participants in both forms of communication with each other in interaction situations.

It is specifically because of the operatively closed nature of both communication systems that structural coupling (which we could also refer to here as integration) of the different types of communication at the process level is needed to create interaction situations in which artists and representatives of art institu-

tions can communicate with students and teaching staff and in doing so 'hop from one thing to another'; that is, constantly switch from the educational to the aesthetic system and vice versa and possibly to entirely different sorts of communication as well, such as economic, political or social. If such educational interaction systems are not provided for on a structural basis then a lot, if not all, of the aesthetic values which may be realized (possibly temporarily) while participating in aesthetic events or receiving films, books or music in the private sphere, will be lost, perhaps not at the individual level, but certainly at the societal level, simply because in the 'ordinary' educational interaction situation there is an insufficient command of the aesthetic languages to be able to escape from time to time, in a responsible manner, from the dominant code of knowing/not knowing. This is, by the way, only a relative escape because the artistic experience as such can be seen as a specific form of knowing.

If, on the other hand, there is an organizational basis available for a structural coupling between educational and aesthetic communications, both processes create a need for each other and where there is a regular coupling, this can ultimately lead in the societal context to a welcome addiction to aesthetic experience. The organizational basis for the interaction systems referred to can take various forms, such as the presence of artists' studios in regular education institutes; long-term cooperation contracts between theatre companies and schools, possibly linked to financial state support; or the involvement of students in doing research for writers. These sorts of conditions are necessary, but not enough. It must also be possible for the desired doubly integrated communication processes (in the sense of mutually coupled and embedded in contexts) to actually take place, with the required regularity and continuity, by ensuring that the education system caters for this in its curricula, staffing and examinations.

Although the total education system, which covers both regular and extra-curricular activities for children and adults, constitutes a very important and also a logical candidate for structural coupling with the aesthetic system, it is not the only one. In the various social life subsystems too, there is constant, direct and also largely indirect communication about perceptions of the world in which implicit use is also made of all sorts of cognitive concepts. Social life interaction is characterized by a constant switching between communication systems, although organized under the binary code of 'being part of/not being part of'. On the one hand these interaction systems are therefore very suitable for linking aesthetic communications; because they constantly question the participants about what they are interested in or committed to and what not, including representations of and views on reality, which thereby find a 'natural cultural' embedding. On the other hand in the reception of art within almost all disciplines there has been a process of individualization which appears to resist coupling of 'receptive aes-

thetic communication' to a system controlled by such a binary code. Moreover, *artistic* communications can indeed bring about identity conflicts within social life systems because of their unpredictable and challenging nature.

Nevertheless, it is necessary to look more closely at the coupling between both systems when considering the opportunities for art to function in society, i.e. to realize its values in society. The results will undoubtedly also apply in other interaction systems, but the social life system is the most obvious example. As has already been noted above, it is in family life that important communication series take place in which reality is represented and discussed and to a more limited extent the same also applies in leisure club and society life and night life. However, because of a general individualization of artistic experience in particular (with a concurrent collectivization of non-artistic aesthetic experience under the influence of the so-called experience economy and, as a consequence, society) the use of such in communication processes which in the first place help to form and control group identities, will not be the obvious choice. Here, the extremely important question arizes of where and how art can have meaning in society if the experience of it cannot play a role in social life systems? That the development of aesthetic competences in the education of some occupies a certain place is known, and that this stops at a certain moment, either at a given age or at a certain moment of development also; and especially that this takes place far too early so that the capacity for aesthetic reception in large groups of the population possibly extends no further than a positive appreciation of aesthetic utterances on the basis of what can be recognized within them. What this means is that for these groups the typical value of artistic communication is of no significance. The larger these groups are, the smaller the role of the arts in that society.

In this respect the key question is then whether the use of artistic experience can be organized in social life systems? And the answer is a cautious 'yes', despite the powerful dominance of an economy which is mainly interested in collective comfortable experiences, supported in this by the media system. A cautious 'yes' because in social systems, more than in aesthetic systems, collective experiences are expected and furthermore because the shift from non-artistic aesthetic communication to artistic communication is a relatively small step within the safe situation of an interaction system through which values can also be generated which enrich the system and give the participants the positive feeling of having participated in something special together. To give a very small-scale and trivial example: in the context of bachelor parties there is a growing trend among groups of friends to spend an afternoon in an artist's studio. This could be limited to making their best efforts to reproduce flowers on tapas dishes, but could also lead to the painting, performing or filming of black comedy scenes or fearsome imaginings concerning the forthcoming marriage. But on a larger scale: theatre

and dance performances do not as such have to take place in their own small (or large) isolation cells for audiences who do not know each other and mostly sit with their backs to one another; they can also just as well be organized as part of existing social customs, such as recently occurred in the Netherlands with a *Philoctetes* which was performed immediately before a town council meeting in the council chambers for the politicians, civil servants and spectators (on the public benches). There are countless examples of artworks which are presented in situations where people will come together anyway (of which art in public spaces is probably the best example) or to groups of viewers who visit an event because of a specific (festive or not) occasion. Without wishing to return to the appealing public nature of the mediaeval arts for urban populations (which in those days generally numbered no more than a few thousand or tens of thousands of people), one can certainly, together with Anne Marit Waade, ask oneself, why so many aesthetic activities still take place behind closed doors instead of in public places such as stadiums, plazas, public buildings or shopping centres.[4] Experienced in social groups and in social space, particularly artistic experiences might have a serious chance of getting 'a second life'.

Notes

1 Meant is roughly the period from 1860 to 1960.
2 This is from the 1956 translation by Eric Bentley (Bertolt Brecht, *The Good Woman of Sezuan*. Minneapolis 1999: 107). To give the reader an idea of the original, here the German version follows:
..........Was könnt Die Lösung sein?
Wir konnten keine finden, nicht einmal für geld.
Soll es ein andrer Mensch sein? Oder eine andere Welt?
Vielleich nur andere Götter? Oder keine?

Verehrtes Publikum, los, such dir selbst den Schluss!
Es muss ein guter da sein, muss, muss, muss!
3 The insertion of this quote, perhaps even the entire fragment on cunning in this text is in itself an example of an artful trick which I have used in the battle against the use of the word 'people'. The quote appears in the first place to serve the point of making clear Brecht's view on cunning, but is in reality mainly intended to point out the danger of using this 'p' word.
4 See note 5 of chapter 9.

Epilogue:

For a Second Life of Artistic Experiences

In the introduction this book set itself the task of examining 'how the organization of art worlds serves the functioning of art in society'. Later, this functioning of art was understood to be the realization of its potential values. In the first part it could be observed that the authors discussed there who, in general, took an institutional approach or variations thereon, hardly broached the way in which art acquires meaning in a society. Their focus was mainly on the dynamics in the field of the aesthetic production – possibly influenced by forces in adjoining fields – and on the notions by which these dynamics can be studied. In that respect, paradoxically enough, institutionally oriented authors are still trapped in a certain autonomism, or at least, are not inclined to adopt the relative nature of the autonomy, that they firmly acknowledge, as a basis to study the way in which aesthetic values can be contextualized. Nevertheless, what did surface as one of the results of this first part was the key art sociological question of 'What does art *do*?' And thus the question put was not only about the values of art, as is asked in the second part of this study, but also about the means and the routes by which these values of art obtain a function in systems other than the aesthetic, a second life so to speak.

In this respect much can be learned from a discipline that is popular in the first place, but, as all aesthetic disciplines, generates decorative, comfortable as well as artistic experiences: pop music. It clearly occupies an unusual position when it comes to the contextualization of its values. It has managed, also in its artistic utterances, to find a relationship between form and matter in which the use of the songs – as well as the concepts at work within them – facilitate social life communication. And, furthermore, it is the only discipline which, through the degree to which the artists as persons 'constitute' the artwork, linked to the economic value the discipline represents, is regularly able to escape the binary code of the media system and let its own voice be heard. Pop musical communication is continuously coupled with other social systems: people sing along in chorus with the songs or sing them for themselves or for other people during special

occasions; the genres in pop music run parallel with or sometimes even determine distinctions in cultural identities, and they do that specifically based on the typical matter-form relationships of the various genres. Pop musicians can even transpose concepts which are already present in their music to political, social or media systems where they are made explicit, for example, to serve a charitable purpose, sometimes temporarily escaping from the dominance of the binary code of the media system, at least in the reception domain. In short, pop music plays a meaningful role in the way in which the world is experienced.

Is this also possible in other aesthetic subsystems which, far less than pop music, can rest on what Shusterman termed physical forms of understanding? Apart from having a personal impact, can reading poetry, seeing a play, cabaret or film, or taking part in an installation, also have a societal impact? If there is the room in other systems, if there are structural lacunas present, certainly so, as in Western Europe in the 1960s and in Eastern Europe in the 1980s. If that is not the case and the room to manoeuvre is limited, one of the difficulties is to escape from the patterns through which dominant forces in the public sphere render artistic experiences harmless. But, in principle, three ways out are worth trying: 1) those involved in aesthetic events can communicate again with one another on the basis of the original experience, particularly in the context of other systems than the aesthetic; 2) people can try to 'share' the values of artistic experience with people who were not there, and 3) it is possible that artistic utterances or events have so much news and/or entertainment value that they indeed find a second (and different) life through the media. In the last case, couplings can be sought with the media system, if necessary in a cunning manner.

But the most fruitful strategy will be to organize artistic communication within or directly related to other social systems which welcome them as stimuli for their own communication. There is no doubt that in many cases the subsystems of distribution, as they organize the encounter between the arts and their users, have to adapt themselves to this task: making the arts function in society by coupling different social systems, instead of helping the arts to live in isolation.

One of the most challenging outcomes of this study is that, even if the research starts from the typical values offered by art production, the question of how the arts function in and for societies can only be answered by studying the systems of distribution, as they organise the encounter between the arts and their users.

This consideration asks for another way of studying the values of aesthetic utterances as well, for they should be discussed within the frame of the aesthetic event as a whole; the event in which aesthetic communication is organised and takes place. It is precisely the distribution domain that organises these events and the types of communication within them, and by that the use of values of aesthetic utterances.

In addition it has to be stressed that the domain of distribution organises its own relationship with other systems than the art system. And the ways in which this is done – from isolating the aesthetic event from other systems to embedding it in the practices of other systems – determine the possible contextualization of aesthetic perceptions to a high extent.

During the last decade, however, the blurring of the borders between different social systems did not only benefit the societal functioning of the arts, but involved a danger for it as well. Particularly the domains of economics and politics saw good opportunities to make use of the arts for their own profits (economically or politically), without basing their use of the arts on the intrinsic values of them. This is not necessarily a problem, but will become one, as soon as the distinction between aesthetic, particularly artistic values and other possible values works of art may deliver, starts to disappear, at least in the communication of various social systems. This danger shows itself in the extent in which the notion of 'culture' has replaced the notion of 'the arts' over the recent years. It is a serious danger, not because the protection of traditional art disciplines should no longer be protected against new forms of art – since each discipline has its own types of decorative, comfortable and challenging values available for people – but because societies, communities and individuals will be limited in their opportunities to profit from the specific values, only aesthetic and artistic communication in particular, can provide them with. For that reason the thinking on the values of art has got such a central position in this study.

To resist the efforts of social systems around the art system to push the extrinsic values forward at the expense of the intrinsic ones is again an important responsibility of the distribution domain, since it is, more than the production domain, susceptible to heteronomous influences, and because the domains of production and reception are fully dependent on the distribution domain if the intrinsic functioning of the arts in society is at stake.

For these various reasons this study can be considered a plea for a certain shift in art sociological research from the domain of production to those of distribution and reception, based on the study of possible intrinsic values of aesthetic communication, framed as they are in different types of (aesthetic) events.

References

Abbing, H. (1989) *Een economie van de kunsten. Beschouwingen over kunst en kunstbeleid.* Groningen: Historische Uitgeverij.

—. (2002) *Why Are Artists Poor? The Exceptional Economy of the Arts.* Amsterdam: Amsterdam University Press.

—. (2005) 'De portemonnee van Hans Abbing' in: *Boekman* 62, pp 29-31.

Althusser, L. (1966) 'Lettre à André Daspre' in: *La Nouvelle Critique*, April 1966.

—. (1970) 'Idéologie et appareils idéologiques d'État (Notes pour un recherche)' in *La Pensée*, no 151 (June 1970).

Baumol, W.J. and W.G. Bowen (1966) *Performing Arts: The Economic Dilemma.* New York: The Twentieth Century Fund.

Beardsley, M.C. (1958) *Aesthetics: Problems in the Theory of Criticism.* New York: Harcourt, Brace and World.

—. (1976) 'Is Art Essentially Institutionalist' in: L. Agaard-Morgensen (ed.) *Culture and Art.* Atlantic Highlands: Humanity Press.

Becker. H.S. (1982), *Art Worlds.* Berkeley: University of California Press.

Benjamin, W. (1966 [1934]) *Versuche über Brecht.* Frankfurt: Suhrkamp.

Bevers, T. (1993) 'Inleiding. Het kunstwetenschappelijk perspectief' in: T. Bevers, et al. (eds.) *De kunstwereld. Produktie, distributie en receptie in de wereld van kunst en cultuur.* Hilversum: Verloren.

—. (2003) 'Introductie' in N. Heinich (2003), pp 14-26.

Blokland, H. (1991) *Vrijheid autonomie emancipatie. Een politiekfilosofische en cultuurpolitieke beschouwing.* Delft: Eburon.

Blumer, H. (1969) *Symbolic Interaction, Perspective and Method.* Englewood-Cliffs, NJ: Prentice Hall.

Boorsma, M. (1998) *Kunstmarketing. Hoe marketing kan bijdragen aan het maatschappelijk functioneren van kunst, in het bijzonder van toneelkunst in Nederland.* Amsterdam, Groningen: Boekmanstichting.

–. (2001) 'A Network Approach to Art Markets'. In: *Nordic Theatre Studies* 14, pp 92-108.

–. (2002) 'Arts marketing and the societal functioning of the arts: the case of the subsidised dramatic arts in the Netherlands', *International Journal of Cultural Policy*, Vol. 8, No. 1, pp 65-74.

Bourdieu, P. (1980) 'Quelques proprétés des champs'. In: *Questions de sociologie.*

–. (1984) *Distinction. A Social Critique of the Judgement of Taste.* London: Routledge & Kegan Paul.

–. (1992a) *Opstellen over smaak, habitus en het veldbegrip.* Gekozen door Dick Pels. Amsterdam: Van Gennep, pp 171-178.

–. (1992b [1980]) 'Enkele eigenschappen van velden' in: P. Bourdieu (1992a).

–. (1992c [1986]) ' Economisch kapitaal, cultureel kapitaal, social kapitaal' in: P. Bourdieu 1992a, pp 120-141.

–. (1993), *The Field of Cultural Production. Essays on Art and Literature.* Cambridge: Polity Press.

–. (1996) *The Rules of Art, Genesis and Structure of the Literary Field.* Cornwall: Stanford University Press.

Bourdieu, P. and L. Wacquant (1992) *An Invitation to Reflexive Sociology.* Chicago: University of Chicago Press.

Brecht (1973 [1935]) 'Fünf Schwierigkeiten beim Schreiben der Wahrheit' in: *Gesammelte Werke*, Tl 18. Frankfurt am Main: Suhrkamp Verlag.

Breeuwsma, G. (1993) *Alles over ontwikkeling: over de grondslagen van de ontwikkelingspsychologie.* Amsterdam: Boom.

Brinton, M.C and V. Nee (eds.) (1998) *The New Institutionalism in Sociology.* New York: Russell Sage Foundation.

Bruch, N. vom (2007) 'Van ontwikkelen naar selecteren' in: *Boekman* 71, pp 92-99.

Callon, M. (2004) 'Actor-Network-Theory – The Market test' in: J. Law and J. Hassard (eds.) (2004), pp 181-195.

Callon, M., J. Law and A. Rip (eds.) (1986) *Mapping the Dynamics of Science and Technology. Sociology of Science in the Real World.* Hampshire and London: The MacMillan Press.

Carroll, N. (1999) *Philosophy of Art. A Contemporary Introduction.* London and New York: Routledge.

–. (2001) *Beyond Aesthetics: Philosophical Essays.* Cambridge: Cambridge University Press.

Chapple, F. and Ch. Kattenbelt (eds.) (2006) *Intermediality in Theatre and Performance.* Amsterdam, New York: Rodopi.

Cremona, V.A., P. Eversmann, H. van Maanen, et al. (eds.) (2004) *Theatrical Events. Borders Dynamics Frames.* Amsterdam, New York: Rodopi.

Danto, A. (2003 [1964]) 'The Artworld' in C. Korsmeijer (ed.) *Aesthetics: The Big Questions*. Oxford: Blackwell Publishing, pp 33-43.

–. (1973) 'Artworks and Real Things' in: *Theoria* no 39, pp 1-17.

–. (1974) 'The Transfiguration of the Commonplace' in: *The Journal of Aesthetics and Art Journalism* no 43, pp 139-148.

–. (1997) *After the End of Art. Contemporary Art and the Pale of History*. Princeton NJ: Princeton University Press.

Davies, S. (1991) *Definitions of Art*. Ithaca, London: Cornell University Press.

–. (2006) *The Philosophy of Art*. Oxford: Blackwell Publishing.

Dickie, G. (1964) 'The Myth of the Aesthetic Attitude' in: *The American Philosophical Quarterly*, no 1, pp 56-65.

–. (1965) 'Beardsley's Phantom Aesthetic Experience' in: *The Journal of Philosophy*, no 62, pp 129-136.

–. (1971) *Aesthetics, an Introduction*. Indianapolis: Pegasus.

–. (1974) *Art and the Aesthetic: An Institutional Analysis*. Ithaca: Cornell University Press.

–. (1984) *The Art Circle: A Theory of Art*. New York: Haven .

–. (1988) *Evaluating Art*. Philadelphia: Temple University Press.

DiMaggio, P.J. (1987) 'Classification in art' in: *American Sociological Review*, pp 440-455.

–. (1991) 'Constructing Organizational Fields as a Professional Project: U.S. Art Museums, 1920-1940' in: Powell and DiMaggio (1991), pp 267-292.

DiMaggio, P.J. and W. Powell (1991 [1983]) 'The Iron Cage Revisited: Institutional Isomorphism and Collective Rationality' in Powell and DiMaggio (1991), pp 63-82.

DiMaggio, P.J. and K. Stenberg (1985) 'Why Do Some theatres Innovate More than Others. An Empirical Analysis' in: *Poetics* no 14, pp 107-122.

Dorleijn, G. and K. van Rees (2006) *De productie van literatuur. Het Nederlandse literaire veld 1800-2000*. Nijmegen: Vantilt.

Edelman, J. (2009) 'Arts Planning in the Irish Theatre: A Cautionary Tale' in: H. van Maanen, A. Kotte and A. Saro (eds.) *Global Changes, Local Stages*.

How Theatre Functions in Smaller European Countries. Amsterdam, New York: Rodopi Editions, pp 229-264.

Eldridge, R. (2003) *An Introduction to the Philosophy of Art*. Cambridge: Cambridge University Press.

Eversmann, P. (1996) *De ruimte van het theater*. Amsterdam.

Foster, H. (1996) *The Return of the Real: The Avant-garde at the End of the Century*. Cambridge, MA: MIT Press.

Gadamer, H.G. (1986) *The Relevance of the Beautiful and Other Essays*. Cambridge University Press.

–. (1986 [1960] *Hermeneutik I. Wahrheit und methode. Grundzüge einer philosophischen Hermeneutik*. Tübingen: J.C.B. Mohr.

Gaut, B. (1997) 'The Ethical Criticism of Art' in: J. Levinson (ed.) *Aesthetics and Ethics*. Cambridge: Cambridge University Press.

–. (2002) 'Art and Ethics' in: B. Gaut and D. McIver Lopes (eds.) *The Routledge Companion to Aesthetics*. London, New York: Routledge, pp 341-352.

Gielen, P. (2003) *Kunst in netwerken. Artistieke selecties in de hedendaagse dans en de beeldende kunst*. Leuven: Lannoo.

Girard, A. (1972) *Cultural development: Experience and Politics*. Paris.

Hadjinicolaou, N. (1978) *Art History and Class Struggle*. London: Pluto Press.

Heidegger, M. (1962) *Being and Time*. New York : Harper & Row.

Heinich, N. (1997) 'Pourquoi la sociologie parle des oeuvres d'art, et comment elle pourrait en parler' in: *Sociologie de l'art* no 10.

–. (1999) 'Légitimation et culpabilisation: critique de l'usage critique d'un concept' in : *L'Art c'est l'art* (coll.). Neuchâtel: Musée d'ethnographie.

–. (1998a) *Ce que lárt fait à la sociologie*. Paris: Aux Éditions de Minuit.

–. (1998b) *Le triple jeu de l'art contemporain*. Paris: Minuit.

–. (1998c) 'The Sociology of Contemporary Art: Questions of Method' in: J. Schaeffer (1998). pp 65-76.

–. (2000a) 'What Is an Artistic Event? A New Approach to the Sociological Discourse', *Boekmancahier* no 44. Jrg 12, pp 159-167.

–. (2000b) 'Howard S. Becker's Art Worlds revisited' in: *Boekmancahier* no 44, pp 200-202.

–. (2002) 'Let us try to understand each other. Reply to Crane, Laermans, Marontate and Schinkel', *Boekmancahier* nr 52. Jrg. 14, pp 200- 207.

–. (2003) *Het Van Gogh-effect en andere essays over kunst en sociologie*. Amsterdam: Boekmanstichting.

Heusden, B. van (2004) 'Torn between two (autonomous) lovers: mimesis and beauty in modern art' in: B. van Heusden and L. Korthals Altes (eds.) (2004) *Aesthetic Autonomy Problems and Perspectives*. Leuven: Peeters, pp 113-129.

Hoefnagel, F.J.P.M. (1992) *Cultuurpolitiek: het mogen en moeten*. The Hague: SDU.

Kant, I. (2000 [1790]) *Critique of the Power of Judgment*. Cambridge: Cambridge University Press.

Kawashima, N. (2001) 'Decentralization in Cultural Policy: Unsolved Problems' in: *Nordic Theatre Studies* 14, pp 109-122.

Kieran, M. (2002) 'Value of Art' in: B. Gaut and D. McIver Lopes (eds.) *The Routledge Companian to Aesthetics*. London, New York: Routledge, pp 215-226.

Laermans, R. (1994) 'Een té grove borstel?: kanttekeningen bij Pierre Bourdieus Les règles de l'art' in *Boekmancahier* no 19, pp 6-25.

–. (1999) *Communicatie zonder mensen*. Amsterdam: Boom.

–. (2000) 'Nathalie Heinich, sociologist of the arts: a critical appraisal' in: *Boekmancahier* no 44, pp 389-403.

Latour, B, (1993) *We have never been modern*. Hemel Hempstead: Harvester Wheatsheaf.

–. (2004) 'On recalling ANT' in: J. Law and L. Hassard (2004), pp 15-25.

–. (2005) *Reassembling the Social. An Introduction to Actor-Network-Theory*. Oxford: Oxford University Press.

Law, J. (2004) 'After ANT: complexity, naming and topology' in: J. Law and J. Hassard (eds.) (2004), pp 1-14.

Law, J. and J. Hassard (eds.) (2004 [1999]) *Actor Network Theory and After*. Oxford: Blackwell Publishing.

Lehmann, H.T. (1999) *Postdramatisches Theater*. Frankfurt am Main: Verlag der Autoren.

Luhmann, N. (1984) *Soziale Systeme. Grundriss einer allgemeinen Theorie*. Frankfurt am Main: Suhrkamp.

–. (1995) *Die Kunst der Gesellschaft*. Frankfurt am Main: Suhrkamp.

–. (2000) *Art as a Social System*. Stanford: Stanford University Press.

Maanen, H. van (1997), *Het Nederlands Toneelbestel van 1945 tot 1995*. Amsterdam: Amsterdam University Press.

– (2001), 'Theatre Systems in Western Europe' In: *Nordic Theatre Studies*, no 14, pp 73-91.

– (1998) 'How to Describe the Functioning of Theatre' in: H. van Maanen and S.E. Wilmer (1998), pp 721-758.

–. (1999) '84 manieren om te vragen naar het functioneren van theatre: Theatersociologische vragen geschematiseerd' in: J. Callens et al. (eds.) *Peilingen. Teksten over Poëzie, Proza en Podiumkunsten*. Brussel: VUBpress.

– (2004) 'How Contexts Frame Theatrical Events' in : V.A. Cremona et al. (eds.). Amsterdam, New York: Rodopi Editions, pp 243-278.

Maanen, H. van, A. Kotte and A. Saro (eds.) (2009) *Global Changes – Local Stages. How Theatre Functions in Smaller European Countries*. Amsterdam, Atlanta: Rodopi Editions.

Maanen, H. van and S.E. Wilmer (eds.) (1998) *Theatre Worlds in Motion. Structures, Politics and Developments in the Countries of Western Europe*. Amsterdam, Atlanta: Rodopi Editions.

Macherey, P. (1966) *Pour une théorie de la production littéraire*. Paris: Maspero.

Marx, K. (1973 [1857]) *Grundrisse der Kritik der Politischen Ökonomie* (The Pelican Marx Library), trans. Martin Nicolaus. Harmondsworth: Penguin.

Mead, G.H. (1934) *Mind, Self and Society. From the Standpoint of a Social-Behaviorist*. Chicago: University of Chicago Press.

Moser, I. and J. Law (2004) 'Good passages, bad passages' in: J. Law and L. Hassard (eds.) (2004), pp 196-219.

Nee, V. (1998) 'Sources of the new Institutionalism' in: Brinton and Nee (1998), pp 1-16.

Nee, V. and P. Ingram (1998) 'Embededness and beyond: Institutions, Exchange, and Social Structure in: Brinton and Nee (1998), pp 19-45.

Nelson, R. (2004) 'Live or Wired? Technologizing the Event' in: V.A. Cremona et al. (eds.) (2004). Amsterdam, New York: Rodopi, pp 303-316.

Nussbaum, M. (2002 [1990]) 'Form and Content, Philosophy and Literature' in: C. Korsmeyer (ed.) Aesthetics: The Big Questions. Oxford: Blackwell Publishing. Publishing, pp 201-208.

Parsons, M.J. (1986) How We Understand Art. A cognitive developmental account of Aesthetic Experience. Cambridge: Cambridge University Press.

Pels, D. (1992) 'Inleiding. Naar een reflexieve sociale wetenschap' in P. Bourdieu (1992a), pp 7-22.

Powell, W. and P.J. DiMaggio (eds.) (1991) The New Institutionalism in Organizational Analysis. Chicago: University of Chicago Press.

Ramachandran, V. and W. Hirstein (1999) 'The Science of Art. A neurological theory of aesthetic experience' in: Journal of Consciousness Studies. Vol. 6 no 6-7, pp 15-52.

Sapiro, (2003) 'The literary field between the state and the market' in Poetics 31, pp 441-464.

Saro, A. (2009) 'The Interaction of Theatre and Society: The Example of Estonia' in: H. van Maanen, A. Kotte and A. Saro (eds.) Global Changes, Local Stages. How Theatre Functions in Smaller European Countries. Amsterdam, New York: Rodopi Editions, pp 41-62.

Sauter, W. (2002) The Theatrical Event. Dynamics of Performance and Perception. Iowa City: University of Iowa Press.

Schaeffer, J. (1998) (ed.) Think Art. Theory and Practice in the Art of Today. Rotterdam: Witte de With.

Schoot, A. van der (1993) 'Mooie dingen en het esthetisch subject' in: M. van Nierop et al. (eds.) Mooie dingen. Over de esthetica van het object. Meppel, Amsterdam: Boom.

Scitovsky, T. (1983) 'Subsidies for the Arts. The Economic Argument' in: J.L. Shanahan et al. (eds.) Economic Support for the Arts. Akron, OH: University of Akron. pp 15-25.

Shusterman, R. Pragmatist Aesthetics. Living Beauty, Rethinking Art. Oxford: Blackwell Publishing.

—. (ed.) (1999) Bourdieu: a Critical Reader. Oxford: Blackwell Publishing.

—. (2000) Performing Live. Aesthetic Alternatives for the Ends of Art. Ithaca and London: Cornell University Press.

Stecker, R. (1997) *Artworks, Definition, Meaning and Value*. University Park: Pennsylvania State University Press.

Stienen, F. (2005) 'Beelden zonder overredingskracht' in: *Boekman* 64, jrg. 17, pp 29-34.

Stokkom, B. van (1995) 'De jazz van de moderne ervaring. Over cultuurvernieuwing, plezier en belevingswaarde' in: *Beleid & Maatschappij*. Nr 6.

Swartz. D. (1997) *Culture and Power. The Sociology of Pierre Bourdieu*. Chicago: The University of Chicago Press.

Veire, F. vande (2002) *Als in een donkere Spiegel. De kunst in de moderne filosofie*. Nymegen: SUN.

Visscher, J. de (2002) 'Inleiding' in: Kant, I. *Over schoonheid*. Amsterdam: Boom. pp 7-26.

Weber, M. (1958 [1895]), *The Rules of Sociological Method*. 2nd ed. New York: Free Press.

Weitz, M. (1956) 'The Role of Theory in Aesthetics' in: *The Journal of Aesthetics and Art Criticism* no 15, pp 27-35.

Zeglin Brand, P. (2003) 'Disinterestedness and Political art' in: C. Korsmeyer (ed.) *Aesthetics: The Big Questions*. Oxford: Blackwell Publishing, pp 155-170.

Index

Made in the USA
Lexington, KY
29 December 2010